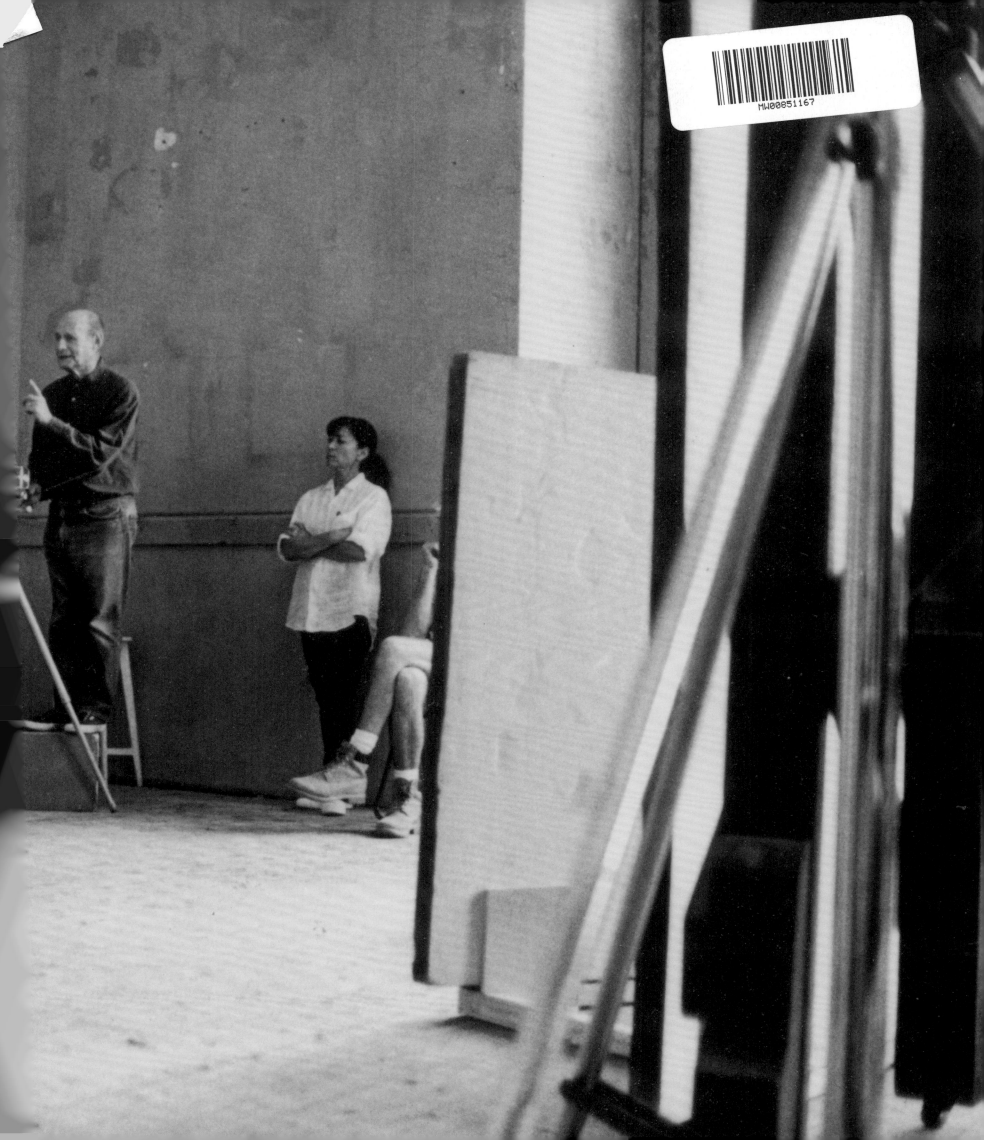

for Irving Penn

STOPPERS

Photographs from My Life at Vogue

Phyllis Posnick

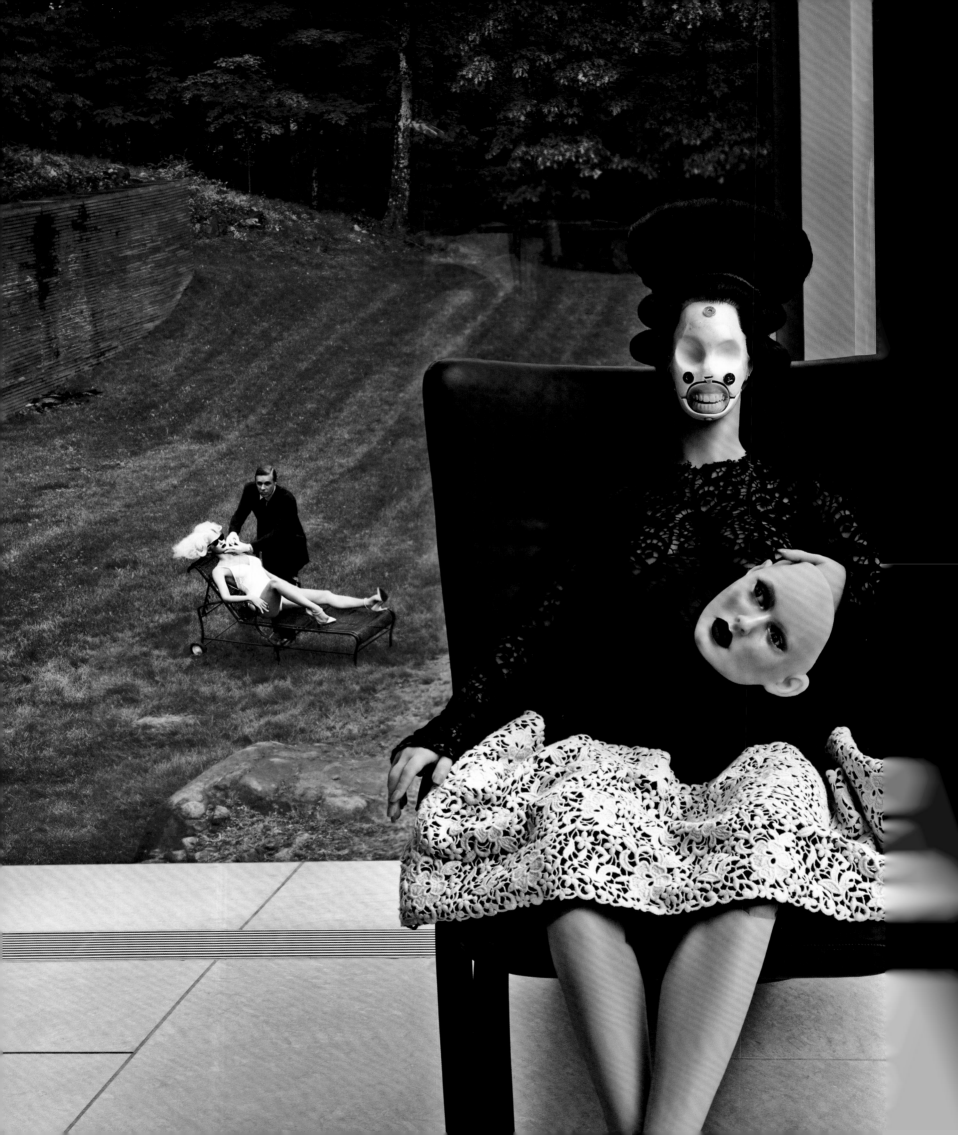

STOPPERS

Photographs from My Life at Vogue

Phyllis Posnick

Foreword by Anna Wintour

ABRAMS
New York

Contents

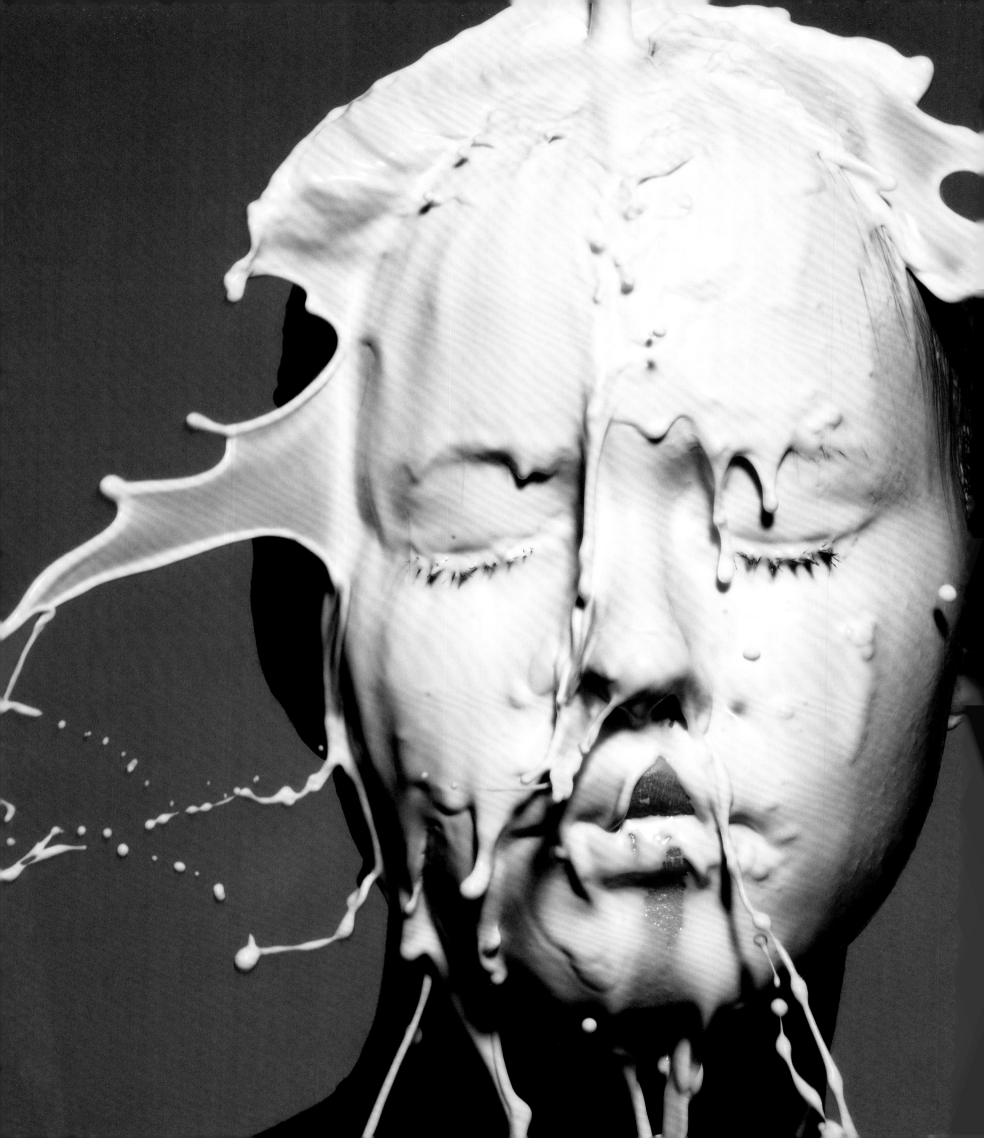

Irving Penn

Cult Creams
New York, 1996

Foreword

Whoever coined the maxim "A picture is worth 1,000 words" clearly had Phyllis Posnick in mind. For more than twenty-five years now, I've had the huge privilege of working with Phyllis and publishing in *Vogue* the fruits of her labors with Helmut Newton, Annie Leibovitz, Bruce Weber, Steven Klein, Tim Walker, Patrick Demarchelier, Mario Testino, David Sims, Anton Corbijn, and, of course, Irving Penn, or Mr. Penn, as he was known around the *Vogue* offices. Phyllis is more than a match for all of these consummate and renowned image-makers, who have no doubt counted themselves extremely lucky to be partnered with such a gifted and formidable collaborator. Yet there was something particularly magical about her pairing with Mr. Penn. That relationship flourished because she, like him, could distill the essence of any given story into one single and solely memorable picture, be it a portrait, a still life, or some wonderful conceptual flight of fancy. But if you have leafed through this book, pausing again and again to gaze at her incredible body of work, which is by turns majestic, intimate, and provocative, then you already know that. One has only to meet Phyllis to understand her particular brand of brilliance. Everything about her is meticulously planned, carefully considered, expertly executed. She herself is a study in rigorous taste (a personal style that borders on the ascetic) contrasted with unexpected flourishes (her passion for monumental vintage modernist Scandinavian jewelry). You could say the same of her approach to her picture-making, which she studiously—and, I'm sure she won't mind my saying, stubbornly—pursues in the name of originality and intelligence. Nothing is ever banal with Phyllis. She could be the creative offspring of Lee Miller and Luis Buñuel: from the former, a deep commitment to photojournalism, that an image should always convey a clear and direct meaning; and, from the latter, a twisted, surreal sense of humor, with Phyllis deploying a little shock value to draw you deeper into the narrative of the picture. She has certainly never shied away from taking risks, walking the line, going that little bit further to make a sitting work. I've always been amused by the tale of one of Phyllis's assistants taking a call one day from her boyfriend, who casually asked where she was. "In a sex shop, again, buying props for a shoot with Steven Klein" came her reply. In Phyllis's time at *Vogue*, she has wrangled everything—flora, fauna, insects, supermodels, movie stars, athletes, and all manner of titans of the cultural and political landscape. Phyllis makes every picture she takes for *Vogue* an adventure, and that, let me tell you, makes coming to work every day absolutely thrilling.

—ANNA WINTOUR

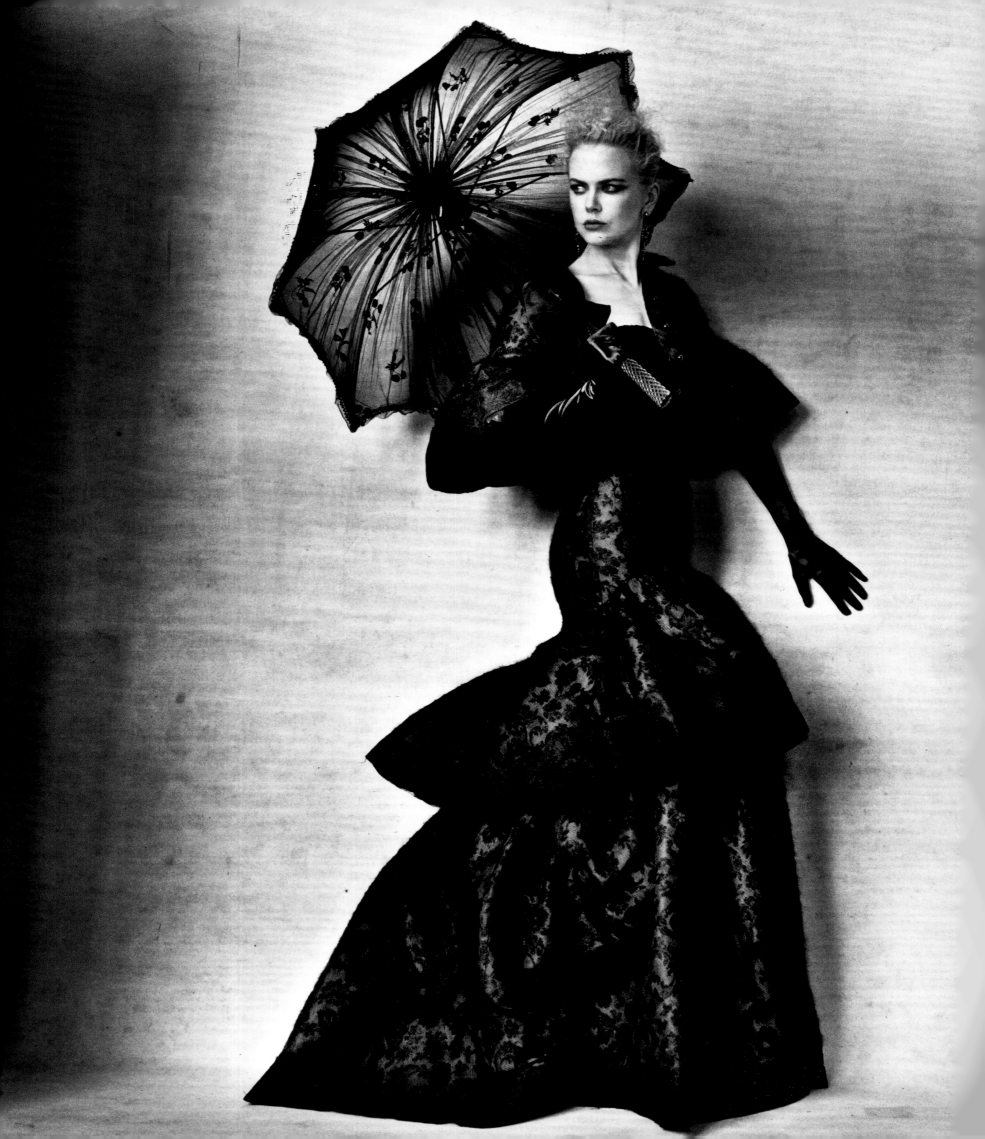

About Phyllis

I've been thinking about the picture Phyllis Posnick chose for the endpapers of this book. It's a photograph of her at work with Irving Penn in a big, largely empty daylight studio in Paris in 1995. He's standing on a wooden box behind his camera, facing a model in a mantilla across the room. He raises the pointing finger of his right hand as if to call for attention, a characteristic gesture that signaled he was pleased with the pose and wanted to arrest that moment. Posnick stands behind him and to his right, her back to the wall, her arms folded, patient, quietly alert, ready for anything; that combination of watchfulness and reserve has served Posnick well. After years at Penn's side, she could anticipate the moment when he would raise his finger, but she knew she had to prepare for the next moment and the one after that: a long day of revelations, frustrations, and astonishing beauty that Posnick has repeated in limitless variations—and with many different photographers— since she began her career in fashion. As a sittings editor at American *Vogue* since 1987, Posnick negotiates the often-fraught relationship between photographer and magazine—soothing, coaxing, and challenging both sides until a satisfying solution is reached. A powerful advocate, an incisive critic, and a canny diplomat, she's responsible for many of *Vogue*'s most audacious, beguiling, and memorable pages—the sort of pictures Alexander Liberman called "stoppers," a vivid term Posnick rightly claims for her title here. Liberman, legendary as the art director of *Vogue* long before he became the editorial director of Condé Nast, heads the list of "very good teachers" (including *Vogue* editors Babs Simpson, Polly Mellen, and Anna Wintour) who recognized and nurtured Posnick's particular talents. It was Liberman who decided she was the woman to handle Penn, a gentle, thoughtful, soft-spoken man who could, she discovered, also be infuriatingly "stubborn, difficult, and perverse." That they became close collaborators on so many extraordinary photographs is a tribute to Posnick's own determination and her willingness to go where Penn pushed her, which was usually beyond—past all expectations, conventions, and preconceived ideas. Her work with Penn helped prepare Posnick to stand alongside—to support, to caution—the many talented photographers whose work is collected here. Unlike most of her colleagues at *Vogue*,

she is charged with delivering single images, whether a cultural portrait or a shoot to accompany stories about health, beauty, and fitness. These pictures aren't illustrations of the article's theme, they're interpretations, often quite fantastic or playful flights of the imagination intended to catch the reader's eye and pique her interest. Paired with a photographer of well-established strengths, Posnick knows how to tweak a signature style and bend it to her purpose. Since many of her pictures aren't about the clothes, but the ideas those outfits dress, she's become especially adept at getting fashion photographers to compress the energy they usually devote to a multi-page narrative into the more focused concept of a single spread. The results are frequently their strongest work, with a serrated edge that Posnick, with Wintour's backing, has carved out a niche for at *Vogue*. Posnick's collaborators here—Anton Corbijn, Patrick Demarchelier, Klein, Leibovitz, Newton, Penn, Mario Testino, and Bruce Weber—illustrate the range, depth, and idiosyncratic creativity of contemporary fashion editorial work. I'll let her tell you about her experiences with each of them, but the variety of their images gives you an idea of the versatility and intelligence she brings to the task. She works without reference pictures, those visual crutches that photographers and stylists like to lean on when conceiving a project. Posnick finds such mood-board stimuli limiting, even stifling. "I don't want to repeat an image," she says. "I want to do something that hasn't been done." She prefers to work without a net, trusting her instincts and quick wit to break any falls; sly humor has buoyed many a picture. Some of the most striking images she works on are as hilarious as they are unsettling, but Posnick, a not-so-secret romantic, also enjoys a lovely bit of fairy-tale fantasy. See Leibovitz's red dress in the grass, Walker's model-turned-beehive, Demarchelier's rose-covered beauty, and Penn's girl behind the black-lace Minnie Mouse mask. "I have one picture, one chance to get the reader to stop, look, and read the article," Posnick says. "So the photos must be strong or unusual or funny or shocking." When Posnick's really on fire, the photos she's worked on can be all those things at once. And you never want to turn the page.

—VINCE ALETTI

Irving Penn
Nicole Kidman in an
Olivier Theyskens Design
for Rochas
New York, 2003

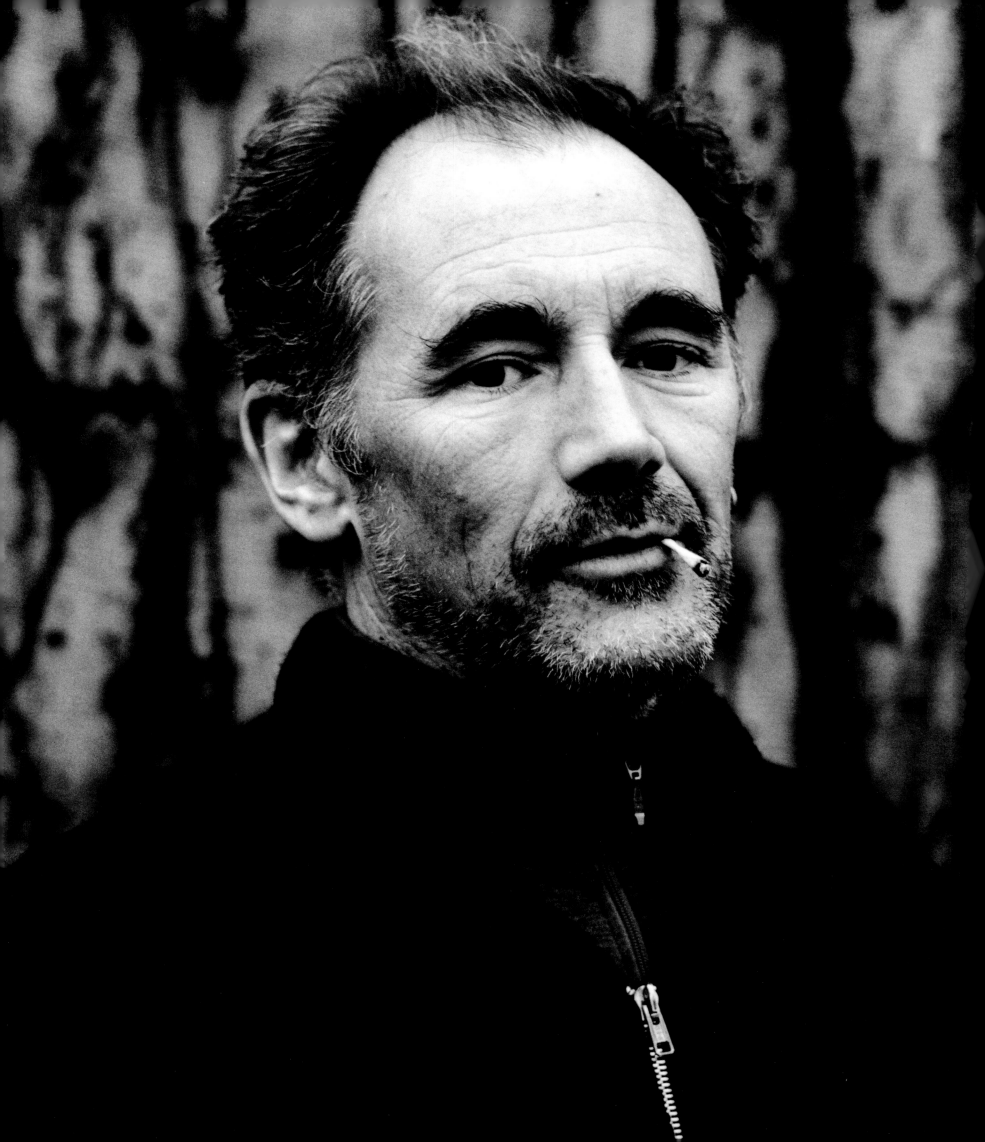

Working

I never worked with an editor, so I was apprehensive and uncomfortable, and whilst part of me wanted to present my European self as above all that "American fashion stuff," I also wanted to make sure I fitted the mold. Mark Rylance's triumphant take on the extraordinary Johnny "Rooster" Byron in the play *Jerusalem* was the basis of one of my first *Vogue* assignments with Phyllis. To show off my grittiness, I took Phyllis to a car demolition lot outside of London, far removed from the average *Vogue* location but connected to the spirit of the play. I wanted to show that my finger was firmly on the pulse of realism. Phyllis was quiet, which I interpreted as admiration of my cool approach. We were done within an hour as is the norm for me. Even more kudos to my coolness. Our nice car took us back to our nice hotel where I went to my room only to discover that my shoes were soaked in oil from the junkyard and I had left traces all through the hotel and room. Not so very cool. A few months later, we did a shoot with Philip Seymour Hoffman and Andrew Garfield, where I got an introduction to a more nervous, aggressive side of Phyllis and I think we found ourselves. It made me realize we were working together to get the best result out of every shoot. I saw how much hard work she puts into them. She is very culturally educated, her thinking is very creative with a curious mind; she is open to suggestions always, her observation is incredibly detailed, and most of all, she pushes me to make "my" photographs and not try to fit into the *Vogue* style. She has a great drive that is switched on whether at 6 A.M. or 10 P.M. When I work with Phyllis now, it is an educational day out. It is not a total Zen experience, but at times we are getting dangerously close to it.

—ANTON CORBIJN

Anton Corbijn
Mark Rylance in *Jerusalem*
London, May 2011

Annie Leibovitz
New York, February 2016

14

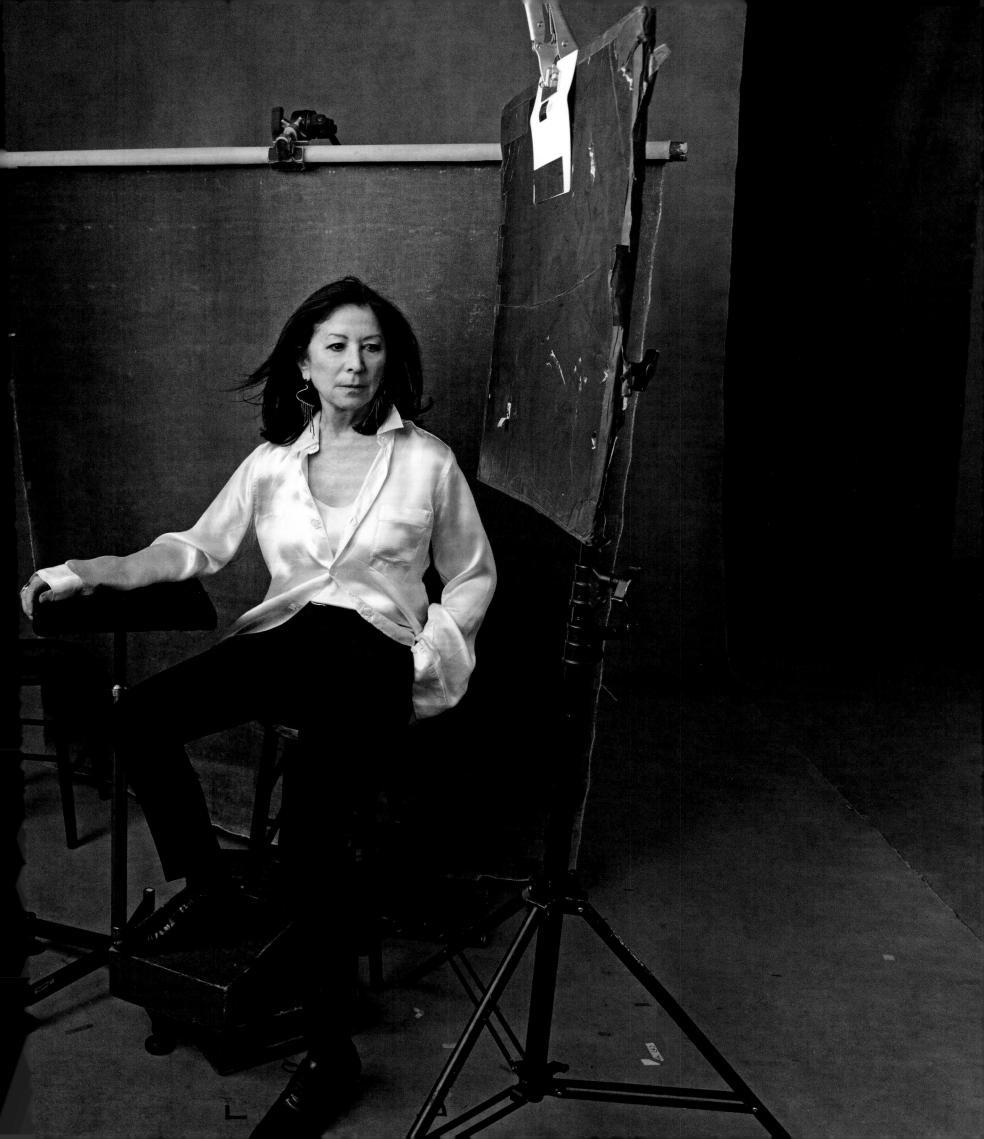

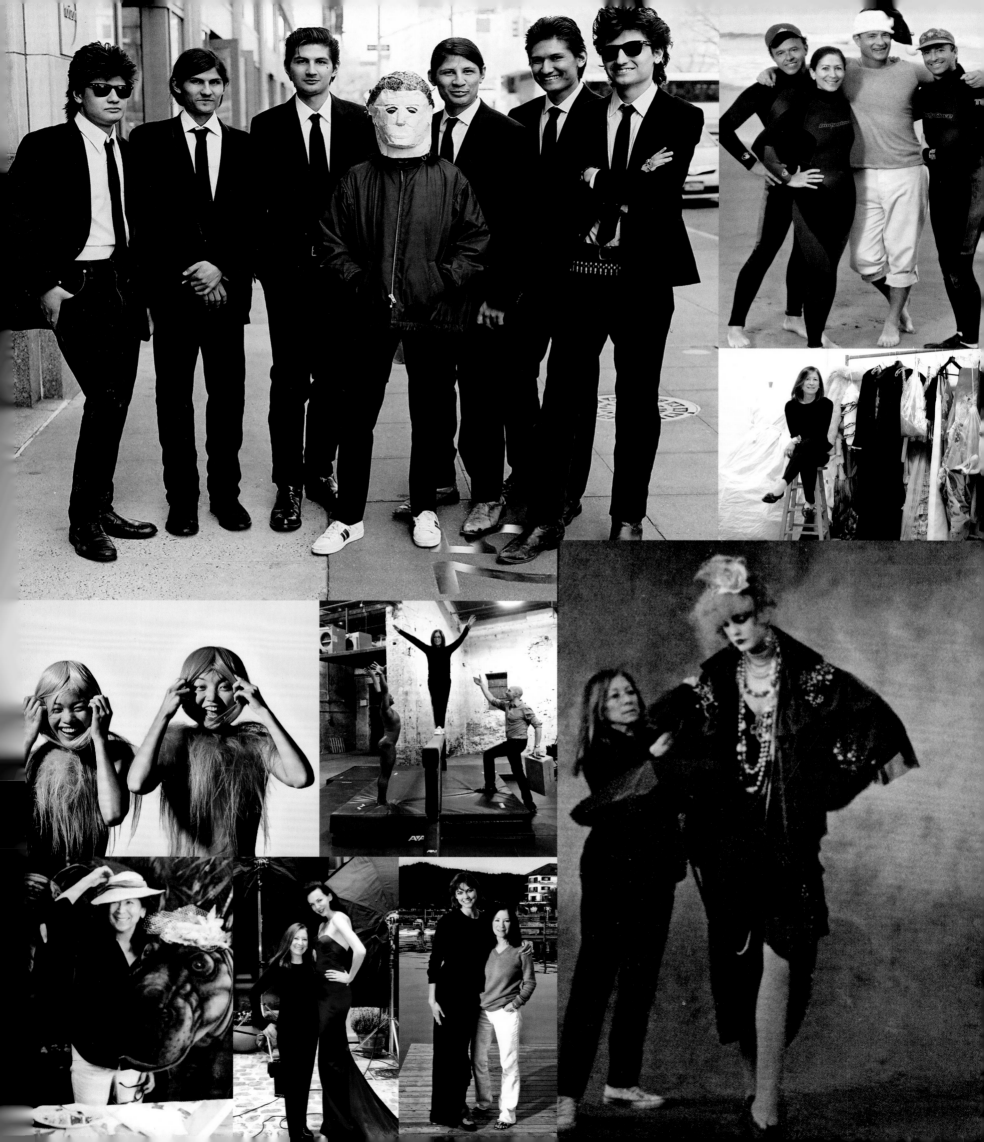

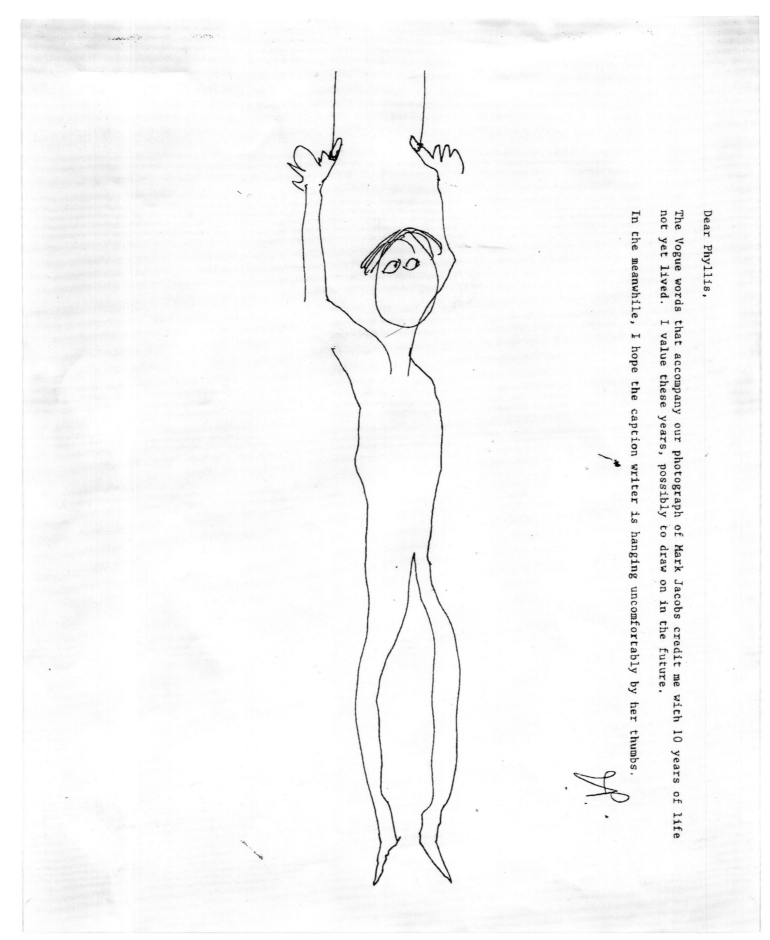

Dear Phyllis,

The Vogue words that accompany our photograph of Mark Jacobs credit me with 10 years of life not yet lived. I value these years, possibly to draw on in the future.

In the meanwhile, I hope the caption writer is hanging uncomfortably by her thumbs.

Note from Irving Penn
November 2001

Photographs by Dan Belknap
Paris, 1995

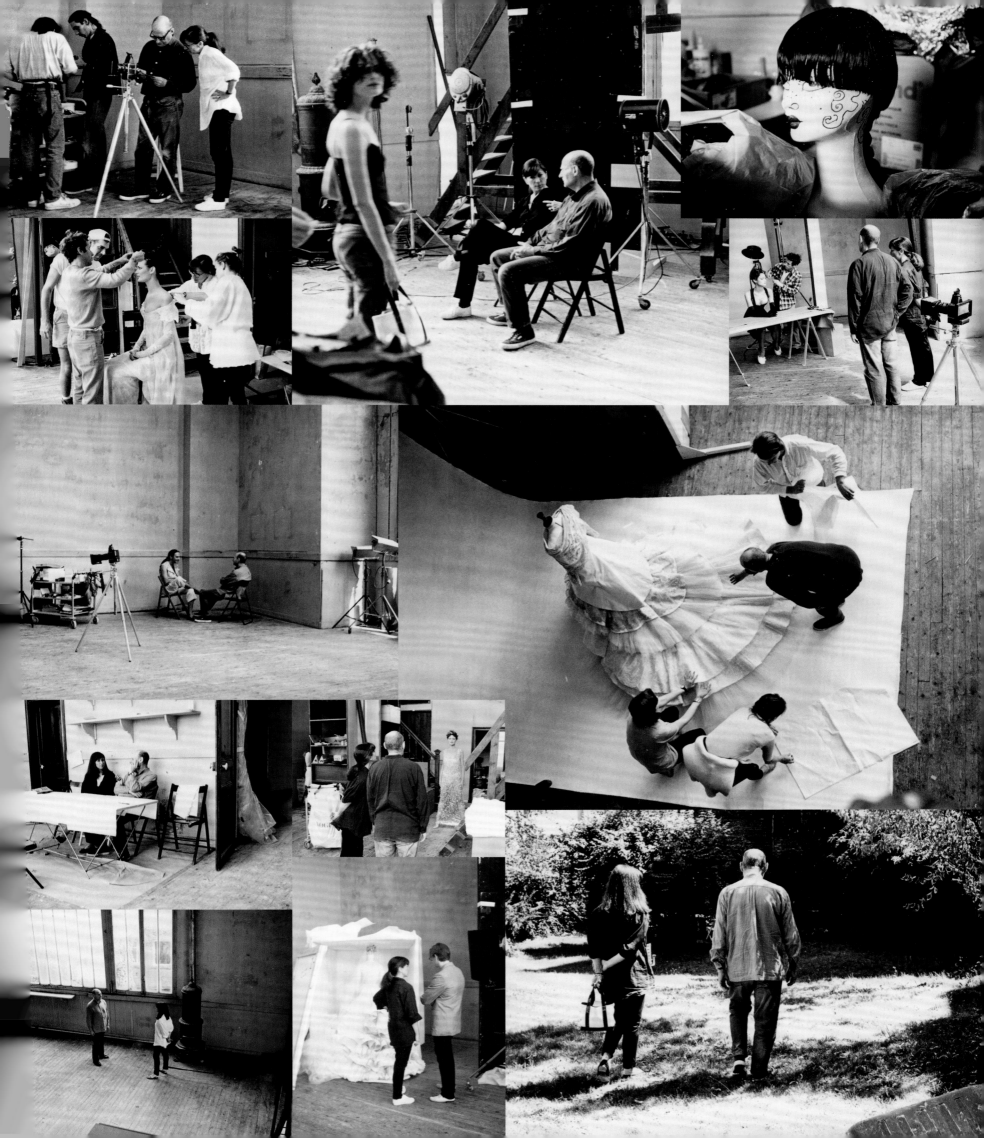

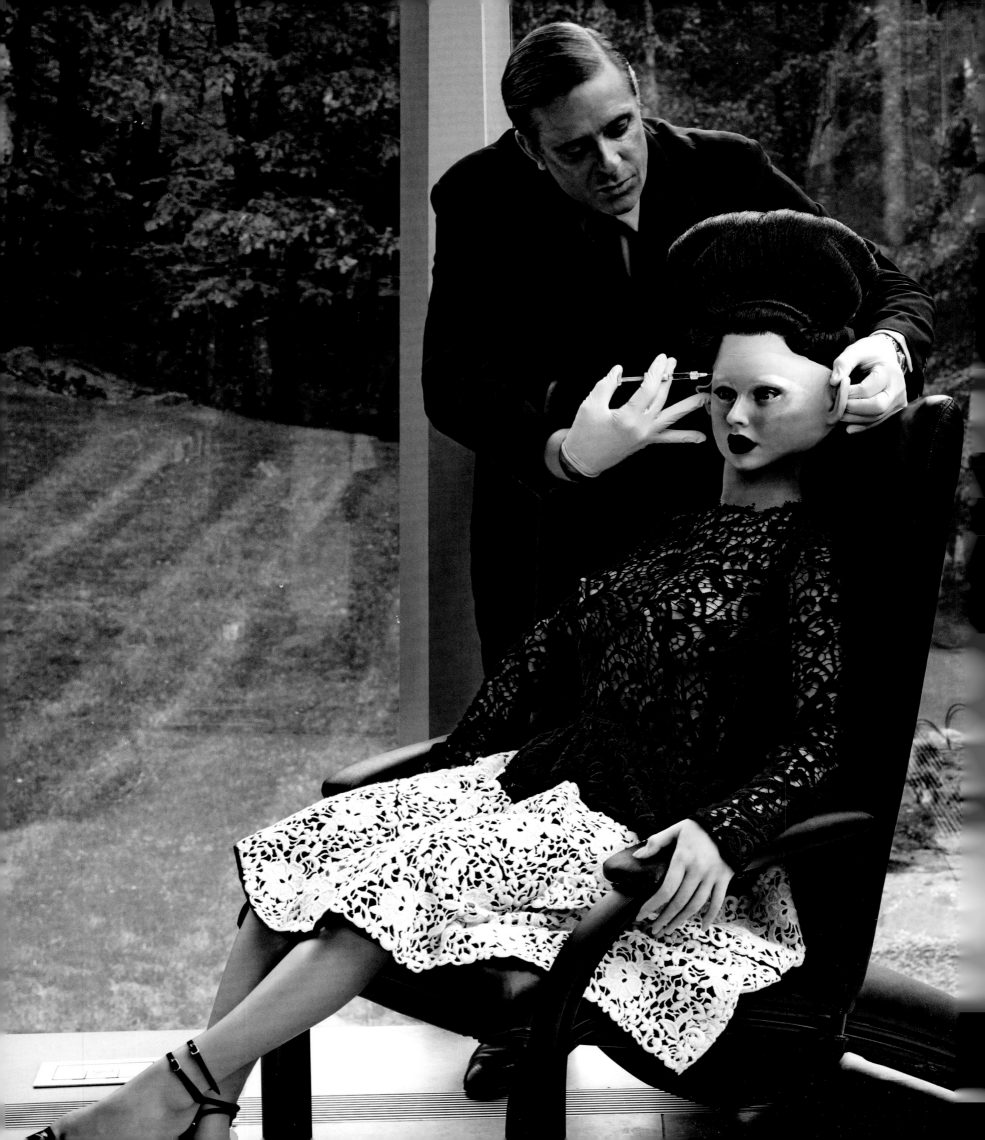

Steven Klein

Steven is the only photographer I know who can turn a child's inflatable pool toy into a sexual predator. The first person I think of when I'm asked to illustrate a health or beauty article is Steven because he has such unexpected ideas, an intelligence that he brings to his subject, and he's really funny. When we're starting to plan a shoot, I try to anticipate which strange direction he'll take with the subject, but I'm always surprised, and usually wrong. We approach a photo from opposite directions. I'm a romantic and, to put it mildly, Steven's vision is anything but romantic. If I imagine a beautiful garden, he's thinking of an abandoned warehouse or underground garage with a sinister figure lurking in the background. I sometimes think we drive each other a little crazy. We're both relentless in pursuing ideas that will make a memorable photo, and no matter how far apart we are at the beginning, we always meet in the middle and hug at the end. We call our collaborations our "Domestic Series." The models are strong chic women, usually in luxurious or bourgeois surroundings, who happen to find themselves in extreme situations. When you look at the subject matter of his photographs, you probably wouldn't suspect that he's the lovely, gentle, warm person that he is.

House Call
Bedford, NY, August 2012

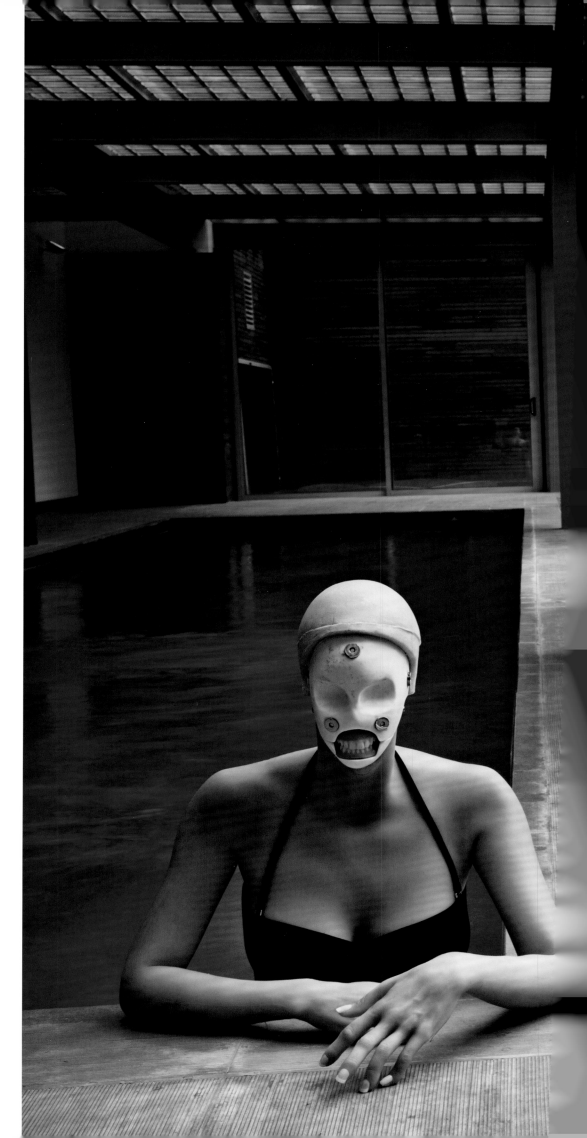

Filler, Botox, collagen, frozen faces, bigger lips, smaller hips. *Vogue* commissioned an article about how, as a result of excessive treatments, women were beginning to look alike. I thought that photographing twins in our picture would make that point, but not Steven! He wanted anatomically correct, articulated, life-size "Real Dolls." They arrived from L.A. in two huge crates and once they were in the *Vogue* closet, assistants struggled to seat them on chairs. The assistants held them up while I did their fitting. It wasn't easy to get clothes on and off 5'5", 70 lb dummies, but I managed to try ten different looks and the fit was perfect. Our location was a state-of-the-art house that had two McLarens in the garage. We needed to change our models' hair and makeup so they looked like *Vogue*, not *Penthouse*. When Linda Cantello began to apply makeup, she made a startling discovery: their faces came off. That made Steven's day and it made the pictures because the dolls looked like real women, except that they had unusual faces. Dr. David Colbert, a respected dermatologist with a sense of humor, agreed to make the house call and appear in the pictures. When the photos came in, some people thought that it looked like he was about to administer a lethal injection instead of Botox. Dr. Colbert was retouched out of one photo and the one on the previous spread never ran.

Suburbia #23
Bedford, NY, August 2012

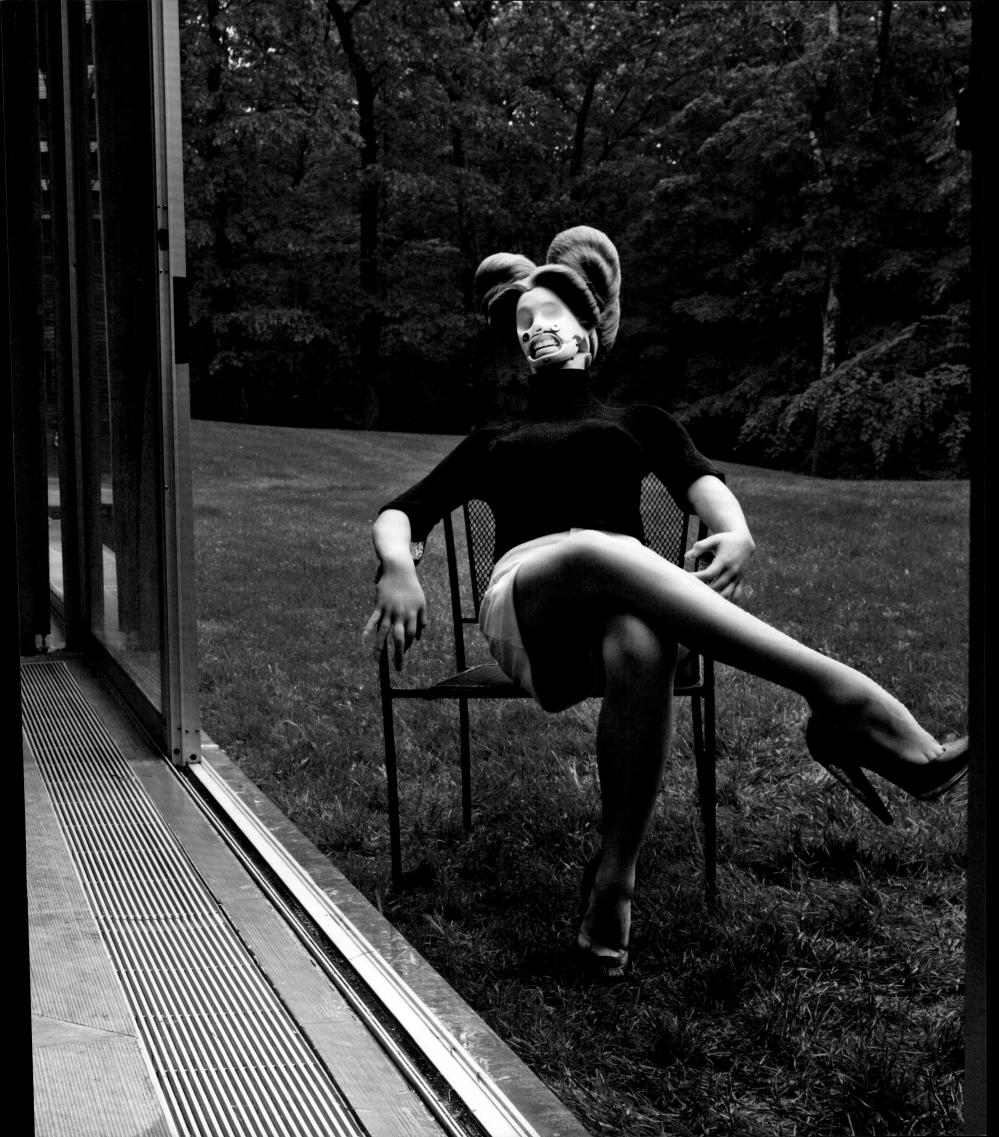

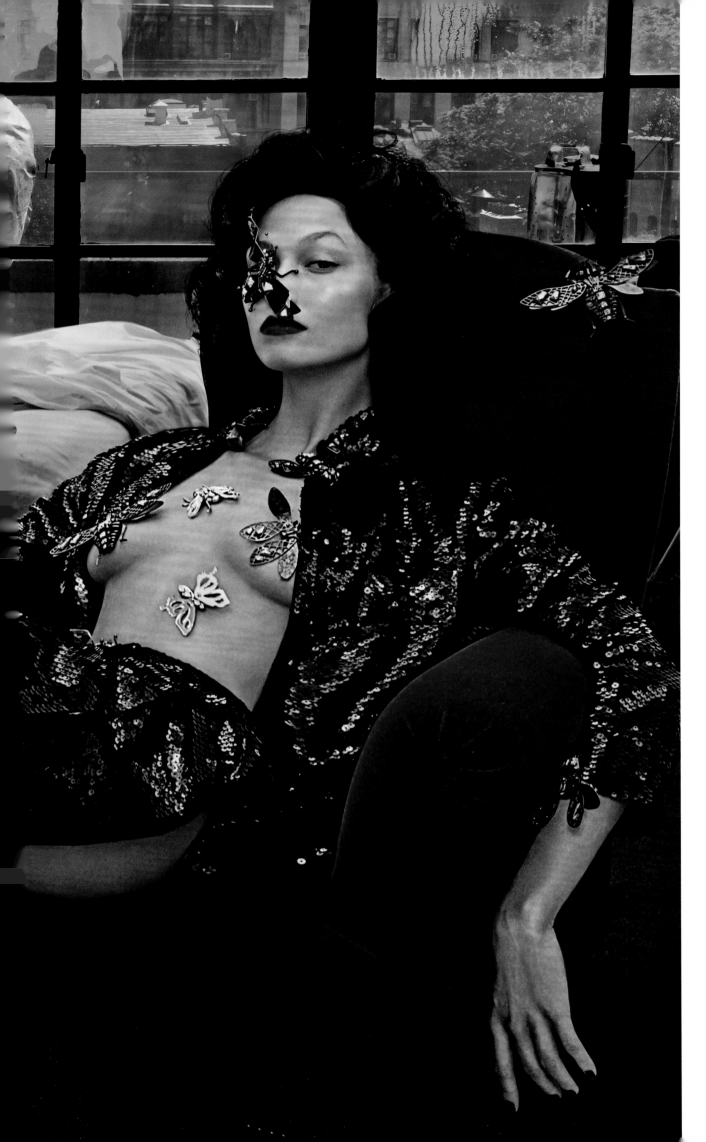

In 2013, epidemics of staph infections in hospitals were rampant and bedbugs were everywhere in homes and theaters. People were afraid to go to the movies. The assignment was to illustrate an article on BUGS. With this on my mind, I went to the S/S 2013 RTW shows in Paris. As the models walked down the runway at Lanvin I couldn't believe what I was seeing—they were wearing huge, glorious bug pins. These pins became the focus of the shoot. Steven added the exterminator, of course. He photographed Karlie for an entire day—standing vulnerable and nude, covered with bug pins, lying in bed covered with bugs, sitting in her underwear covered with bugs, on the floor half dressed covered with bugs. Garren styled her hair. First it was long and blonde, then short and red, short and blonde, then black. We tried everything but Steven wasn't happy. It was getting late, and I was sure we weren't going to get the picture. Then with less than 30 minutes before we had to be out of the location, I dressed Karlie in the Marc Jacobs sequin jacket and a bikini. Steven sat her in the chair. Still not right. She needed a skirt, but her position was perfect and there wasn't time to put it on, so I threw it over her legs. It worked! It wasn't until Steven and I reviewed the pictures that we realized that Karlie's bottom was in full view.

Bugs
New York, November 2013

"Working on special photos with Phyllis and Steven can be very creative. Actually, it is creative! Phyllis has the article she must illustrate and it's up to Steven to visualize it. Knowing Phyllis, it is an unconventional photo that tells a story, and working with Steven, it's all about the abstract narrative. That means anything can happen. I must be prepared for both Phyllis and Steven. Hair is very important for Steven and I come with an arsenal of wigs and more. We keep changing to get the perfect look. Going back and forth between the two of them can be very funny. Phyllis needs her picture and Steven needs an amazing abstract. Phyllis introduced me to the world of *Vogue*: my first *Vogue* shoot, first *Vogue* cover. She works with the world's most influential photographers, hair and makeup artists, and models, and understands how to choose the perfect team to make her vision come to life. She creates pictures that are important. I've been fortunate to be part of her world for three decades."—GARREN

Drug Store
New York, May 2012

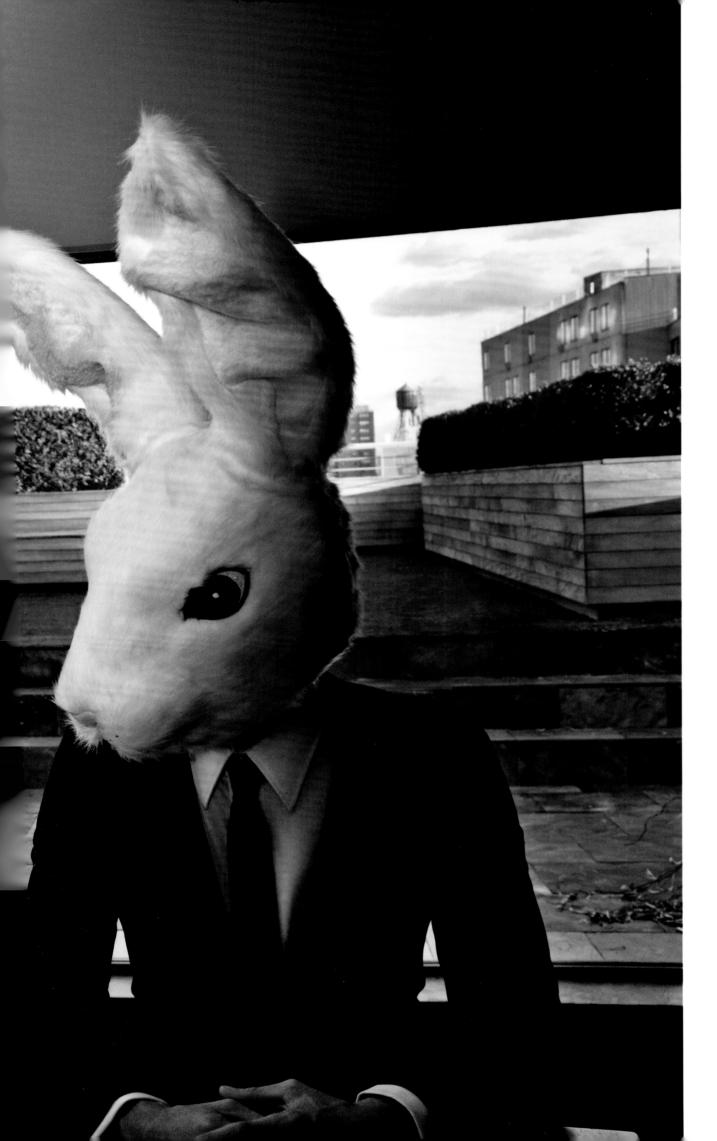

In 2010, the search to ignite sexual desire and to create female Viagra was producing some controversial results. Our problem was how to illustrate an article about sex, seduction, and desire in a way that hadn't already been done. While he was surfing the Internet for "desire," Steven came across a strange dark video of a man dressed as a rabbit. (I'll say no more about that!) He thought that man as rabbit would do it for us. And it did!

Rabbit Test
New York, February 2010

31

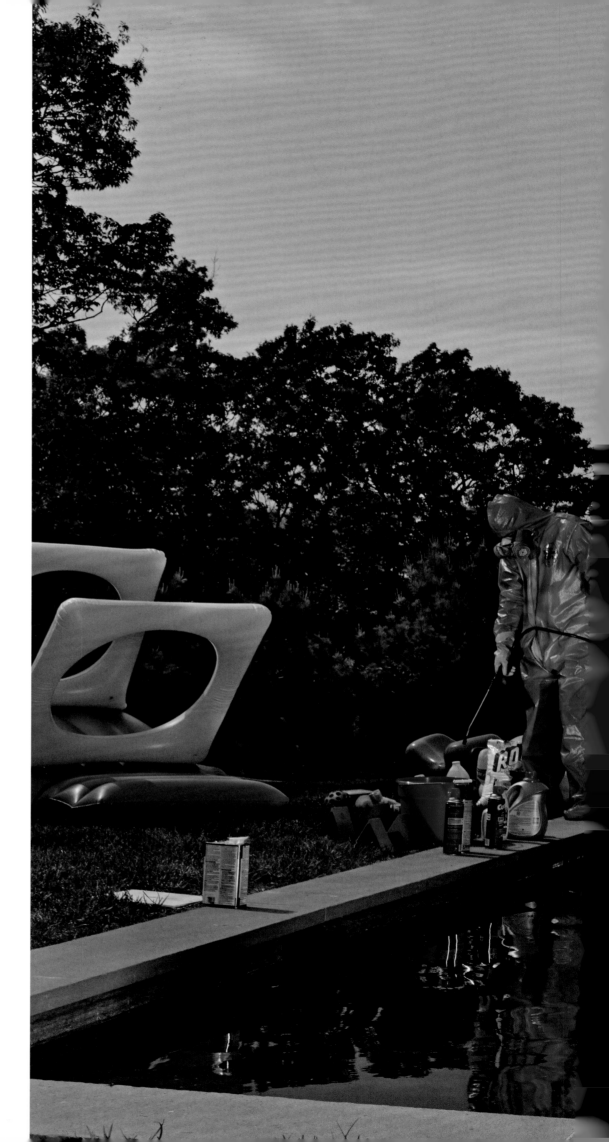

"It starts out with the proposal of an idea. And usually what is required is one single image representative of the idea, the concept visualized into pictorial grammar. Minimalist, since at the most two images may be required, but for the most part a single image must tell the story or perhaps allude and point the way to the narrative. We have a back and forth motion to our procedure. Bouncing the ball of the idea, sometimes a good serve, sometimes the ball is lost but we keep going at the game, each one serving our best in this tennis of ideas. Neither one of us can compromise the integrity of our skills. We never settle for less but strive, strive, and strive until the bell rings, the pivot scores, and the crowd inside our skulls roars with victory. It starts out one way, ambiguous and unsure, and ends another way, a definite image, an emblem in the dark."—STEVEN KLEIN

Toyland
August 2007

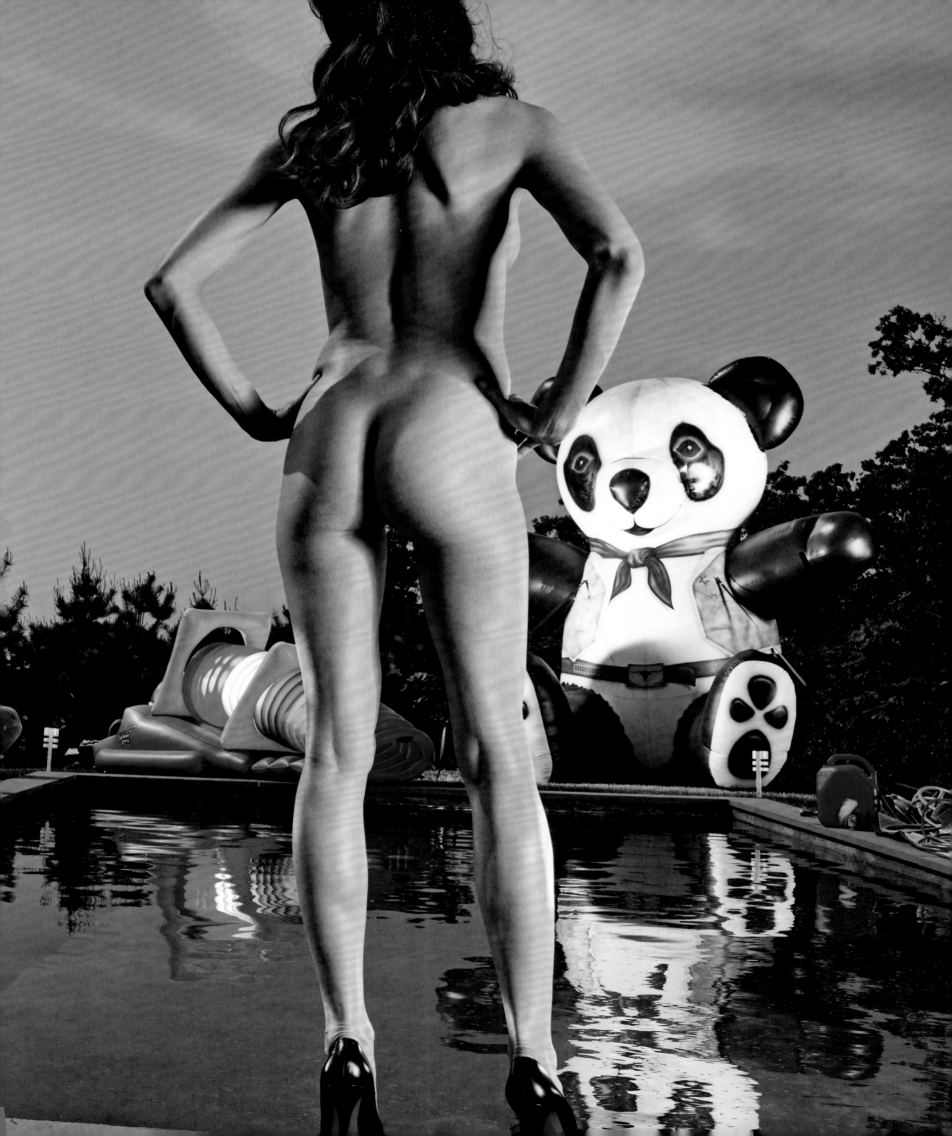

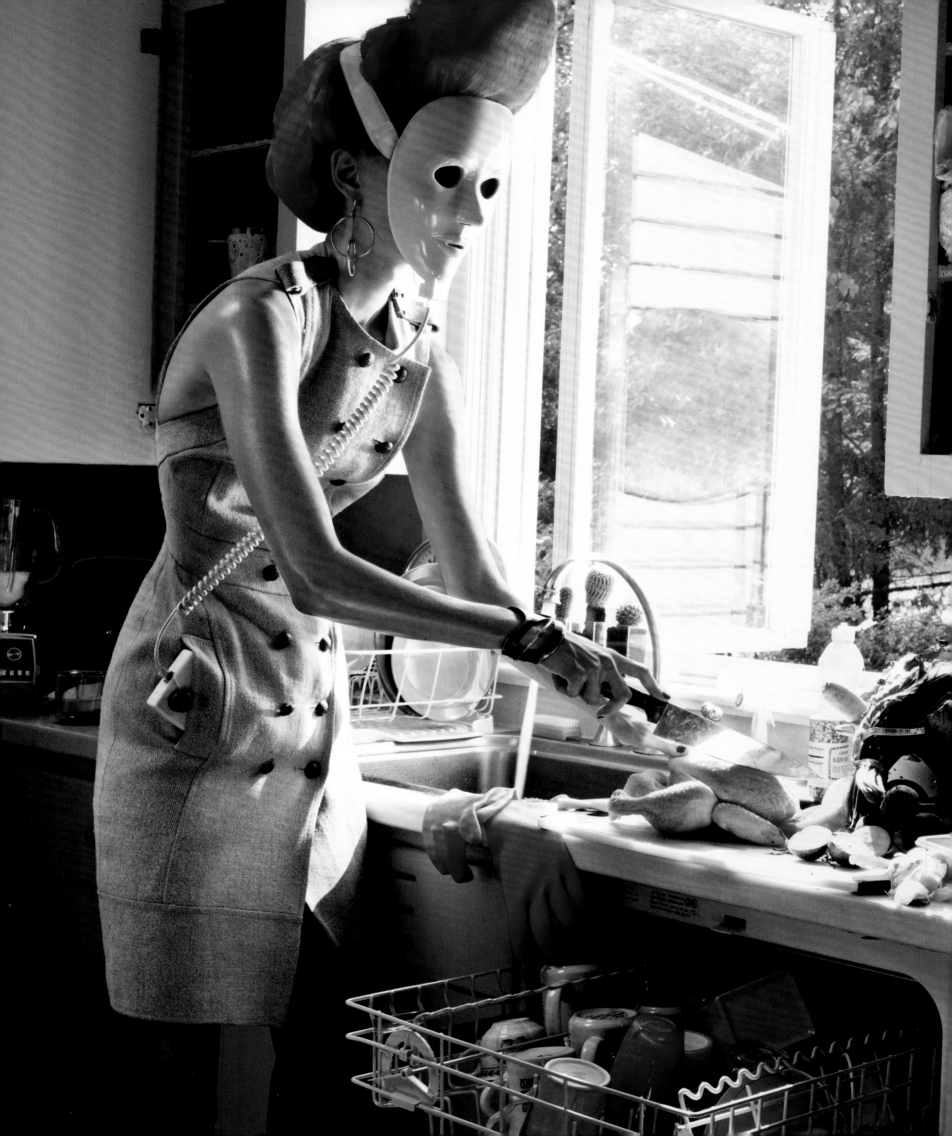

New Jersey, December 2007

Much of the time, the photograph that we envision before a shoot doesn't end up exactly the way we thought it would. Skin protection in winter was the story, but the products became invisible once they were applied. It was July in New York and we needed a cold place to shoot, but didn't have the budget to travel. Steven thought a meat locker filled with hanging carcasses would be perfect. I wasn't expecting Anna Wintour to approve this but when I told her, she said "sounds good" without blinking. We had expensive coats, fine gloves, and scarves for the shoot, but when I dressed Caroline Trentini and put her in the meat locker, she didn't look cold or chic, she looked ordinary and boring—like she was shopping for dinner. Even the red wig didn't help. The clothes weren't right. We didn't have a picture but needed to stop because Carolini, as we call her, was going to Paris. As she was walking out the door, I thought, "What would Helmut Newton do?" I asked her to come back, quickly dressed her in black tights and stilettos, Julien put the red wig back on, Steven got his shot in 15 minutes, and she made it to the airport in time for her flight.

Meat
New York, November 2004

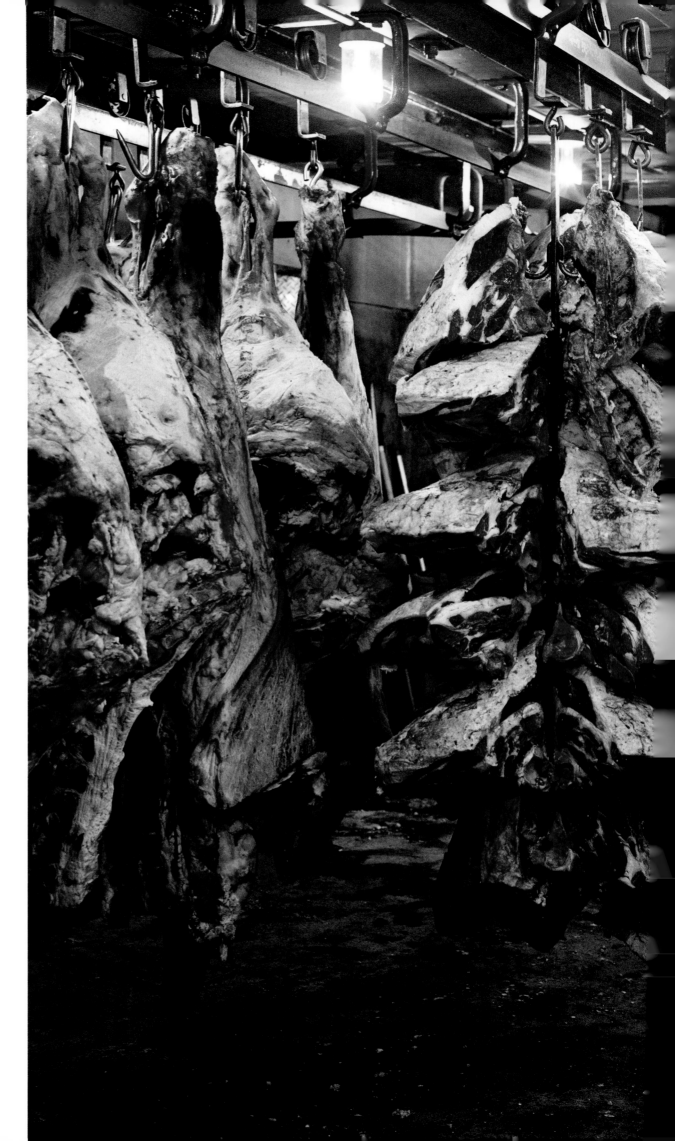

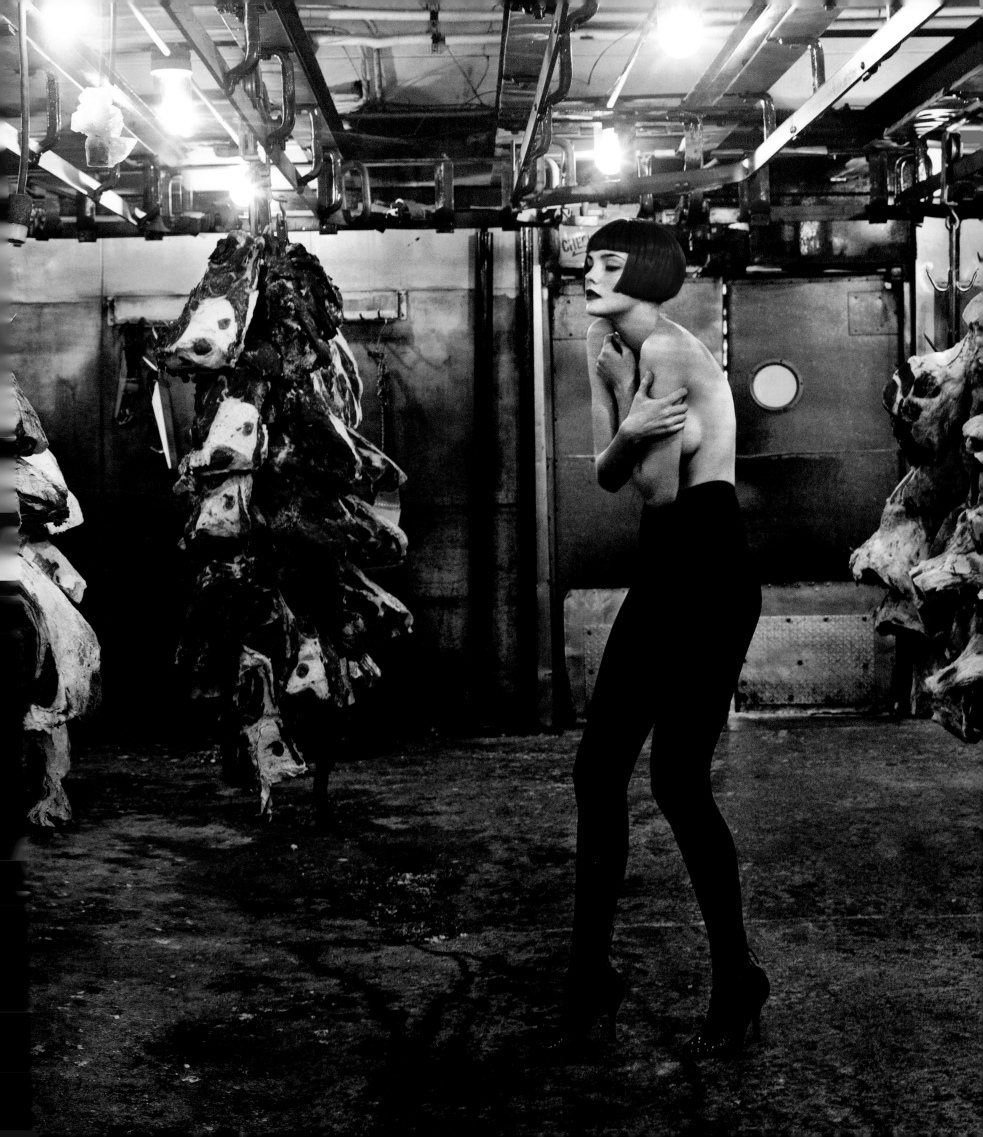

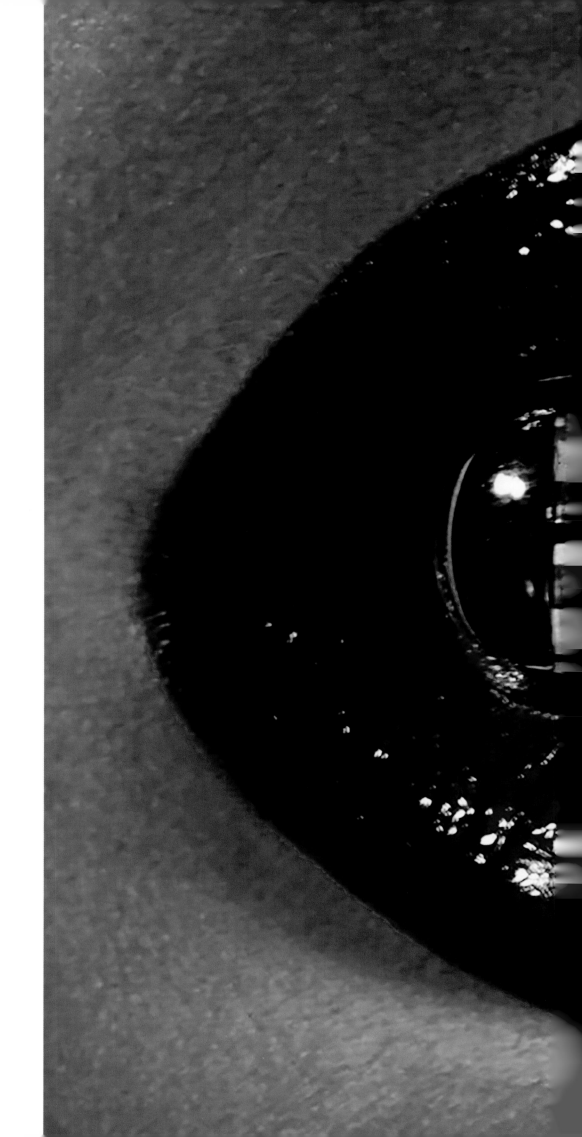

Body Camera
New York, January 2006

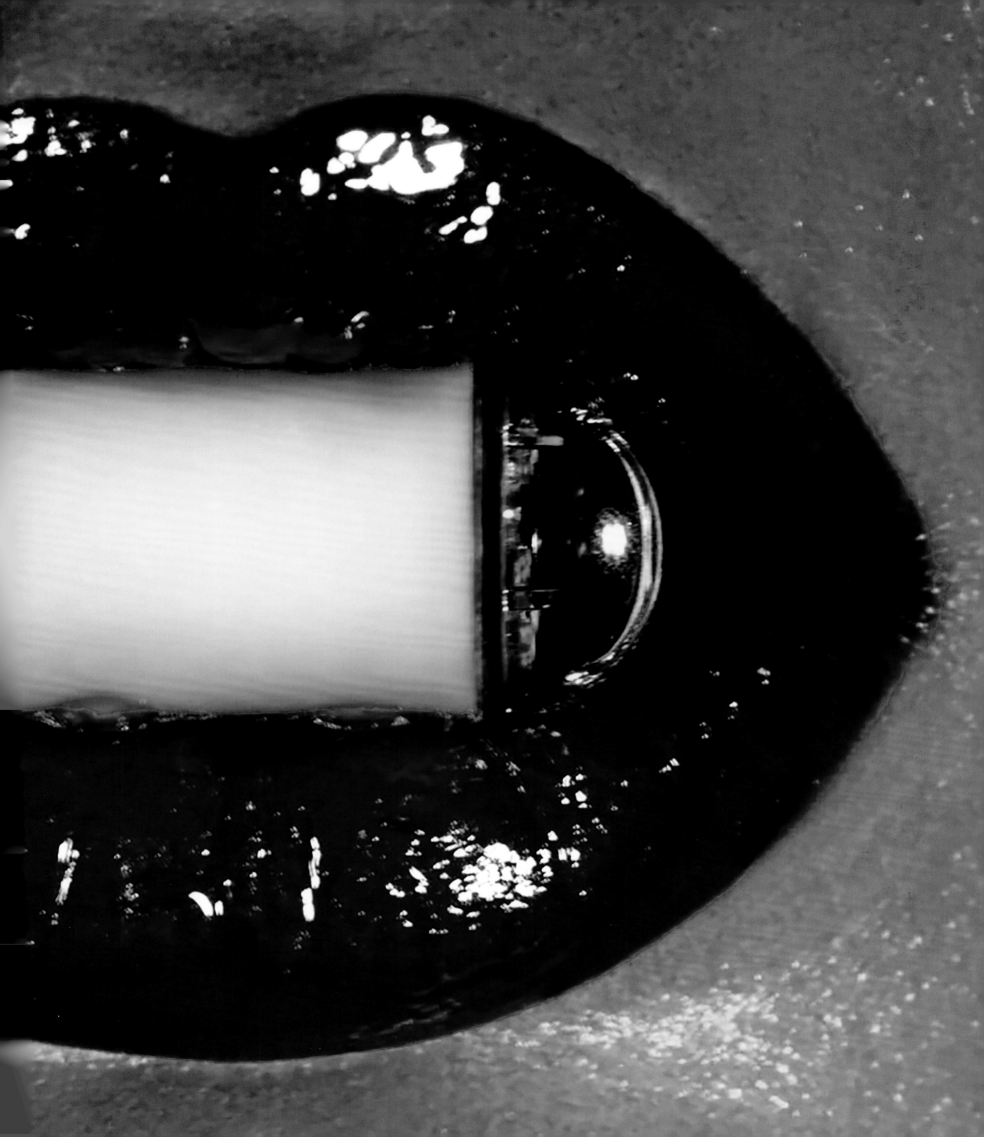

American Psycho
New York, March 2016

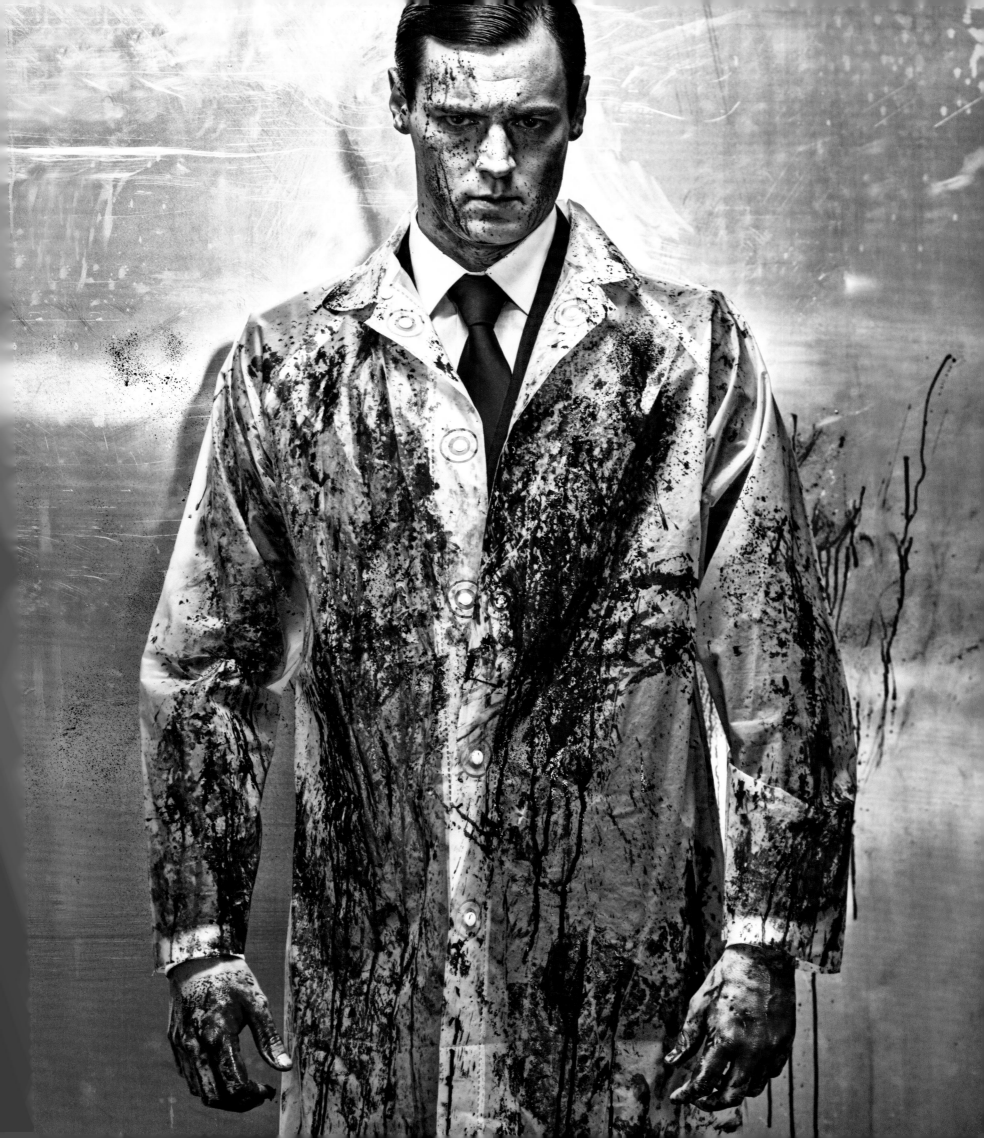

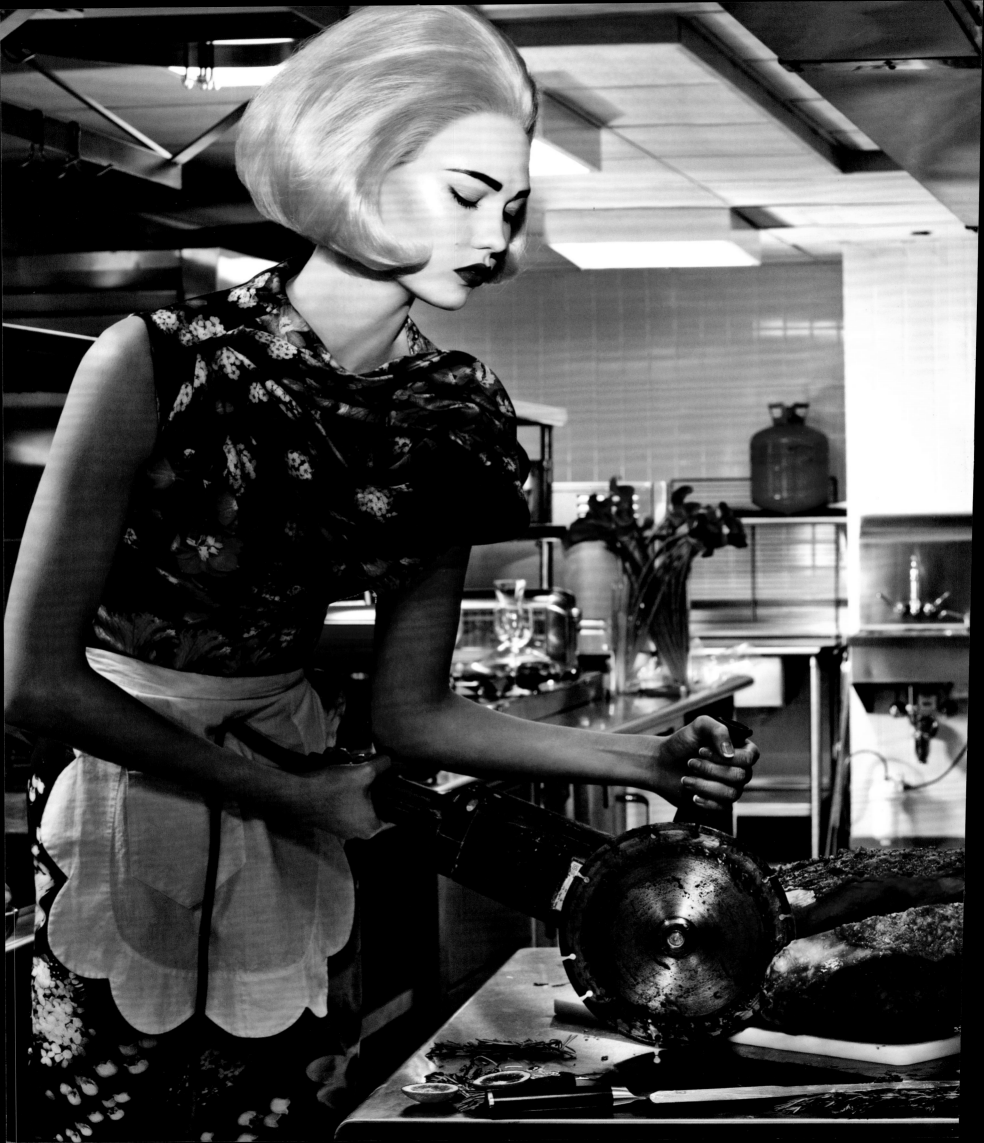

Garren is the master of chic and I work with him as often as I can. He knows how to make a woman look powerful (opposite) and make a picture stronger. We met years ago when I was the Beauty and Health Editor of *Vogue* and I'd been asked to produce a special *Vogue* beauty supplement. When none of our usual hairdressers wanted to work on this project, I very reluctantly booked an inexperienced young man I didn't know and, worse, had never heard of. I wasn't expecting much and just hoped that the shoot wouldn't be a disaster. When Garren arrived at the studio, we liked each other immediately. He began to do the model's hair, quickly creating one great look after another, it was obvious that he was someone special. As soon as the other *Vogue* editors saw the hair he'd done, they immediately booked him for all their upcoming shoots and he didn't have any time left for me. It was months before I worked with him again.

Gourmet Gadgets
New York, May 2011

Mechanic
New Jersey, August 2006

Marilyn Manson and Dita Von Teese
Los Angeles, March 2006

Climbing the Walls
New York, December 2008

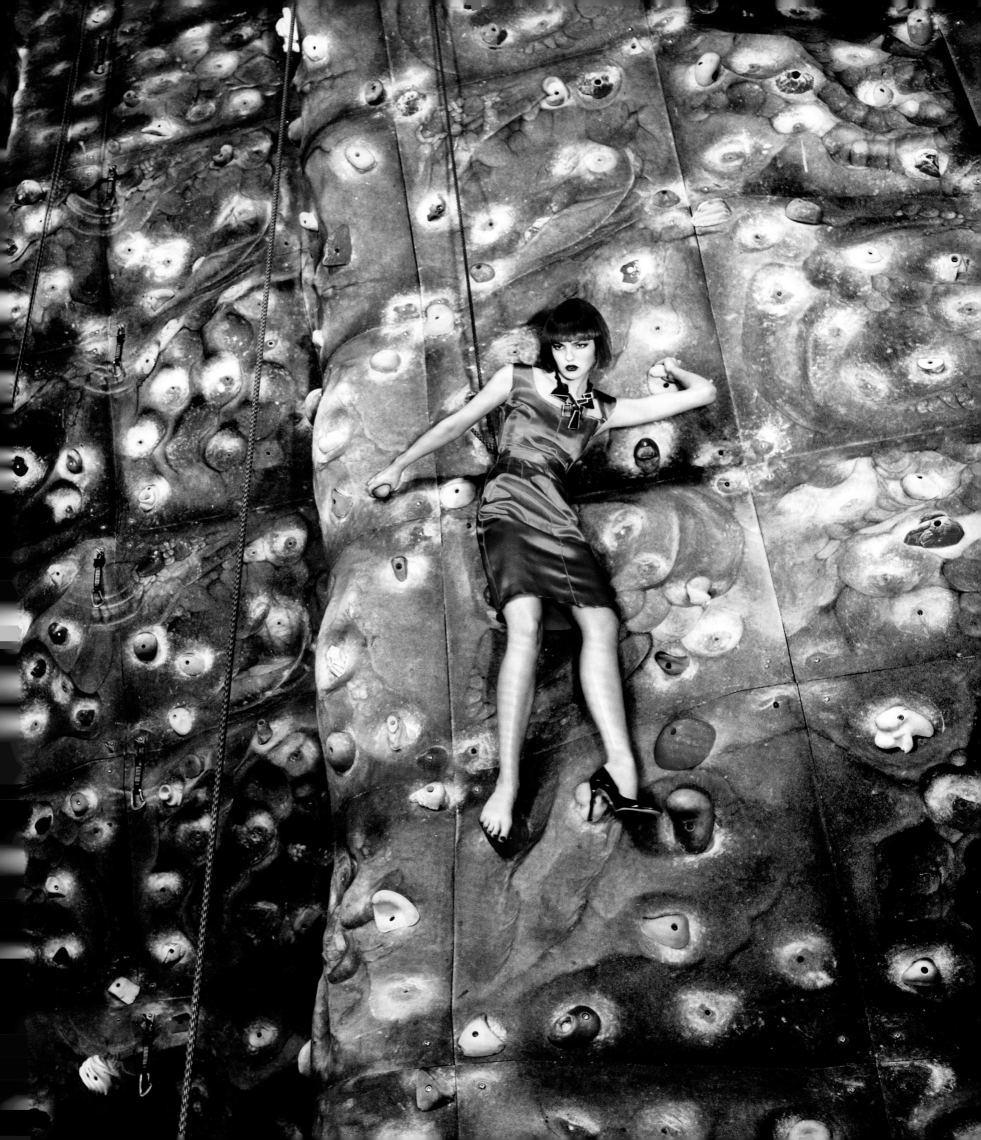

"Phyllis is a true artist bringing timeless stories to life on the pages of *Vogue*. Her focus, research, and vision draw in legendary teams to create iconic works that capture full narratives in a single photograph. Having the privilege of participating in any of these shoots is a lesson in excellence and magic."—KARLIE KLOSS

Standard Hotel
New York, August 2009

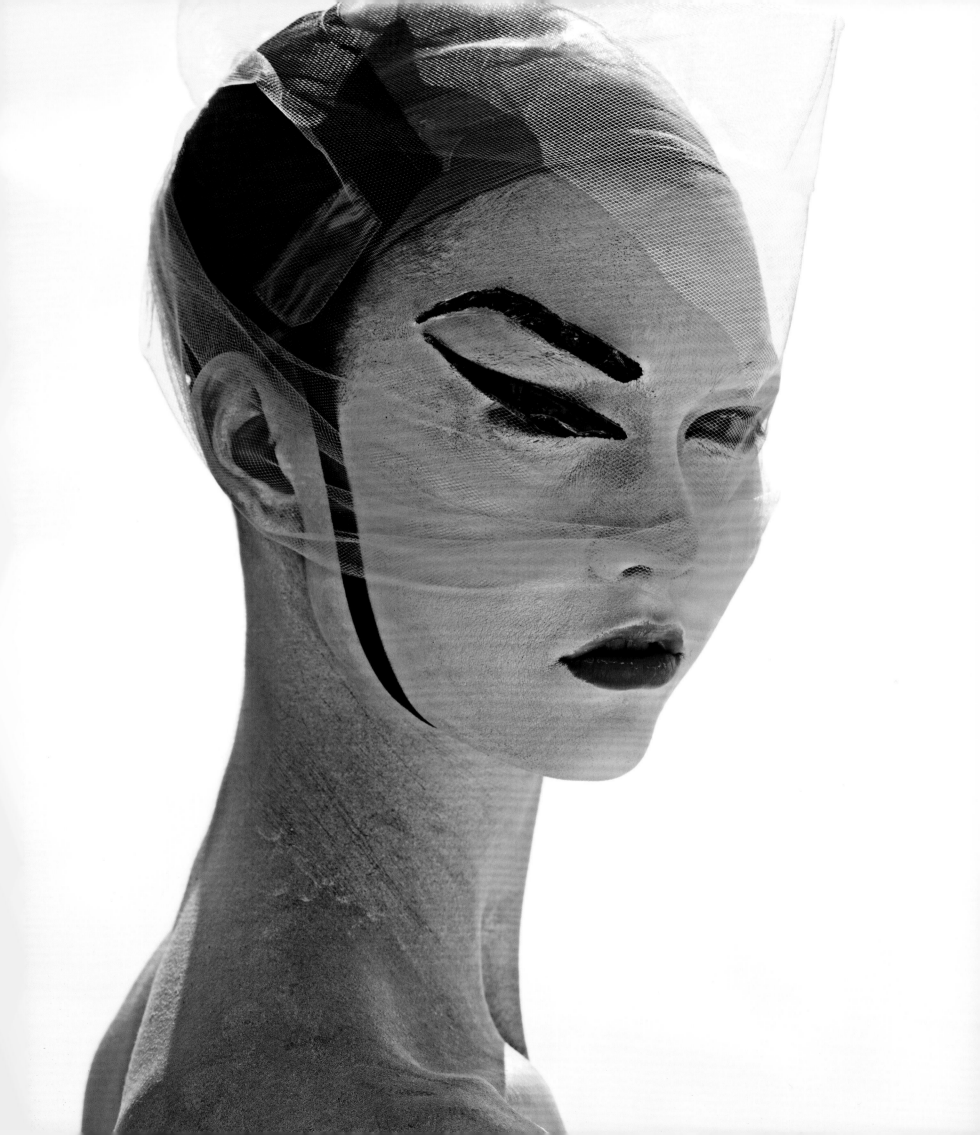

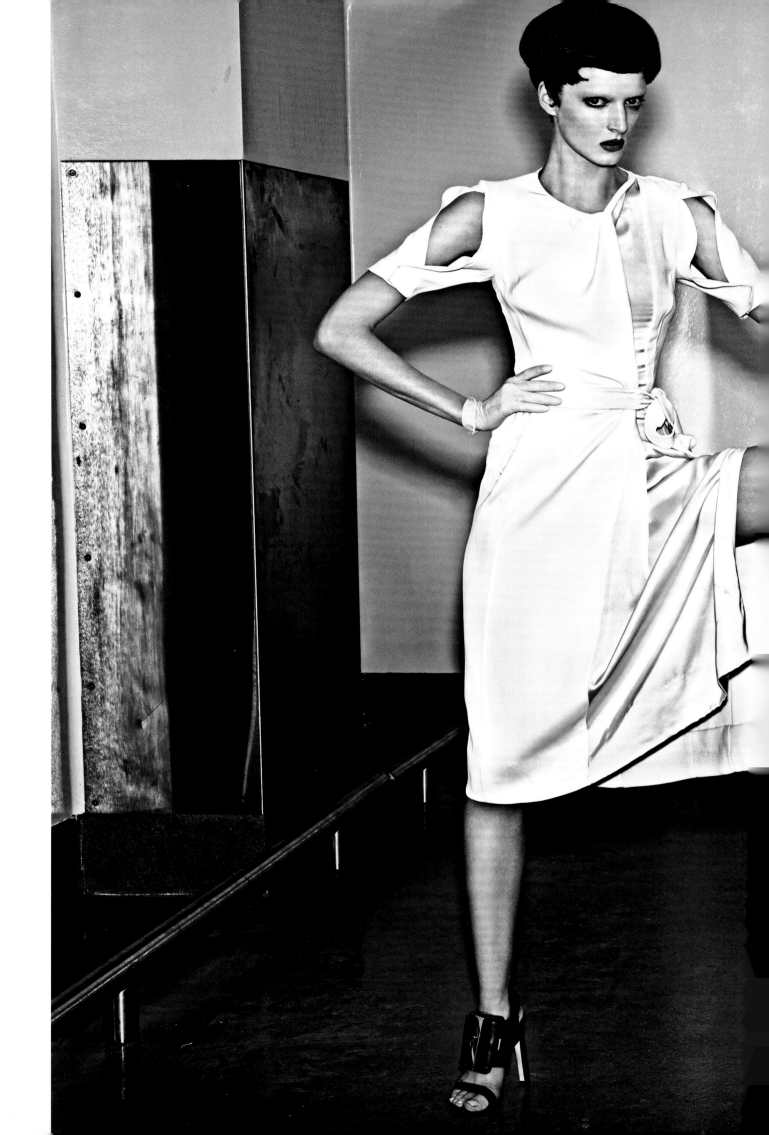

Woman and Medical Chair
Brooklyn, NY, May 2014

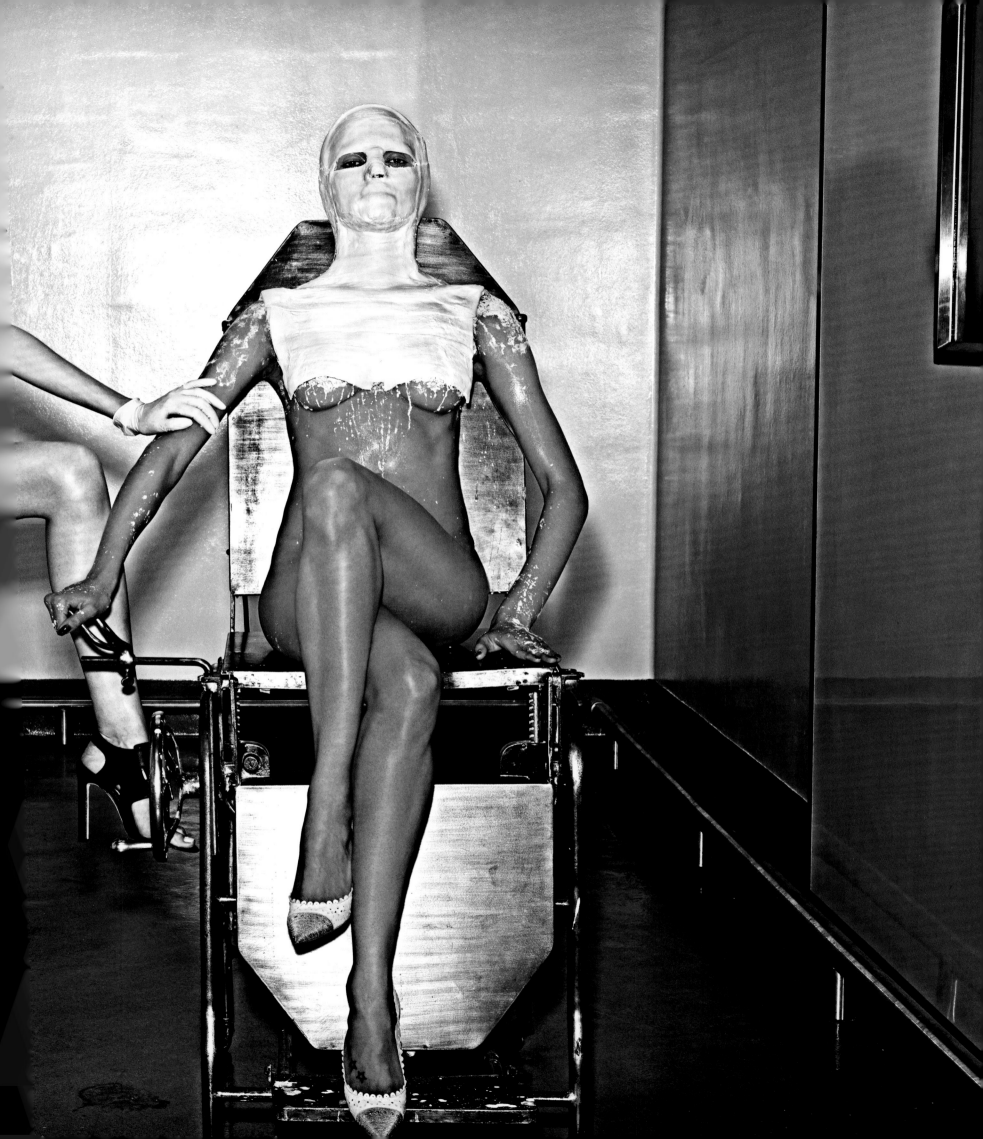

This was one of my first shoots with Steven. It illustrated yet another article about new beauty creams. Sometimes art or films will inspire or give direction to a photo, and this idea came from a George Segal sculpture of a plaster cast figure that I'd seen in an auction catalogue. We did the photo in a tiny restaurant in SoHo that no longer exists. It took two weeks to find the right cream that wouldn't dry or crack. On the shoot day, it took hours to make a very patient model's body perfectly smooth and white, get her hair right, and set up the picture. By now it was time for lunch, so our model stood in her heels, covered with cream, and ate very carefully. When Steven's (former) agent saw this photo on the monitor, he froze and said that it would never run. It was strange, nothing like any photo he'd seen in *Vogue*. It ran precisely for that reason—because it was different.

White Woman
New York, January 2002

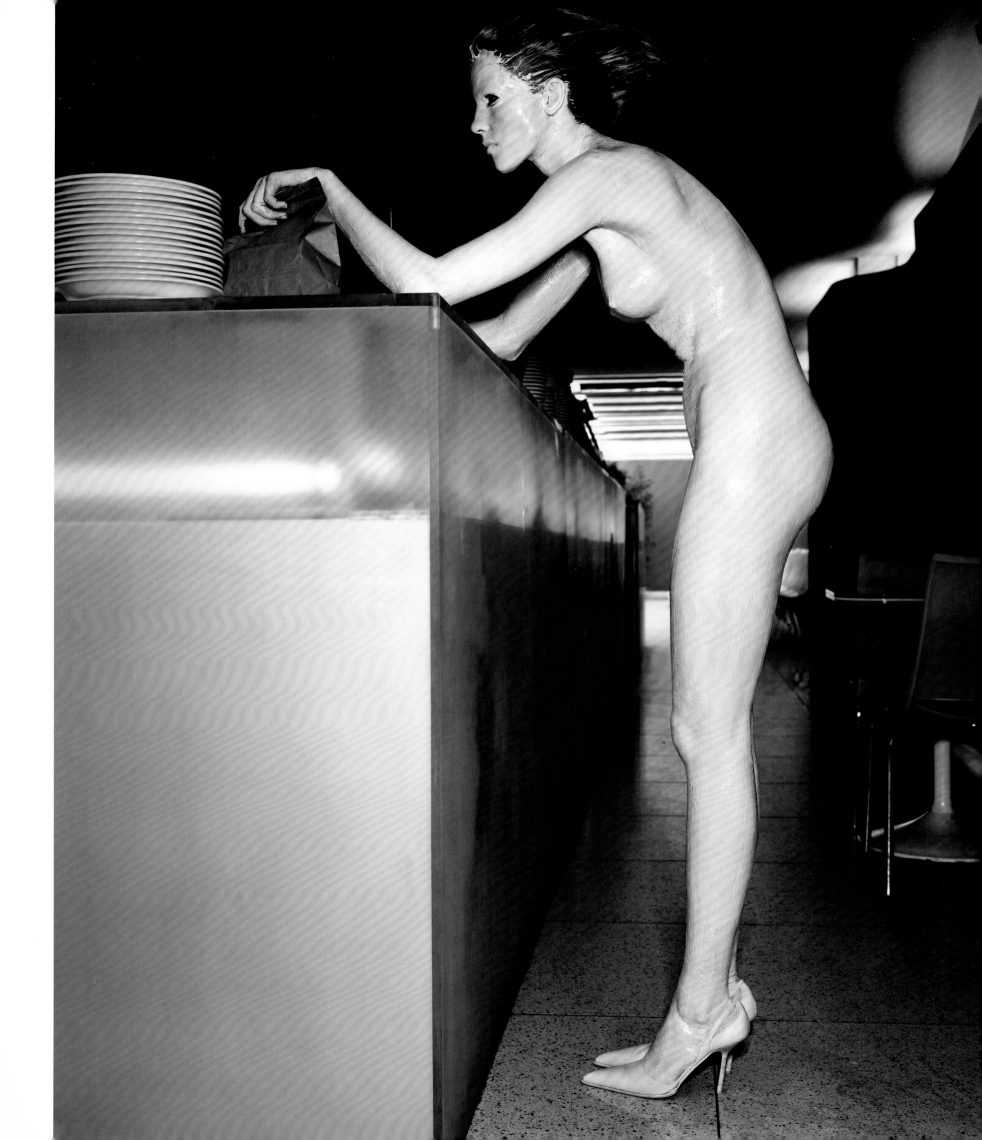

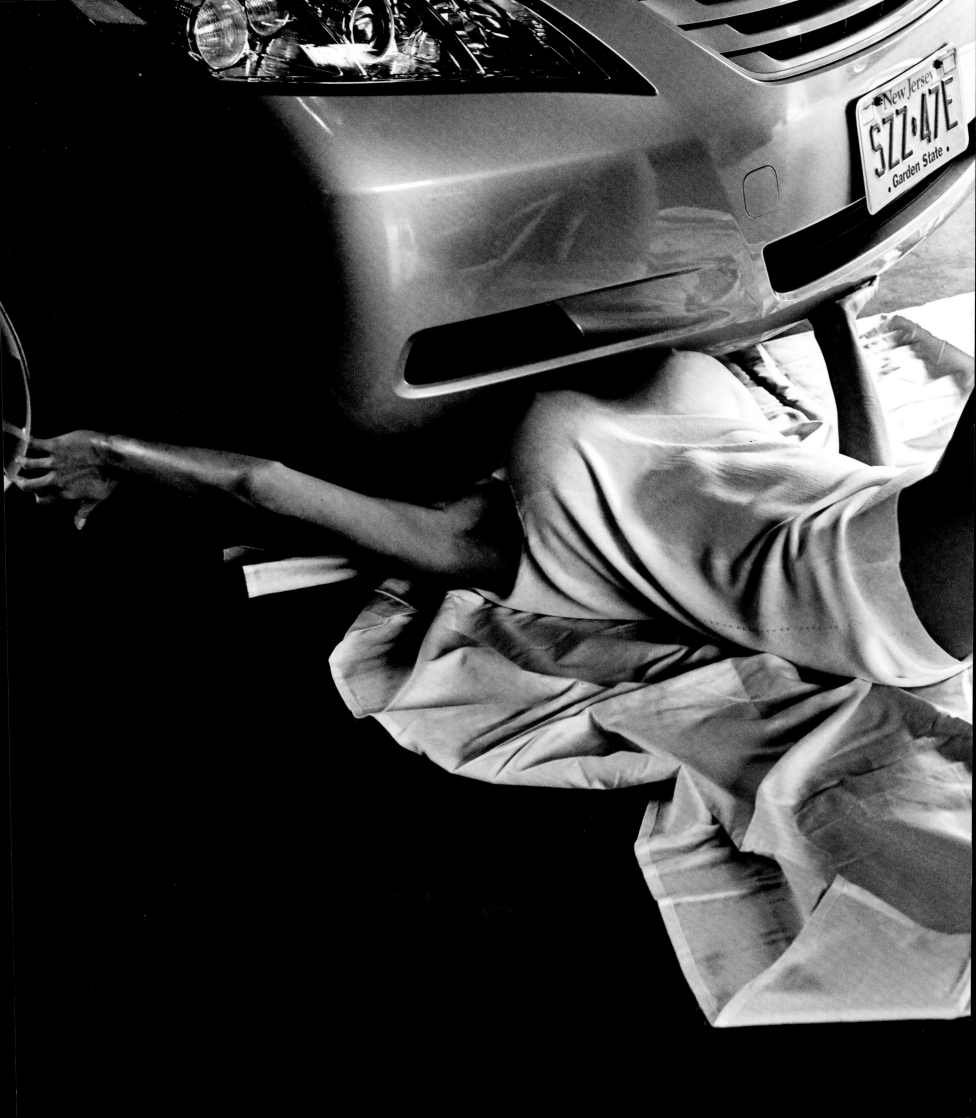

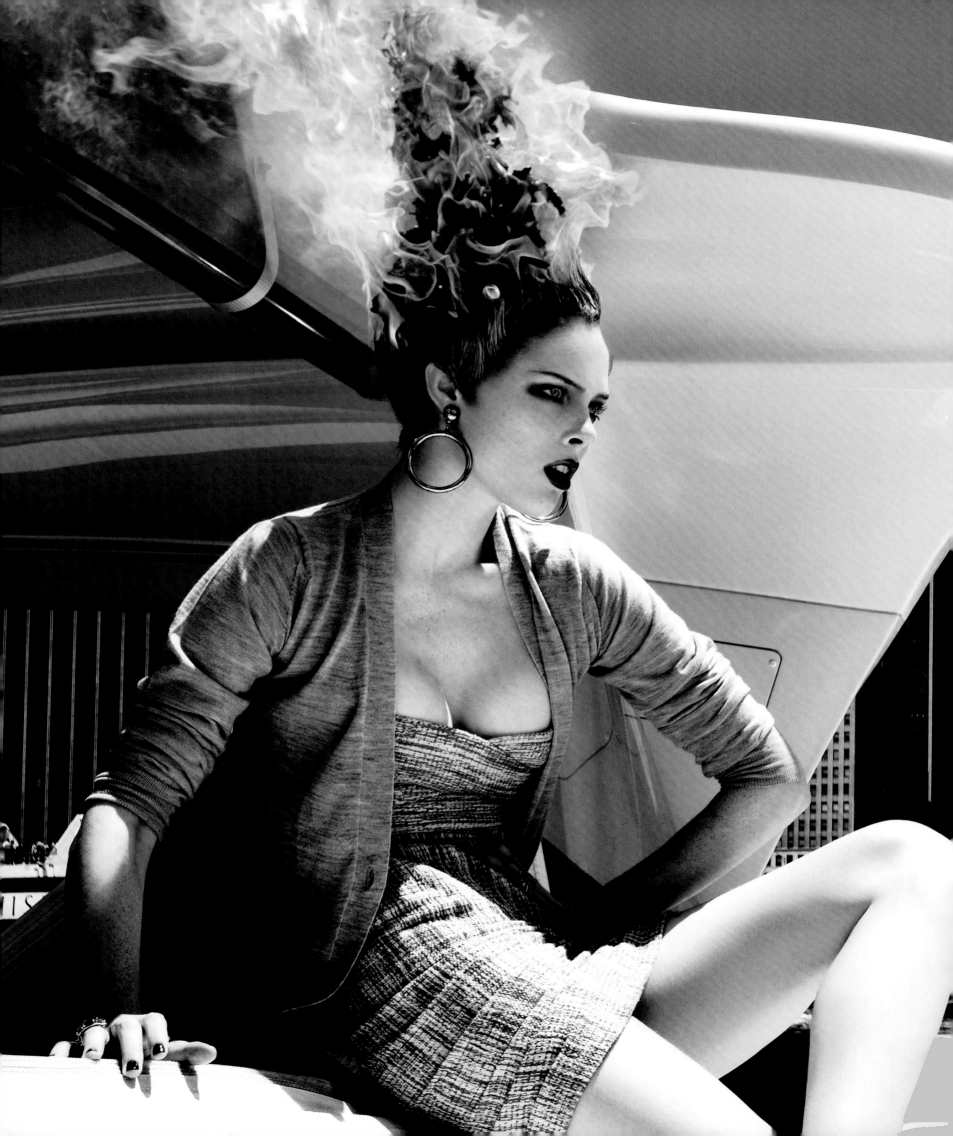

Woman on Yacht
New York, November 2008

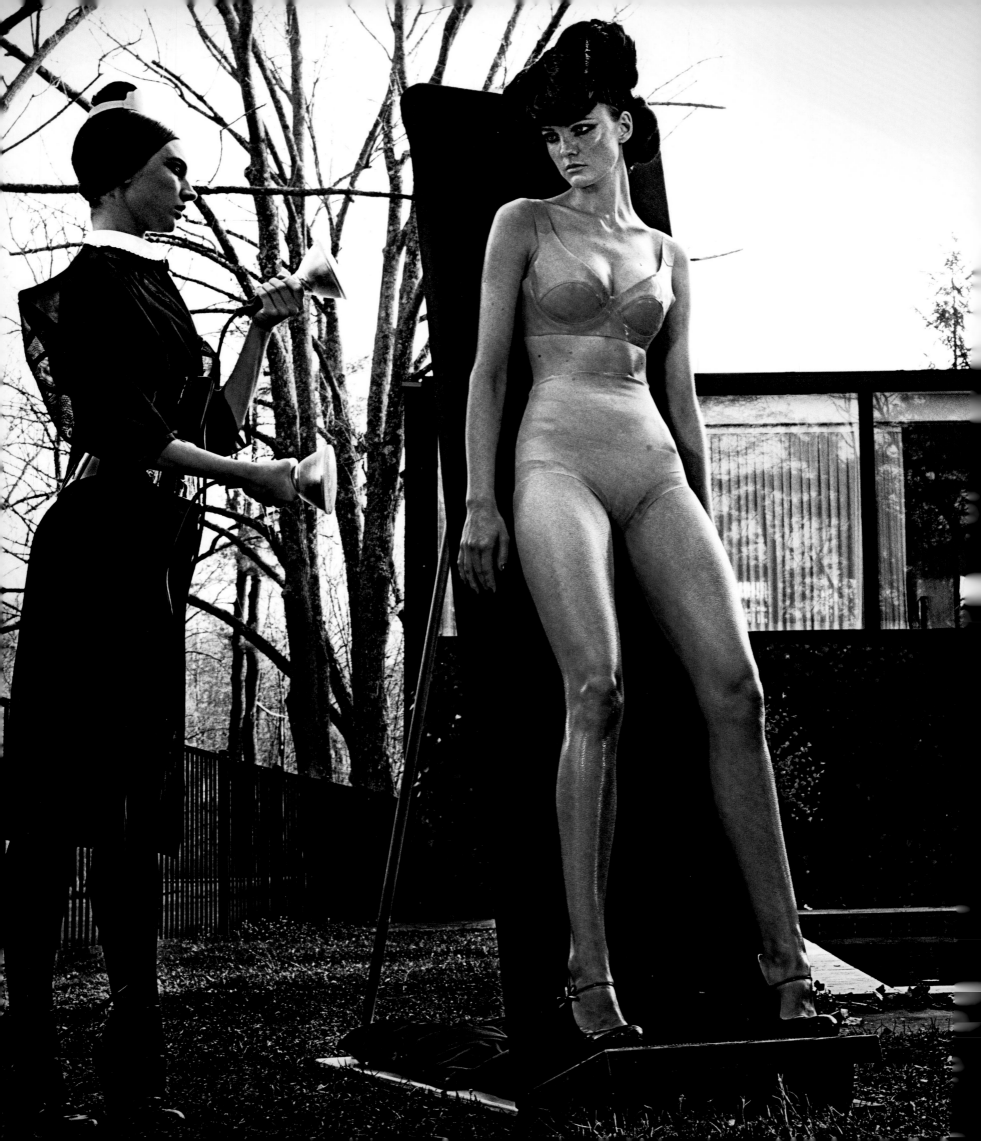

Surburban Woman #29
Chappaqua, NY, July 2011

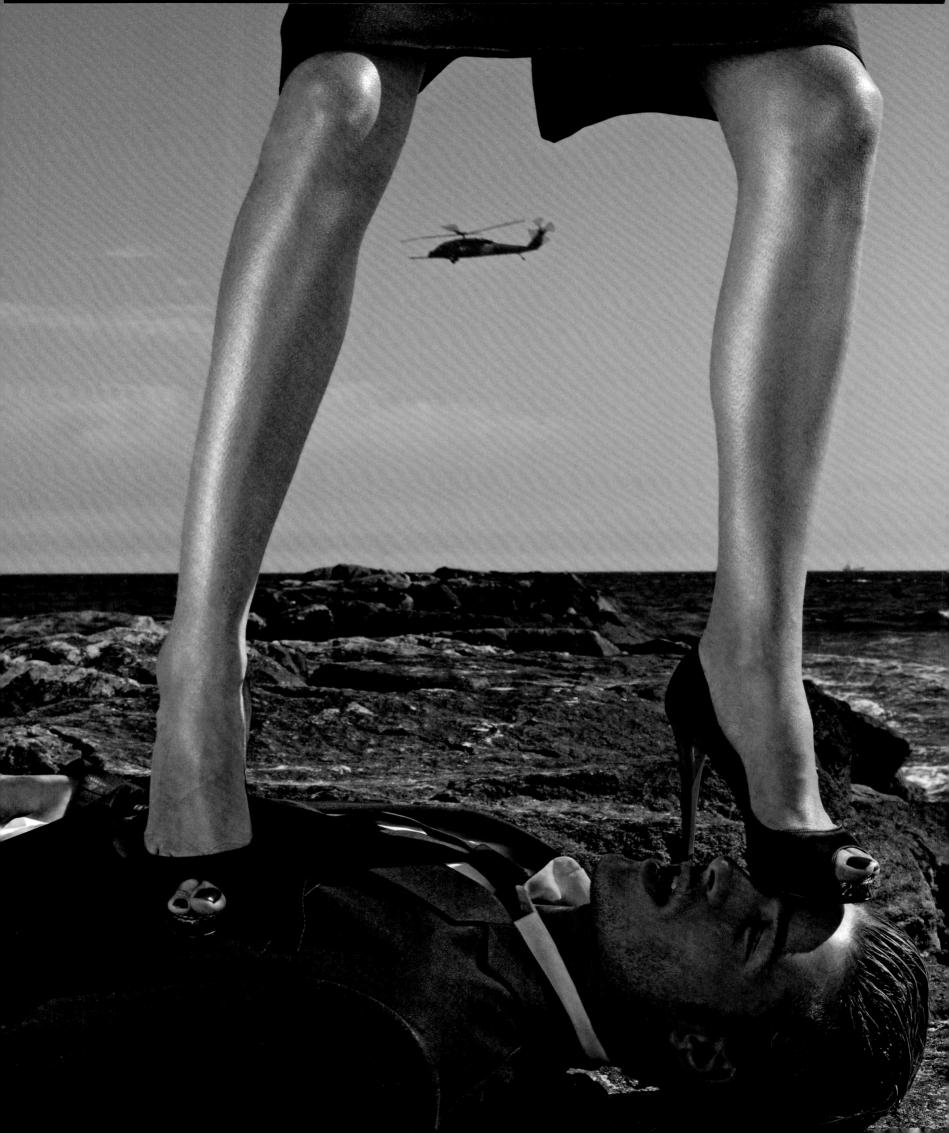

Killer Heels
New Jersey, August 2008

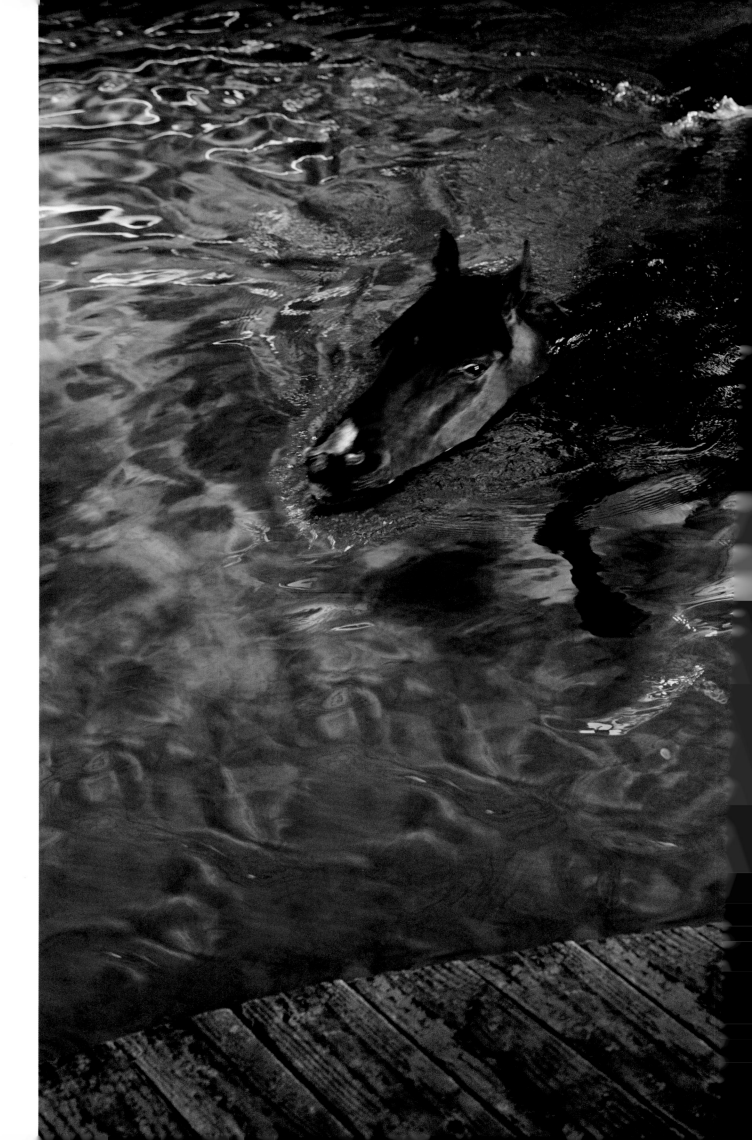

Horse Pool
Windsor, CT,
June 2005

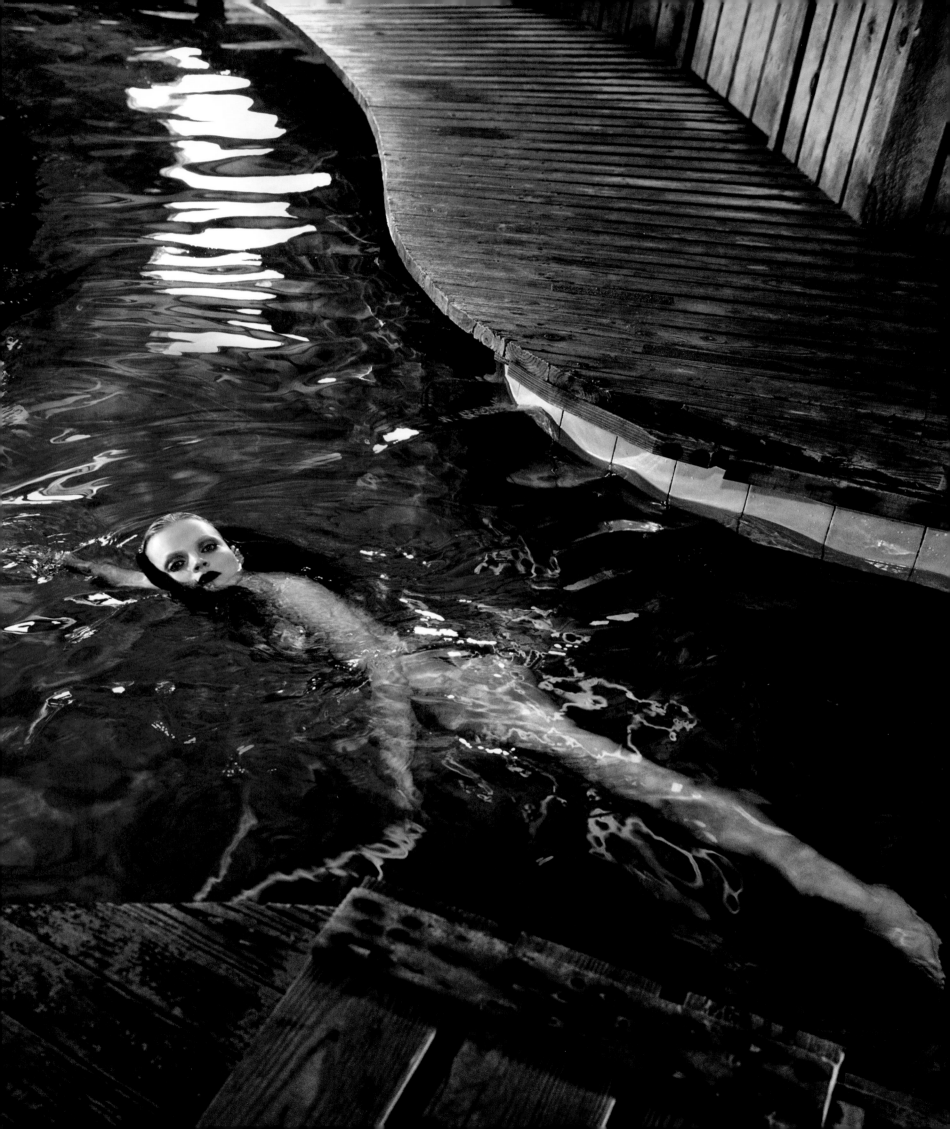

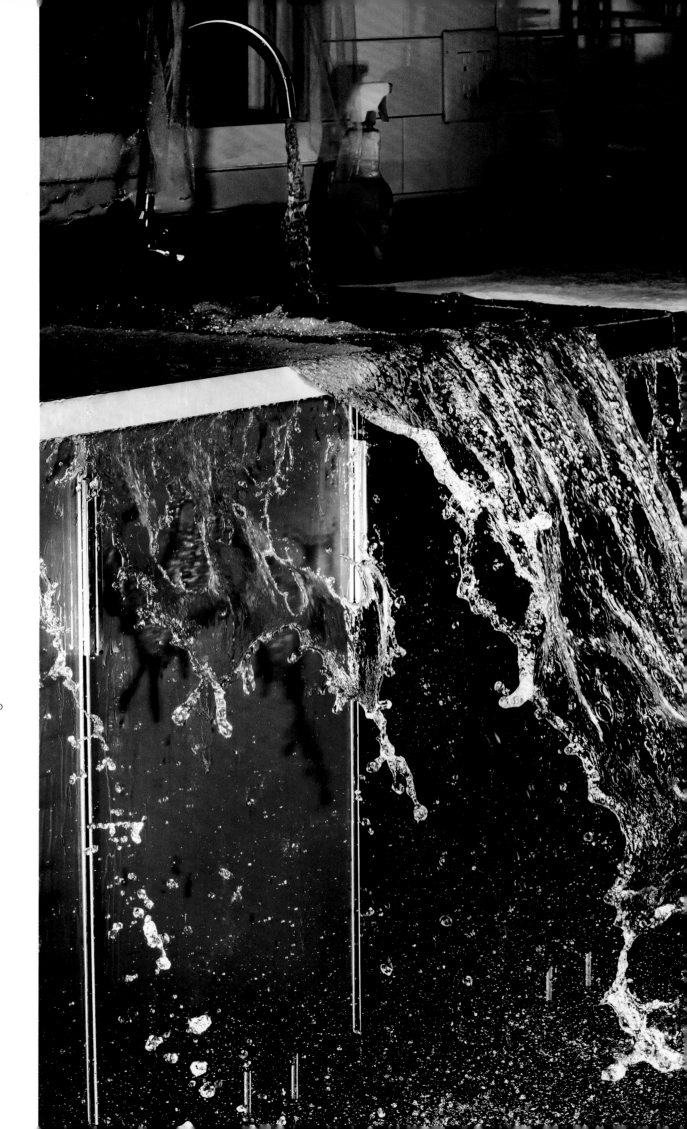

When set designers and prop stylists do their job well, the reader shouldn't be aware that a location isn't "real" or that the couch, table, mirror, bed hadn't always been there. We weren't able to shoot this picture in a real kitchen, because we planned to flood the room, so we needed to be in a studio with a drain in the floor. Anyone who's ever renovated a kitchen knows how expensive they are to build. Our production designer, Mary Howard, searched for more than two weeks for the right components. The day before our shoot we still had no set because everything we needed to rent or buy was over our budget. Once again a last minute idea saved us. IKEA sells modular kitchens and they generously donated and delivered the cabinets and counters in a few hours. Mary designed it, tiled the walls, added the window, brought the table, toaster, pots, the remote, and everything you see except Karlie. Her crew began work at 5 A.M., assembled the pieces, hooked up water so the sink was overflowing, and made it all look like a kitchen in someone's home by 10 A.M.

ADHD
New York, October 2011

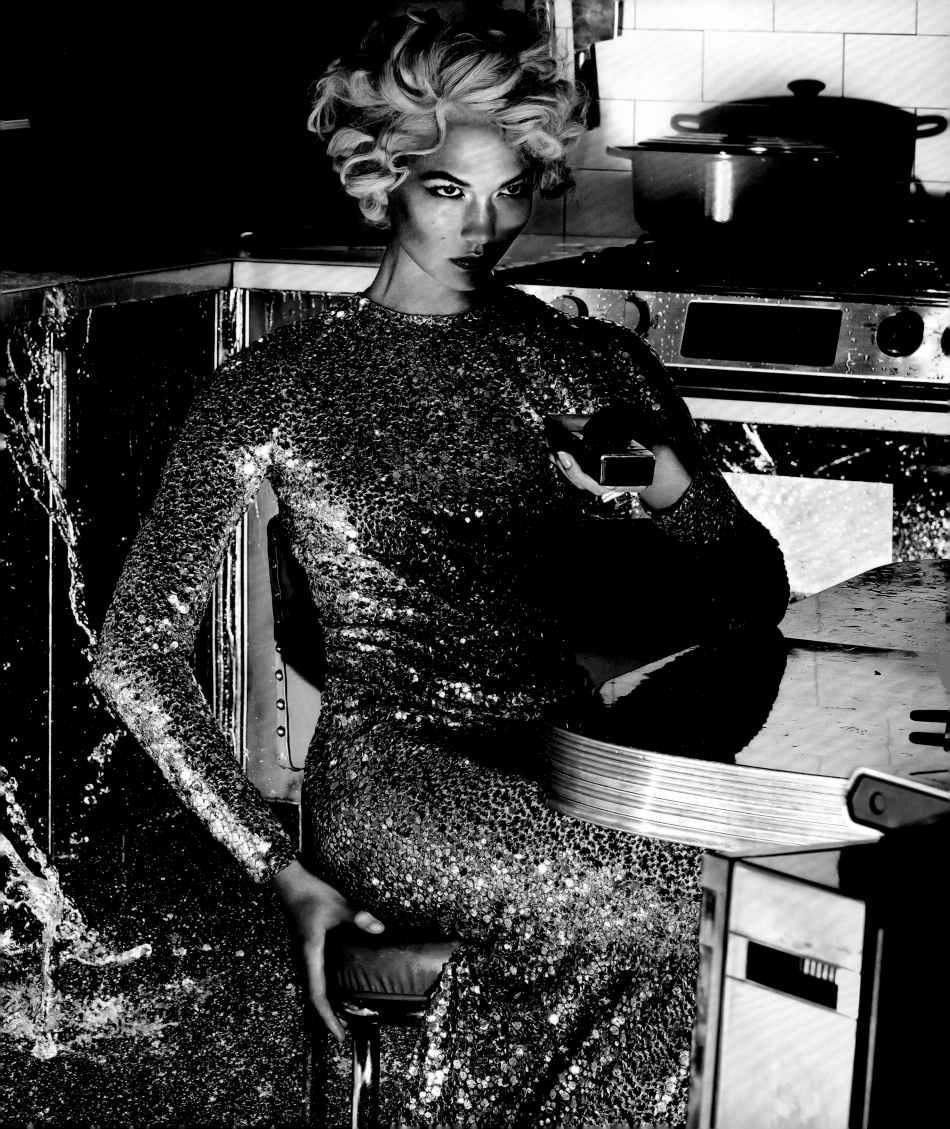

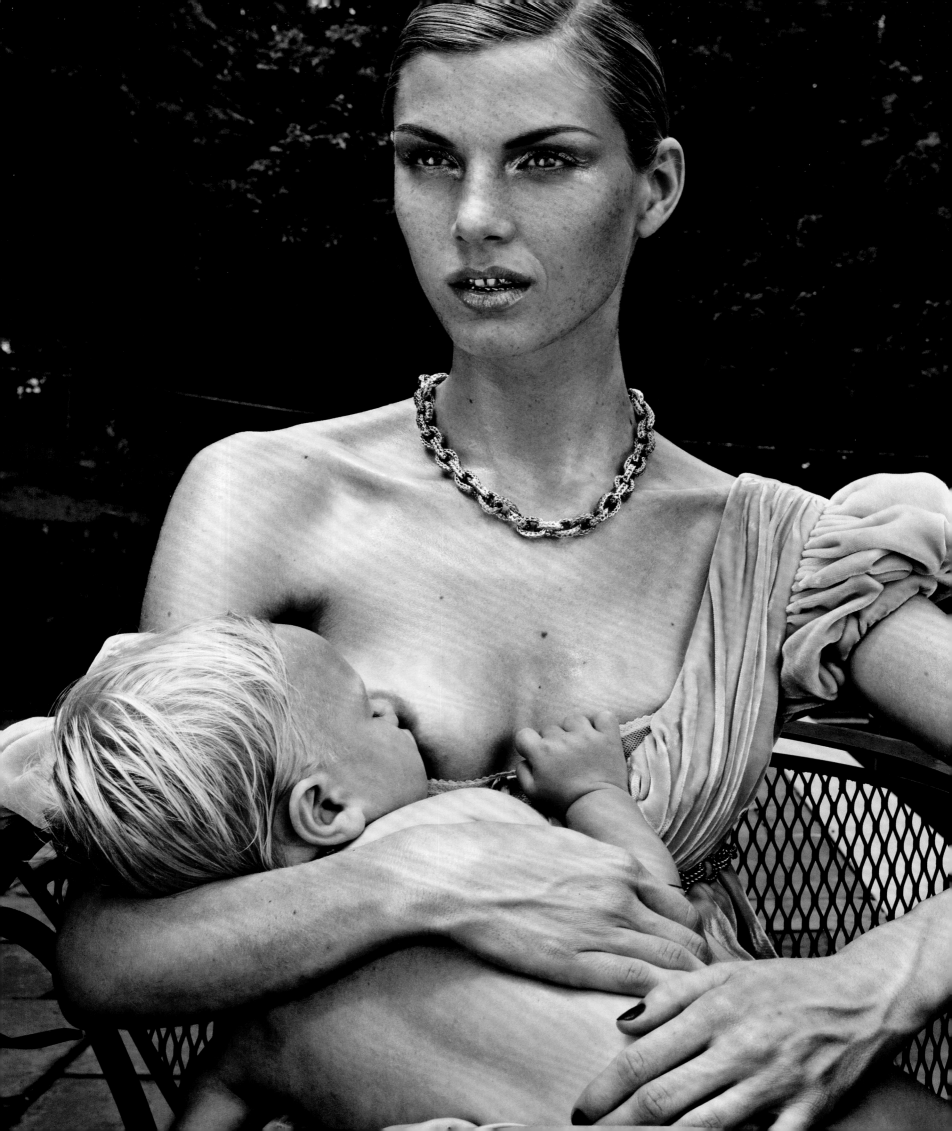

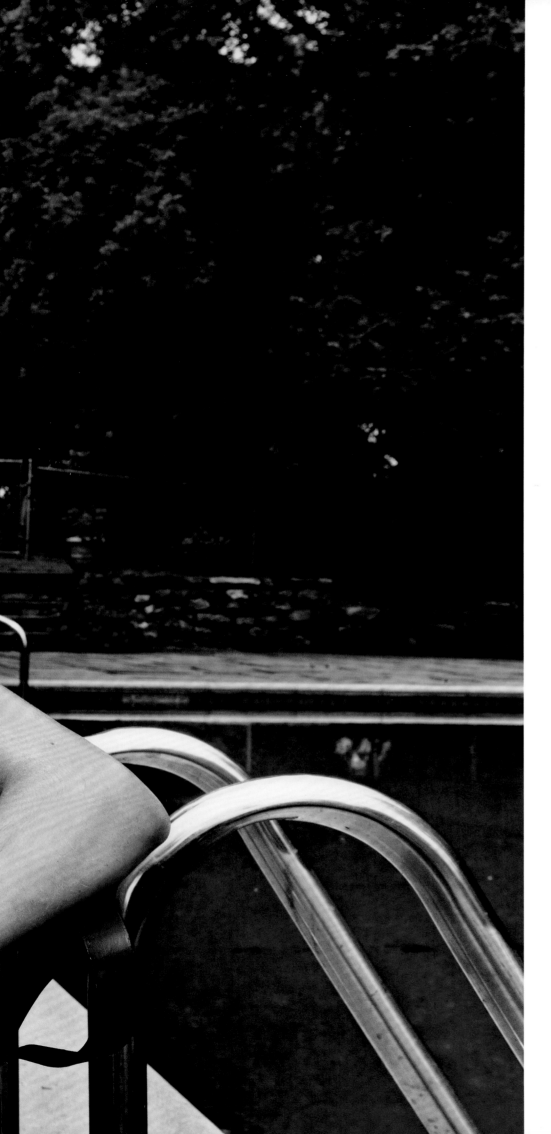

Another new invisible product, braces. Don't ask why, but when Steven and I talked about the shoot, the first thing he thought of was a Madonna and child. He wanted the child to be nursing, and our Madonna needed gold teeth. This, of course, had nothing to do with braces, but it was about teeth and I thought it would make a good picture. I didn't see how we could make it happen. Babies don't pretend to nurse, especially with a stranger. There would be tears from the baby . . . or me . . . or both! Then I remembered that Angela Lindvall, one of our favorite models, had a 14-month-old son and she liked the idea. But how to find real gold teeth that would fit our model? Steven knew the man who made 18-karat gold teeth for the rappers and sent Angela to Queens to be fitted and cast for her own personal set which she probably still has.

Surburbian Woman #10
Mountainville, NY,
August 2006

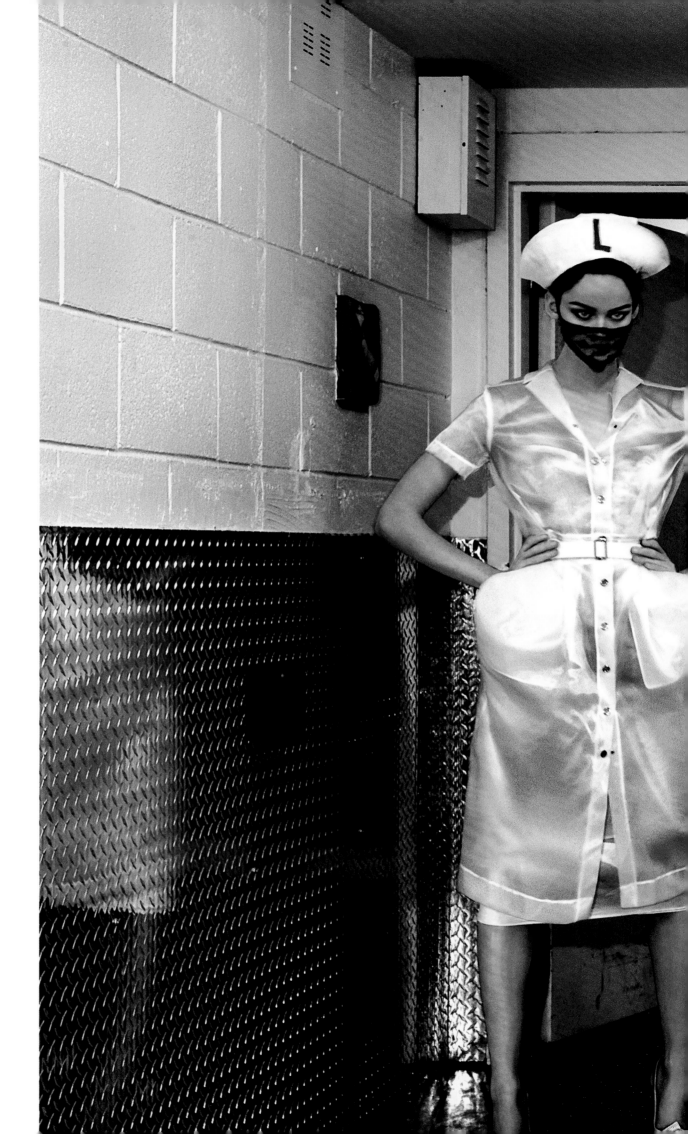

Cosmetic procedures don't always go as planned and I was happy that *Vogue* was writing an article about the mistakes and how to correct them. My own particular obsession was women who had "trout pout" lips. Couldn't they see how they looked? For years I'd wanted to do a picture using the big red wax lips that children play with. I had a few pairs sitting in my desk drawer waiting for the right moment . My other obsession at the time was the "nurse" that Marc Jacobs sent down the S/S 2008 Louis Vuitton runway. She made me think of Nurse Ratched in *One Flew Over the Cuckoo's Nest*. Here was the perfect photo for both. We added lipstick to the wax lips. Lisa Cant became our nurse. We actually shot this in a hospital, but with Steven's eye and Guinevere in a wheelchair (seen in the mirror), it looks more like a prison.

Hospital Drama
New York, May 2008

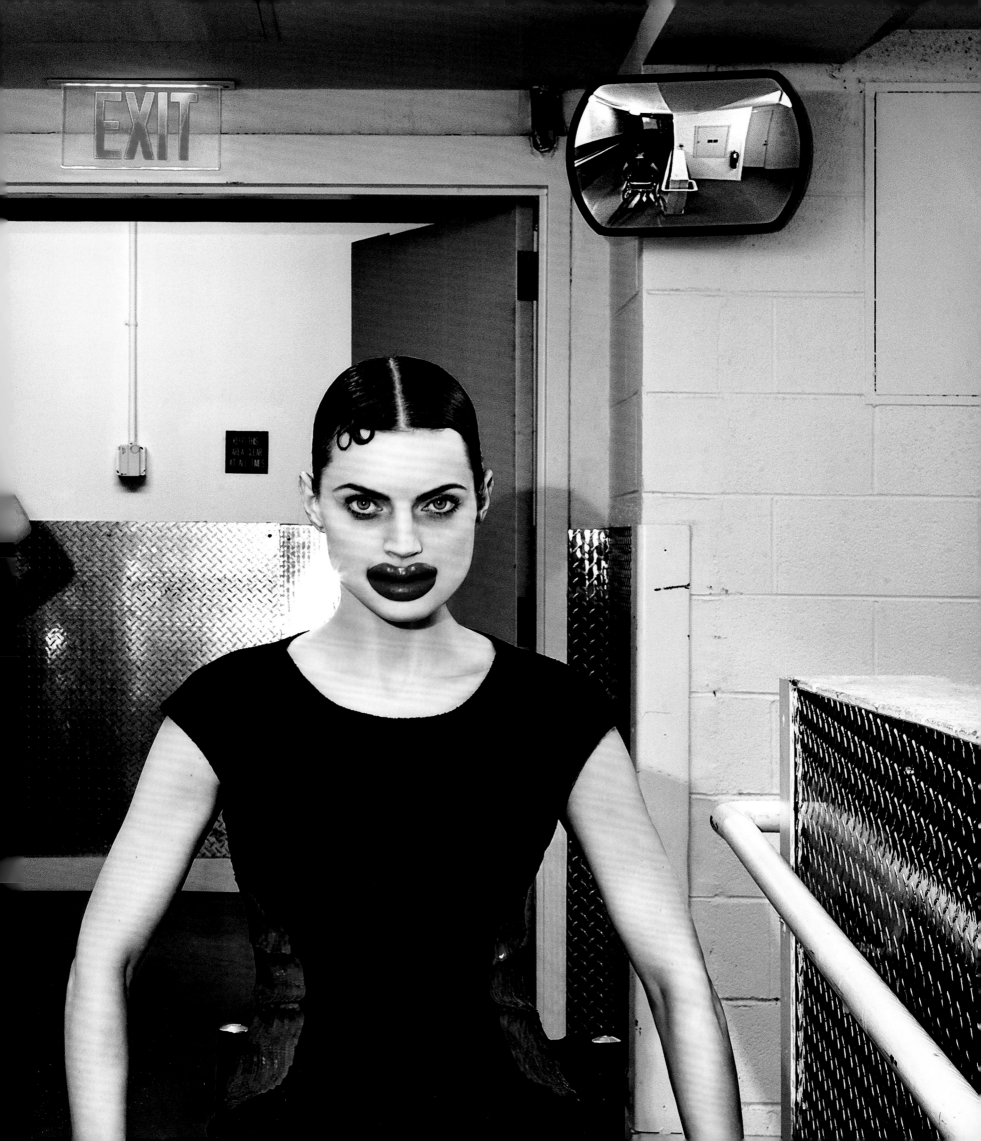

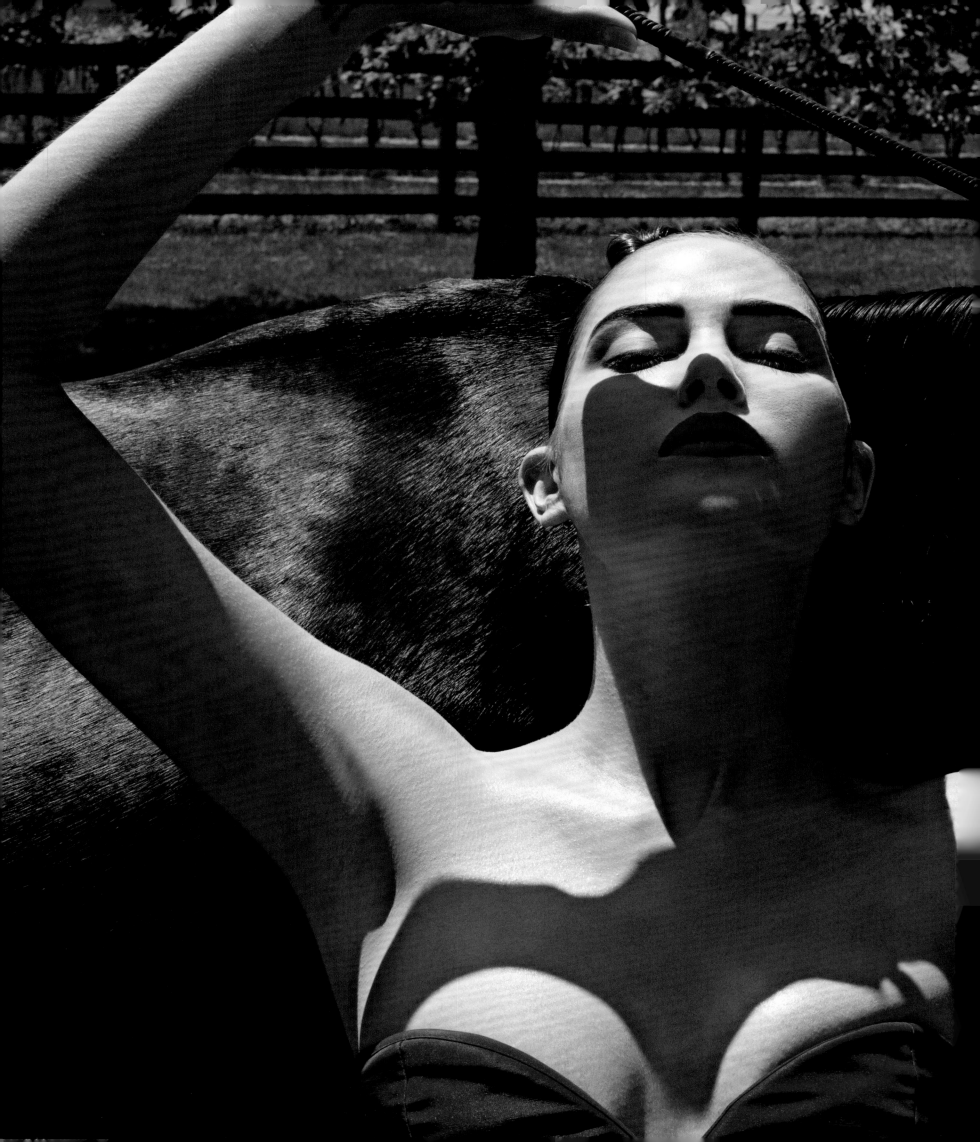

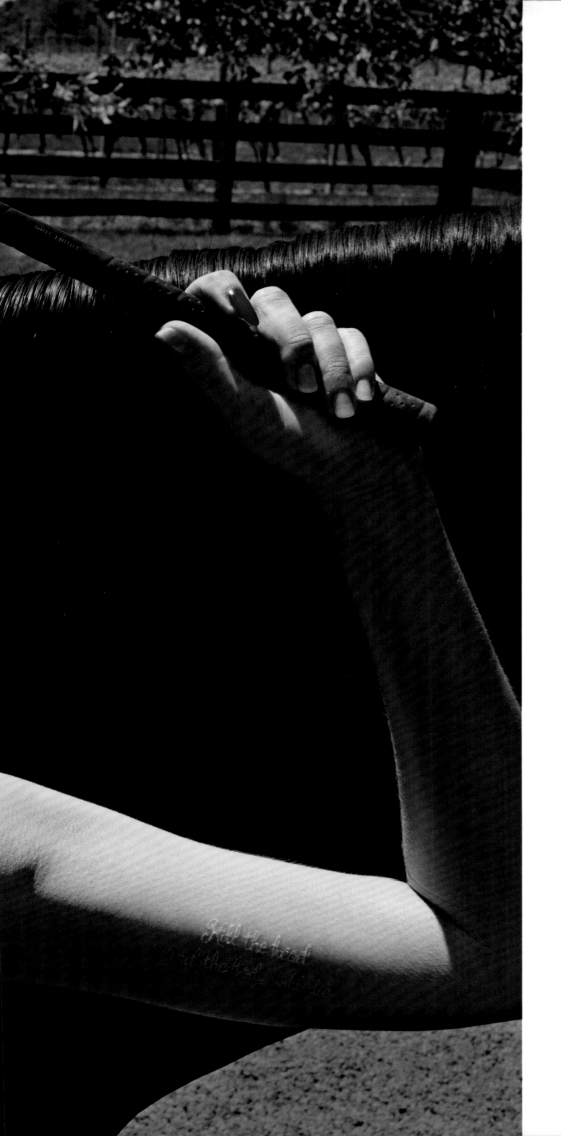

Woman, Horse, Riding Crop
Bridgehampton, NY,
August 2008

Red Dress in Surgical Room
New Jersey, January 2006

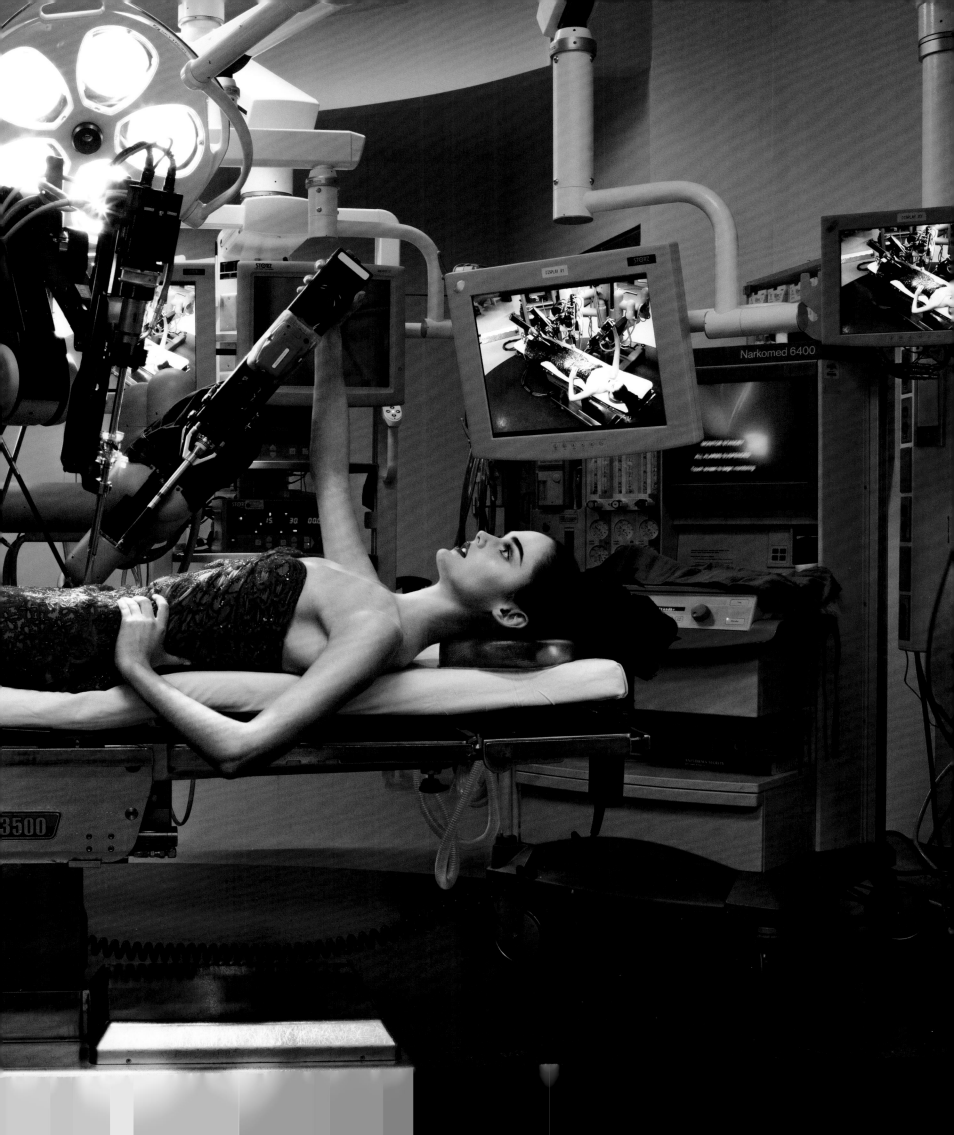

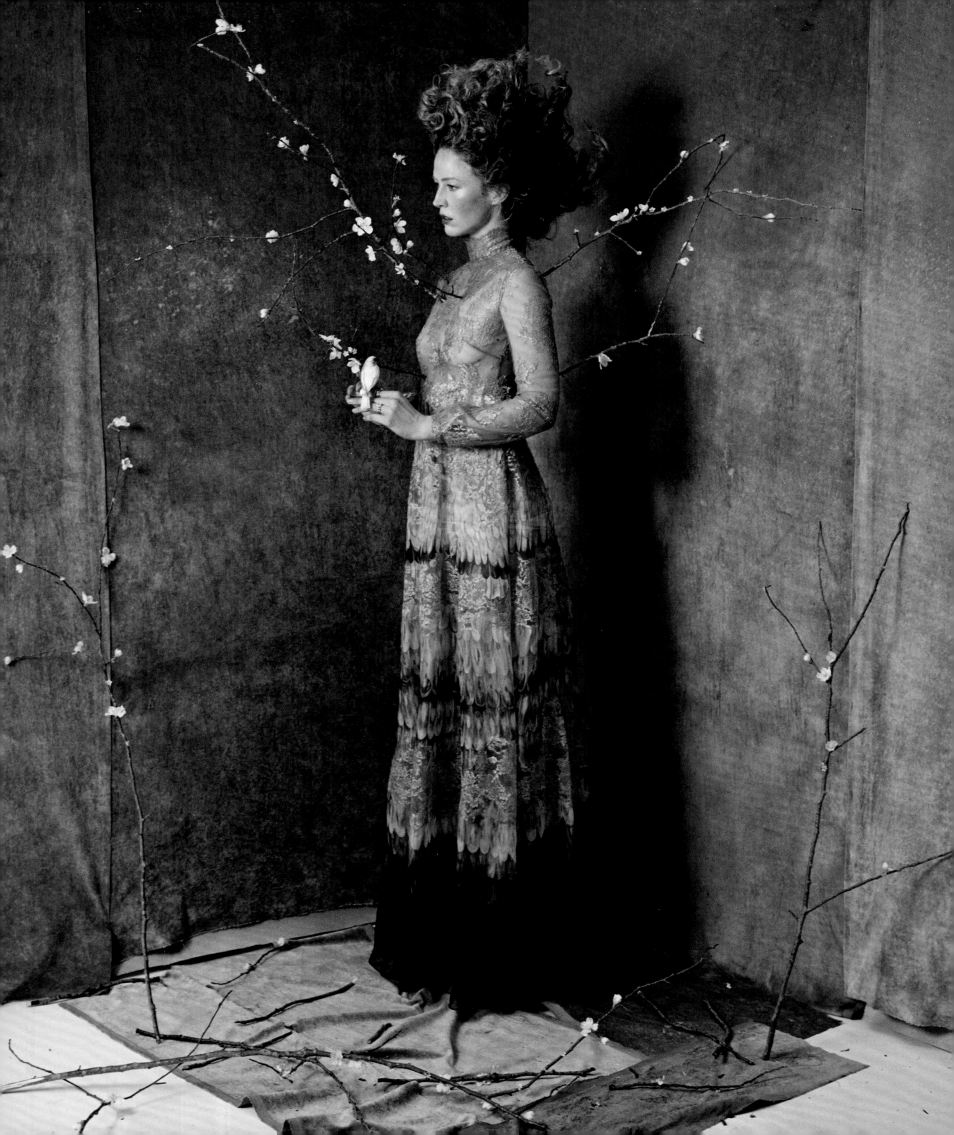

Tim Walker

To anyone who knows his work, a Tim Walker picture means quirky, romantic, feminine, beautiful, unexpected, fantasy, timeless. He has wonderful ideas and a great English sense of humor. He's an original storyteller who knows art and fashion, has breathtaking color sense, thinks like a set designer, loves to travel, and brings all this to his creative process. It's exciting to work with Tim because the photographs we do for *Vogue* surprise our readers and sometimes surprise our editor in chief because they don't always look like "American *Vogue.*" Persuading Tim to do a picture is a process—sometimes short, other times, not—which can be challenging. That's a good thing because it takes us away from a familiar place to somewhere more creative and original. After the call to let him know what we're illustrating, Tim e-mails fine detailed drawings of a few versions of what he'd like to do, and we talk . . . and talk . . . He knows what's necessary—props, set design, location, and more—to make his photos. If he doesn't get them he could very well change his mind and refuse to do the shoot, and he has. I like this strength and determination and respect him for it. I love his photographs and am always curious to see where his unique style will take us. Who else could have taken the photo of Raquel, opposite? It looks like the beginning of a fairy tale.

Forces of Fashion (Valentino)
September 2015

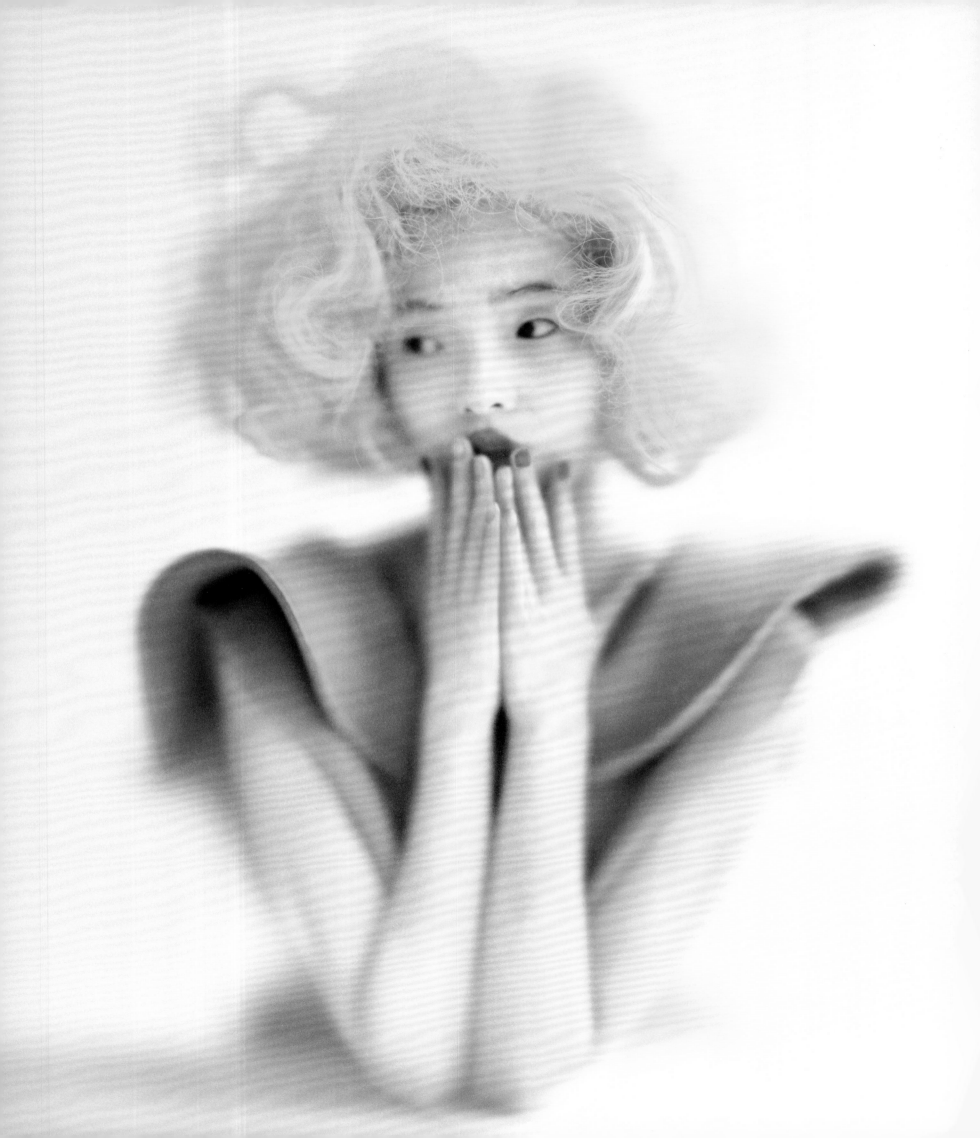

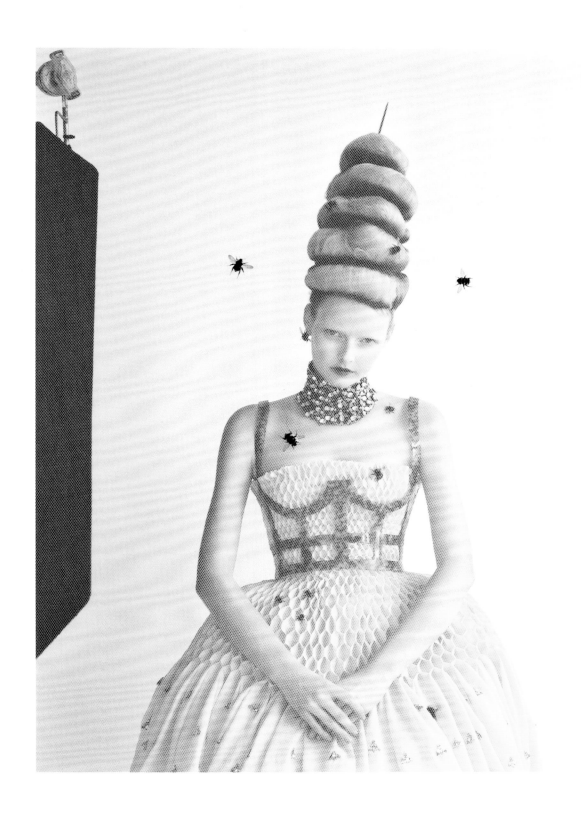

Vogue wanted to report on the 1960s beehive hairdos that we had seen on the S/S 2013 runways in New York, Milan, and Paris, but collections were quickly coming to an end and I was struggling to find a way to turn a beehive into an interesting picture. Then Sarah Burton's collection for Alexander McQueen came down the runway with models wearing the most beautiful honeycomb dresses. The collection was all about bees. Now my only problem was which dress to photograph. . . or so I thought. On the day of the shoot, Julien d'Ys gave Elza a very exaggerated beehive, Val Garland did her makeup, and I dressed her in the McQueen. Tim put her behind a scrim and added bees, but it just looked like a good fashion picture. There was no focus on the beehive. We were stuck until we finally thought of . . . a BEE! Julien added even more height, sprayed yellow stripes, and gave it a stinger.

THIS PAGE:
Honey-Do
March 2013

OPPOSITE:
To Dye For
September 2012

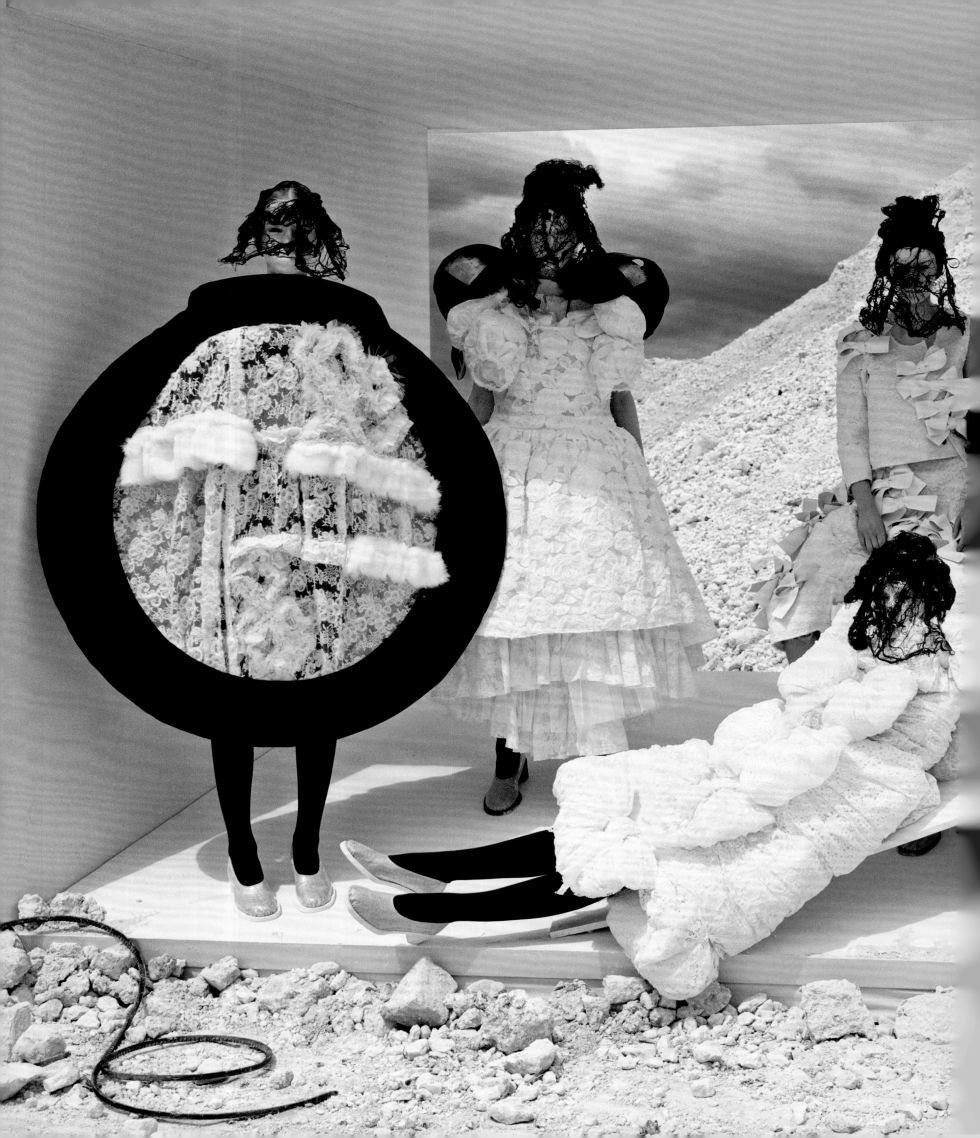

"When I look at the photographs made between myself and Phyllis, I see mistakes. Lots of them. They are extremely subtle and would go unnoticed by the majority of people speeding through the pages of *Vogue*, but they are there, nonetheless. It is these mistakes, I've come to understand, that are the life that makes the photograph alive. That 'life' could simply be a sort of documentation of the day's struggle to verbalize beauty . . . the Nike scuff on the white Colorama paper, the Coca-Cola can, the back of the set that fell over to reveal the chalk mountain. I clearly remember the manicurist saying, 'Of these, which red is best' as she held up the hand of Xiao Wen Ju displaying the plum, burgundy, and fire engine red lacquered nails to accompany the yellow Monroe wig picture illustrating the day's craze to colour hair in primary, punky dyes. 'Leave it !' said Phyllis. 'Don't touch a thing.' Leave the fraying canvas untrimmed on the blue painted backdrop, leave the twig that fell to the floor, leave the power cable and the apple boxes, leave the string that suspends the giant white sun hat, leave Julien's pearls on the table . . . don't touch a thing . . . the blood trickling down the blade of the chef's knife is beautiful . . . LEAVE IT! I think it's very interesting that in the time Phyllis and I have been collaborating the perfecting possibilities of the manipulated image have reached their zenith, yet it's the knowledge NOT to perfect that speaks beauty. Perfection is perfect but beauty is something different. These 'leave its' are holes, fragile mistakes, that removed render a photograph lifeless . . . it really is such a tiny detail, but that really is where the divine lurks in the weaving of the photograph. Phyllis taught me that mistakes are good."—TIM WALKER

**Forces of Fashion
(Comme des Garçons)**
September 2015

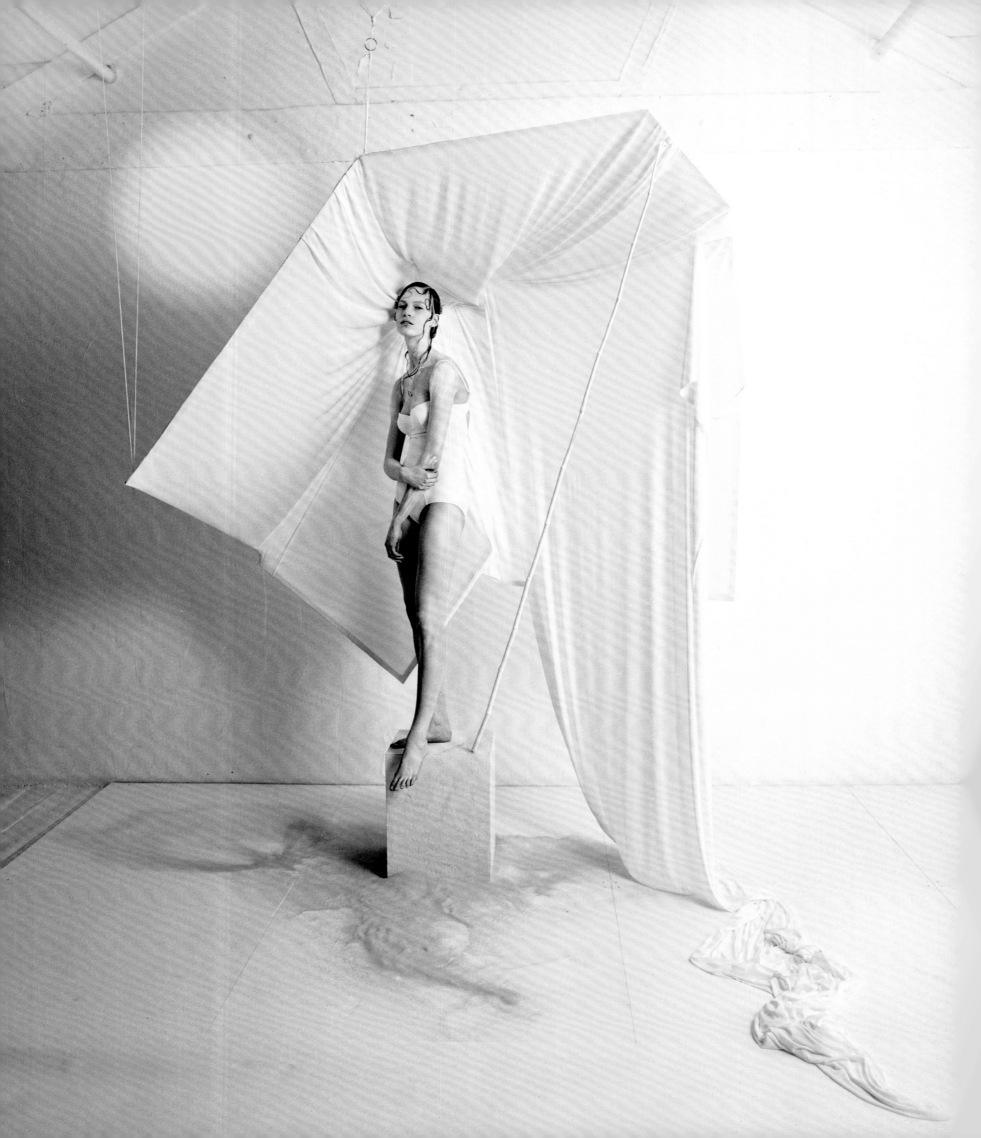

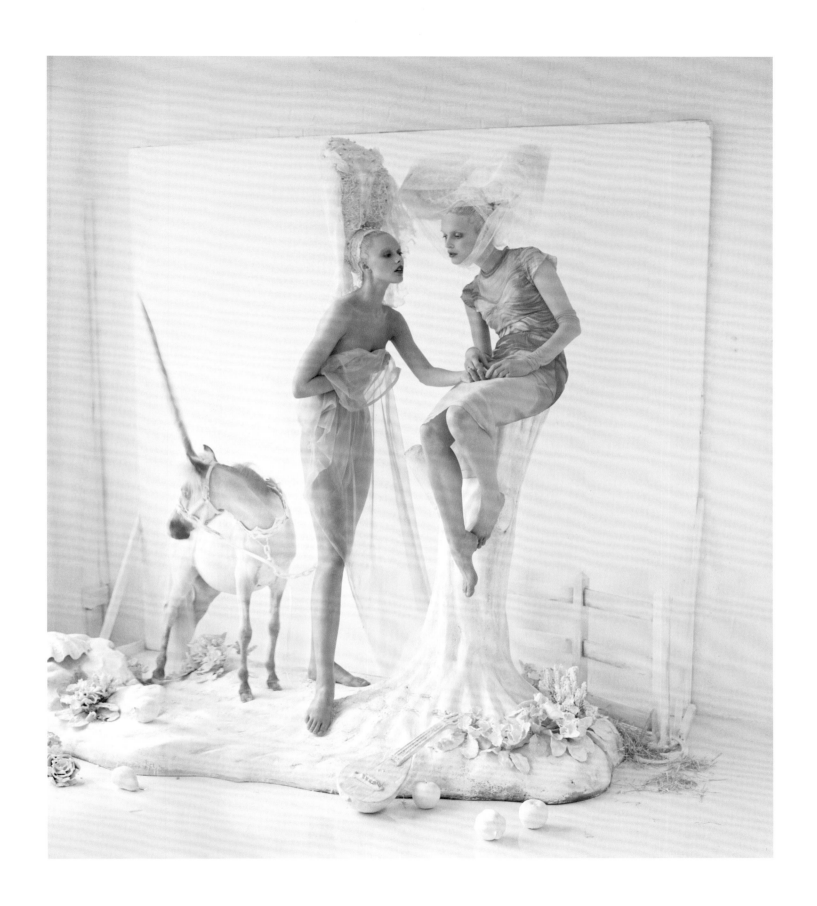

THIS PAGE:
Flight of Fancy
May 2012

OPPOSITE:
Fair Game
June 2015

83

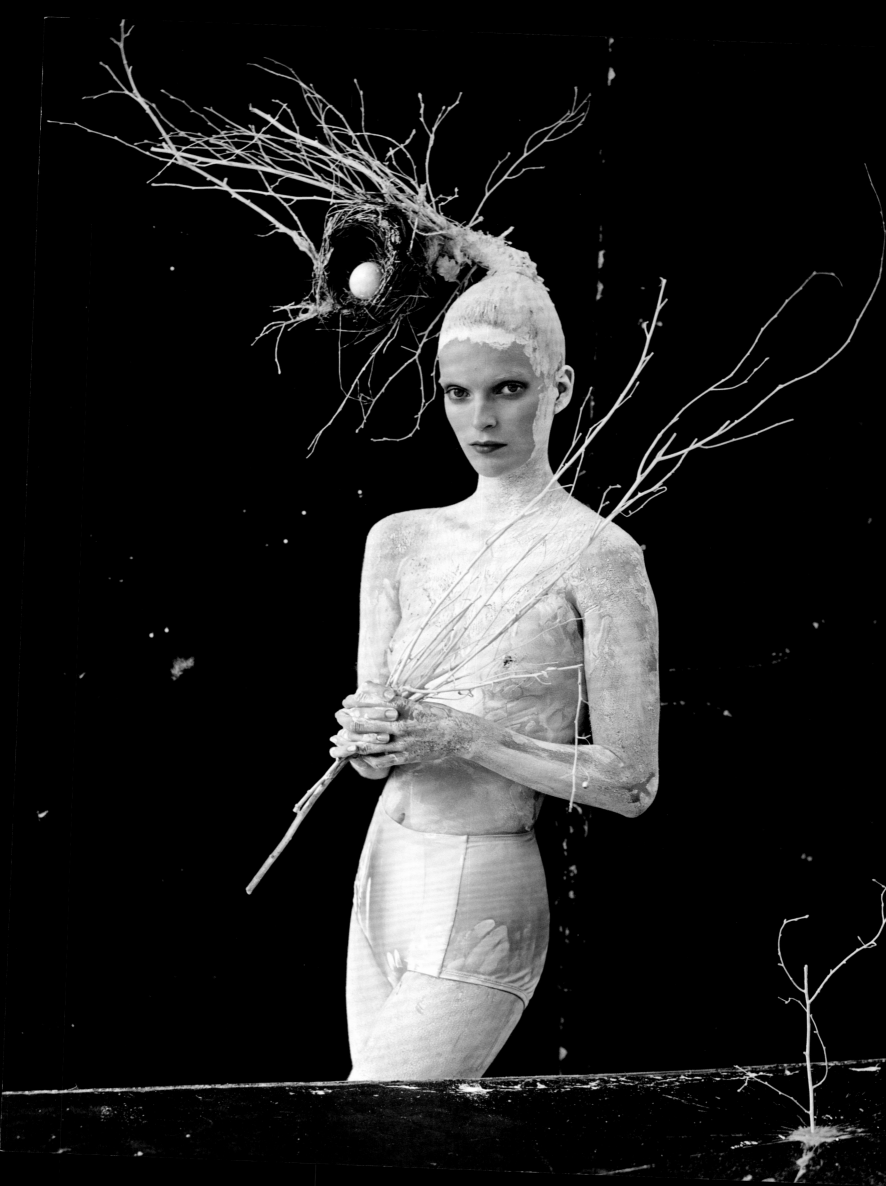

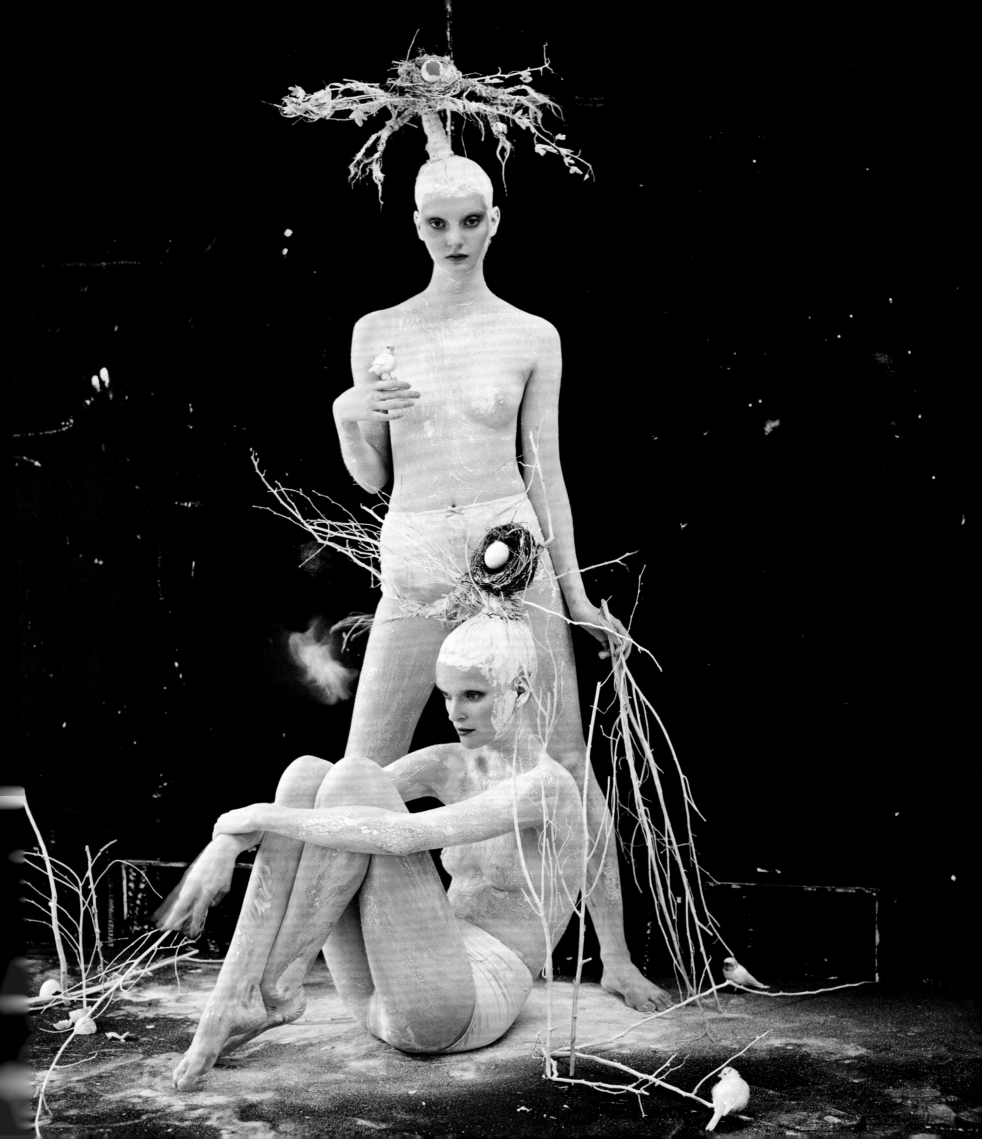

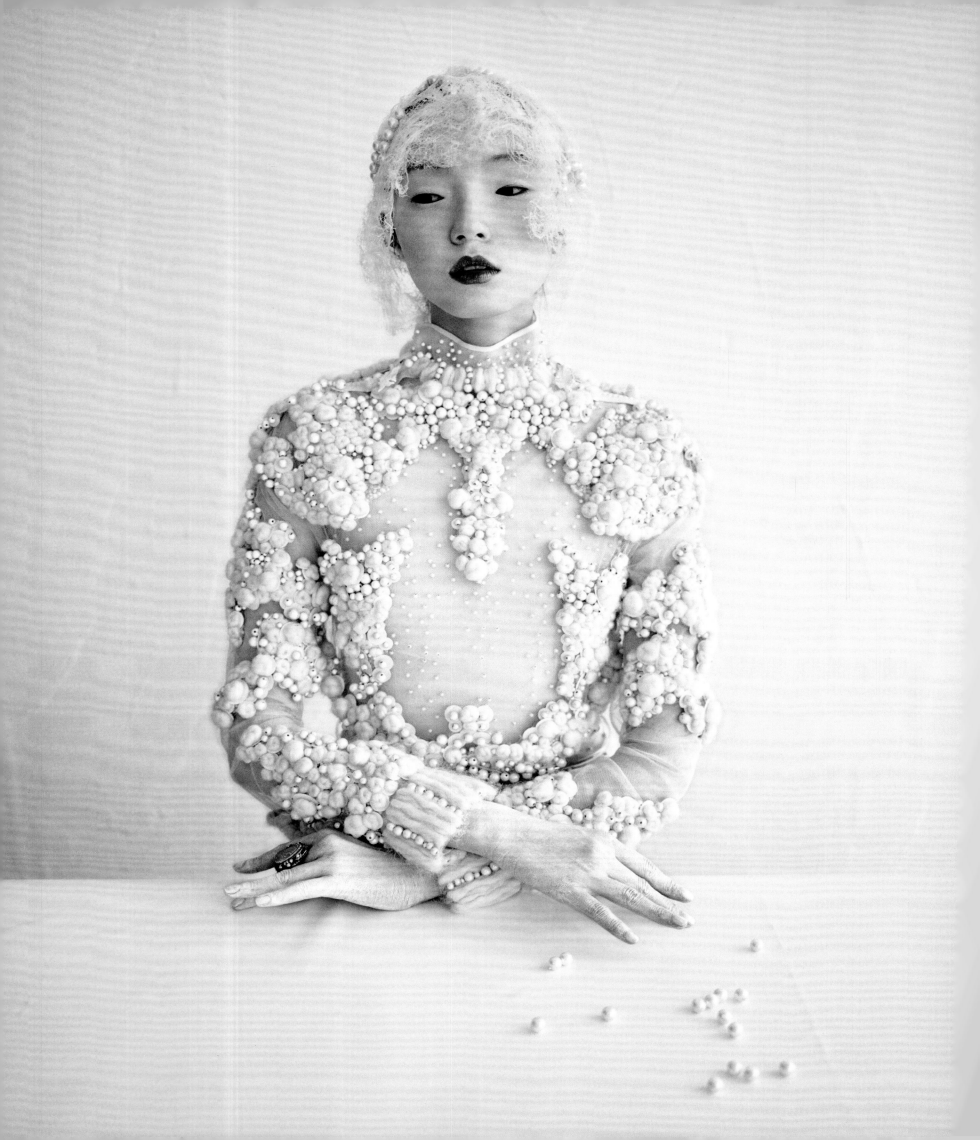

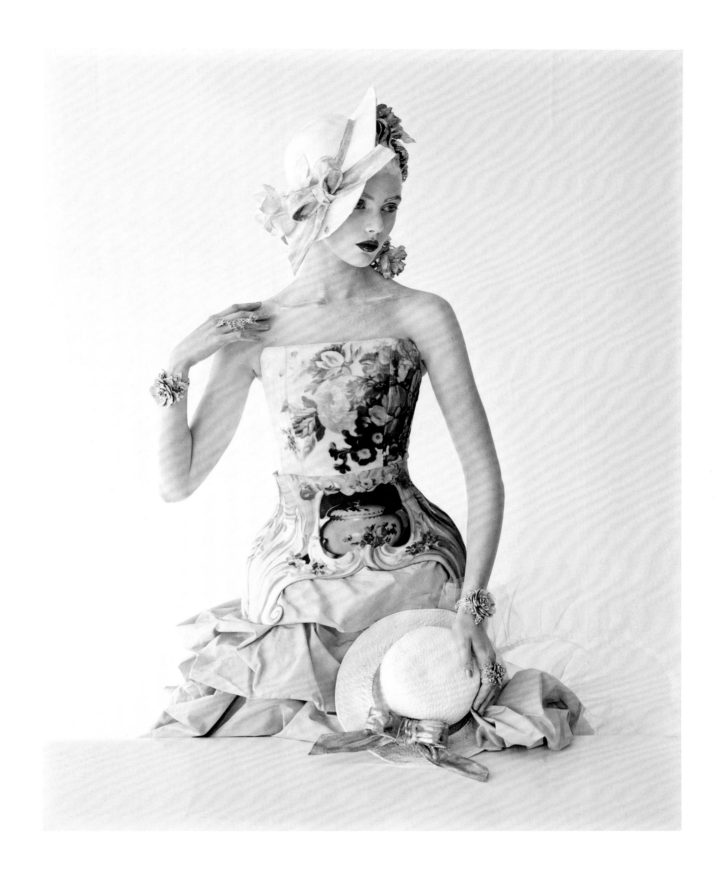

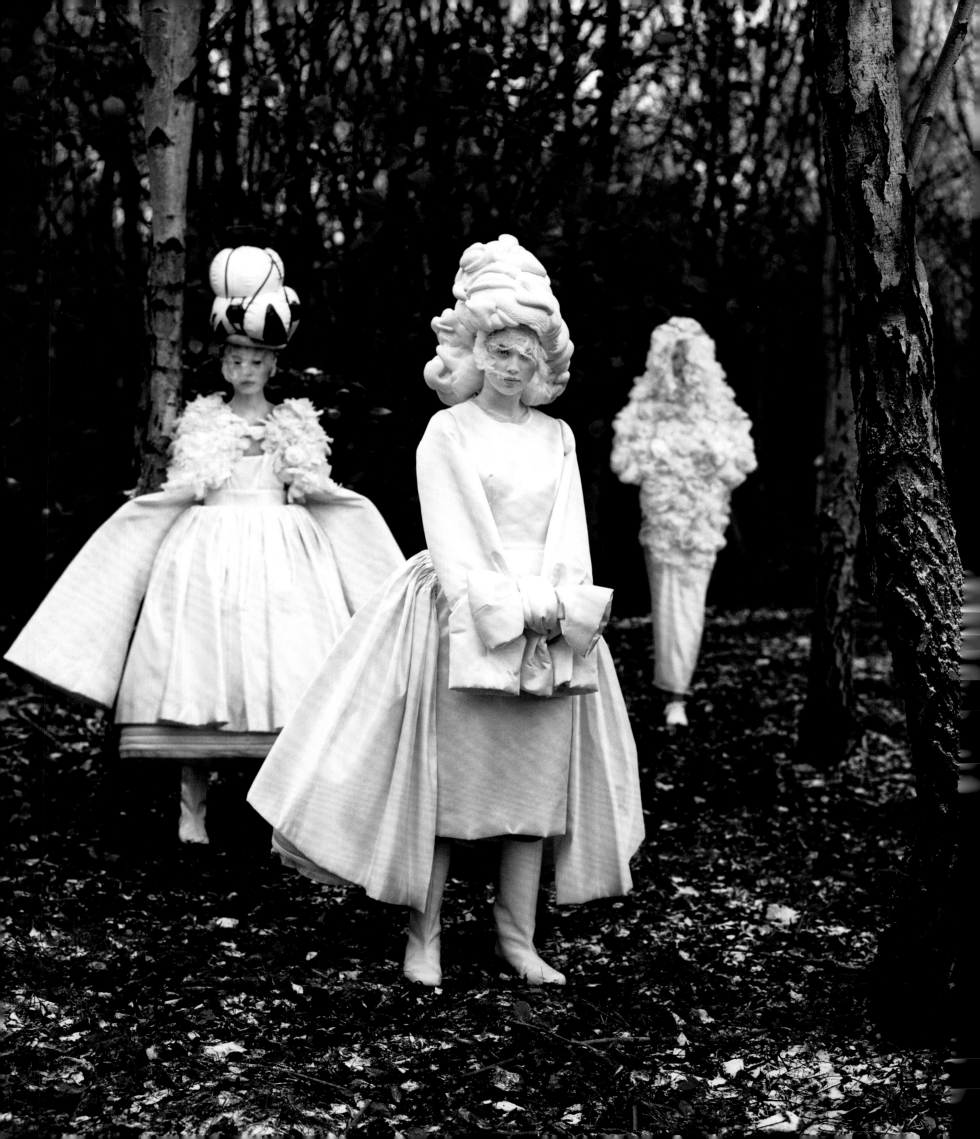

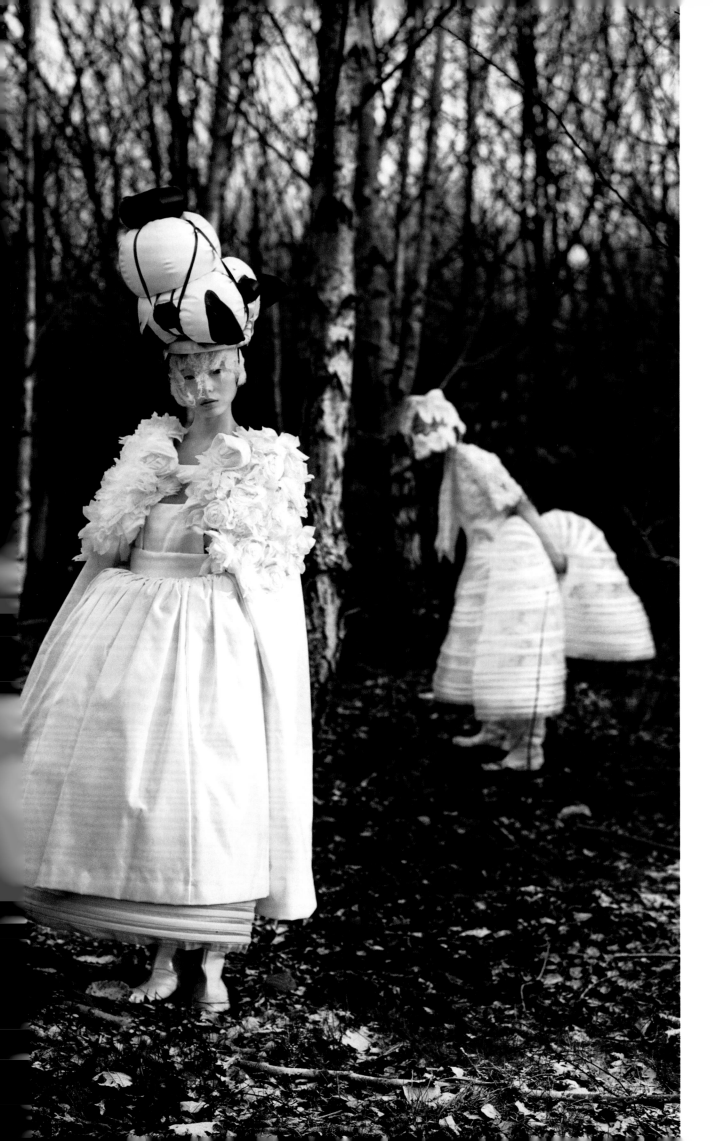

Rei Kawakubo is one of my favorite designers. The S/S 2012 collection was extraordinary and Anna encouraged me to do a shoot with Tim, who is a great admirer of Rei's. Comme des Garçons likes to exercise strong control over editorial shoots, and we had endless discussions before an agreement was finally reached so I could have the clothes. The condition was that we would photograph in the studio. It was January in London, it had rained, the ground was muddy, and it was cold, but when I got to the studio, Tim was determined to do the picture in the woods. He was ready to go: had thermal underwear for the models, a minivan waiting on the street, and had already put boards on the ground so the spotless white boots would stay spotless on the way into the birch forest. As soon as we arrived, he had the forest sprayed with snow and did this picture in no more than an hour. Comme des Garçons loved it.

Comme des Garçons
May 2012

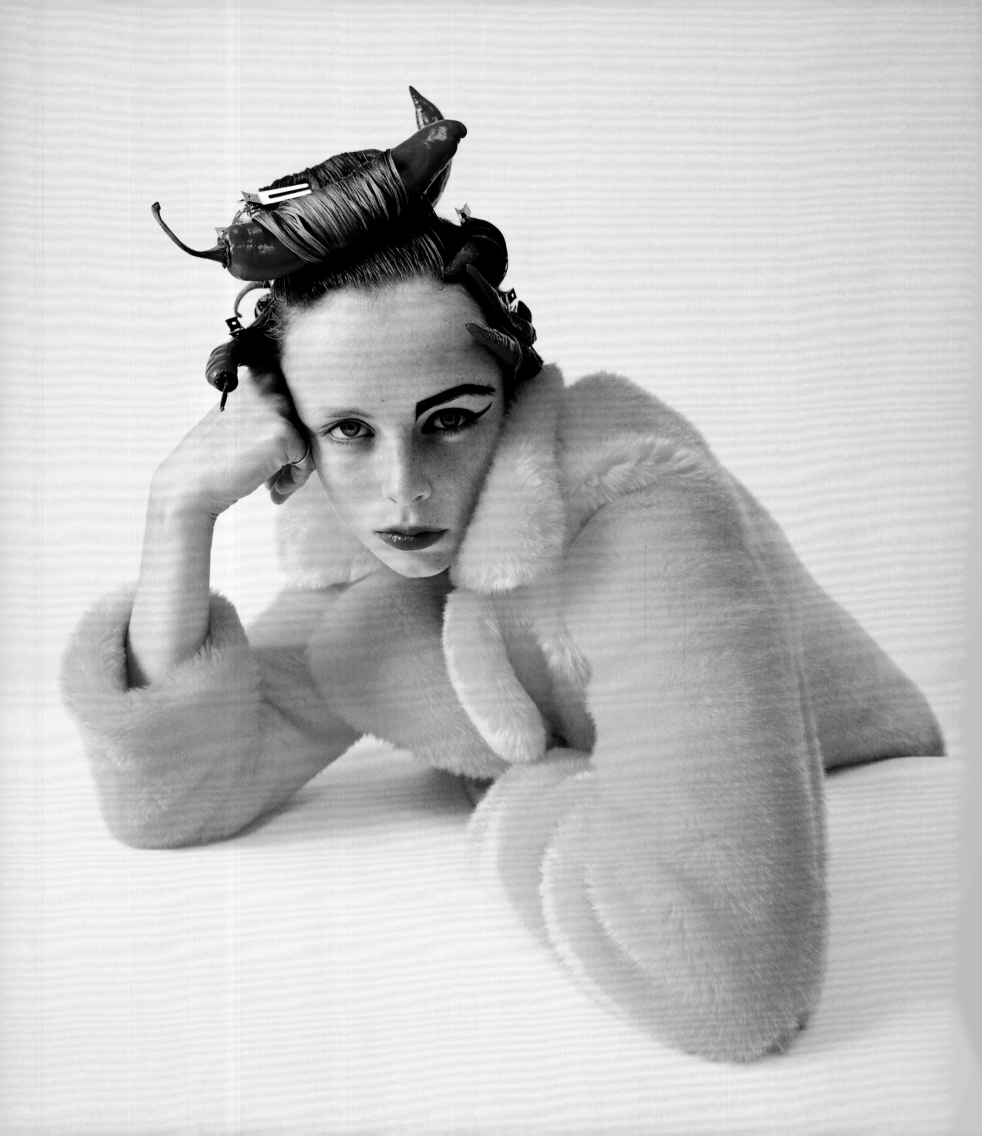

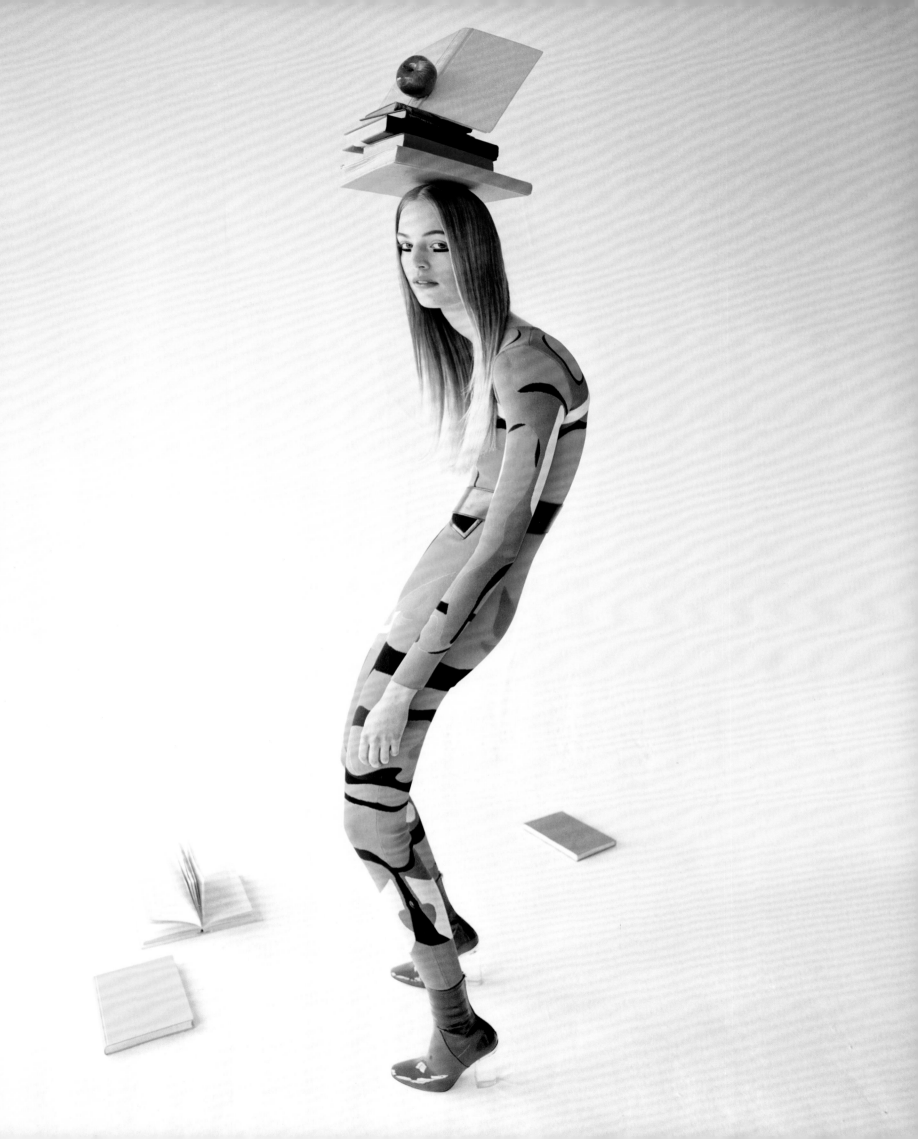

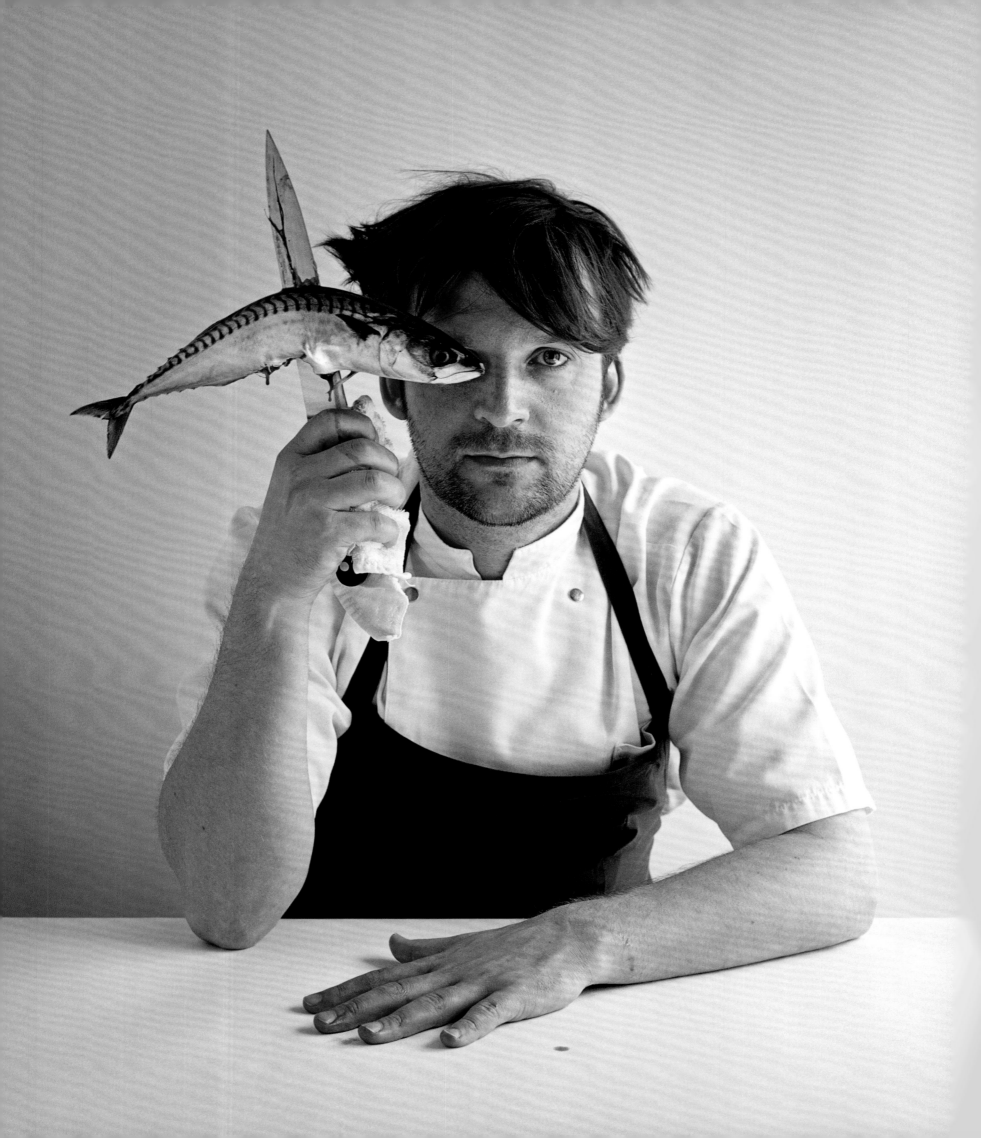

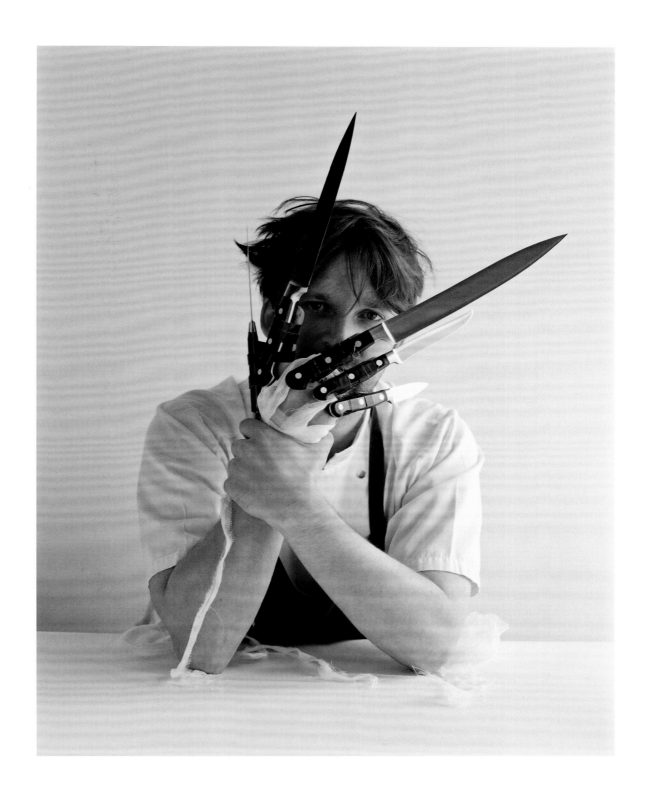

In 2010, Noma had just been named "Best Restaurant in the World" on the San Pelligrino list and we were in Copenhagen to do a portrait of the very young chef, René Redzepi. Tim wanted to photograph him as Edward Scissorhands. René was charming and liked the idea. While we taped knives to René's fingers, the large kitchen staff of aspiring chefs from all over the world was busy preparing for lunch and dinner, working with foraged ingredients like moss, wood sorrel, and wild mushrooms, plus locally sourced squid, langoustines, and lamb. At the time, no one had ever heard of "foraged," which has now become an overused word that has no relationship to the unique food at Noma. Tim did two different portraits, as he often does. The one that ran was "Scissorhands," but the alternative was just as good, if not better. But I have to admit that the best thing that day was meeting René and having my first incredible meal at Noma.

PREVIOUS PAGES:
Hot Head
November 2015

Posture Police
July 2015

THIS PAGE:
René Redzepi
September 2010

OPPOSITE:
René Redzepi #2
September 2010

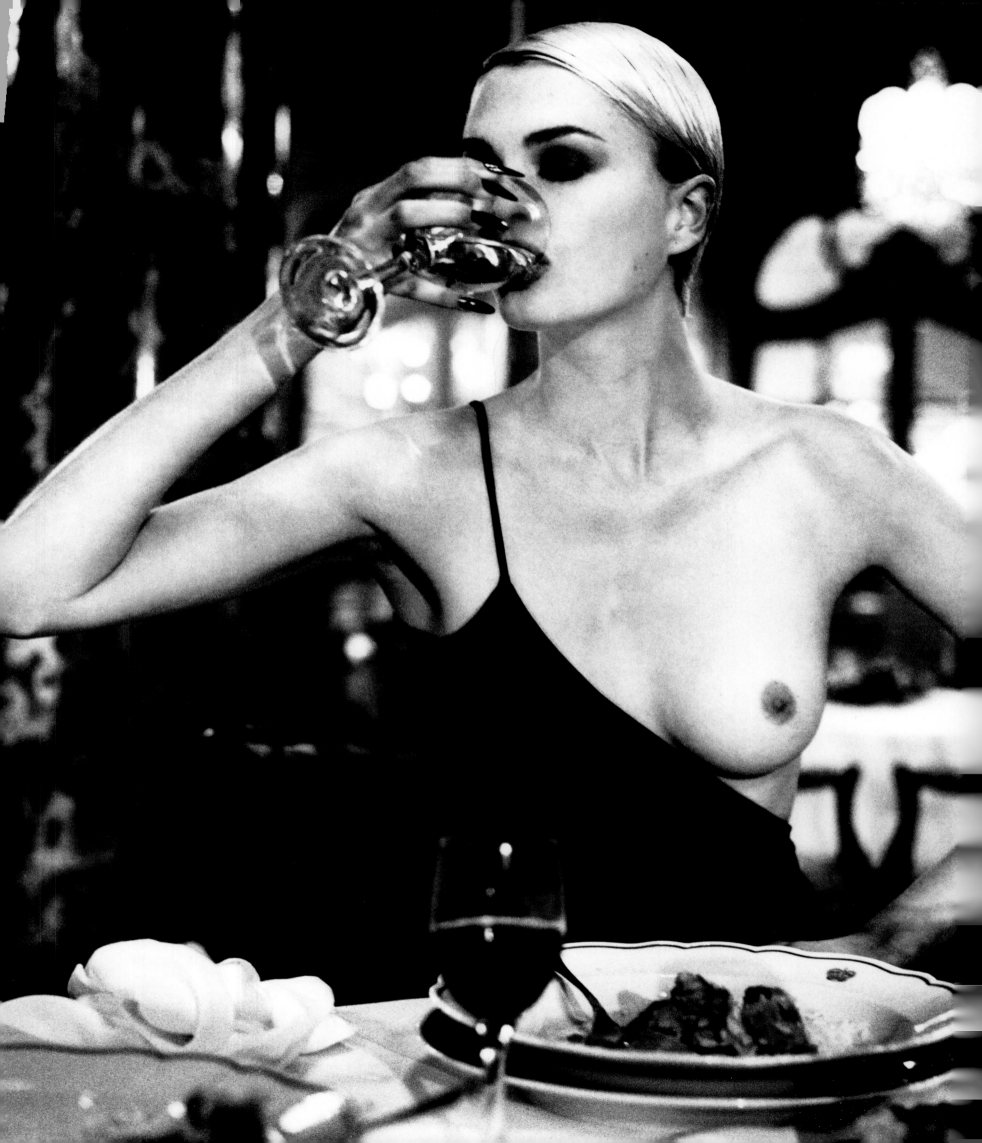

Helmut Newton

Helmut could do strong photographs anywhere—day or night: in the noon sun, under a street lamp, in a phone booth, using a car's headlights, or in the underground garage of his building. He rarely shot more than three rolls of film, sometimes only one. I had to be prepared. There was no second guessing, no "Can we try a different dress, shoe, earring." He was fun, it was never, ever dull, and I loved working with him. It was exciting to see him take a model, put her in place, and see the Helmut Newton photo appear. After our initial call to discuss the idea and the models, his faxes would start to appear on my desk. One of my favorites was written when I tried to convince him to work with a model he didn't know: "Dear Phyllis, For our sitting, please make sure you get a gal with some muscle and meat on her—none of those starved females!! Horrible matchstick women. Love Helmut." We usually worked in Monte Carlo, where he lived. He knew every corner of that place. He wrote, "My immediate surroundings are always more mysterious and exciting to me than exotic islands and far away places. I like photographing places and objects I see every day. . . . And places that are out of bounds for photographers have always had a special attraction for me." He always knew exactly how he was going to do a picture. I didn't, and it made me nervous. I remember once asking him to tell me where he was planning to shoot and "Why? Do you want to take the picture?" was his response. I told him that I thought he was being a bit tough with me and he replied, "I'm not tough; I'm just a pussycat."

The Naked Truth
May 1997

95

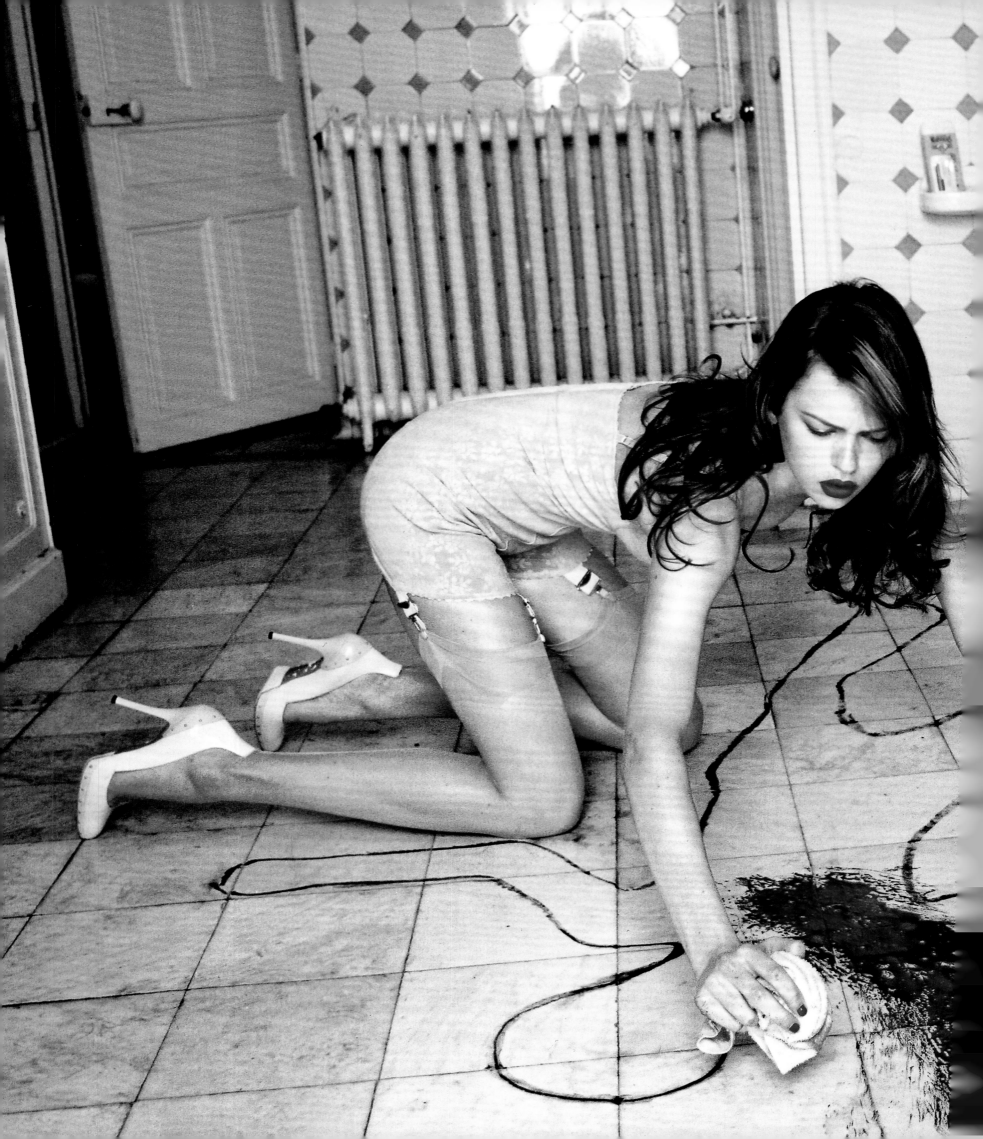

Vogue readers were horrified by some of Helmut's photographs that we published. He was no champion of cozy domesticity. His women were empowered, whether they were on their knees, on their backs, or in a wheelchair. We would get letters complaining and canceling subscriptions. He loved to provoke. This photo, for an article on aging knees, is from a series showing everyday things women do on their knees, wearing everyday clothes, at least in Helmut's world. After the photos ran, this fax arrived: "Dearest Phyllis, I'd love you to fax me the anti-Newton letters for my archives! Thanks a million. Love as ever Helmut." If there were no letters, he would be disappointed.

Knee High
July 2003

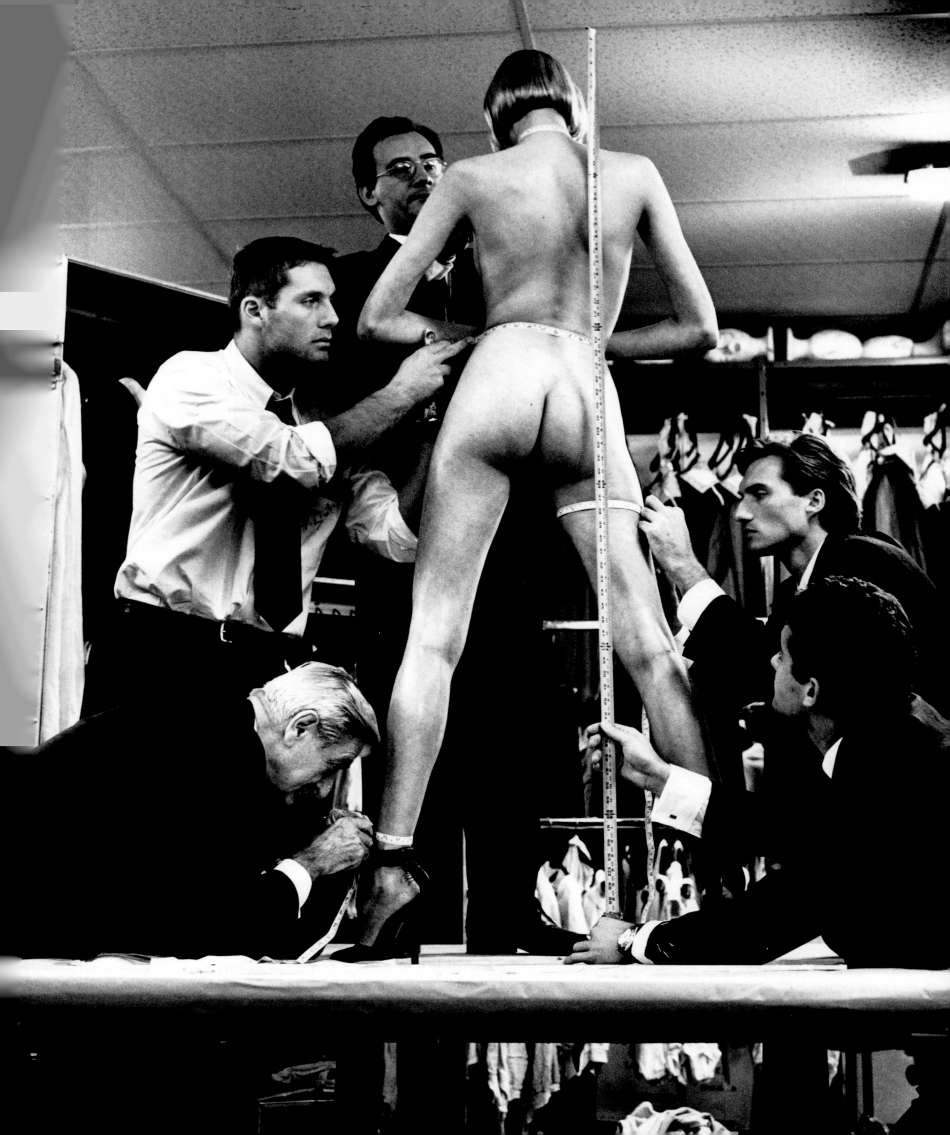

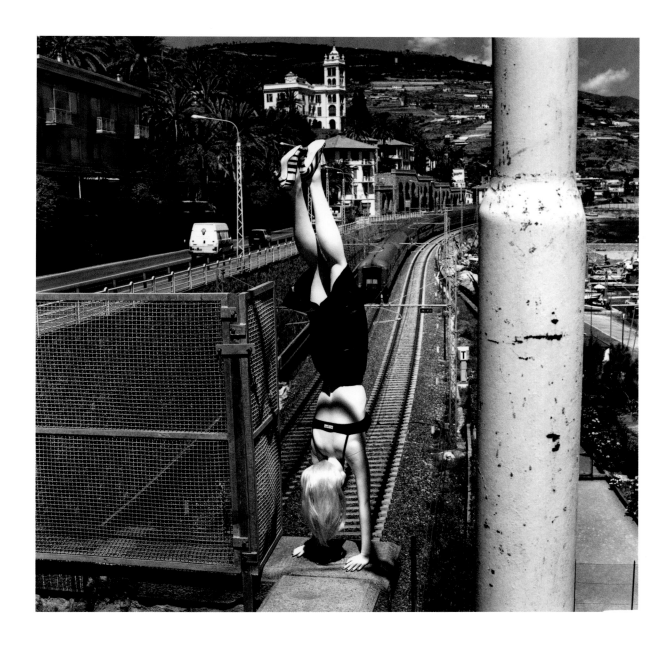

THIS PAGE:
On the Right Track
January 1997

OPPOSITE:
Measuring for Success
January 1997

Helmut collaborated intensely with June, his wife of more than 50 years. She was his accomplice and he adored her. She was often with us, observing with her keen eye and filming the shoot. They were a team and any discussion of Helmut's work, his influence, and vision can't fail to mention June's extraordinary role in his success. I'd suggested using a bed of nails to illustrate new cosmetic injection procedures for the body. Helmut knew exactly where to have one made to his specifications, in Nice. It was trucked to Monte Carlo and delivered to a location that only Helmut could have liked—the corniche where heavy commercial traffic and flashy cars drove by all day. Our small group set up on the side of the road. We put tiny pads over the nails so Daria Werbowy could lie down and Helmut went to work. When he finished shooting, the film went to the lab to be developed and we all had lunch at Helmut's favorite spot, Café de Paris in the main square. Then I went to the hotel to pack and he went home to wait for the photographs. Around 6 P.M., Helmut called to say that the film was back and when June saw it, she said that it would have been stronger if he'd shot at night. "We need to get the bed of nails and shoot tonight." It was back in Nice and the workshop was closed. After hours of frantic phone calls, and another hour of transport, Helmut did the photo in the same spot on the corniche late that night. This is one of his Polaroids.

No Pain No Gain
March 2004

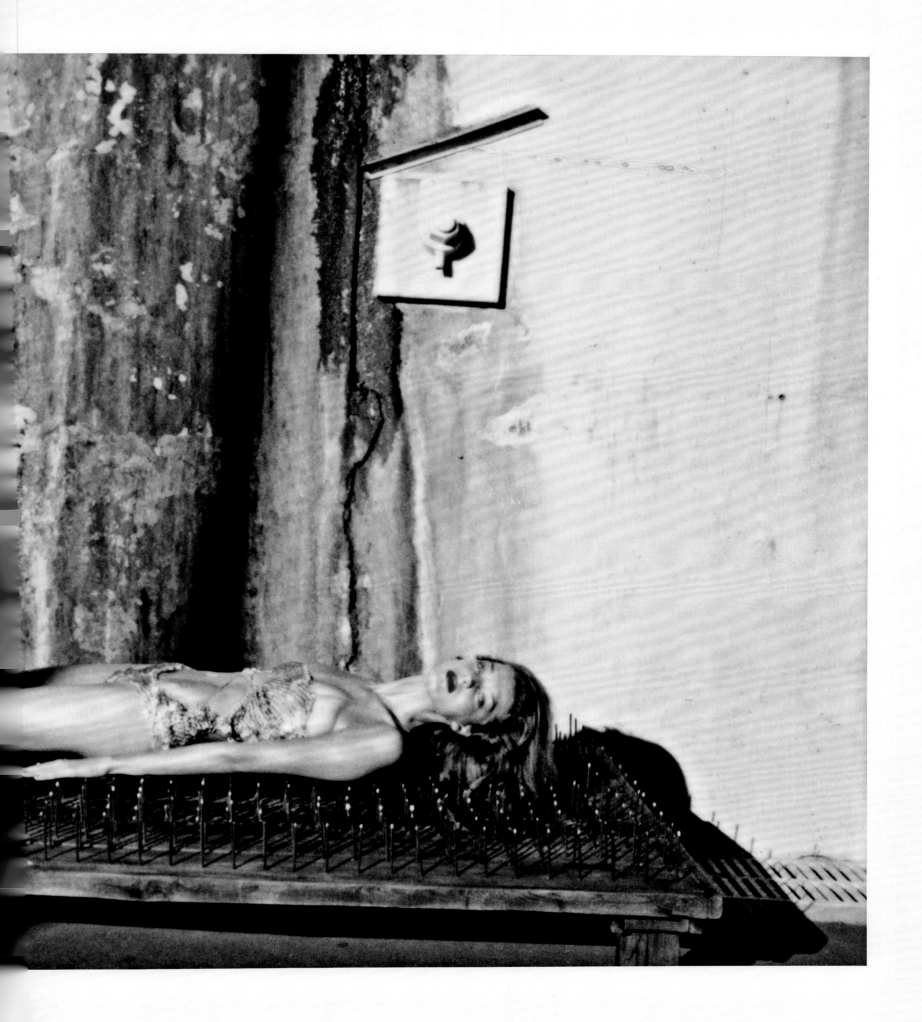

Helmut liked to keep his shoots simple. He hated big productions. He worked without an entourage and had one assistant. He shot fast with any camera, even ones used by amateurs, and occasionally used one-hour photo labs to develop his film. Hard to imagine in today's world of digital photography. He had his favorite locations and often used friends in his photos. The article was about "space age" technology for machines that exercised, massaged, slimmed, and soothed. We'd had the 405 lb bicycle shipped from the United States and it was sitting on a flat back truck on top of the hill, "in nature" as Helmut described it, ready for our picture. Kristen McMenamy came from London to be the dominatrix shouting instructions through Helmut's personal bullhorn, and the "robot" with her made-to-order "suit" came from the Thierry Mugler runway in Paris. On the day of the shoot, I woke up to a very early call from Helmut telling me that it was pouring rain and he needed to figure out what to do. I think he was secretly happy to see the rain, because we ended up in one of his favorite places, the underground garage in his apartment building, listening to the expensive purr of Rolls-Royces, Maseratis, Aston Martins, Ferraris, and Hummers driving in and out all day.

Machine Age #1
November 1995

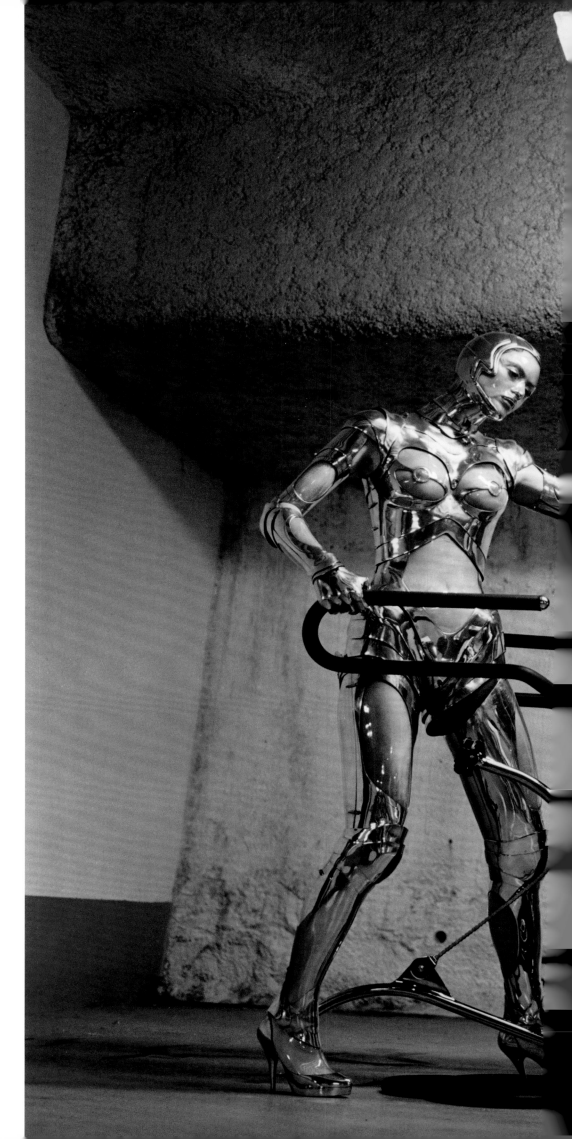

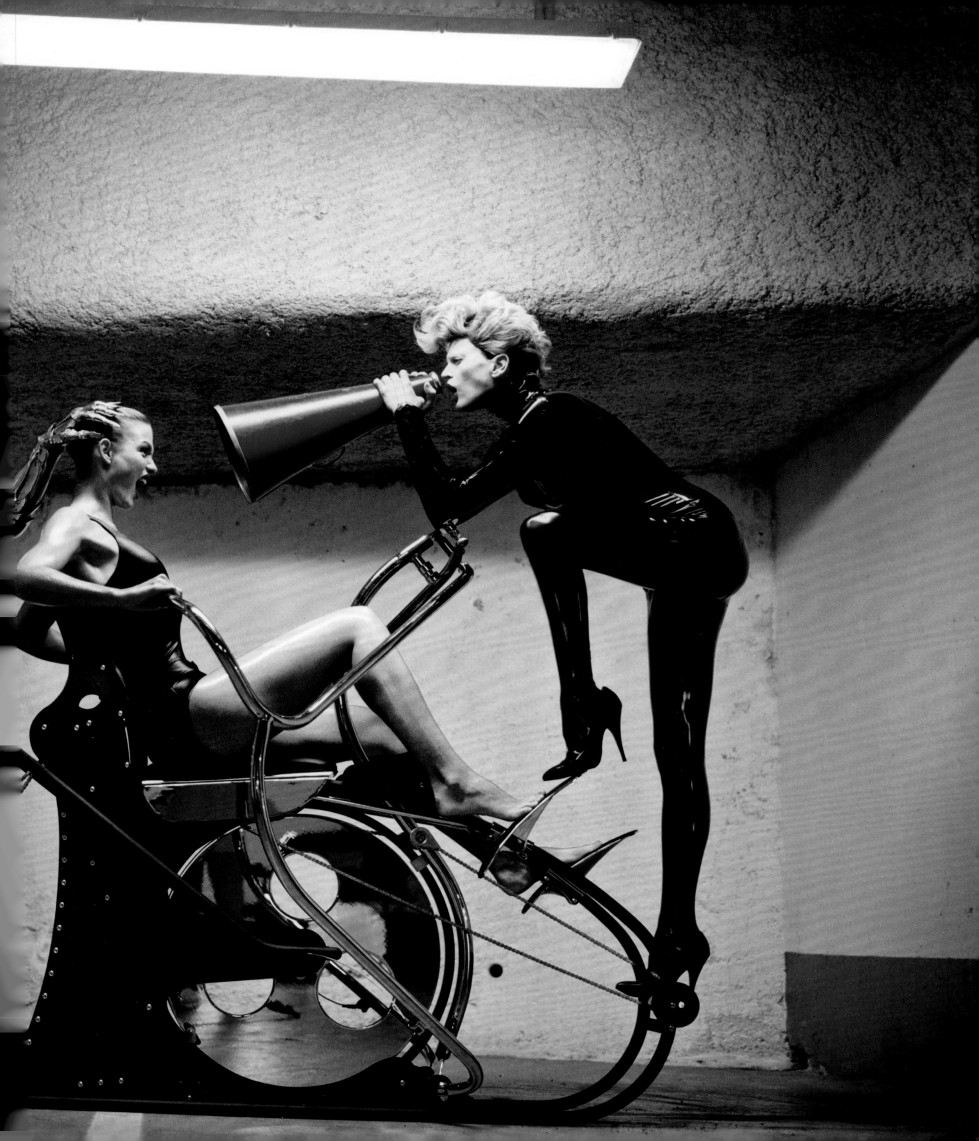

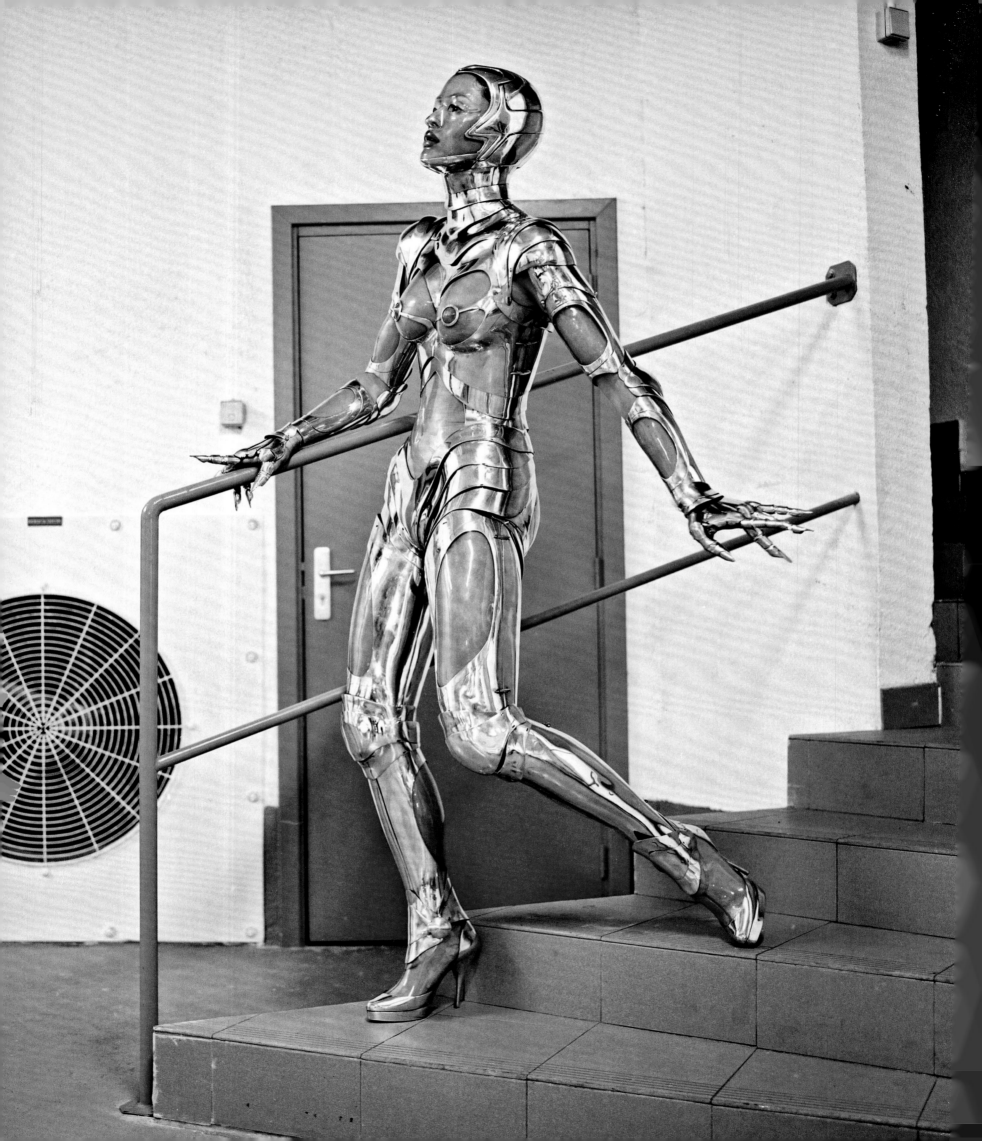

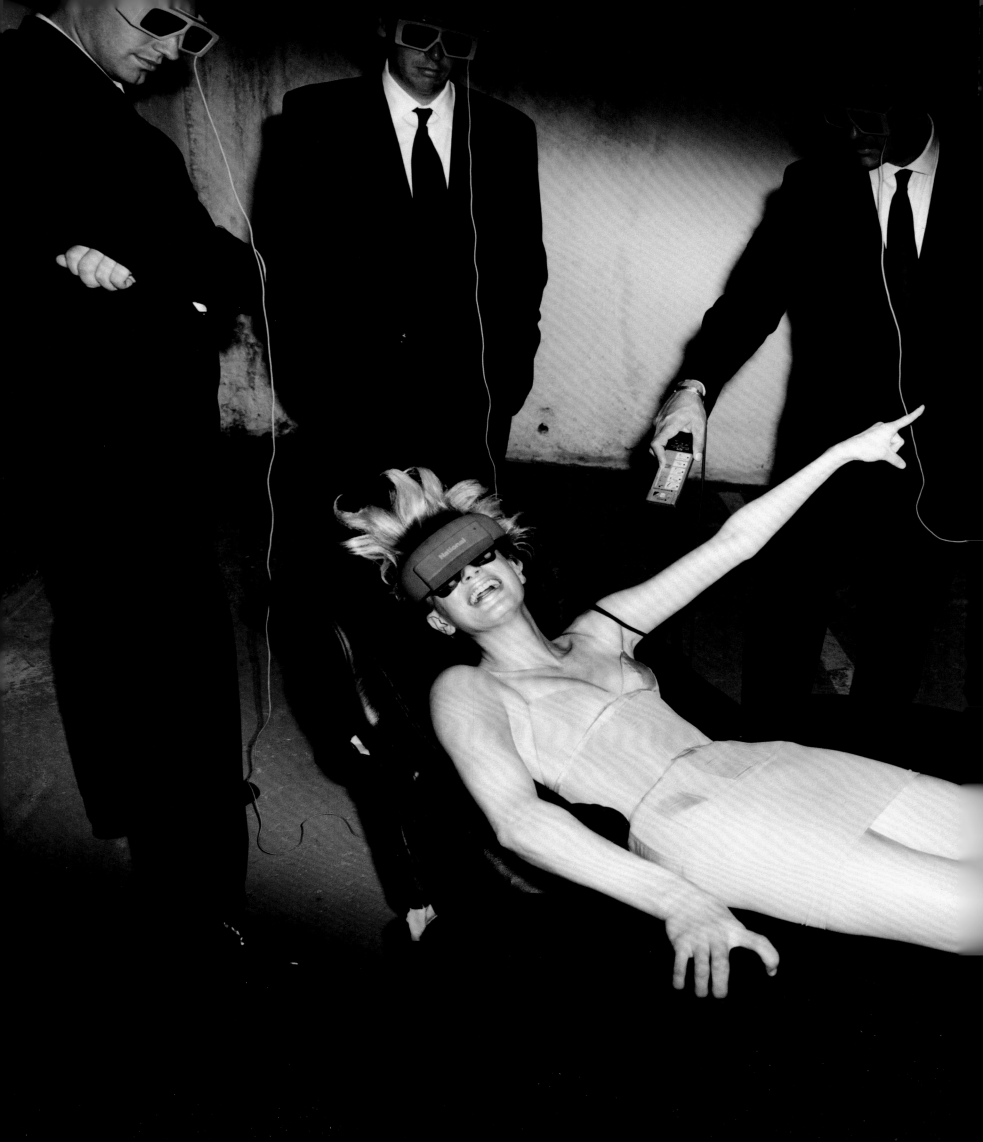

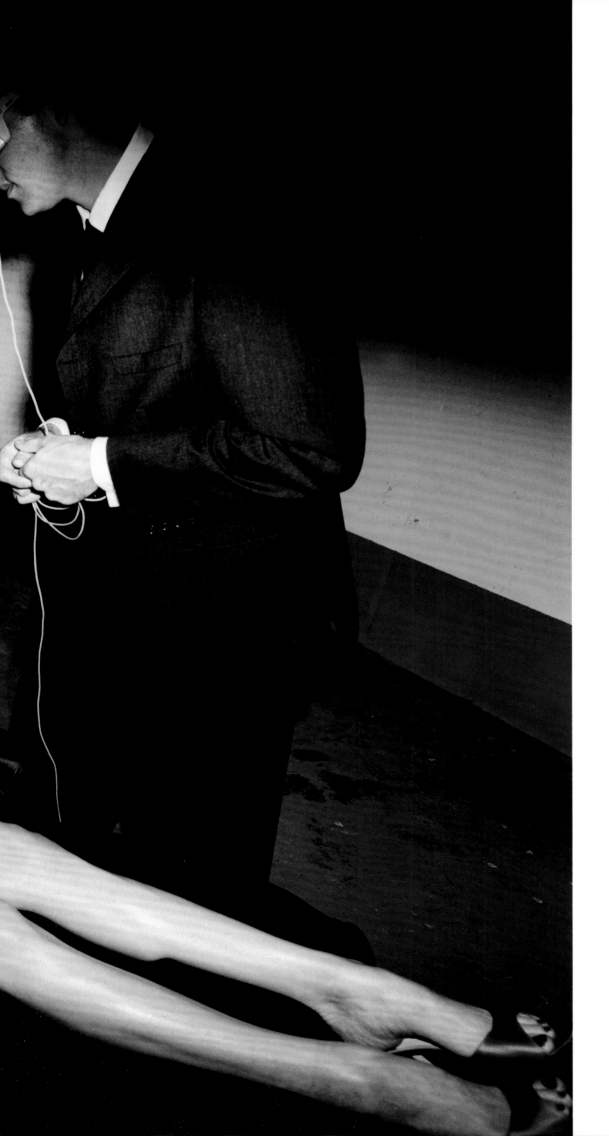

After photographing Kristen shouting instructions to the model on the bicycle, Helmut did this photo of her in a chair that massaged, stimulated, vibrated, and soothed but not necessarily at the same time. She's surrounded by four of his friends as Svengalis, each holding the control for a different function. The chair was also shipped from the United States. Do I miss that long-gone era of big budgets!!! Times have changed and this shoot could never happen today.

Machine Age #3
November 1995

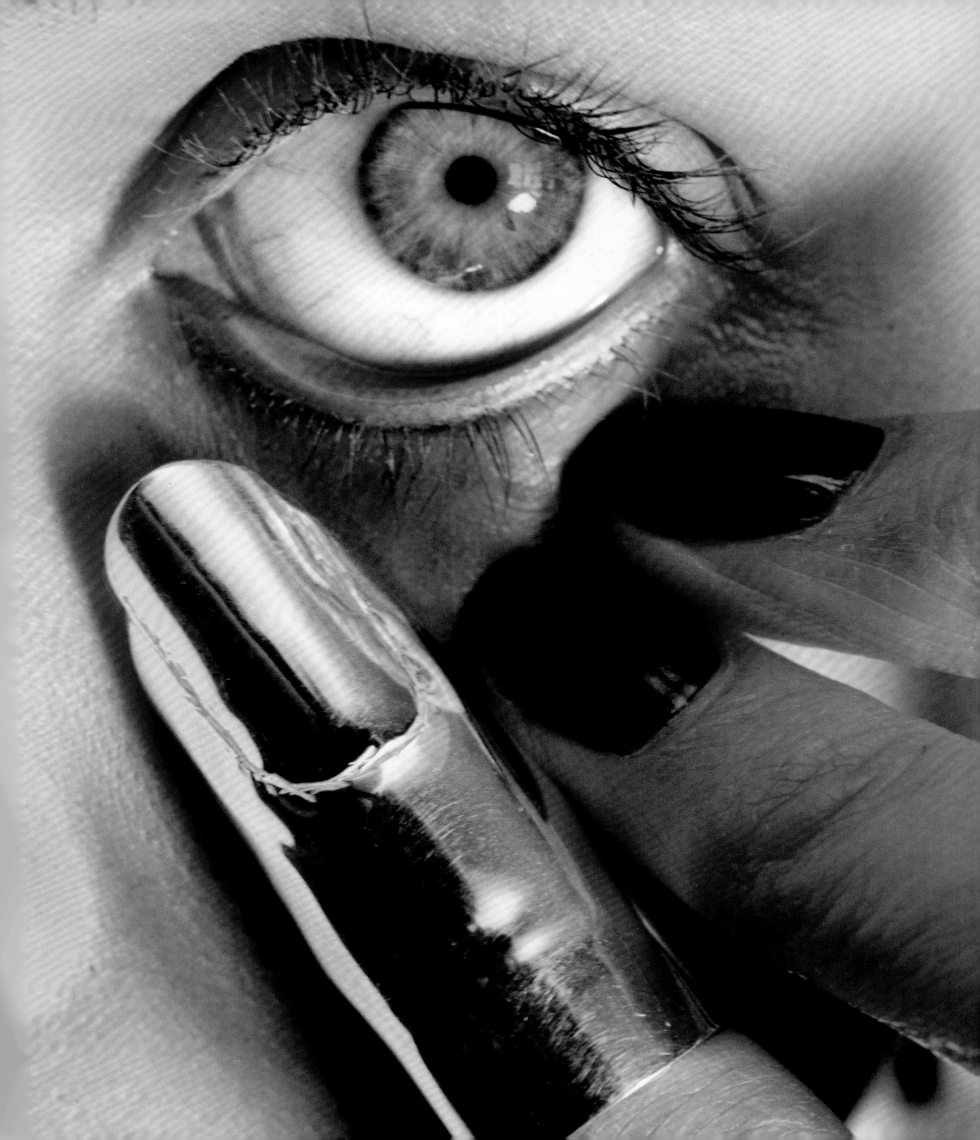

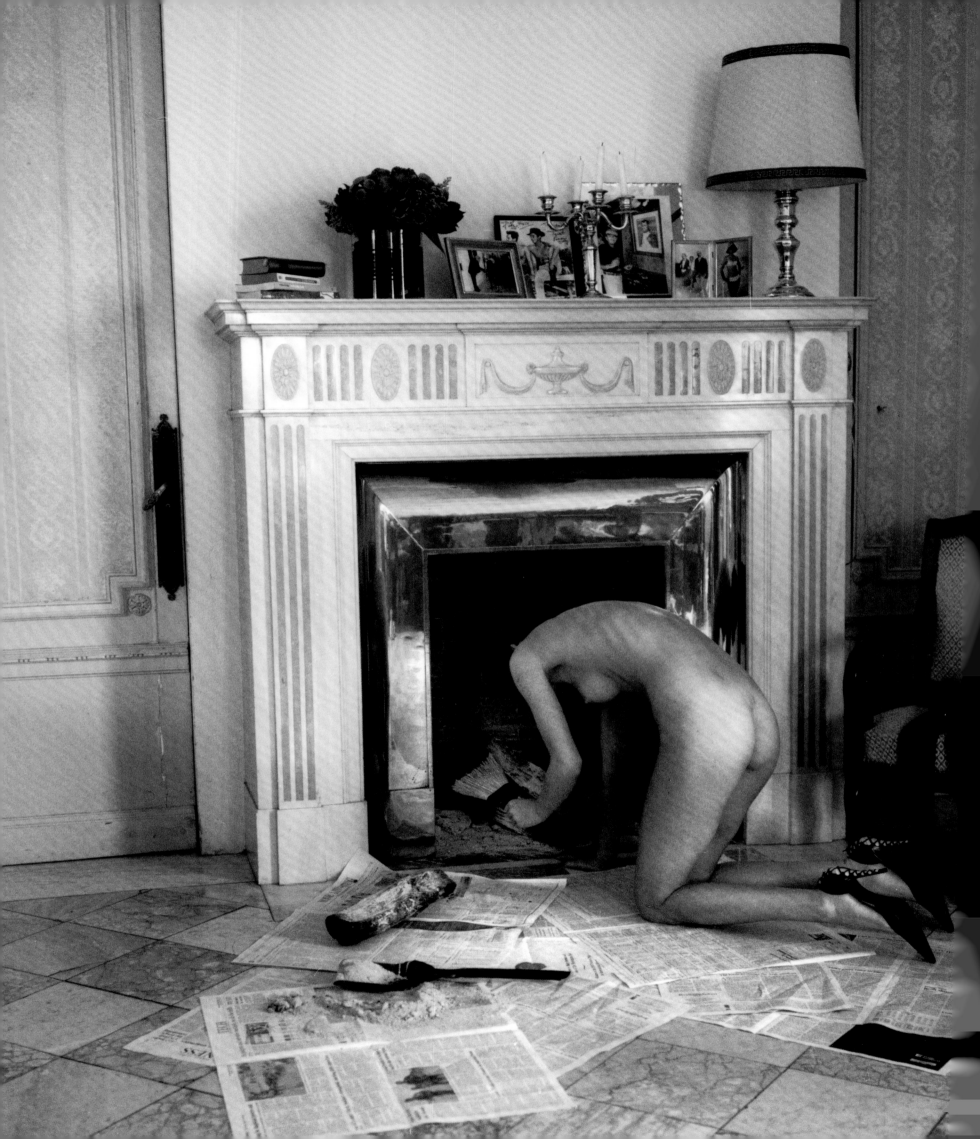

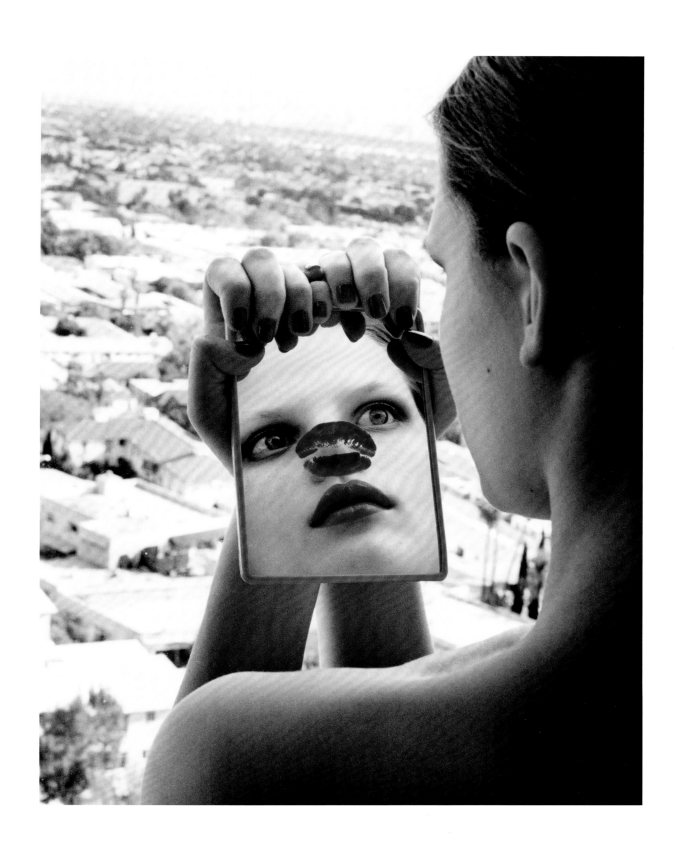

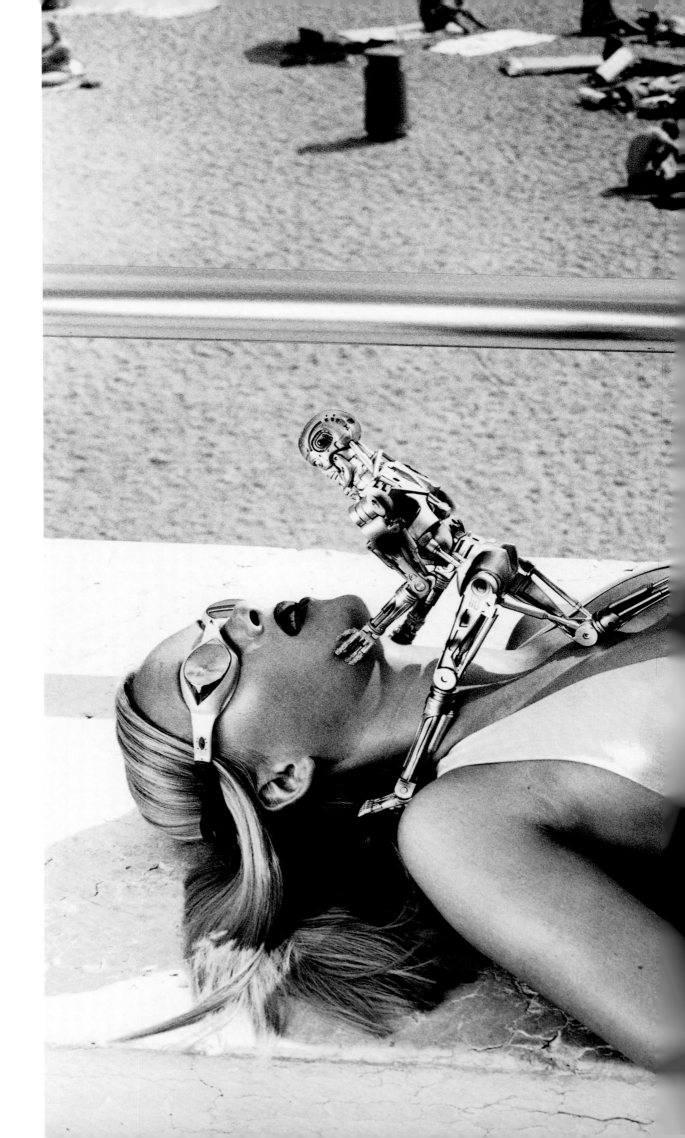

The Shoe Game
November 1998

When I'm on a shoot, I usually have
a worried look on my face. As we got
to know each other, Helmut saw that
I had another expression when I was
thinking about something to do with
the photo and he'd say, "Tell me what
you're thinking." I was reluctant to
tell him, obviously. He'd ask again. "I
want to know what you're thinking!"
Finally I'd tell him. There would be a
pause, then he would look directly
at me and say, "That's a really
dumb idea!" Sometimes bits of that
idea would creep into his photo.

Get Out of the Gym
January 1997

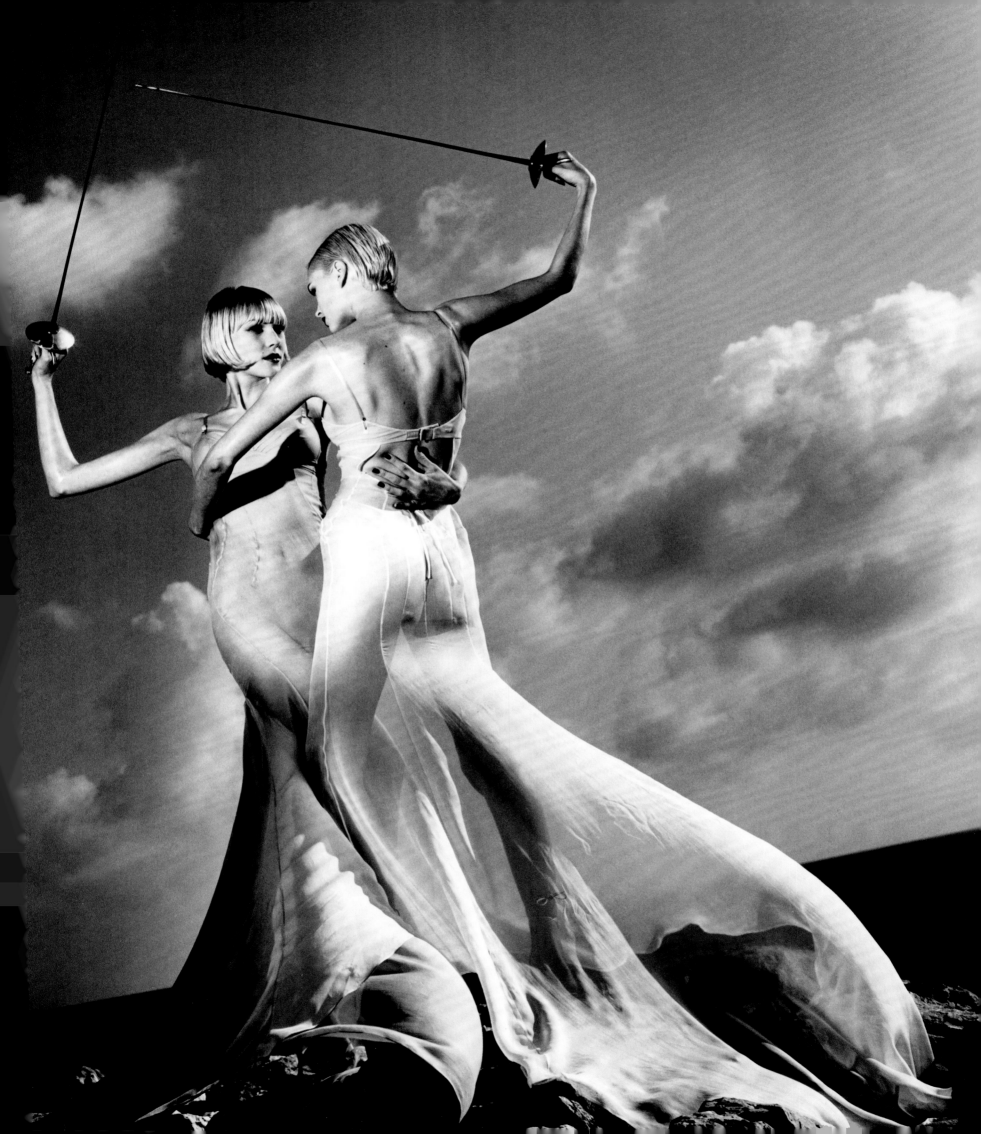

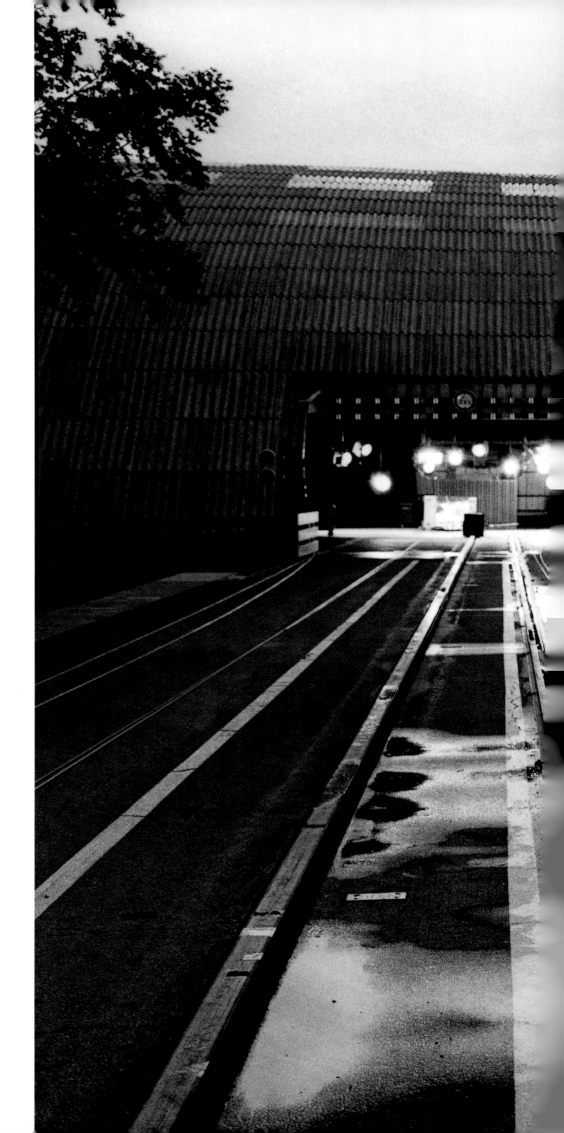

Slash Test
October 1997

116

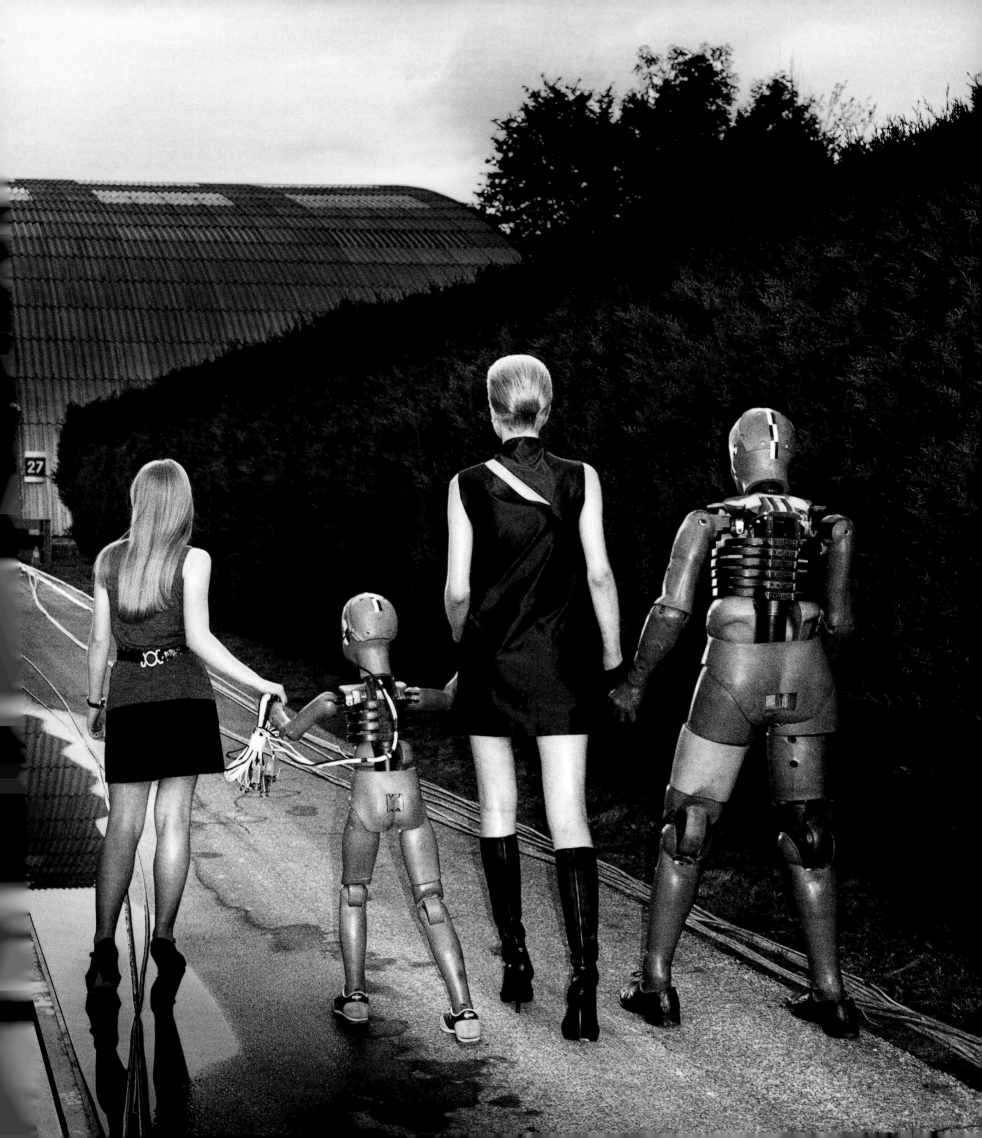

"I've always wanted to photograph a chicken wearing high heels." This was Helmut's response when I told him we needed a photo for an article about fried chicken. I was already planning a shoot with him in Monaco three days later, so there was little time to find stilettos for a chicken. No luck in New York. Within two days, our Paris editor, Fiona Da Rin, found four pairs at the Doll Museum in Paris and had them overnighted to Monte Carlo. Helmut liked two pairs but he wanted to be sure I had the right shoes for the right chicken. Was he serious?! The minute I arrived, his assistant walked me up the hill behind the apartment to the local butcher to do a fitting. There was a long line. When I finally got to the counter, the dour round man with a moustache and rosy cheeks wearing a bloodstained apron asked in French, "Can I help you?" Oui. S'il vous plaît. I took the little shoes out of my bag. "Helmut Newton is doing a photograph and I hope you will help me try these shoes on your chickens. I need to see which are the best fit," I said in English, as Helmut's assistant translated. Silence. Without a smile and without saying a word, the butcher carefully tried the shoes on every chicken in the case. I bought the two birds with perfect legs.

Praise the Lard
October 2003

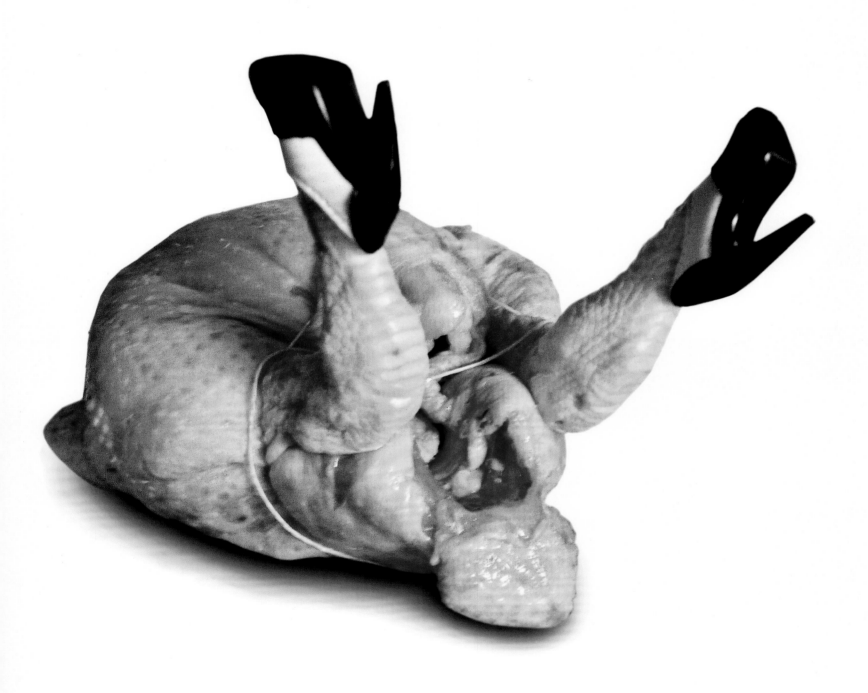

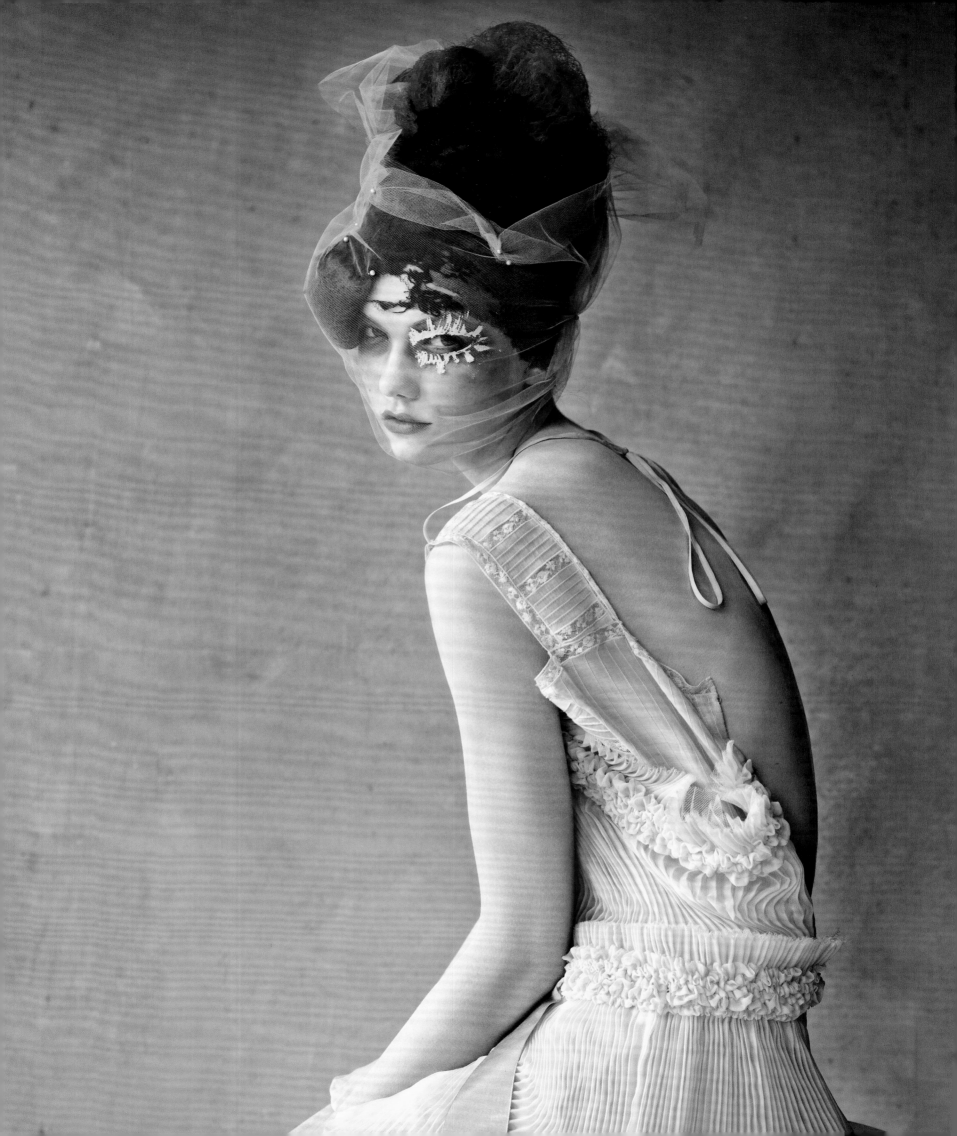

Patrick Demarchelier

Extreme Eye #1
February 2010

Patrick was part of a group of young good-looking French photographers who came to work in America in the late 1970s. We met soon after he arrived. He could barely speak English, and when he did, he had such a strong French accent I couldn't understand a word he said. I still can't, though now his English is fluent. He isn't easy to understand in French either. But his elegant photographs are easy to understand. He simply makes women look beautiful. Whenever I ask him to do a photo, he says yes even before he knows what the subject is, and his enthusiasm is contagious. *Vogue* doesn't publish conventional beauty pictures. The ones that Patrick takes are as close as we get to "pretty," but they have a little twist that makes them unusual. His photos look deceptively simple, but they're not simple at all. Often when I illustrate an article, the concept can be more important than the woman in the picture. Not with Patrick. He loves women and it shows.

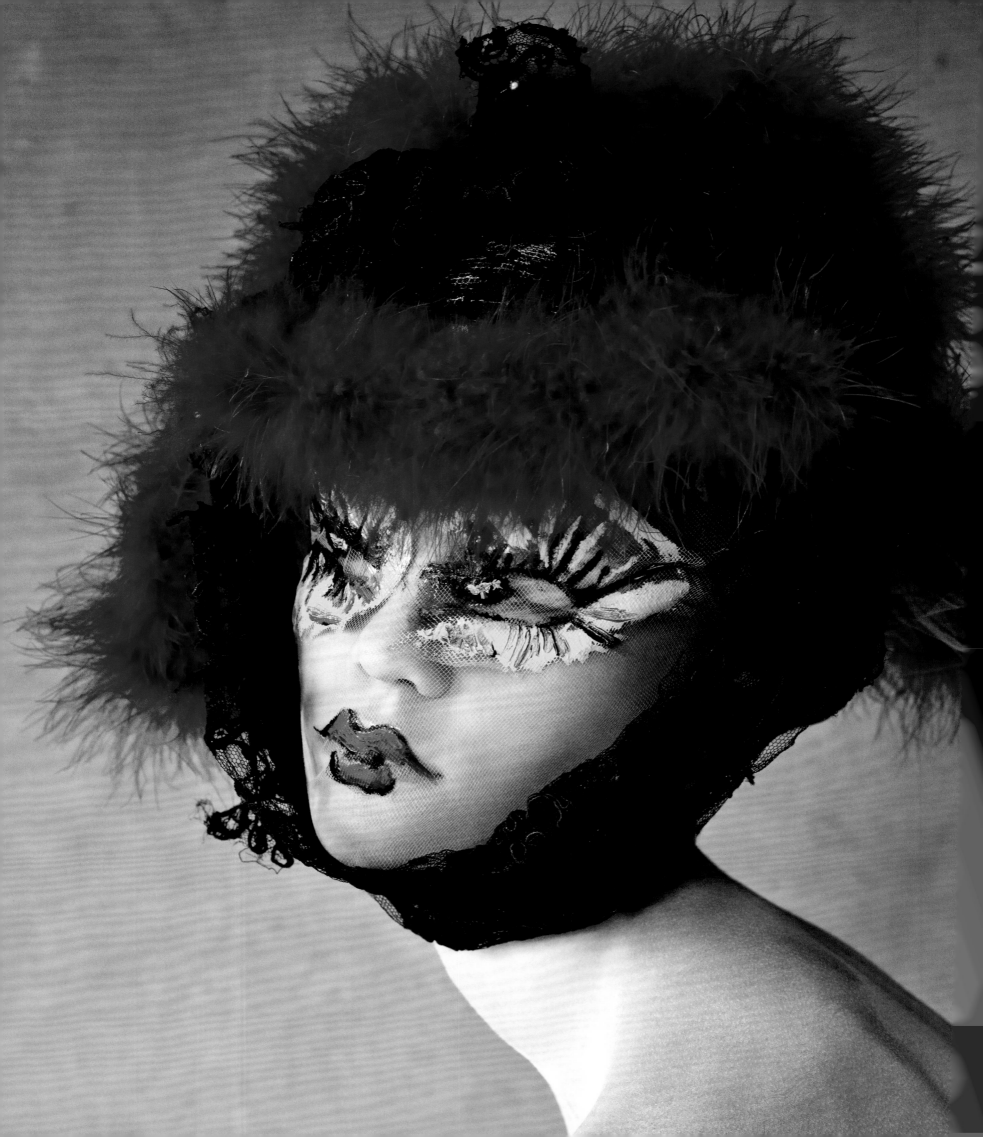

Karlie Kloss, Julien d'Ys, and Patrick were available to do this shoot, but none of our favorite makeup artists were free. We tried changing the date but it made no difference. I didn't know what to do, especially as the shoot was about extreme eye makeup that we'd seen in the S/S 2010 collections. Then I had an idea. When he isn't on a shoot, Julien draws and paints in his atelier in Paris. I asked him to do the makeup in addition to styling the hair. At first he was reluctant because he didn't want to upset his makeup artist friends by venturing into their territory. He decided that rather than put makeup on Karlie's face, he would paint on colored tulle wrapped around her head, and this is one of three photos we did that day. A second is on the previous page. It isn't eye makeup anyone would wear but is extreme and suggests that women can and should be creative.

Extreme Eye #2
February 2010

123

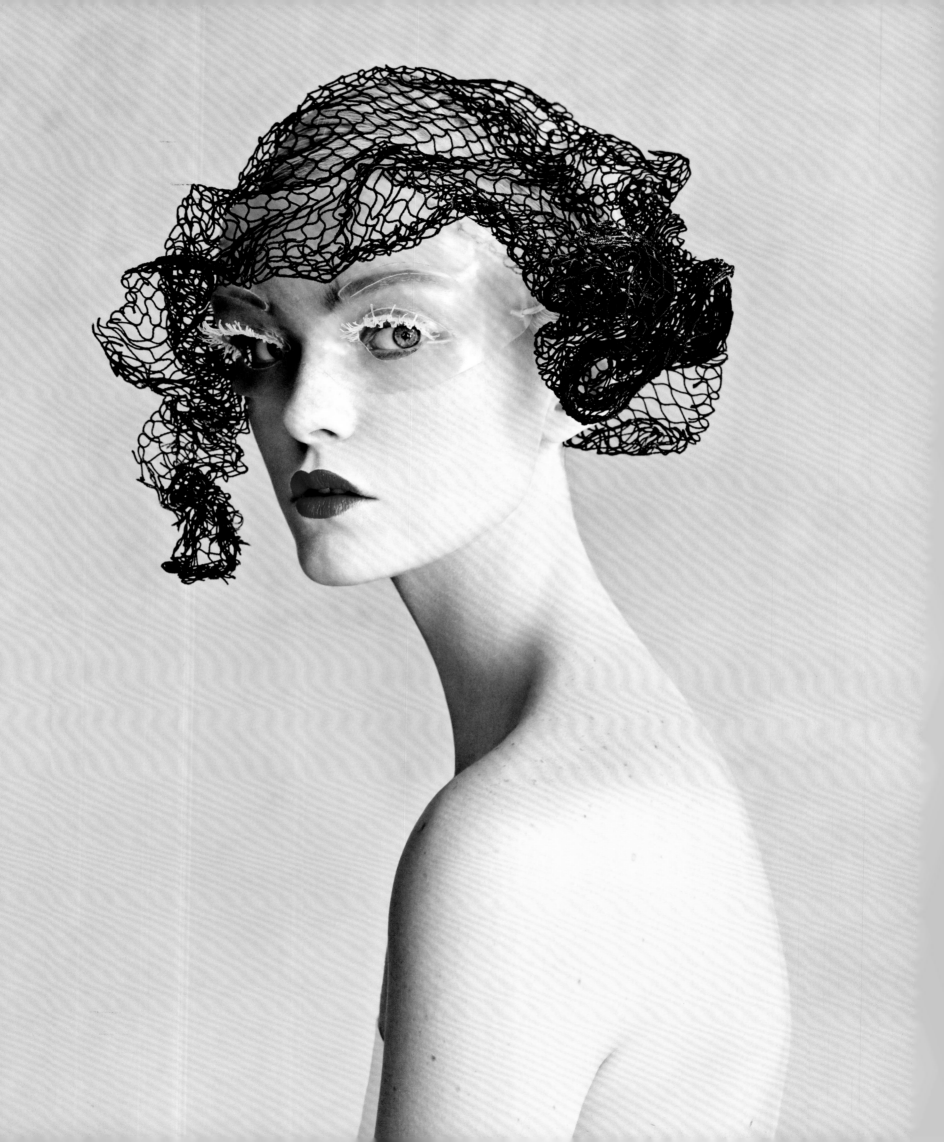

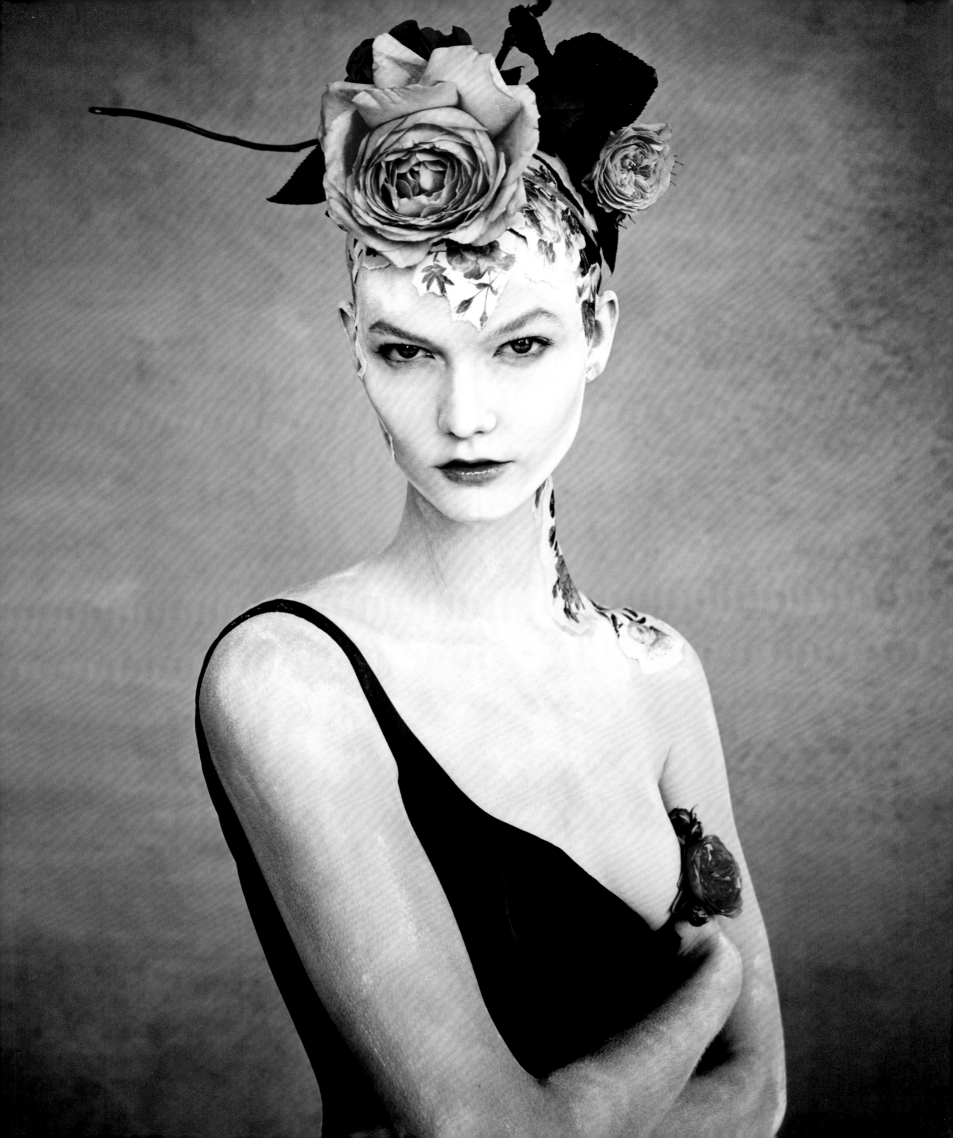

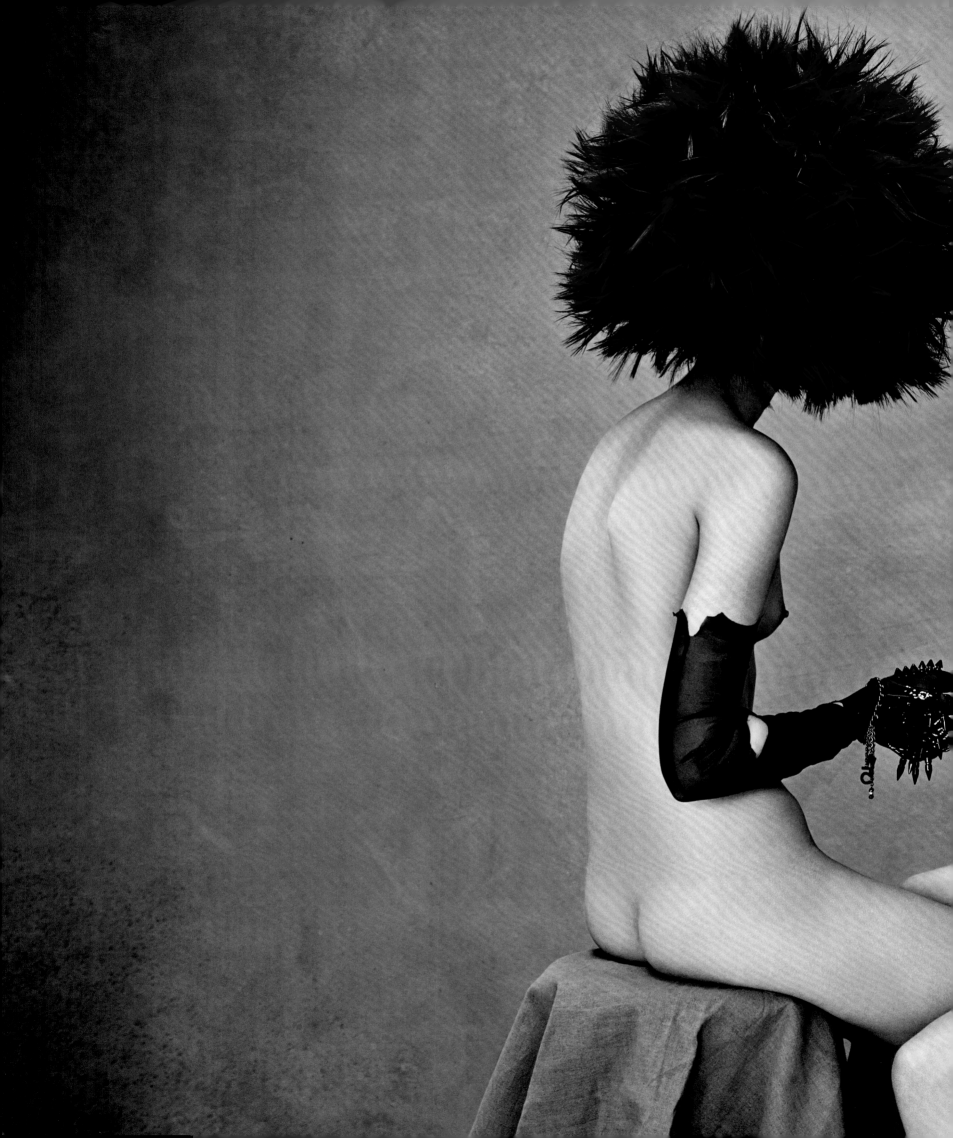

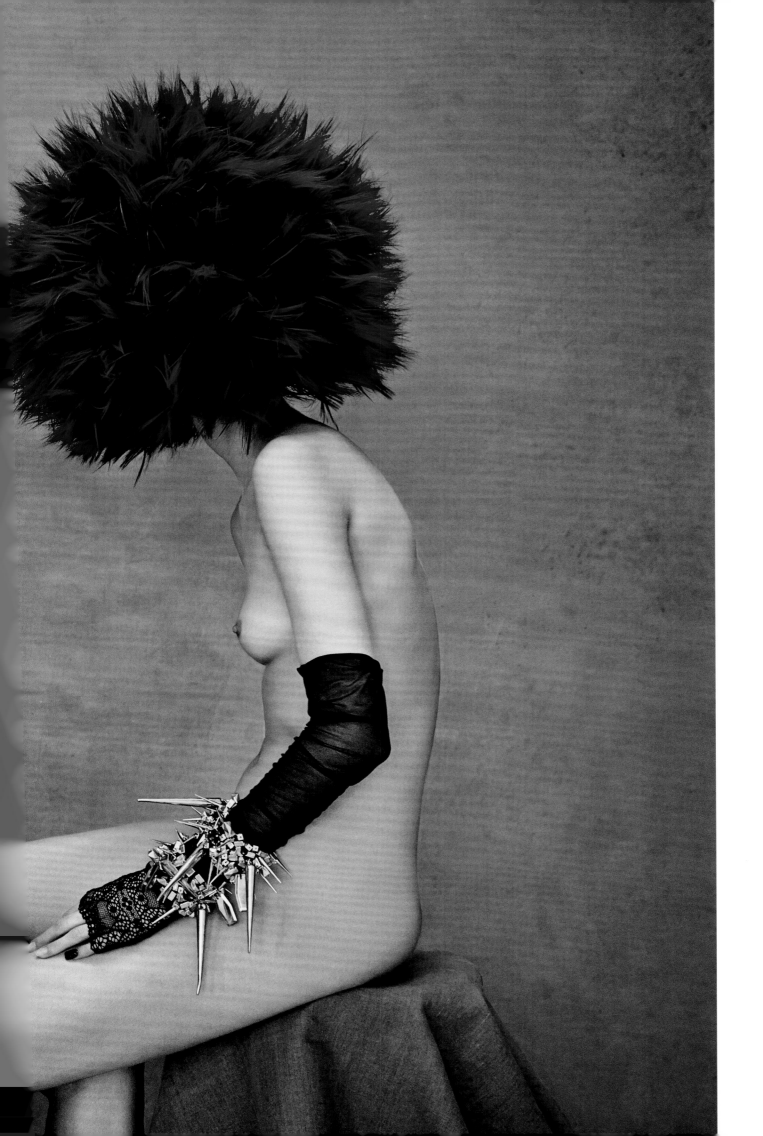

PREVIOUS PAGES:
Eye Care
September 2015

Belle Fleur
November 2014

THIS PAGE:
Guido Palau Wigs for the
Costume Institute's "Punk:
Chaos to Couture"
May 2013

127

A Good Fit
New York, October 2013

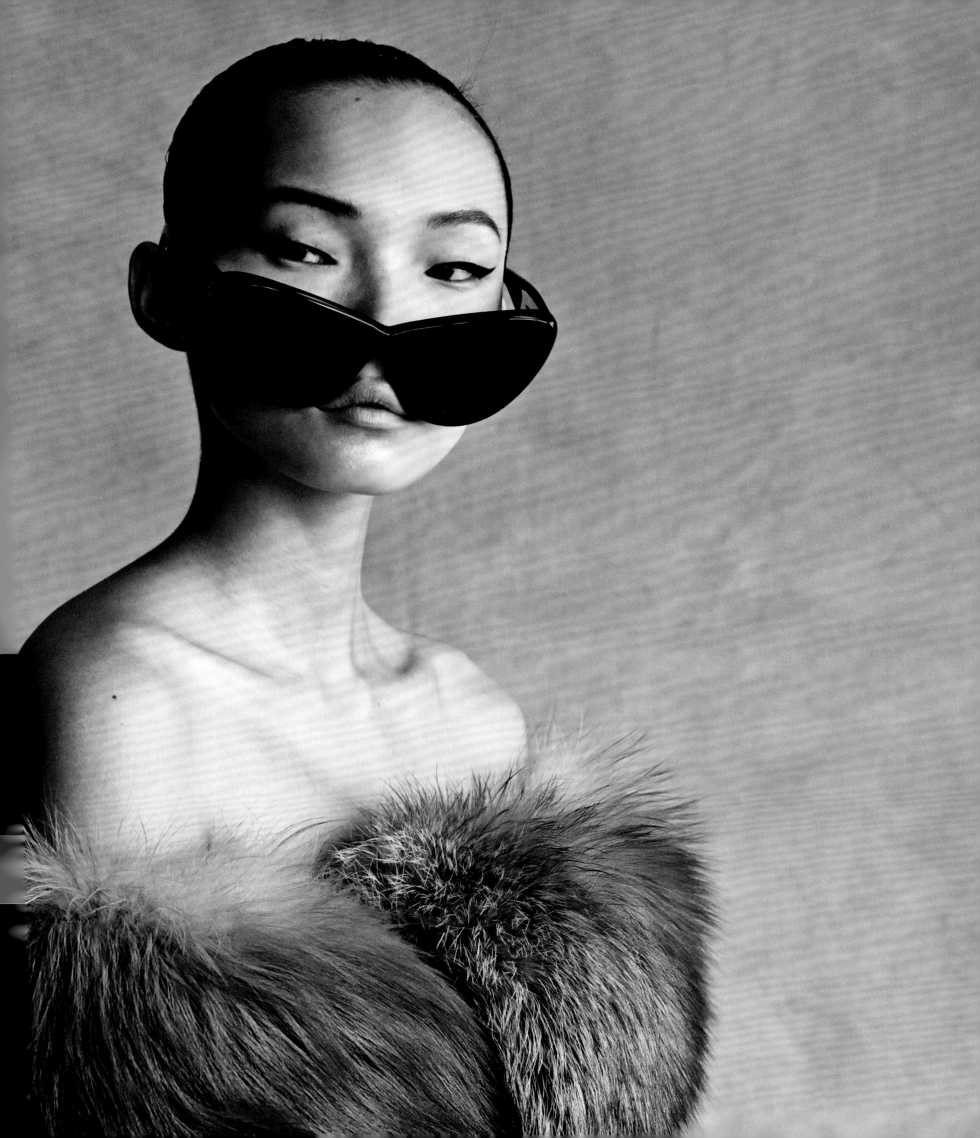

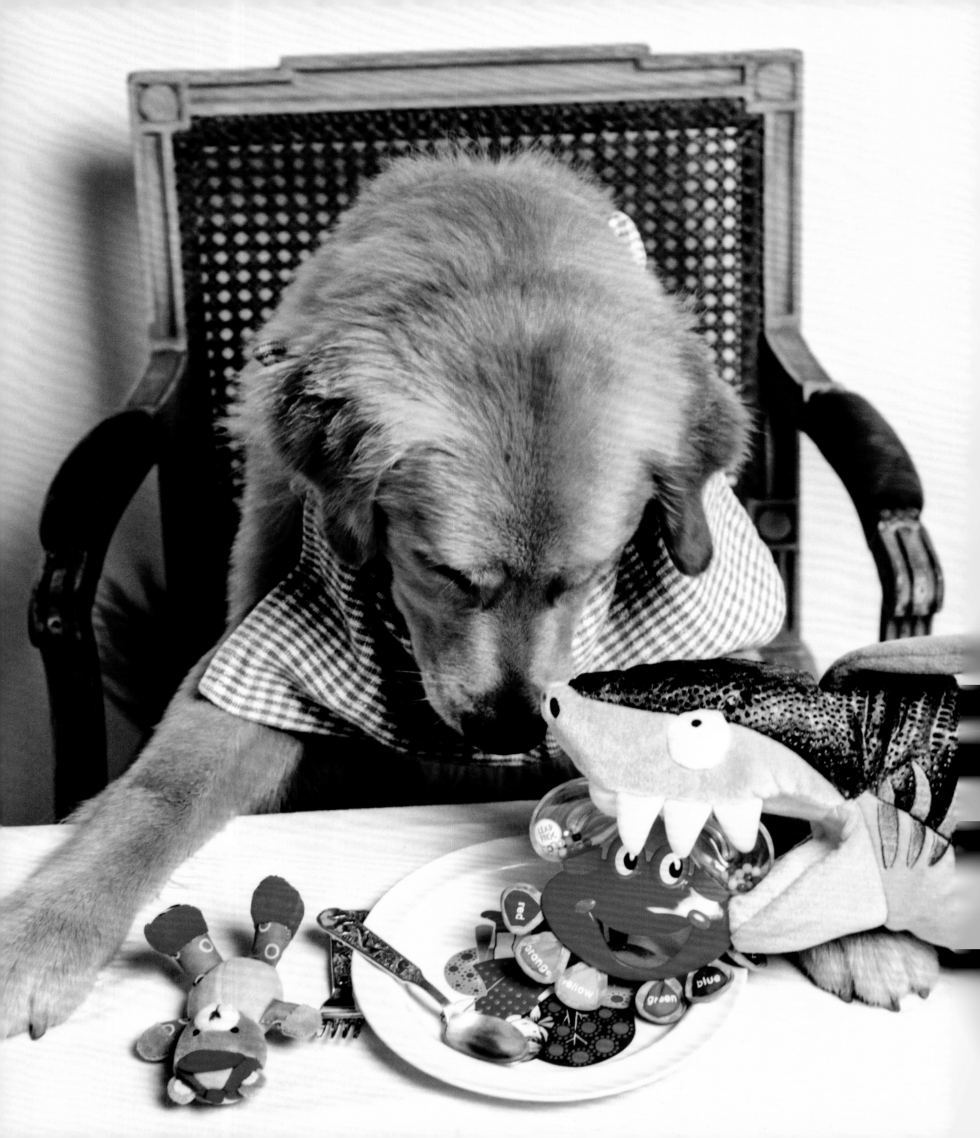

Bruce Weber

One of the great regrets of my career is that I haven't worked more with Bruce. We've been friends for so many years but somehow have only managed to do few shoots together. It's not for lack of trying. During the early eighties, when Bruce was working nonstop with Grace Coddington and Liz Tilberis at British *Vogue* and influencing the direction of fashion photography, I was the Fashion Editor at *Glamour*. At first, he didn't have the time and was very reluctant, but I finally persuaded him to work with us. The photographs were beautiful, and I looked ahead to a long collaboration. That promising beginning ran into trouble when the published photo credit read "Bruce Plotkin" (one of his former assistants). To make matters worse, as an apology, the *Glamour* art director gave Bruce a baby picture of himself. Thankfully, that was just an interruption of our collaboration. A few years later I went to *Vogue*, where we've worked on special projects with Olympic athletes and photographed some exceptional people, and, of course, his dogs. One of the real challenges for Bruce is when I call asking him to illustrate an article that's almost impossible to illustrate in an interesting way. He never disappoints. The photograph opposite accompanied an article about seafood that's safe for children to eat. He found the most charming, unique, and unexpected way to do the picture, as he always does. Anyone who works with Bruce becomes part of his vast universe of musicians, writers, actors, sports icons, artists, photography, and adopted cities (Detroit). It's a heady trip and I'm very proud to be part of it.

The Angulo bothers had spent their lives confined to an apartment on New York's Lower East Side. They were homeschooled by their mother and rarely permitted to go outside by their father who had a Utopian vision of having his children grow up together untarnished by the world. The boys let their hair grow long and lived, in the words of one son, "like a tribe." Their lives abruptly changed after Mukunda escaped on January 23, 2010, when he was fifteen years old. Before that time, all that the children knew came from interacting with each other and from the movies they watched on TV. These films shaped their lives and inspired the brothers to recreate scenes from them at home. Within this small domain they demonstrated great talent, making costumes and props and filming themselves acting out roles they had seen in the movies. Their lives are chronicled in the documentary *The Wolfpack* that won the 2015 Grand Jury Prize for a documentary at Sundance. Given their unusual upbringing, Bruce and I weren't sure what to expect when we met them at a studio in New York to do this portrait. We certainly didn't expect that they would already know Bruce from his films. They had watched several of them and meeting Bruce was like meeting a mythological figure. We were especially struck by the strong bond that existed between these brothers who for most of their lives had only known each other. They were extremely intelligent, engaging, charming, and overwhelmed by all the attention they were receiving as a result of the success of the documentary about them—and by meeting Bruce.

From left: The Angulo brothers: Eddie and Glenn dressed like characters from *Reservoir Dogs* with their brothers Narayana, Govinda, Bhagavan, and Mukunda wearing masks inspired by *The Dark Knight*.

The Wolfpack
New York, June 2015

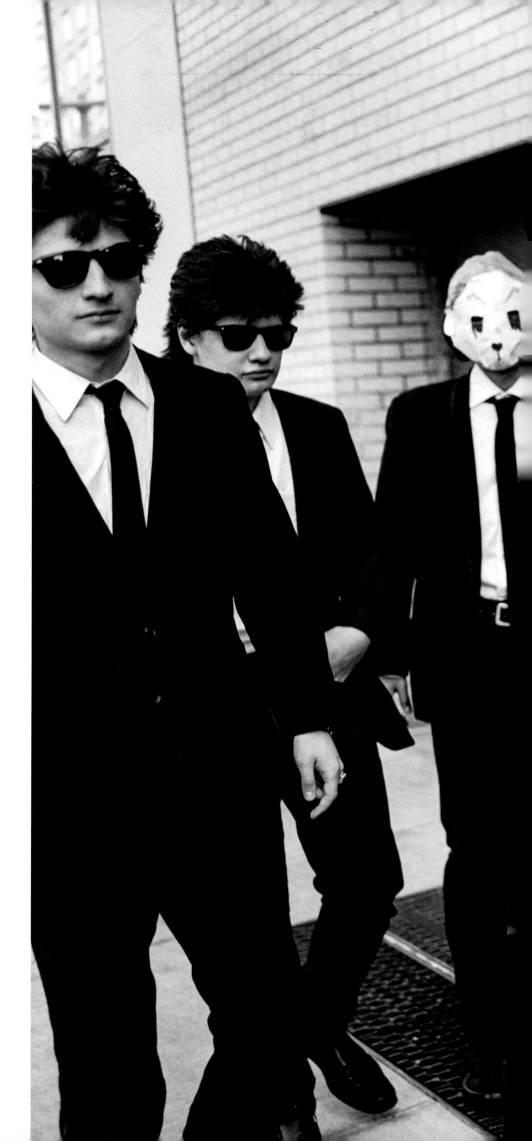

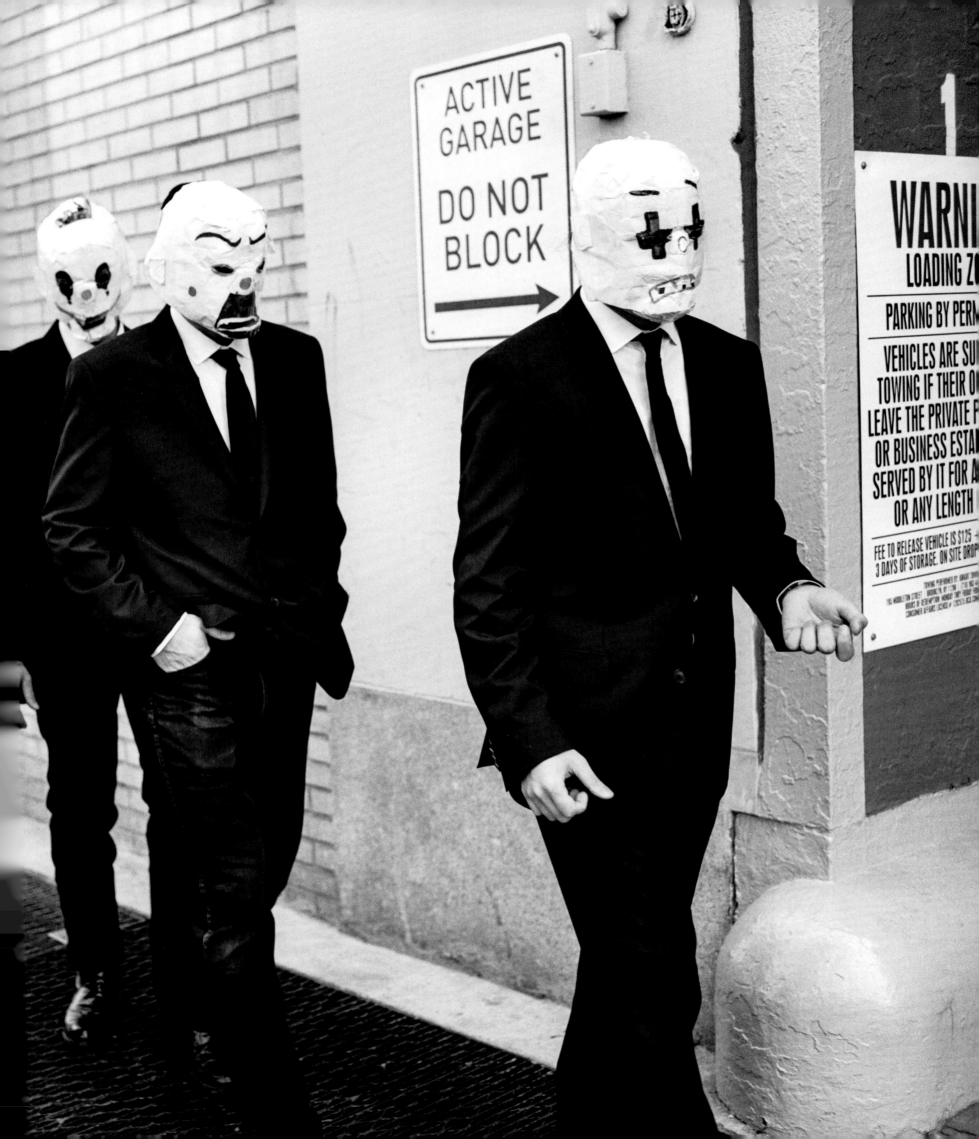

"It's ironic, but photographers are like babies sometimes—we need to be loved and sung lullabies by editors of magazines. Wondering how to look at something new is Phyllis's specialty. Everything is questioned, everything is a frustrating process—but one that makes you focus and forget your anxieties about what it should or shouldn't be. By the day of the sitting, you've already done some meditation with your dog or cat— and when you look into Phyllis's eyes, you see somebody who cares more about it being great than most people ever will. I want to ask her sometimes, 'Phyllis, does it always have to be so difficult?' And she would probably say, 'I don't know what you mean!' I can't tell you how many times she'll be whispering while I'm taking a picture, 'They're never going to run that!' But then sometimes to both of our surprise, they do run it in *Vogue*, and we're proud that we didn't give up the ship. She asked me to write something for her book, and said it didn't have to be about her. But why else would I do this, since Phyllis has been a friend for so many years that I cannot even count them. We first met while I was assisting William Connors at his studio and she was working for *Glamour*. Phyllis was very nice to me then, as she always is to young people just getting their start. But I have to admit, you earn your medals not so easily when photographing with her! Phyllis, you can always pin one more on my shoulder."
—BRUCE WEBER

Michelle Rodriguez
August 2000

Olympic Athlete Carmelita Jeter
June 2012

Olympic Athlete
Jennifer Parilla
May 2000

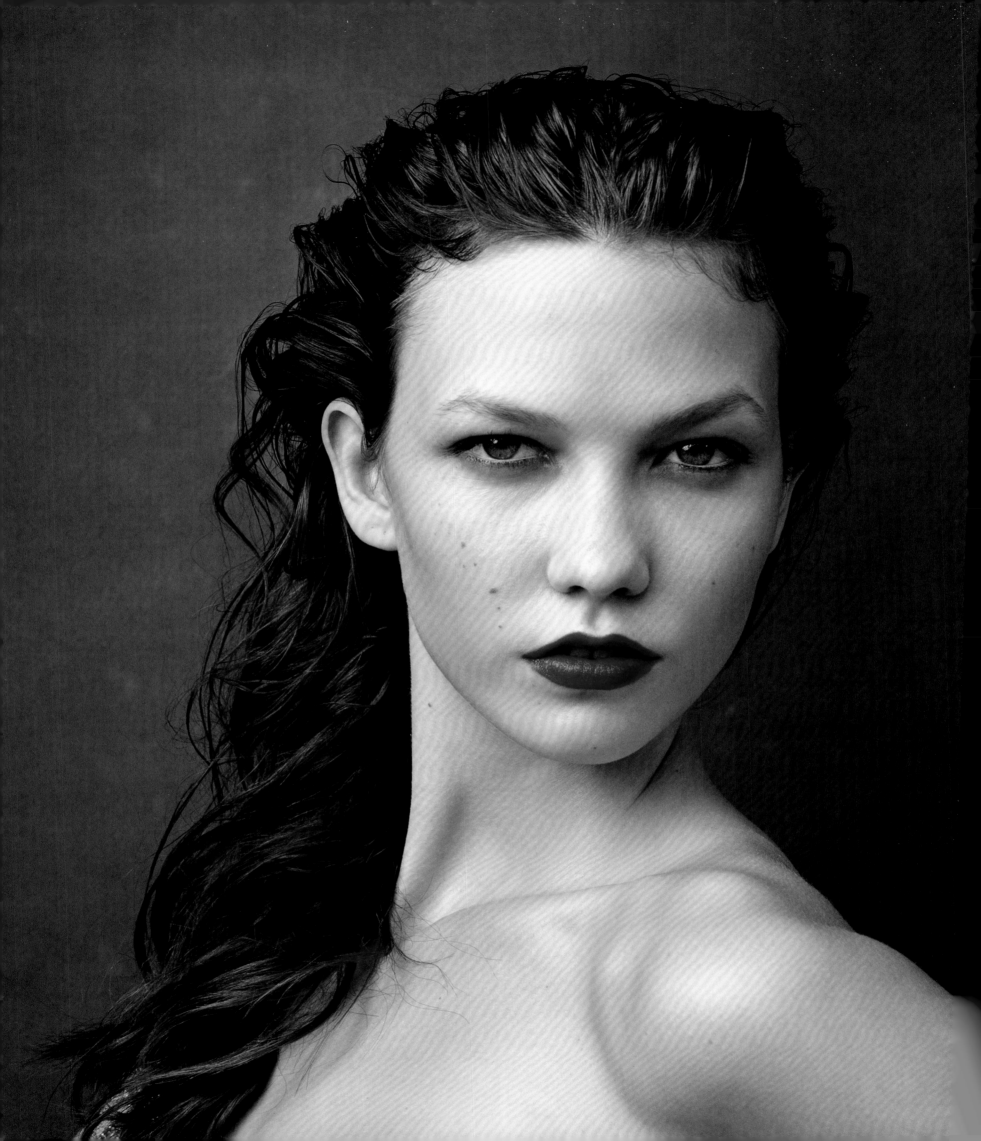

Annie Leibovitz

On February 26, 2015, Annie did my portrait for an *Industrie* magazine article about me (see pages 14–15). She approached this shoot with the same meticulousness that she brings to everything she does. When I got to her studio, she had everything set up, knew how I should sit, and had the floor platform tilted in a way that gave her the angle she wanted for the picture. She'd studied my face and gestures and consulted a folder of photo research. I brought my two "uniforms:" white shirt and black pants, and black sweater, pants, and coat, plus my silver Art Smith earrings and bracelet. For the next two hours I was transported into her world. I changed clothes, removed my jewelry (she doesn't like jewelry), and followed her directions. I saw from the inside how hard she works and how much she cares about her subjects. I felt the intensity of her laser-sharp focus as her soft voice guided me. Things had not started out well that day. In the morning, Annie and I had done a shoot at the Whitney Museum building, which was still under construction, and tension had developed—not an unusual situation between Annie and her editors. She didn't like the clothes I'd brought and she was having difficulty finding an area that was right for her picture. We'd scouted the exhibition spaces two days before, but paintings and packing crates had been moved so the rooms looked different. By the time the shoot was over, we were barely speaking. I didn't see how she could photograph me in the afternoon. As soon as we finished, her mood completely shifted as my role changed from editor to subject. She's written, "I never set anyone at ease. I always thought it was their problem. Either they were at ease, or they weren't." But Annie put me at ease. More than that, I felt the intimate connection she has with her subjects, whether Angelina Jolie, Benedict Cumberbatch, or the queen of England. After my shoot, she sent me three choices but indicated on one, "This is the way I see you." Of course, it's the one I used.

It was 2006 and people couldn't get enough of Angelina Jolie and Brad Pitt. Annie photographed Angelina for our January 2007 issue at Barstow-Daggett Airport, which was half way between L.A. and Las Vegas. Jolie, a licensed pilot, flew her own Cirrus SR22 single-engine plane to the shoot. We arrived a day before and drove to the airport from a motel that was exactly like you'd expect a roadside motel in the middle of nowhere to be. Angelina looked beautiful and the shoot went well. At the end of the day, we had almost finished when we heard the sound of a plane landing. To our surprise and delight, the pilot was Brad, flying his plane to be with Angelina. She told us that she and Brad liked to fly to Barstow in their separate planes to meet and ride their motorcycles. And that's what they did.

Angelina Jolie
January 2007

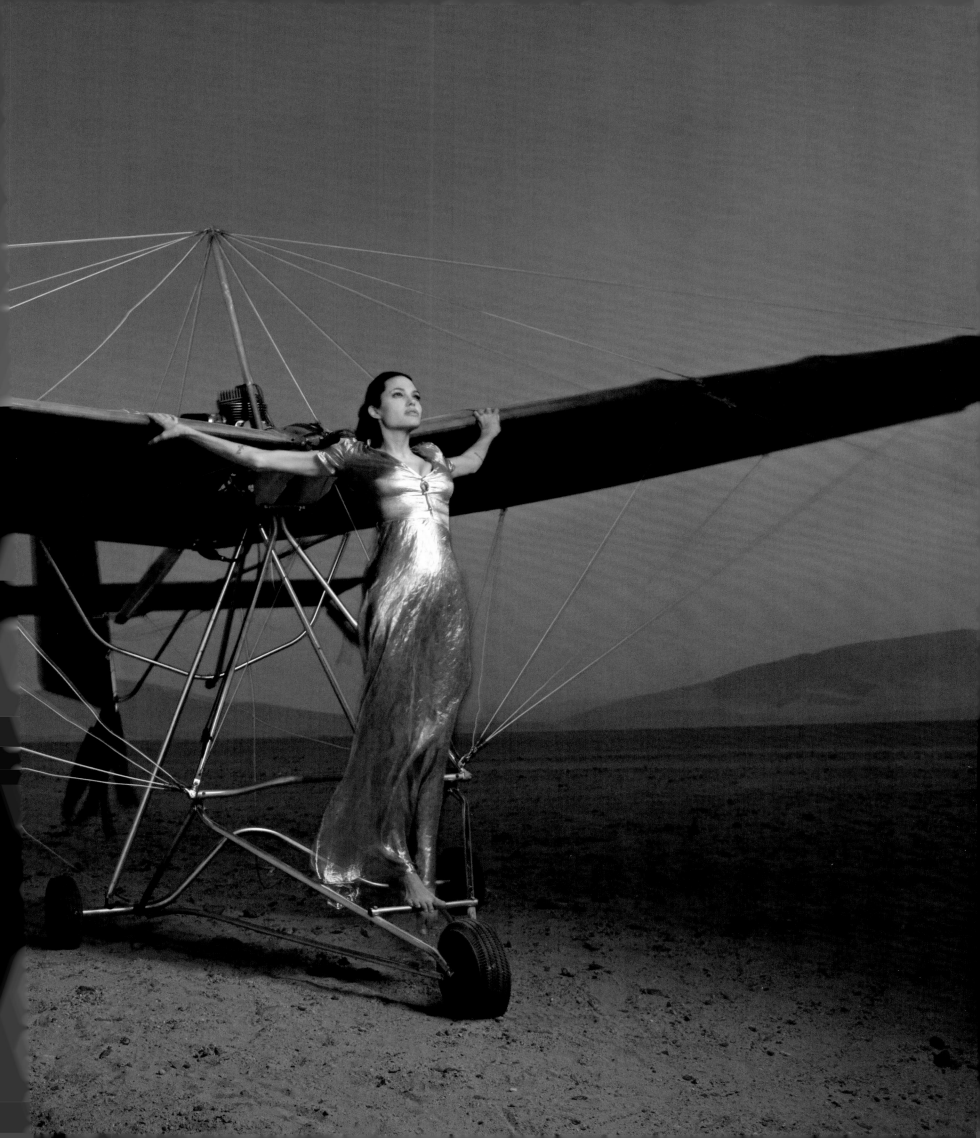

L'Wren Scott was the most gracious, warm, smart, very tall woman. Annie did this portrait in L'Wren's Paris apartment on the Île Saint-Louis, which was filled with furniture by Prouvé, Charlotte Perriand, Le Corbusier, and other mid-century icons. She made us feel like we were special guests at a private party. When she was dressed and ready for her portrait, L'Wren brought out a tiered box filled with the most beautiful vintage jewelry that Mick Jagger had given her and put on a ring.

L'Wren Scott
April 2009

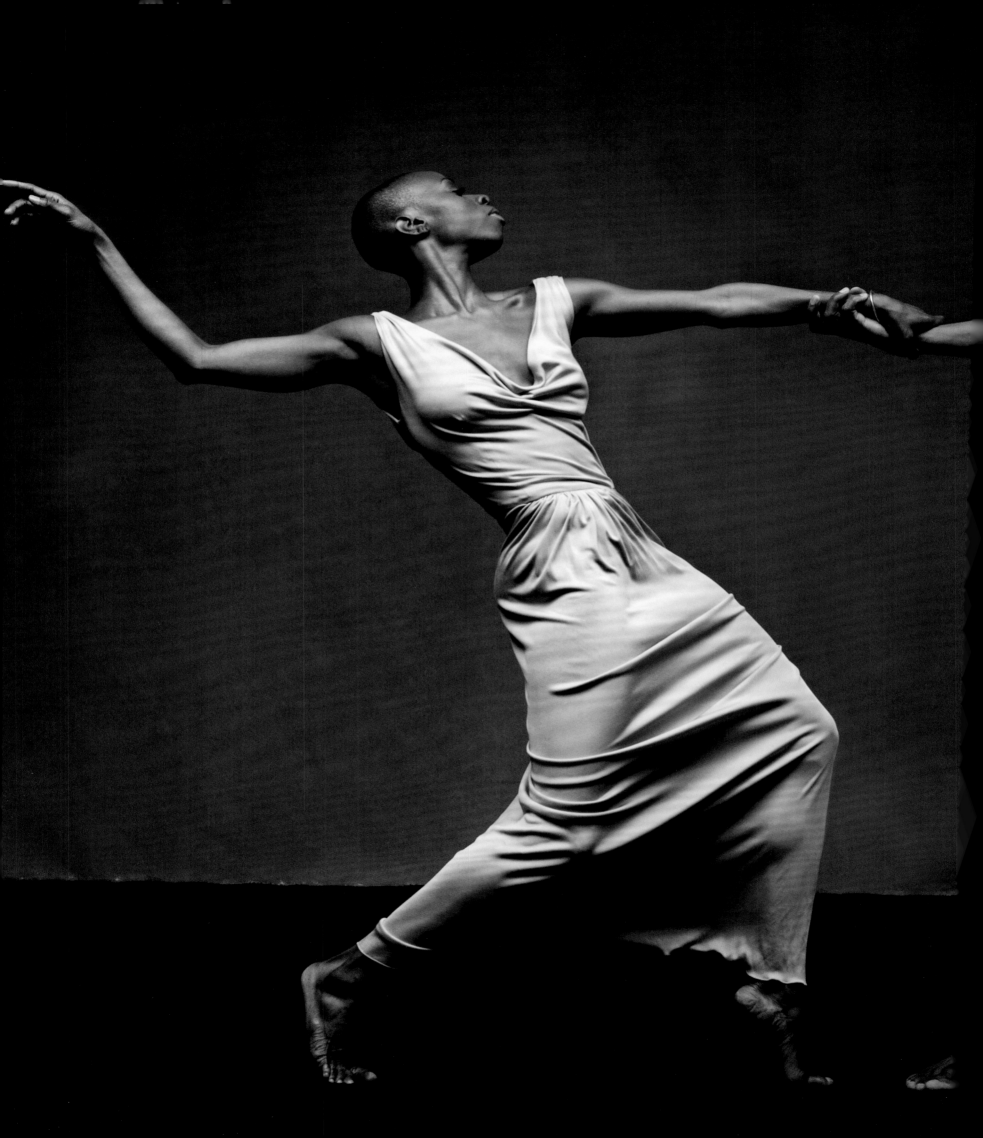

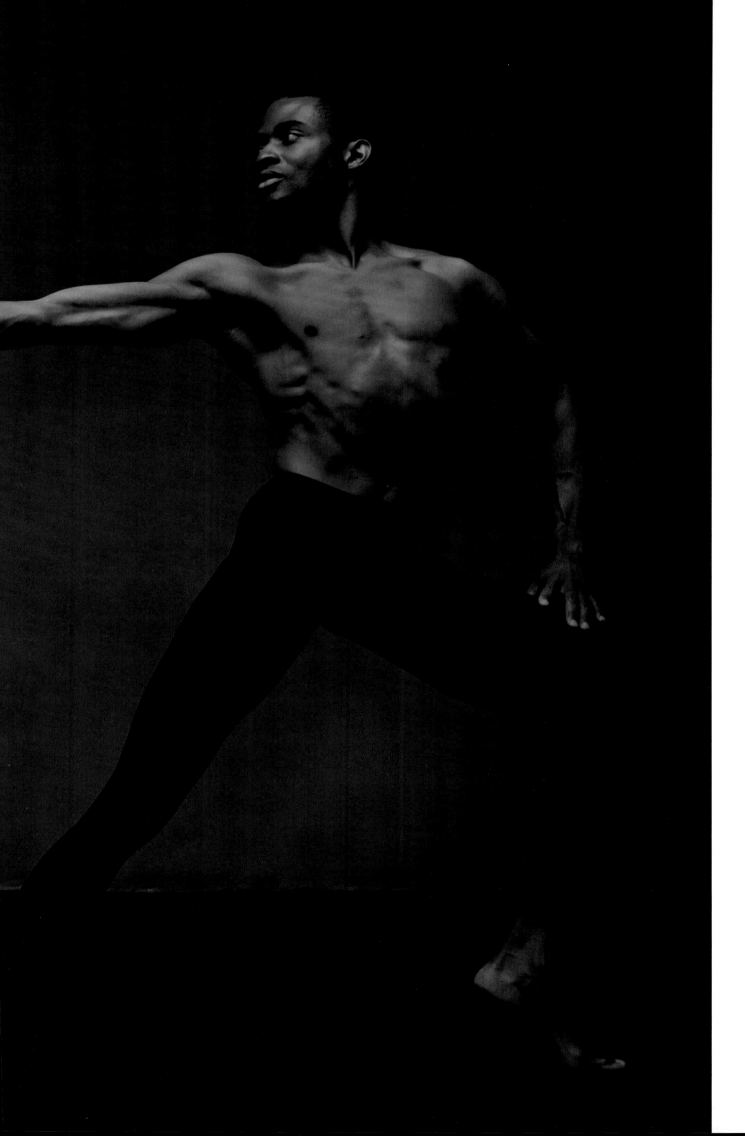

Dwana Smallwood and
Amos J. Mechanic Jr.,
Alvin Ailey American
Dance Theater
April 2007

Ronda Rousey,
Olympic Athlete
April 2008

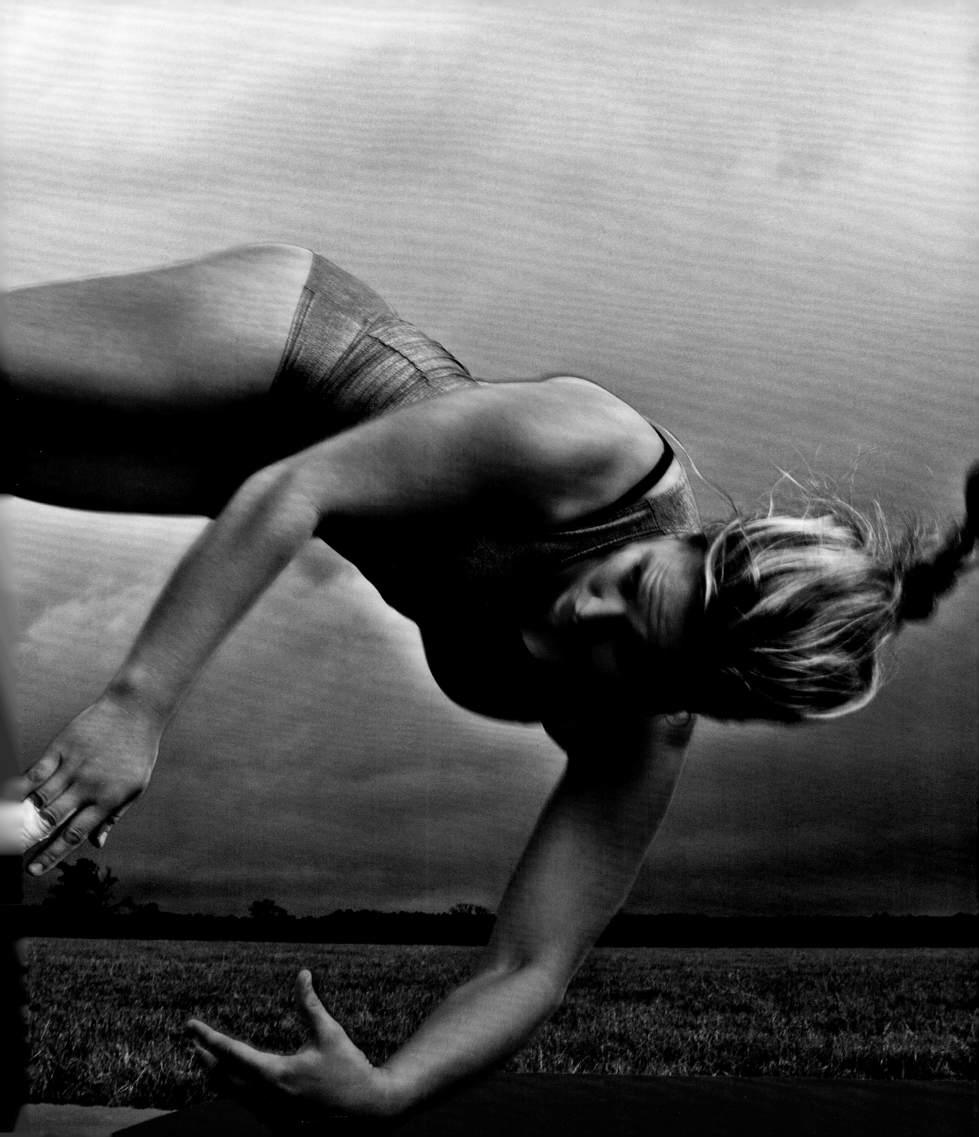

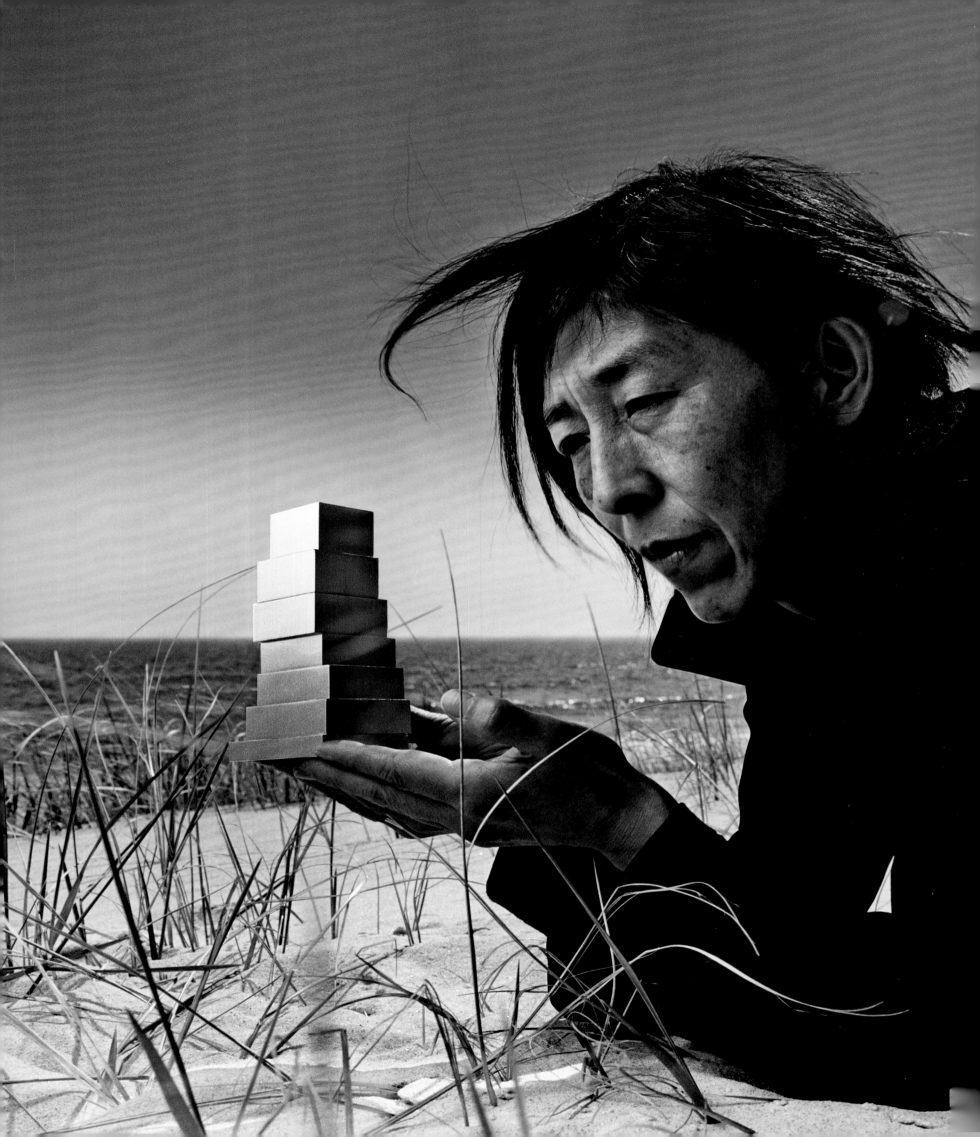

"It is hard, maybe impossible, to explain what it is like when you are on the verge of taking a good picture. When you are close. The excitement has been building and then everything is still, like in the eye of a storm. No one else gets it, probably because you are kind of insane at that moment. Obsessed. Phyllis is in the thick of it then—determined, demanding. Her eyes become wider. She drives you on. She knows. We live for this. Of all the fashion editors I've worked with, Phyllis has the best understanding of what goes into a photograph—what a good photograph is. Those sittings with Irving Penn and Helmut Newton—among others—are in her bones. They are part of her, which has always intrigued me. Penn's grace. Helmut's irony and intelligence. Their strange, fierce sensibilities merged. Fashion can be an integral part of a portrait. There is a thin line. When Phyllis and I argue, it is about this. What to leave in and what to leave out. When to leave well enough alone. When to alter something. When to make something new. She knows that I don't want fashion to overtake the picture, but I also know that fashion can very well make it. I will do almost anything for a photograph. Phyllis is always somehow willing to do more. I'm not sure she knows when to stop. I love her for that."—ANNIE LEIBOVITZ

Kazuyo Sejima
November 2006

Wangechi Mutu
April 2009

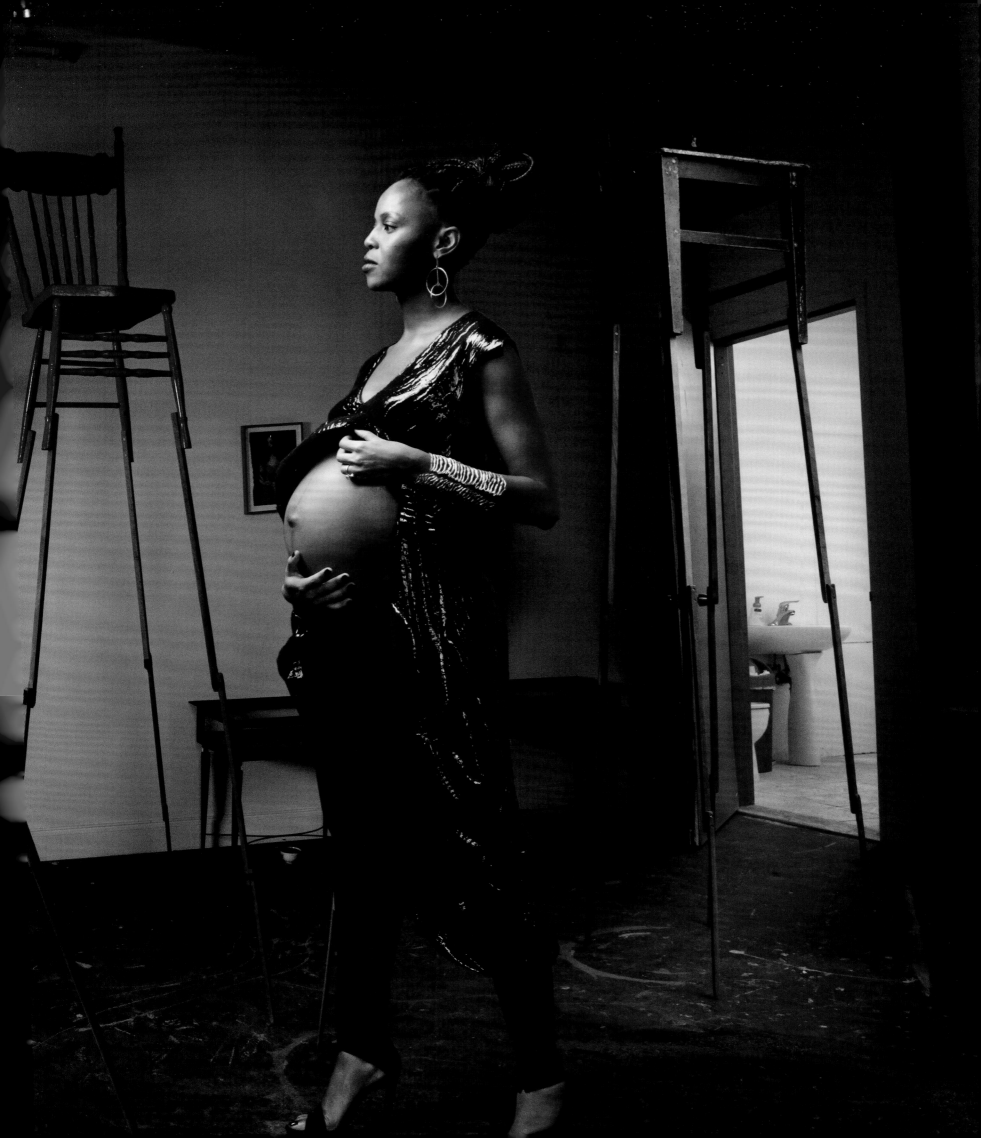

Most of the photos that Annie and I collaborated on have been portraits, but once in awhile, she's able find time in her frantic schedule to do a special fashion shoot. There were beautiful backless dresses in the F/W 2009 collections and Annie agreed to photograph three of them. She was excited about shooting at Oak Terrace, a beautiful nineteenth-century estate where Eleanor Roosevelt had spent her summers as a child. Roosevelt's maternal grandparents had once owned the magnificent property that commanded spectacular views of the Hudson River. It was now a beautiful derelict house and that's what Annie liked about it. It had rained the night before our shoot and the sky was filled with stormy gray clouds, which made perfect light for her photograph. She did two photos inside looking out at the river, and then this one of Karlie lying in the grass behind the house. All went well and it was an easy day. Things started going downhill after Annie finished this shot. Karlie stood up and discovered ticks all over her dress. Then, when we began the drive back to New York, Annie's SUV got stuck in the muddy driveway and it took all of the crew (a small army) a very, very, long time to get it out.

Splendor in the Grass
July 2009

154

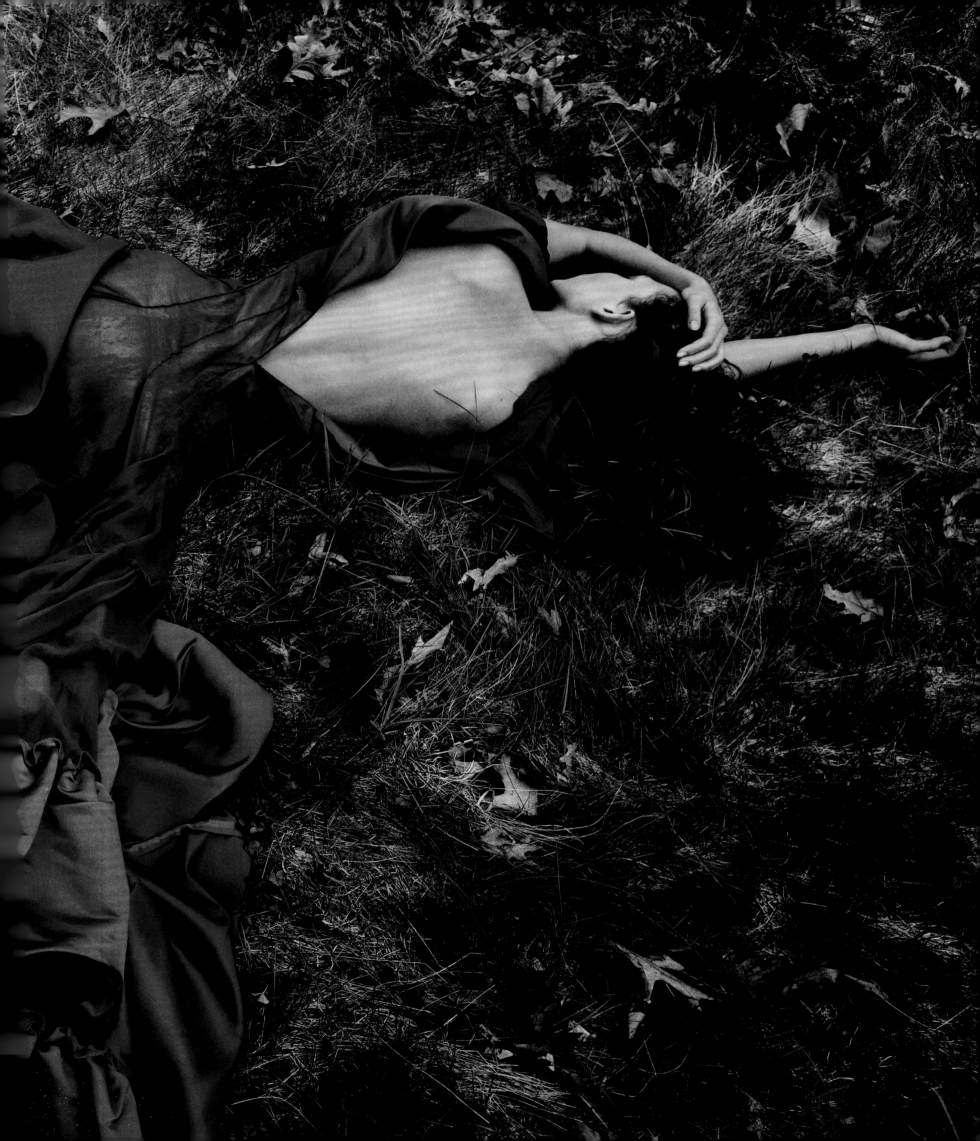

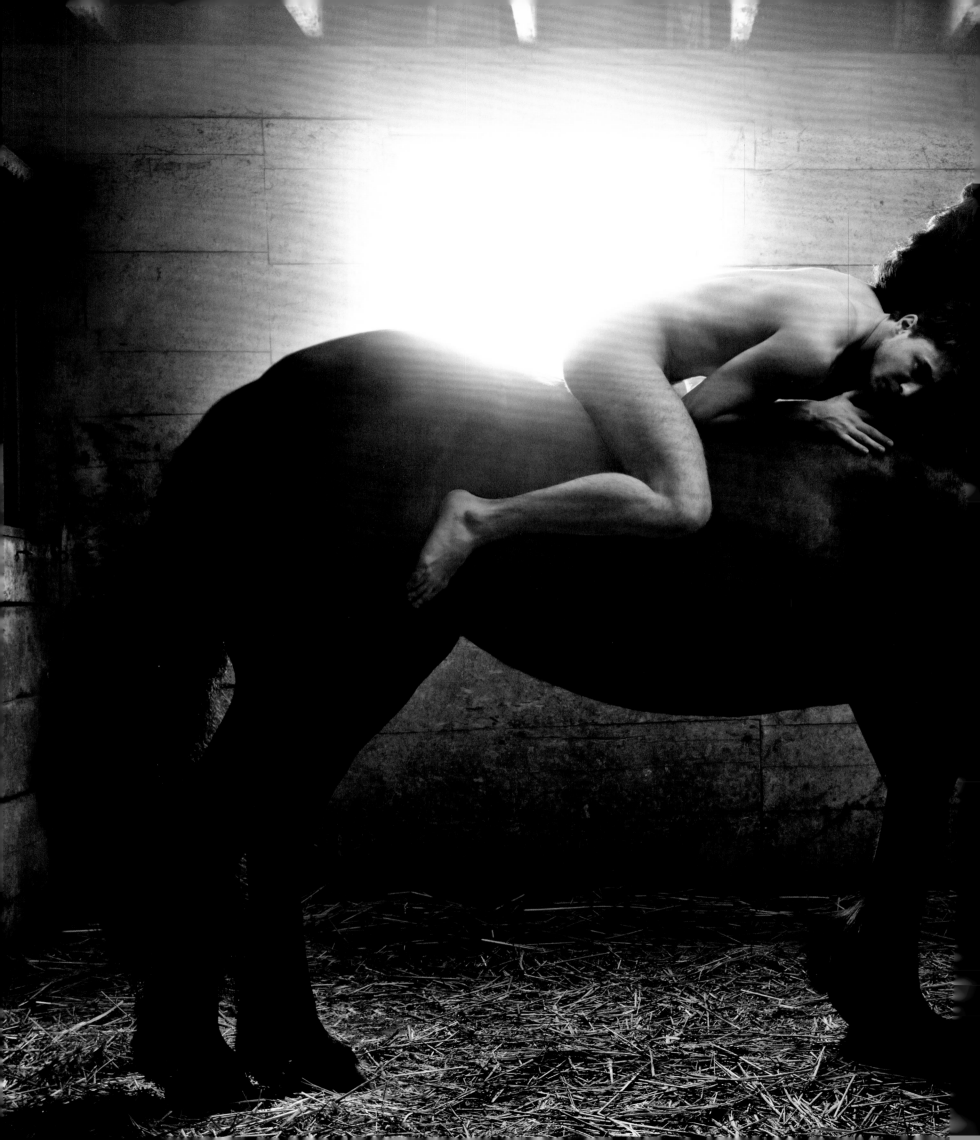

Daniel Radcliffe and
Richard Griffiths in *Equus*
September 2008

157

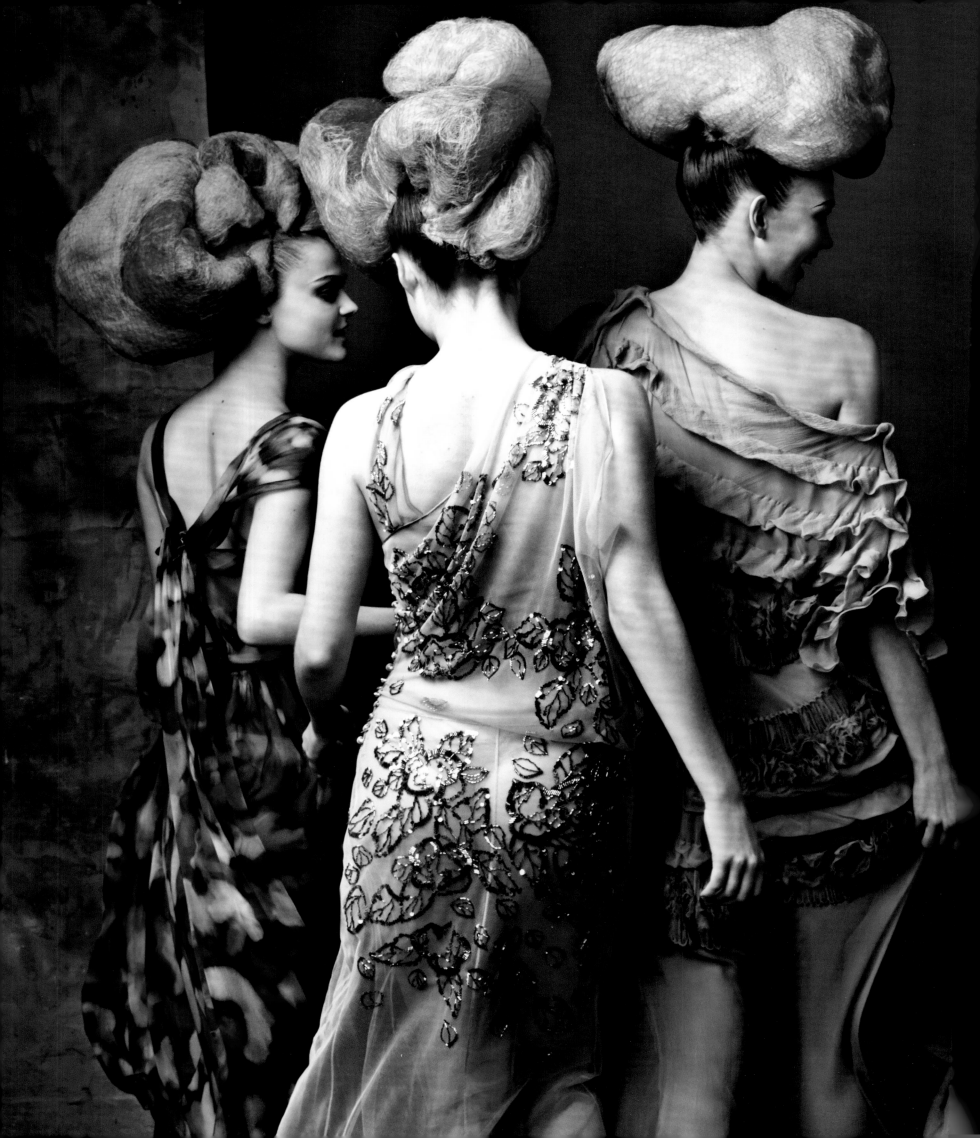

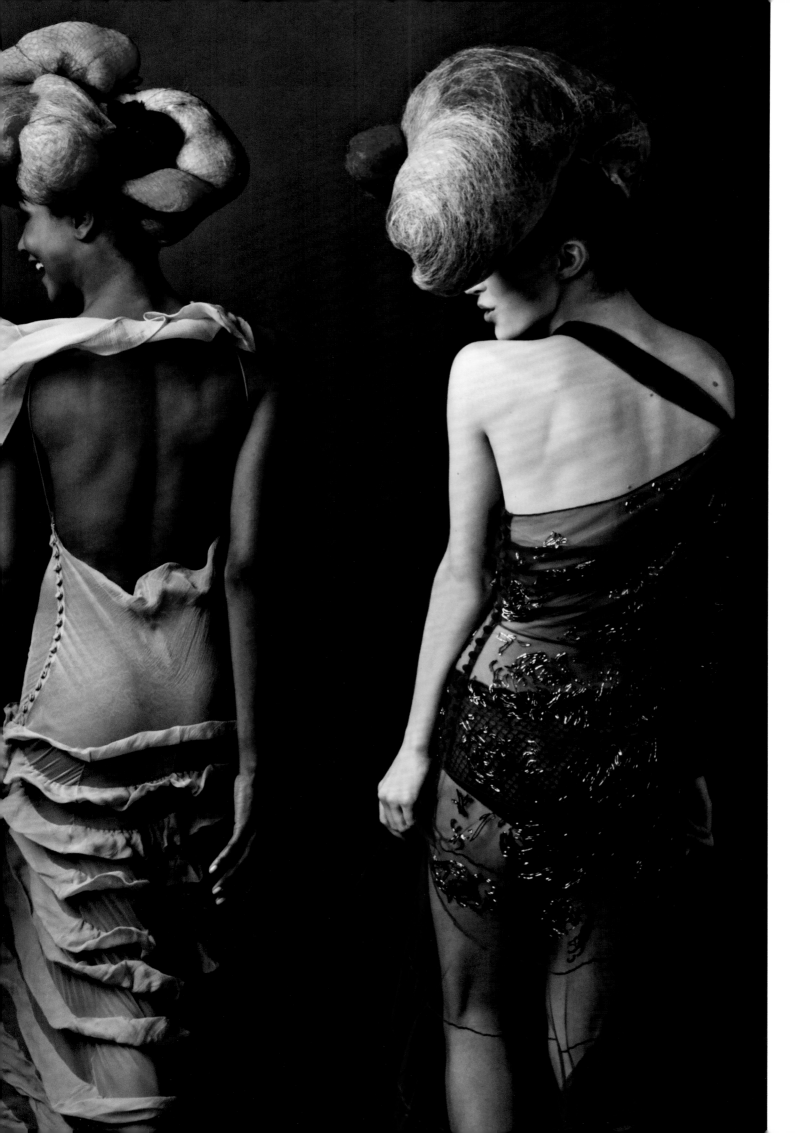

Julien d'Ys has been my friend and
invaluable collaborator on most of the
hair looks on shoots with Steven Klein,
Tim, Patrick, Mario, and Penn. I say "looks"
because often what he does isn't "hair"
at all. It's the column of white fluff you see
here, the cotton candy on the previous
spread, a hornet's beehive complete
with stinger, lace veiling covered with
pearls, or hair made of red feathers for
"Madame Bijou." Look in his suitcases
and you'll find hair in every color, texture,
and length, plus fabric, veils, plastic
shapes, wire, ribbon, twine, gold leaf,
silver foil, Saran Wrap, spray paint, and
more surprises than I can describe. He
is an artist who can transform a model
by using a wig that seems like the wrong
color, wrong shape, and wrong length,
except that in his hands, it's exactly
right. We always discuss before but
we can never know what the hair will
be until the day of the shoot. Things
can become tense and Julien is very
sensitive. Sometimes one look or a
comment from me or the photographer
can quickly cause a meltdown. Julien
cares so much. What makes him special
is his talent and his eye, and he never
gives up. While we're shooting, he sees
the picture and changes and adjusts
whatever he's put on the model's
head and makes the photo stronger.

Julien d'Ys,
Power Hair #2
March 2009

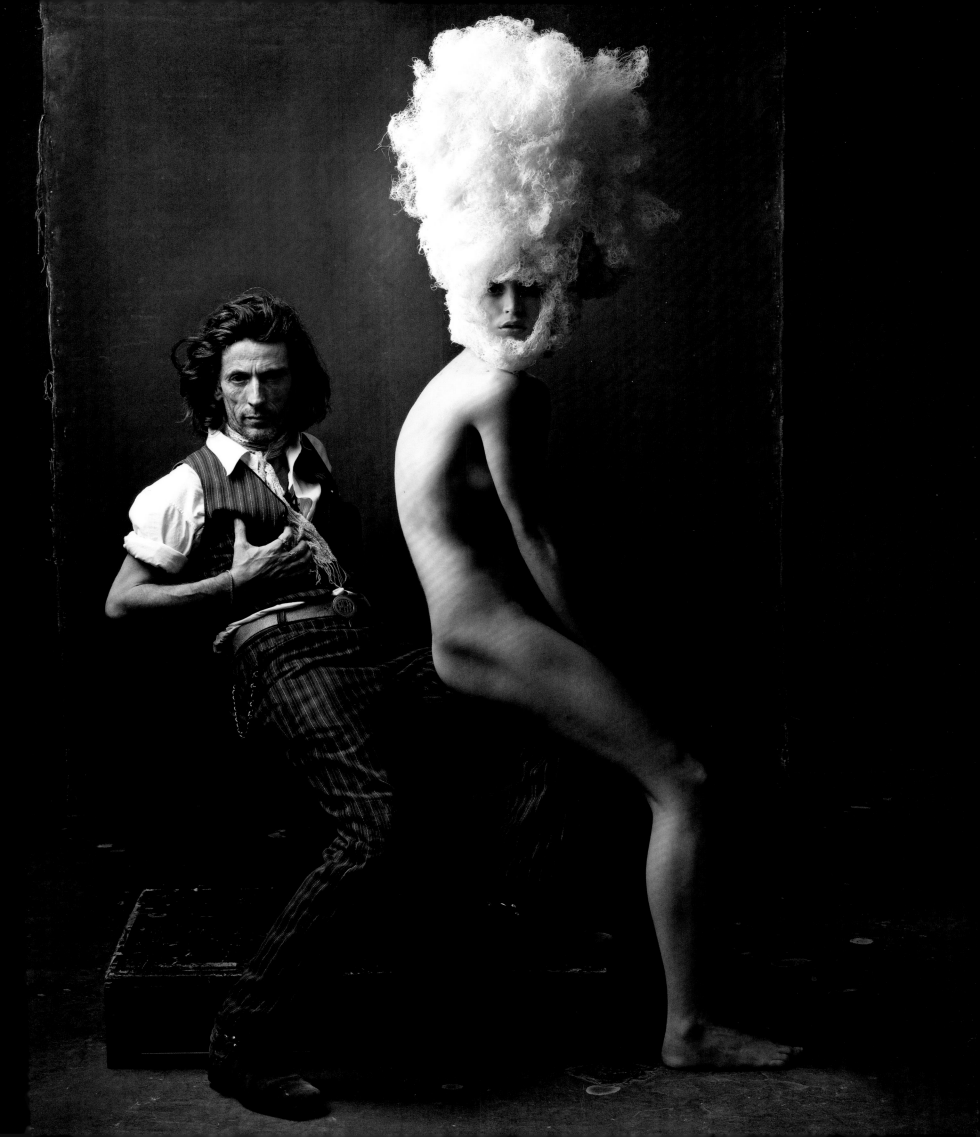

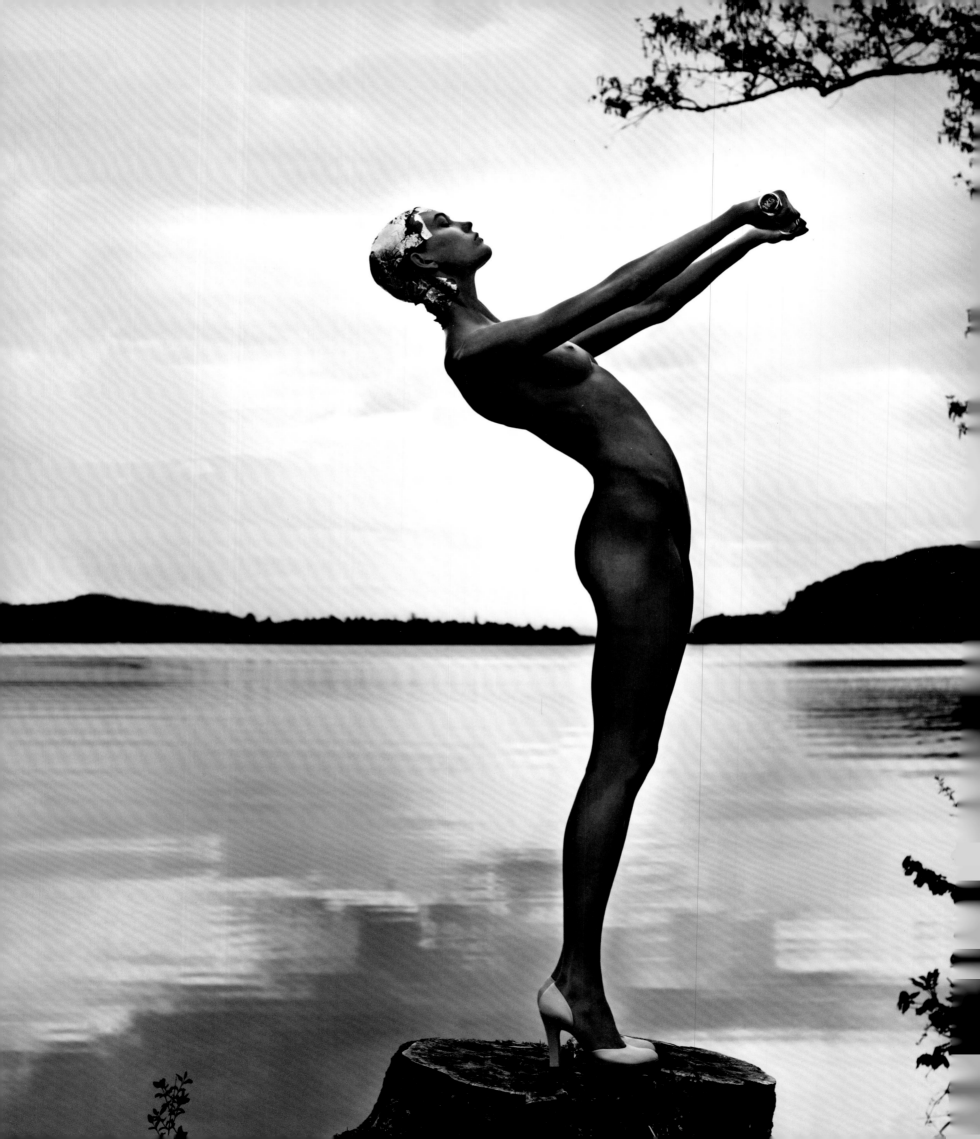

Mario Testino

Mario is a great travel companion. He's at home anywhere in the world, knows people everywhere, speaks five languages, and quickly adjusts to any new environment. He makes his shoots seem easy when they aren't, and if he's stressed, it never shows. His charming manner makes the impossible happen, and makes everyone around him feel good. Each trip I've done with Mario has taken us away from his familiar locations—a beach in Rio, a grand mansion, or a sophisticated world capital—to remote spas. To get to these distant places, the team often travels for almost two days, changing planes then driving hours on bumpy roads. Not Mario! He flies private and arrives rested and ready to shoot. Very early on our first morning at the fantastic Viva Mayr clinic, we had an idea to photograph Karlie as a 1920s dancer (opposite). Mario saw that the light was perfect, knew exactly how he wanted to shoot, and decided on this spot in a few minutes. I think his favorite part of our trips and the shoots is that the photographs aren't about fashion, but rather about illustrating ideas, often without clothes.

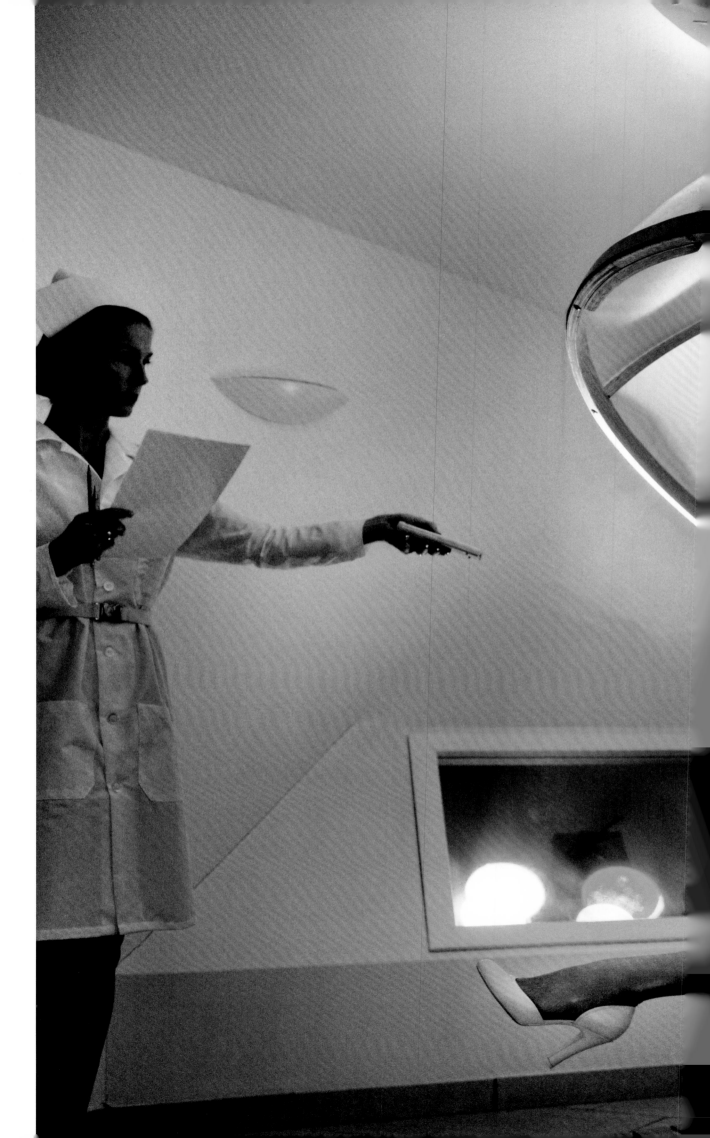

"For me, fashion editors are the people that take us photographers by the hand and help us stay in tune so we can do the pictures we do. With Phyllis, she not only keeps us on track, but she elevates us, allowing new possibilities and helping us look elsewhere to create a picture. Phyllis is constantly thinking of how to capture a better image, always thinking out of the box. What light will make a better picture? What is the best time to shoot? What more to create on the subject we are photographing? It is a constant search for the new and unseen. We photographers are so lucky to have other eyes helping us see differently and elevate our work. It is this that I treasure most about Phyllis and she is probably one of the best at it. We first met in the 1980s, and I am so glad that thirty years later, I am still working with her." —MARIO TESTINO

Destination Detox #2
July 2013

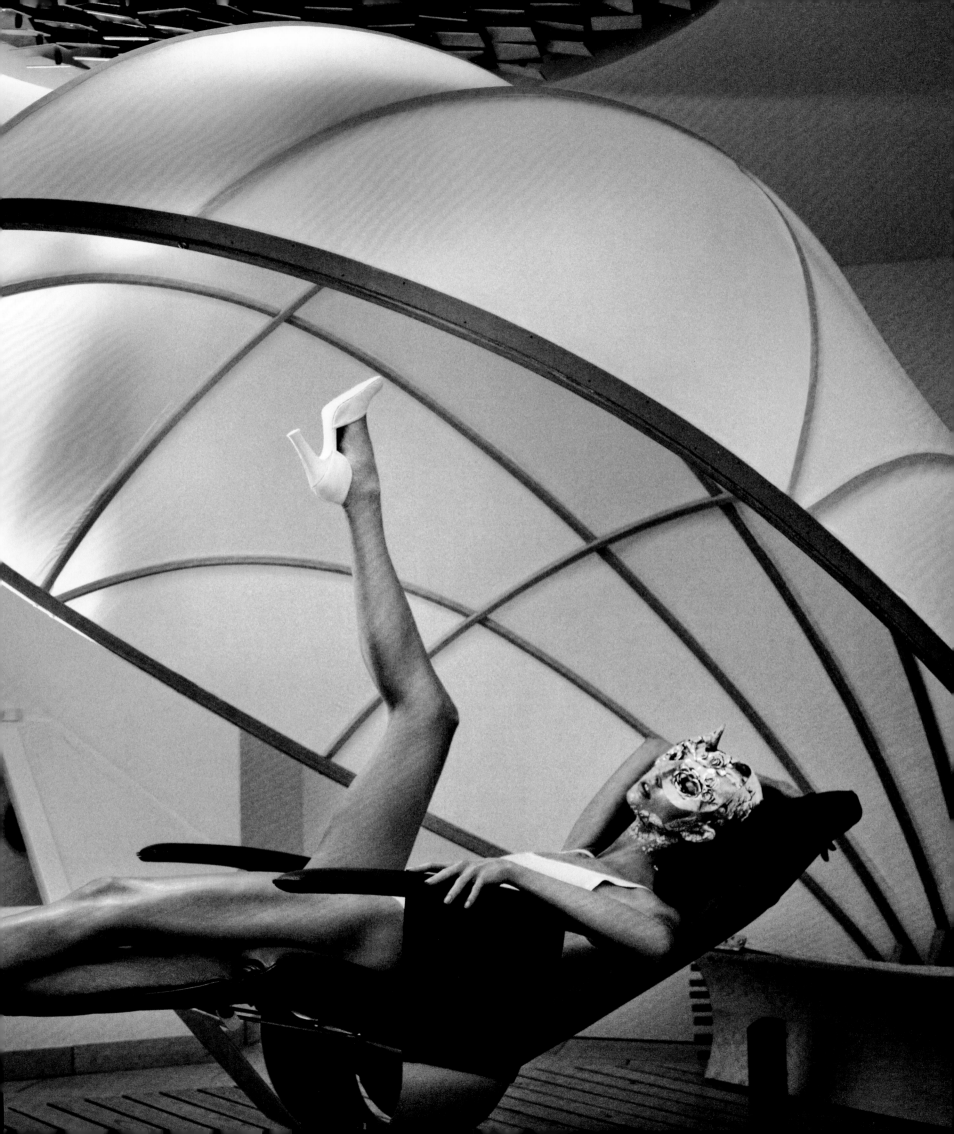

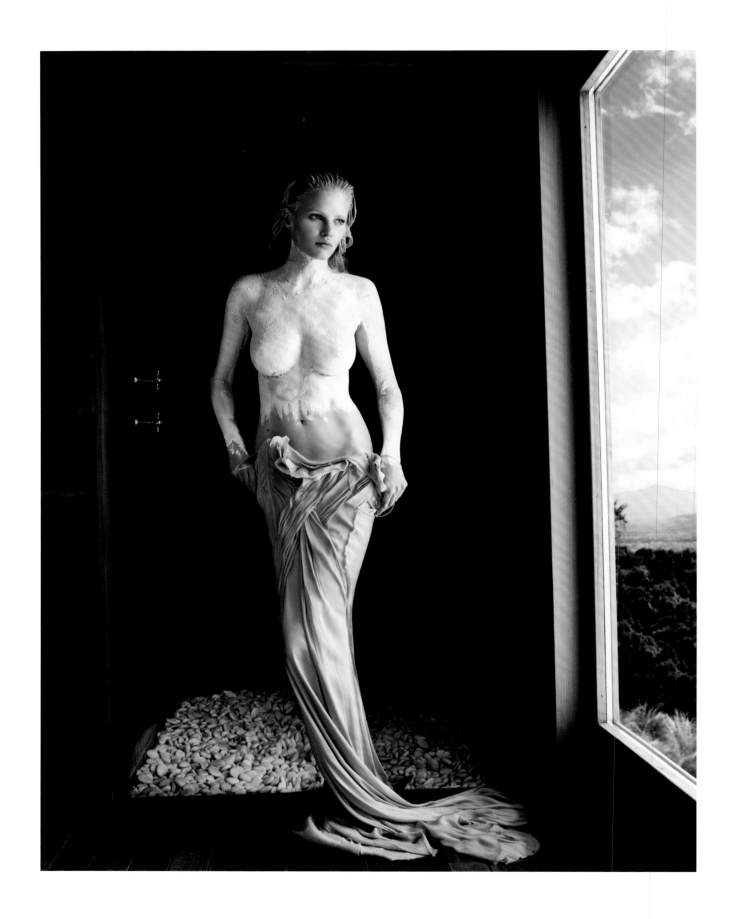

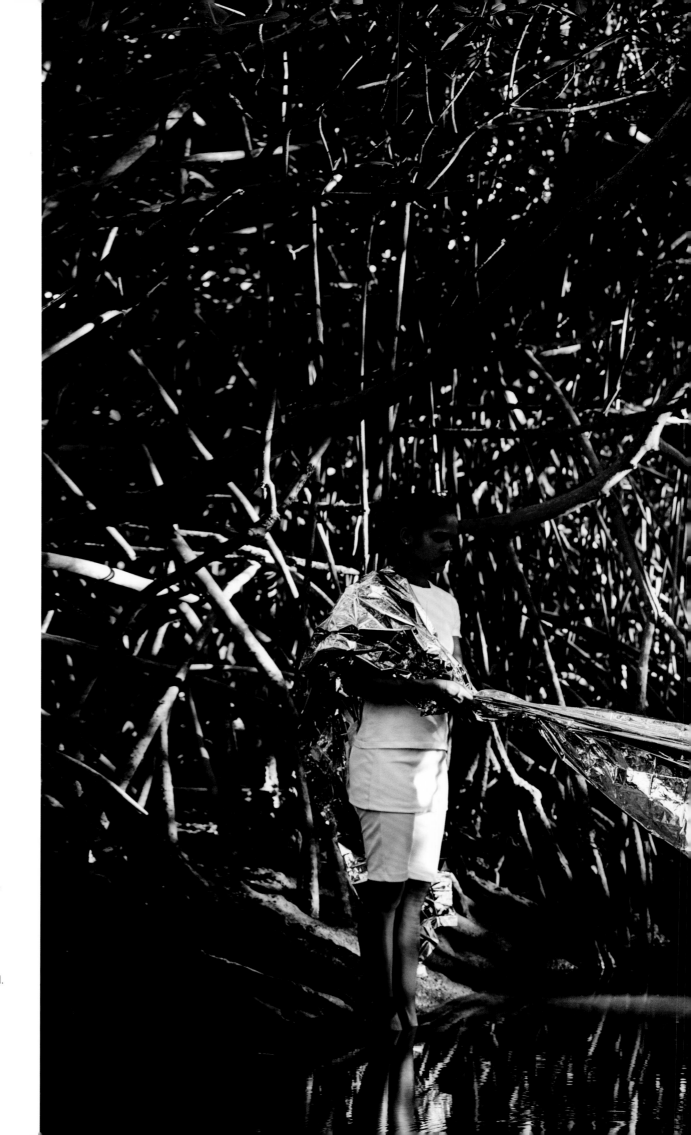

This photograph was taken in Trancoso, a tiny historic village on the ocean in Bahia. Nearby, are vacation houses of prominent Europeans, Brazilians, and Americans. Our destination was Uxua Casa Hotel, a beautiful new spa where the treatments take advantage of natural springs, clay cliffs, and beautiful landscapes. We wanted soft afternoon light and planned to shoot in the mangroves near the hotel after lunch on the beach. The problem was that our lunch was too long and we were late getting to our spot. Mario had to be in the water to get this angle, and as soon as he began to shoot, the tide came in. He calmly got his picture as the water got higher and higher, while I stood by stressed on dry land.

Mermaid
July 2012

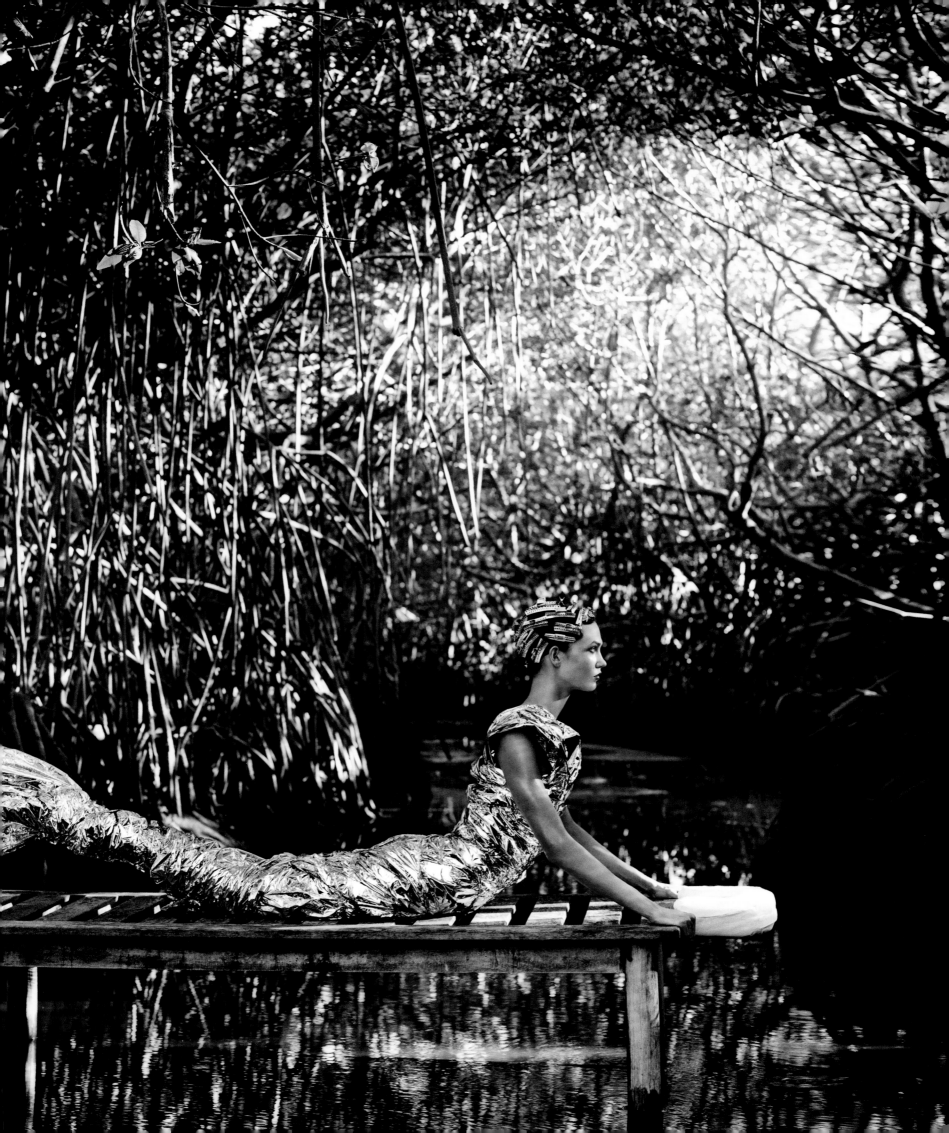

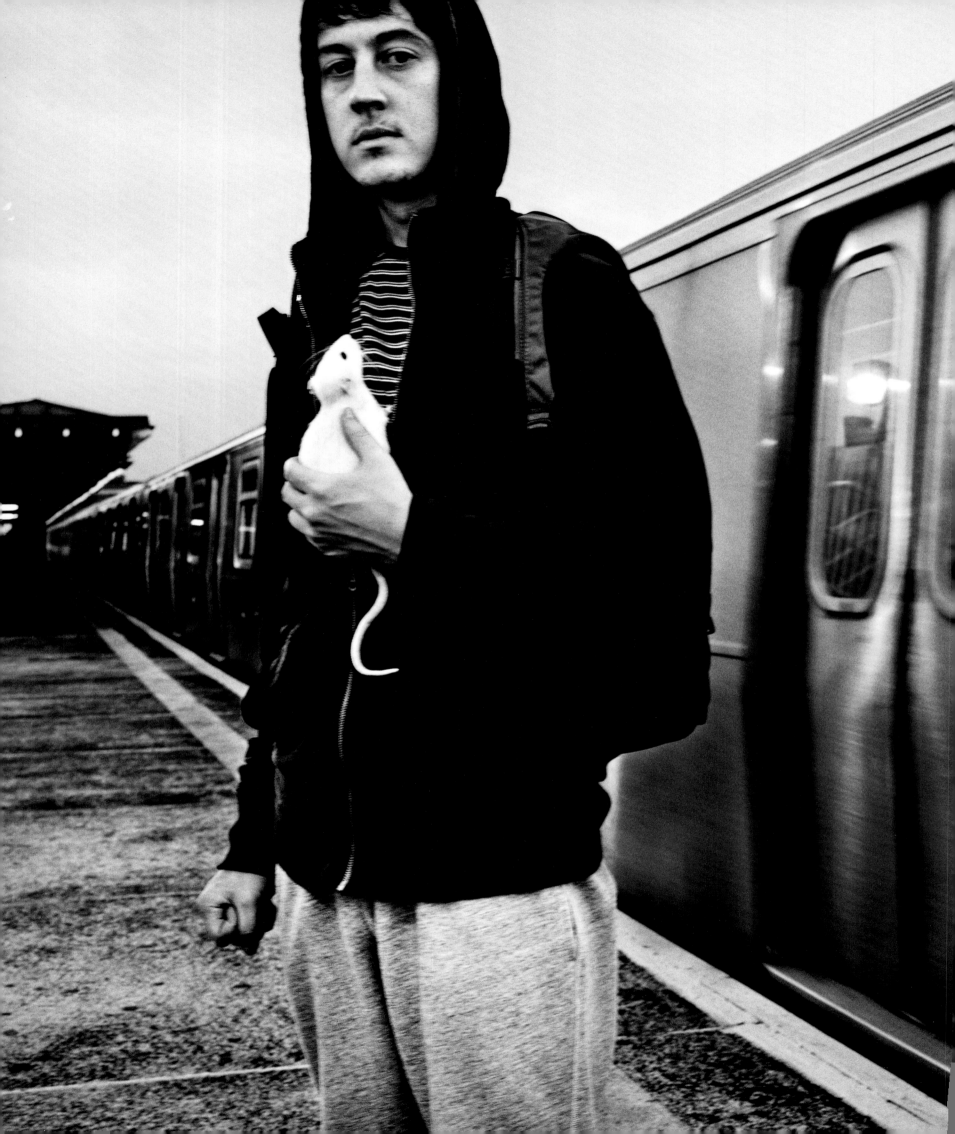

Anton Corbijn

Anton Corbijn is a brilliant photographer and filmmaker. He's especially well known in the music world and has collaborated on photographic works with Tom Waits, done portraits of almost every important music figure, and made videos for U2. He became a cult figure after he made his first film, *Control*, in 2007. People will do anything for him. His work style is the antithesis of most of our *Vogue* photographers. He shoots film, preferably in grainy black and white, has one female assistant, and rarely needs more than an hour to get his picture. It's exciting to work with him because I know he'll always get a memorable photo in his distinctive cinematic style. And he does all the work. We discuss approach and concept, and while I make suggestions, the picture is all his. We talk about locations and he finds them. He tells me how he sees the photograph, sometimes on the day of the shoot. When we did this portrait, Alex Sharp was still a student at Juilliard, about to make his Broadway debut in the starring role of Christopher in *The Curious Incident of the Dog in the Night-Time*. Alex was funny, engaging, and smart. He was so extraordinary in the play that it came as no surprise to us that he was the youngest winner of the Tony Award for best actor in a drama. To connect his photo to a scene in the play, Anton photographed him on a train platform during rush hour, shooting as the train left the station and the platform was finally empty. This was shot in New York so when the crowds exited the train, no one seemed to notice the young man holding a white rat.

Alex Sharp
New York City, September 2014

171

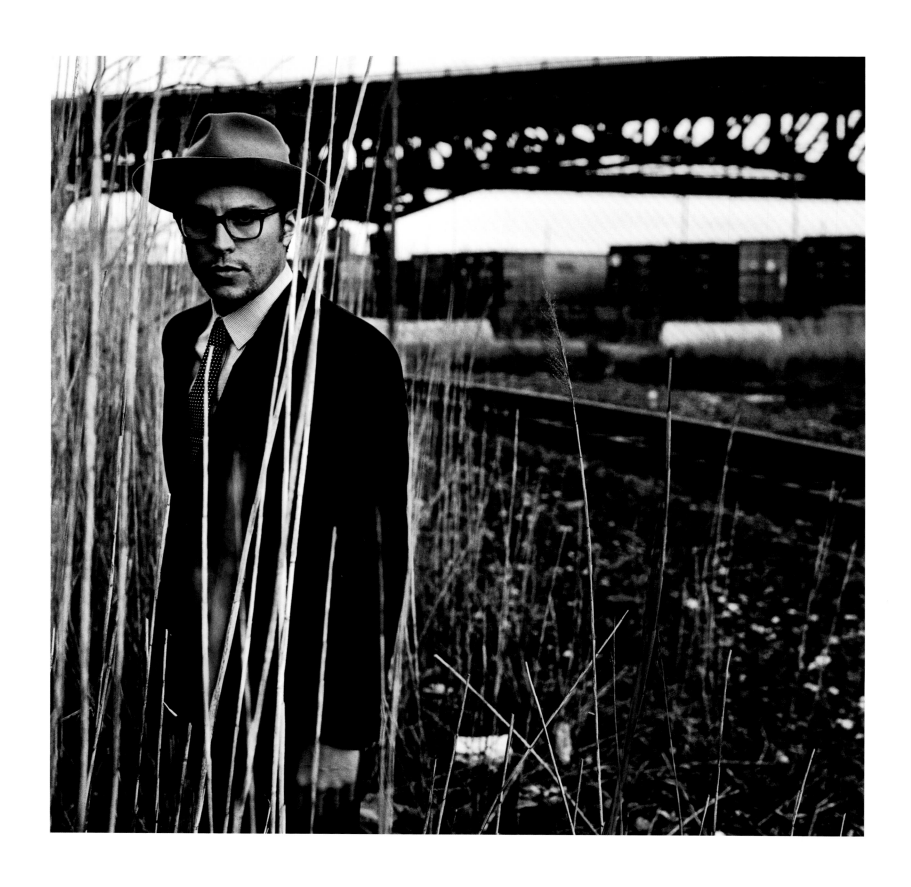

Cary Fukunaga
New Jersey, November 2015

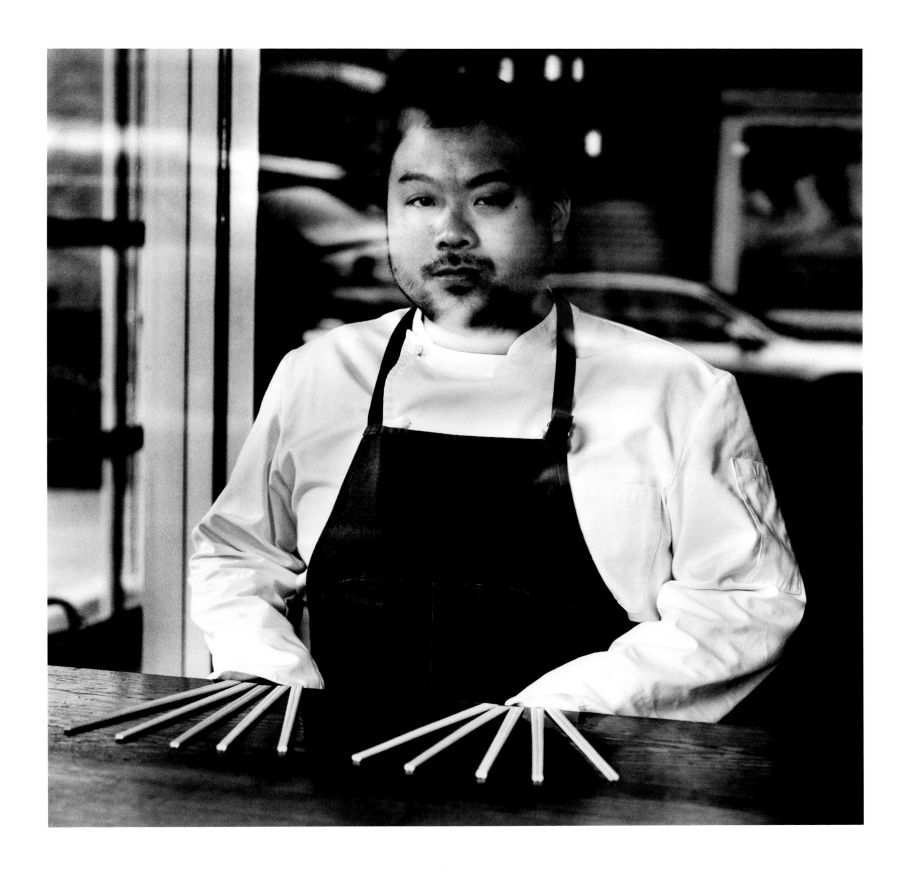

David Chang
New York, September 2013

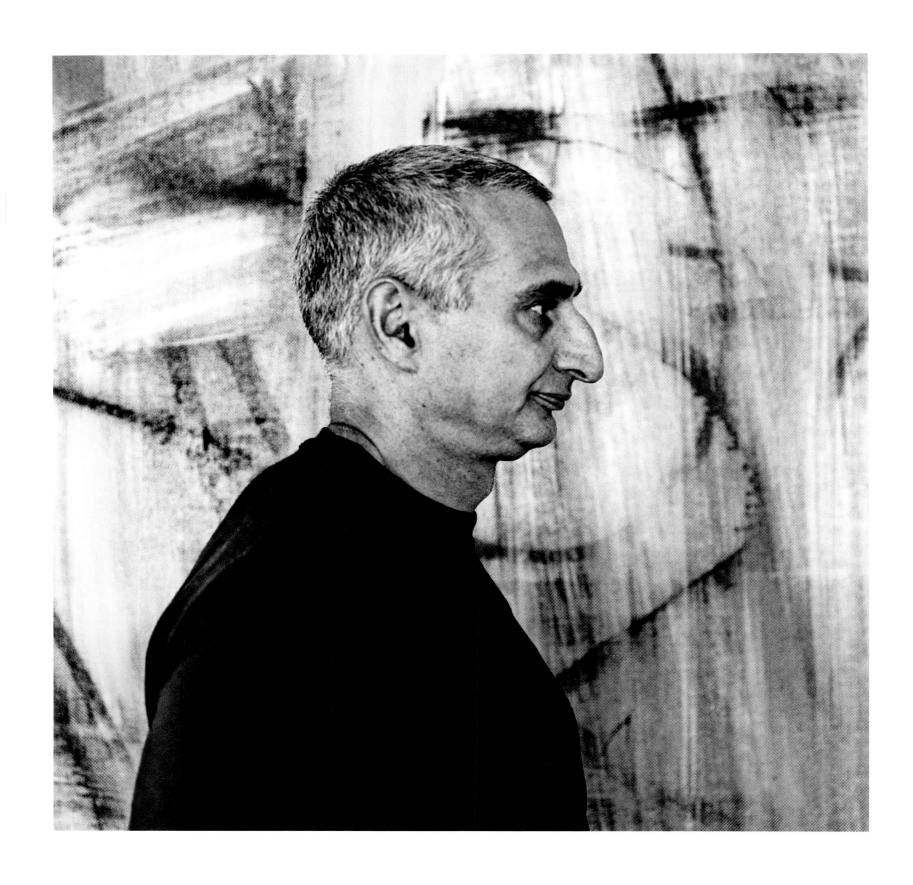

Christopher Wool
New York City, October 2013

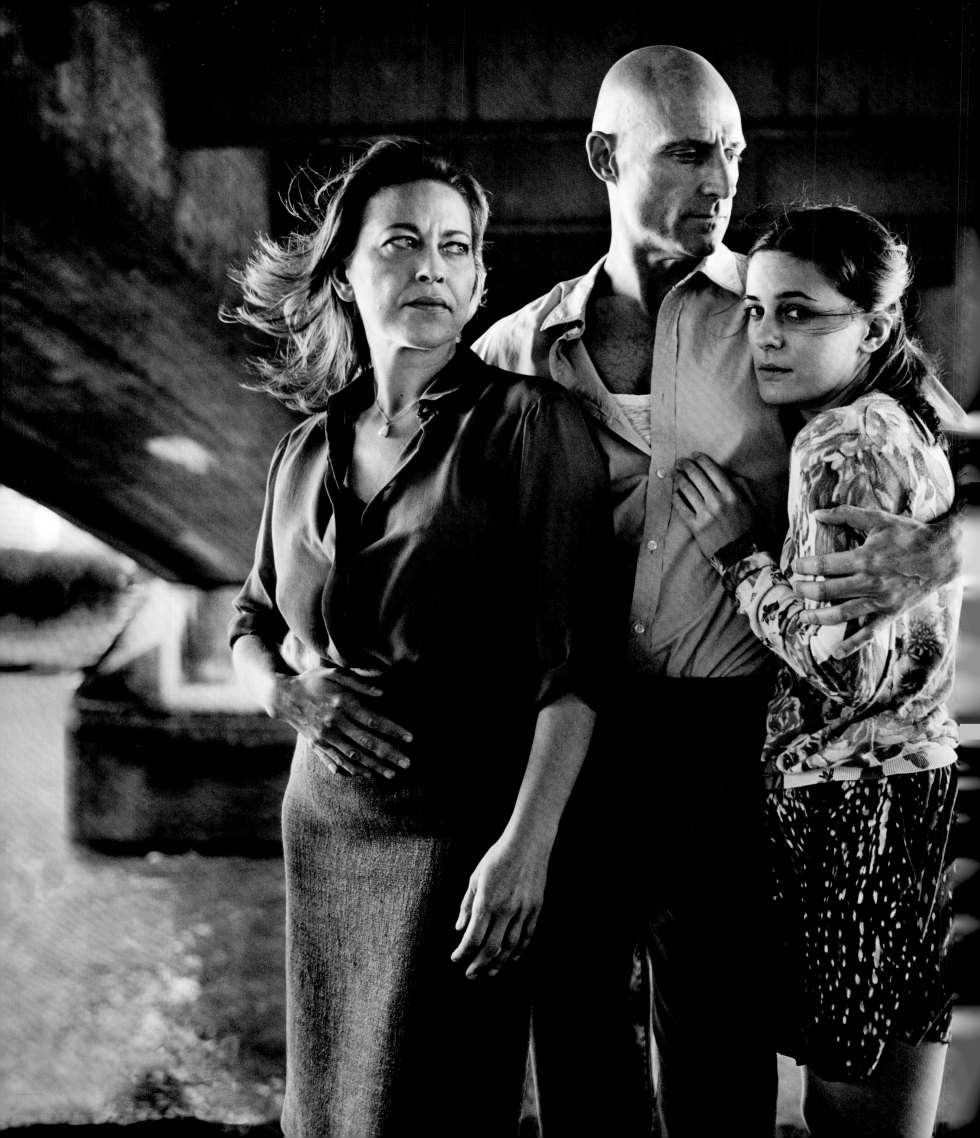

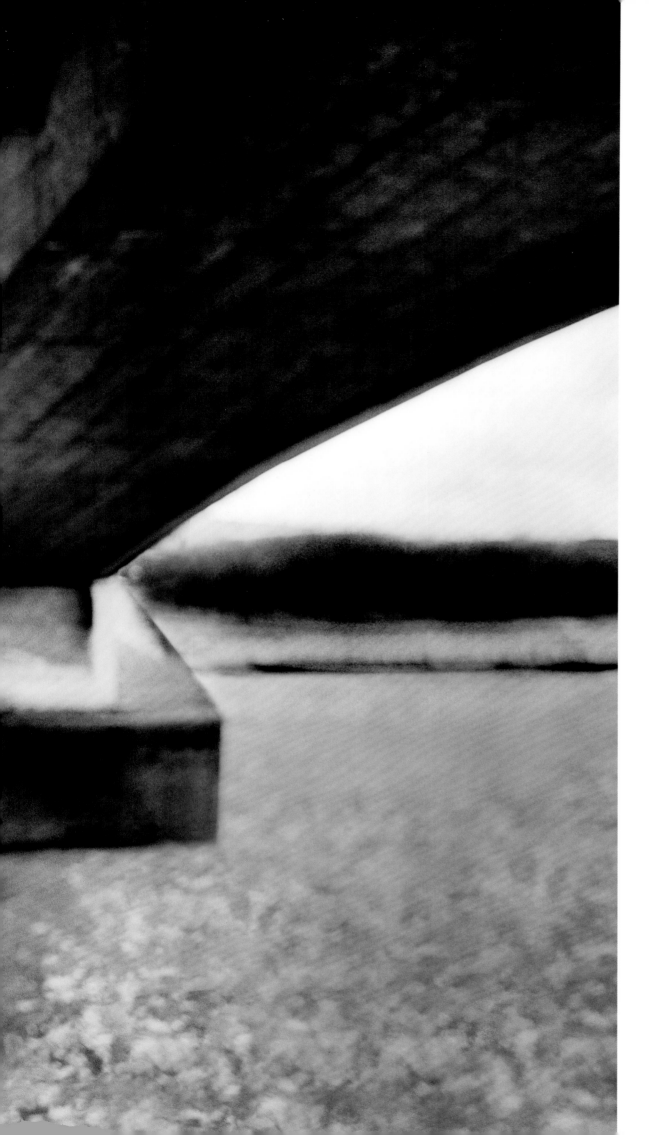

Nicola Walker, Mark Strong, and
Phoebe Fox in *A View from the Bridge*
London, October 2015

177

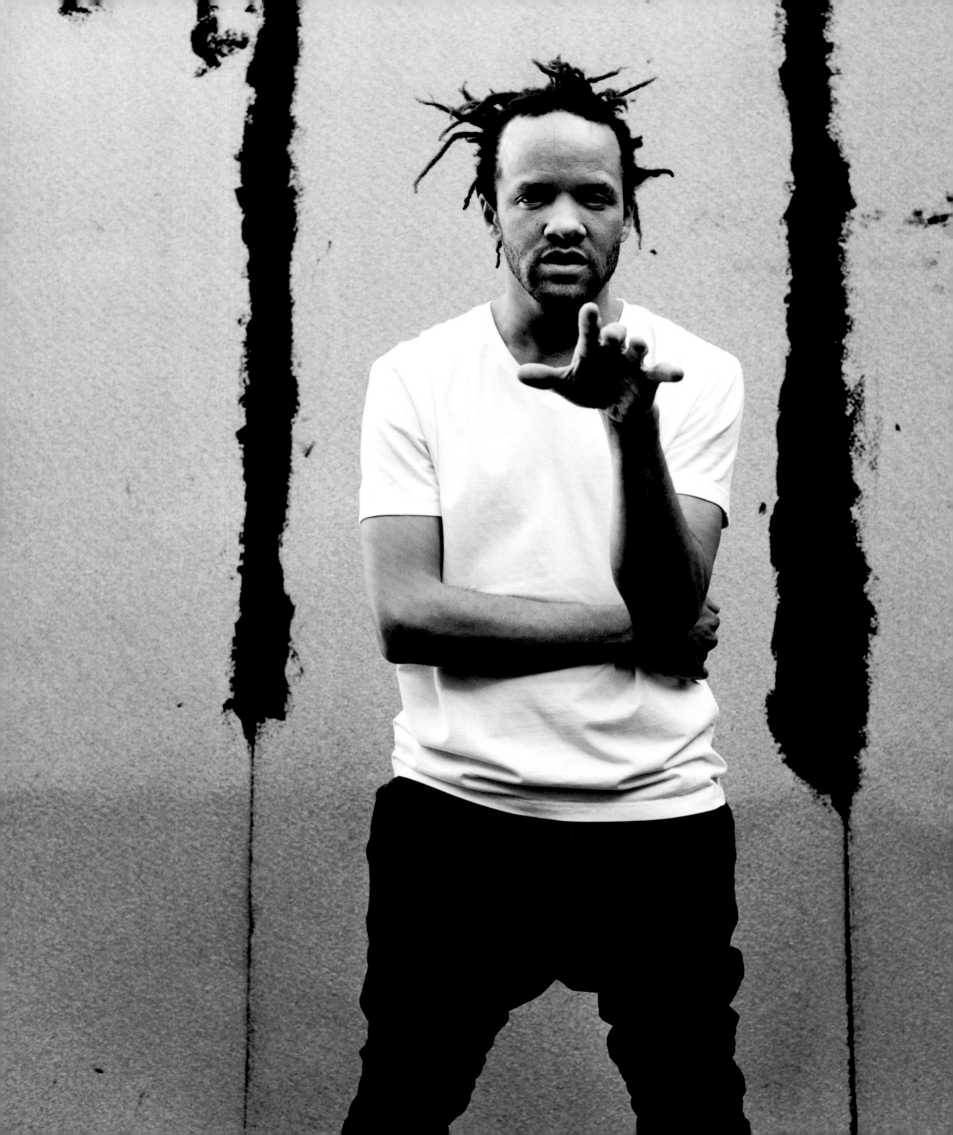

Savion Glover
Brooklyn, May 2016

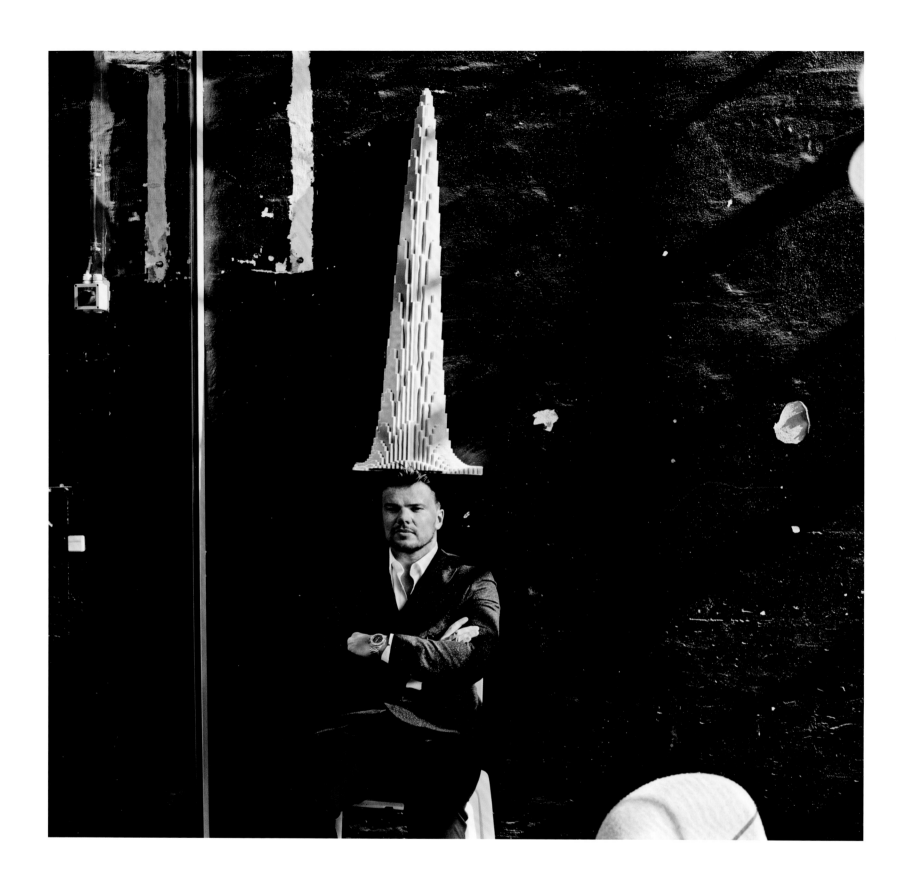

Bjarke Ingels
Copenhagen, November 2015

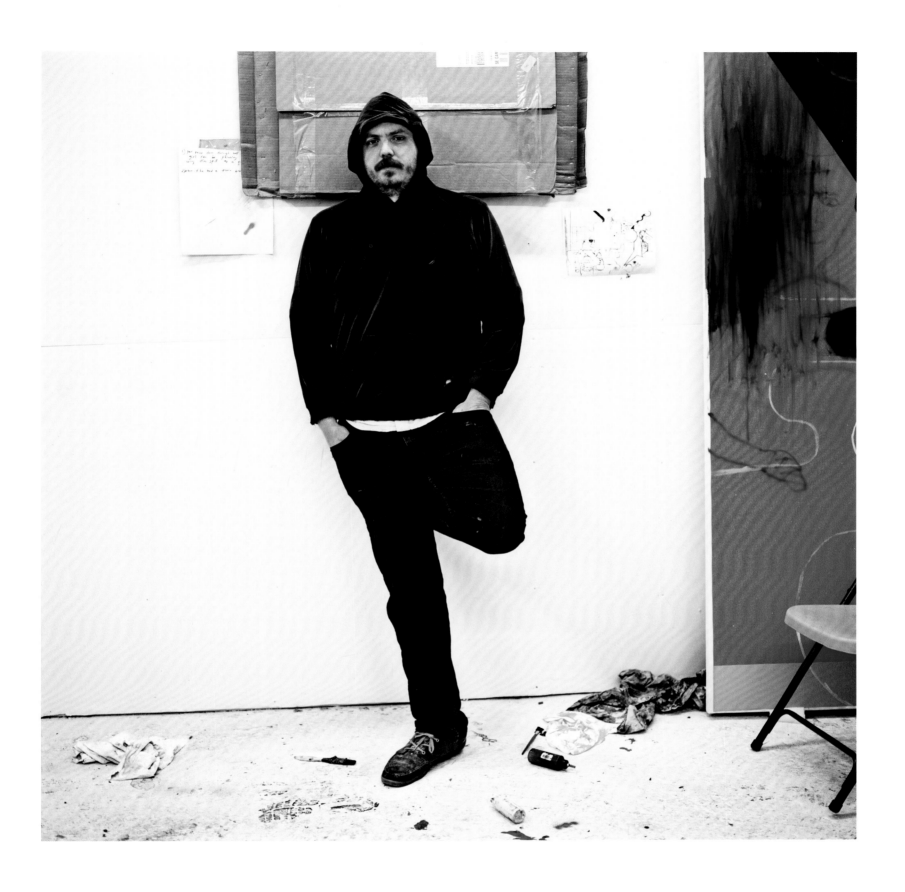

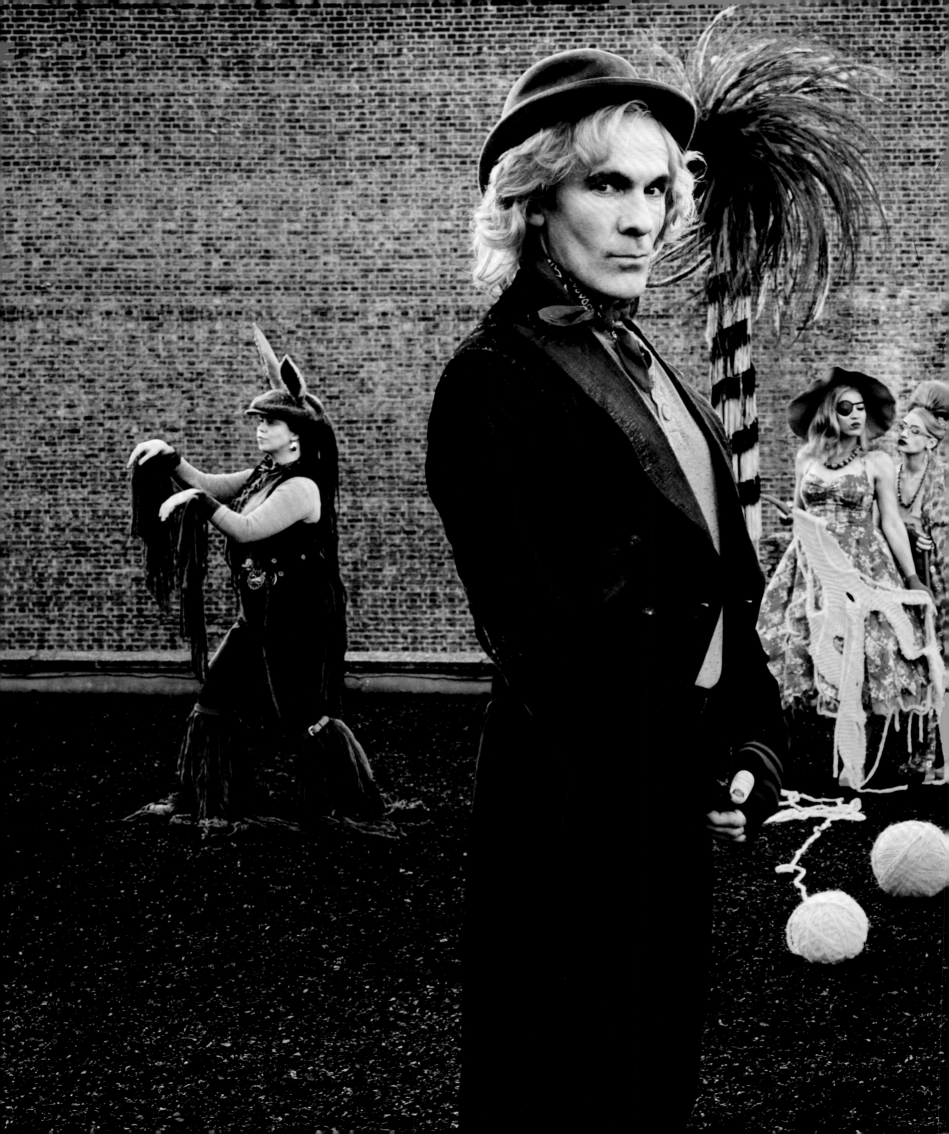

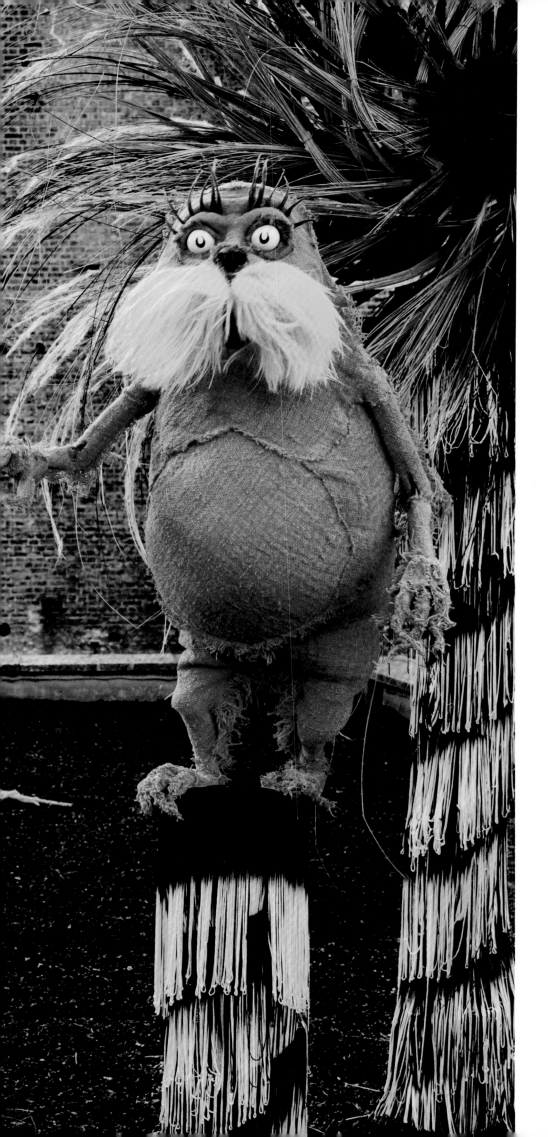

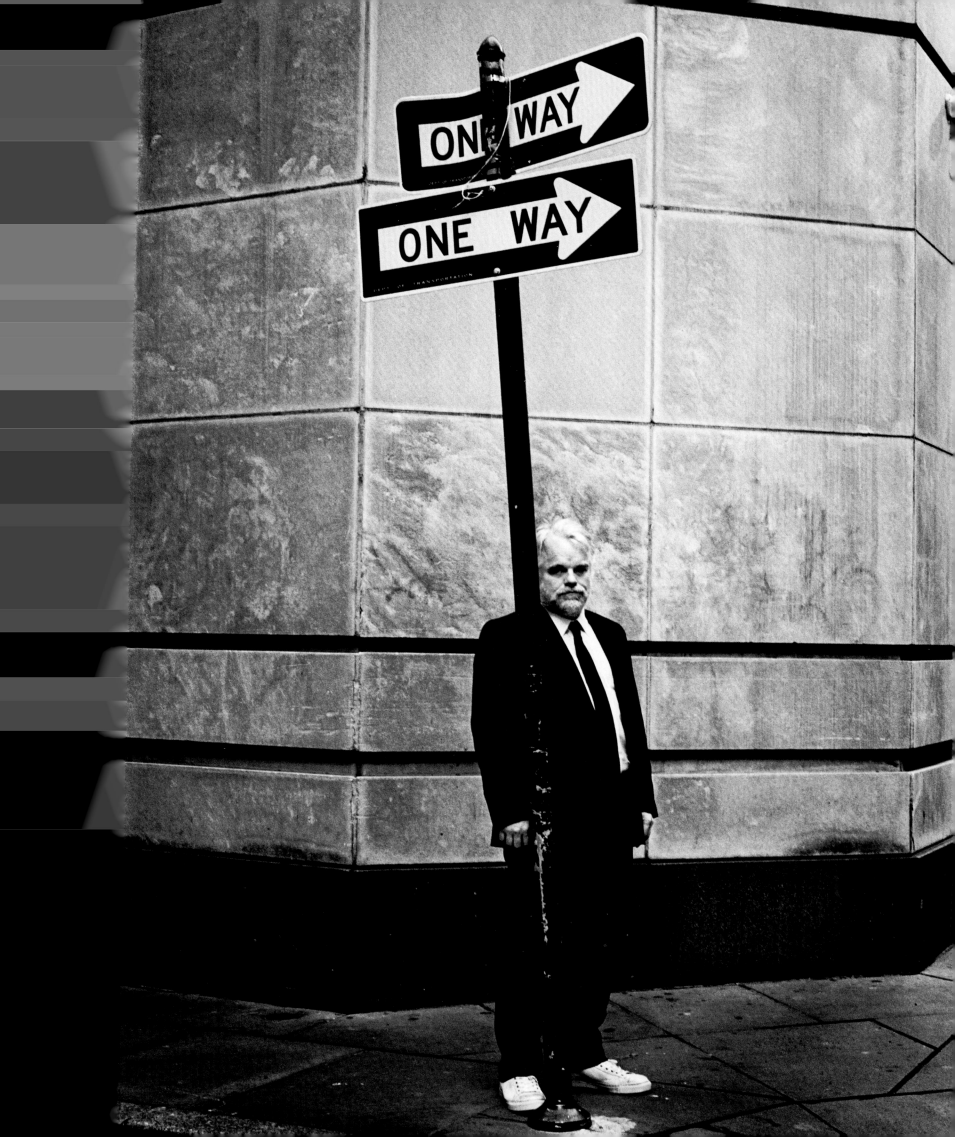

Philip Seymour Hoffman didn't enjoy having his portrait done, but he sometimes agreed to promote one of his films or, in this case, a play, *Death of a Salesman*, on Broadway. We had met when Penn photographed him, so I was expecting a relaxed shoot. This particular morning he arrived in a bad mood. Anna Wintour was hoping to see him in a suit, but Philip wore casual, "lived-in" clothes and wasn't comfortable dressed up or being dressed by editors. He definitely didn't want to wear a suit. I tried to convince him to wear anything but the clothes he arrived in, but without success. Then Anton took over and soon I was getting a suit tailored. His understanding of the actor's psyche and his gentle manner calmed Philip. The shoot took more time than usual for Anton because he had chosen two locations at opposite ends of the city, but as we drove, the two men clearly enjoyed the ride. They hadn't met until that morning, but became close friends, and the last film Philip made was *A Most Wanted Man*, directed by Anton.

Philip Seymour Hoffman
New York City, March 2012

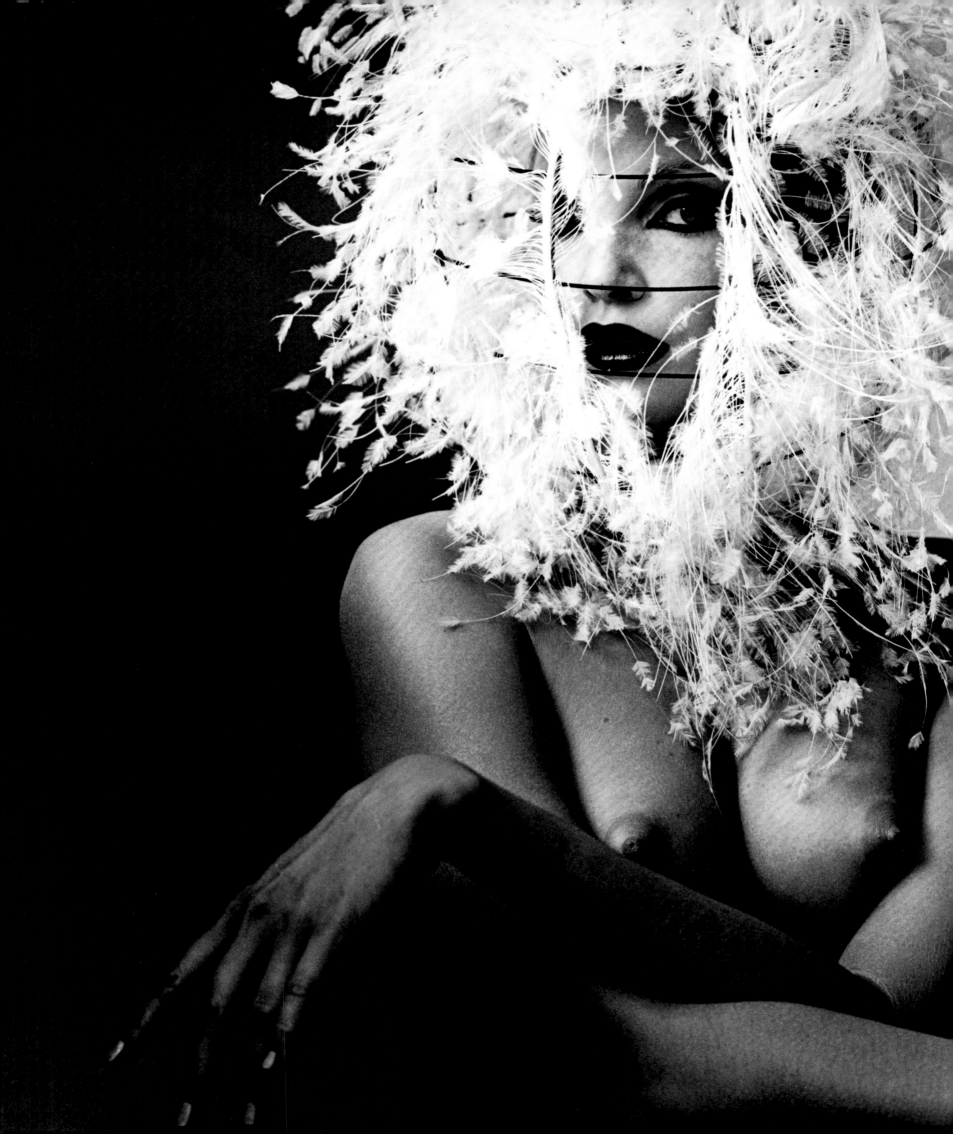

Irving Penn

In the twenty years that I worked with Penn, we collaborated on over 400 photographs. He was my greatest teacher, my severest critic, and over the years he became my very dear friend. At first, I was intimidated by him. His standards were so high and he had a reputation for being difficult. And he was. It often took more than two months from our first conversation about a subject to the day of the sitting (never a shoot). These conversations established the direction his picture would take. Sometimes he would challenge me: "I don't think you really believe in this picture." I would have to prove that I did. At other times, he was gentle, patient, and prodding, and gave me openings to say what I thought. I learned to go beyond the obvious to illustrate an idea and to speak in a visual language that could inspire him. He had a dry wit and a sly sense of humor. One day when we were having lunch and complaining about our aches and pains, I told him that my shoulder problem was so painful that it hurt when I lifted a fork. He looked at me with a twinkle and said, "Perhaps you should put less food on it." Anna wanted Penn in each issue, which meant that we spoke almost every day, first on the phone, then in his studio where I hoped to persuade him to illustrate an article or do a portrait or photograph fashion. He had studied painting and drawing at the University of the Arts in Philadelphia under Alexey Brodovitch, the innovative and influential graphic designer. Often as we talked, Penn sat across the table from me and drew the image he wanted to photograph. Sometimes, when I got back to the office, he had faxed me another drawing. He liked bold strokes, nothing "bitsy." He taught me to consider every detail in advance, be better prepared, and more sure of myself. He would ask what I was going to put on the model's head/arms/feet—was I planning to leave her neck bare, what was the makeup, the hair? Of course, things changed on the sitting, but he wanted to "see" the picture and know that I saw it. As I came to know Penn better, we would sometimes disagree. One day we were arguing about the look of a model. I was fighting him because I was afraid the picture would be killed. When I told him this, his response was "I'd rather have a good picture killed than have a mediocre picture run." After that, we began to do our best work and I still hear his words on every sitting that I do.

Nadja in Feather Mask
New York, 1994

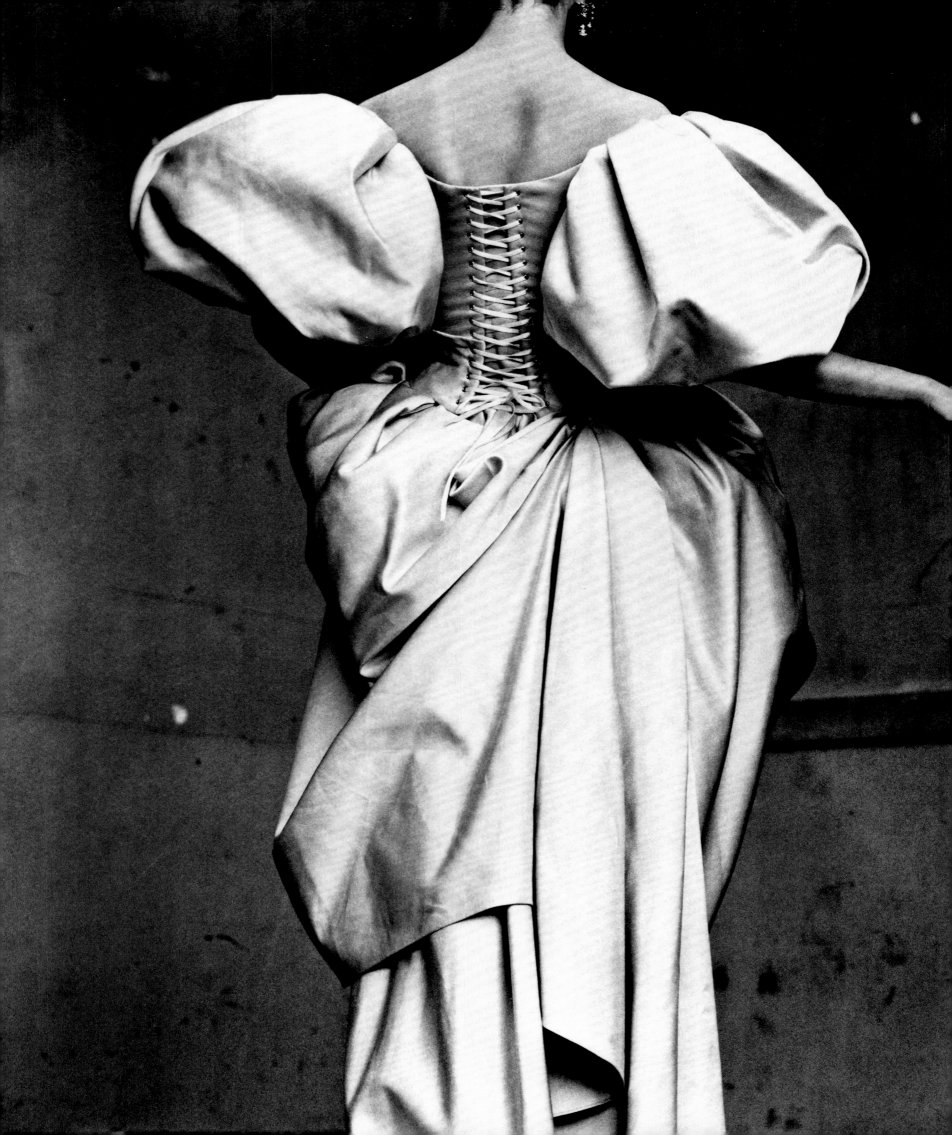

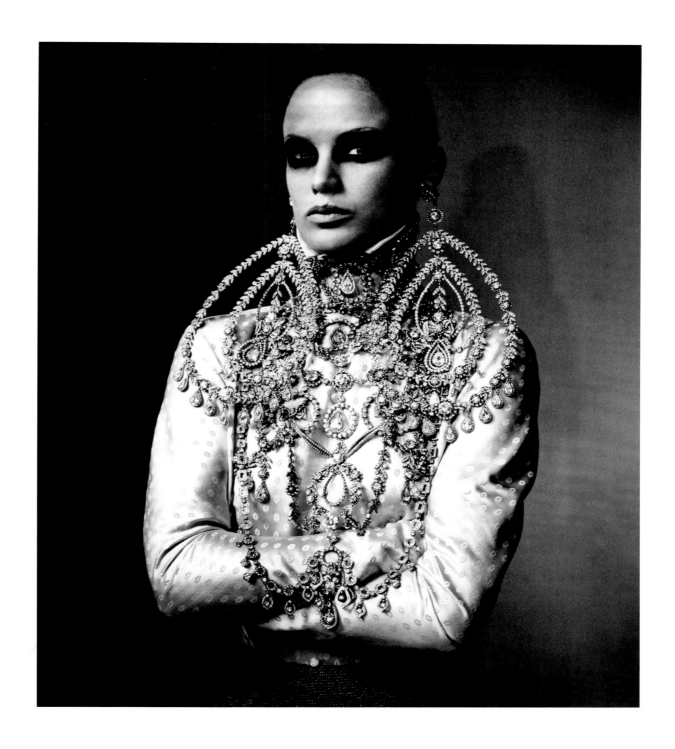

We were planning a sitting in Paris to illustrate the "Haute Couture" 1995 exhibition at the Metropolitan Museum of Art. To prepare for the trip, Penn and I talked about his iconic couture photographs from the fifties, which were shot using natural light. The look of those extraordinary pictures was rich, textured, and almost three-dimensional. When I began to work with him in 1989, he was using a strobe light which created a harder, less intimate image. I asked if he would consider using daylight and he smiled. "Yes, but only if you can find a studio like the one I used in Paris in the fifties. But you never will." It wasn't easy, but our Paris editor, Fiona Da Rin, found one with the same filthy skylights that filtered light, with dirty windows facing north, and the same old squeaky floors as his New York studio. She had it scouted and Penn liked what he saw. The Christian Lacroix Couture dress on Shalom Harlow is the first photograph we did there, and after this sitting, Penn rarely used strobe again unless it was for a still life. Using natural light changed the way he approached his subjects, changed the look of hair and makeup, and freed him to take the pictures he really loved. It softened the look, which made his woman more romantic.

OPPOSITE:
Christian Lacroix
Duchesse Satin Dress
Paris, 1995

THIS PAGE:
Young Woman with
Large Earrings
New York, 1997

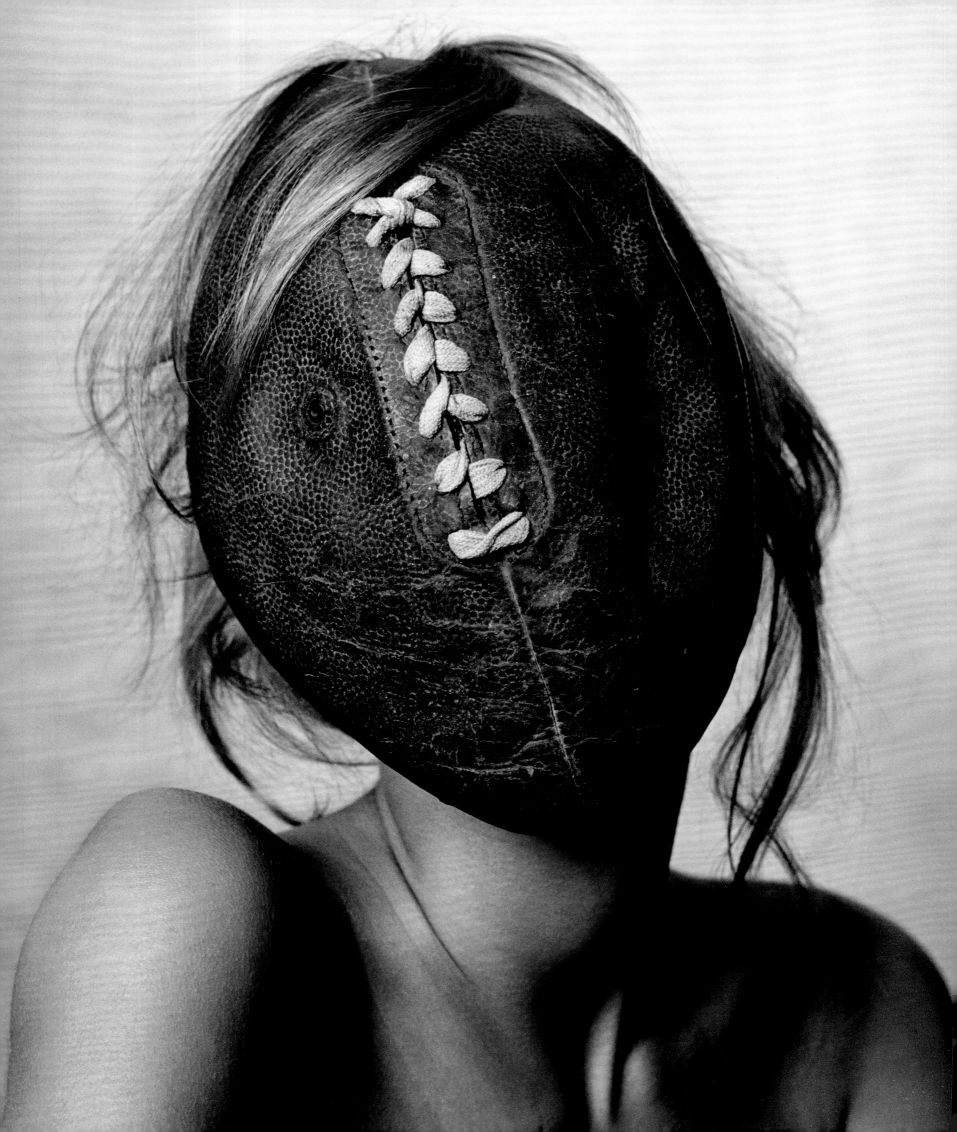

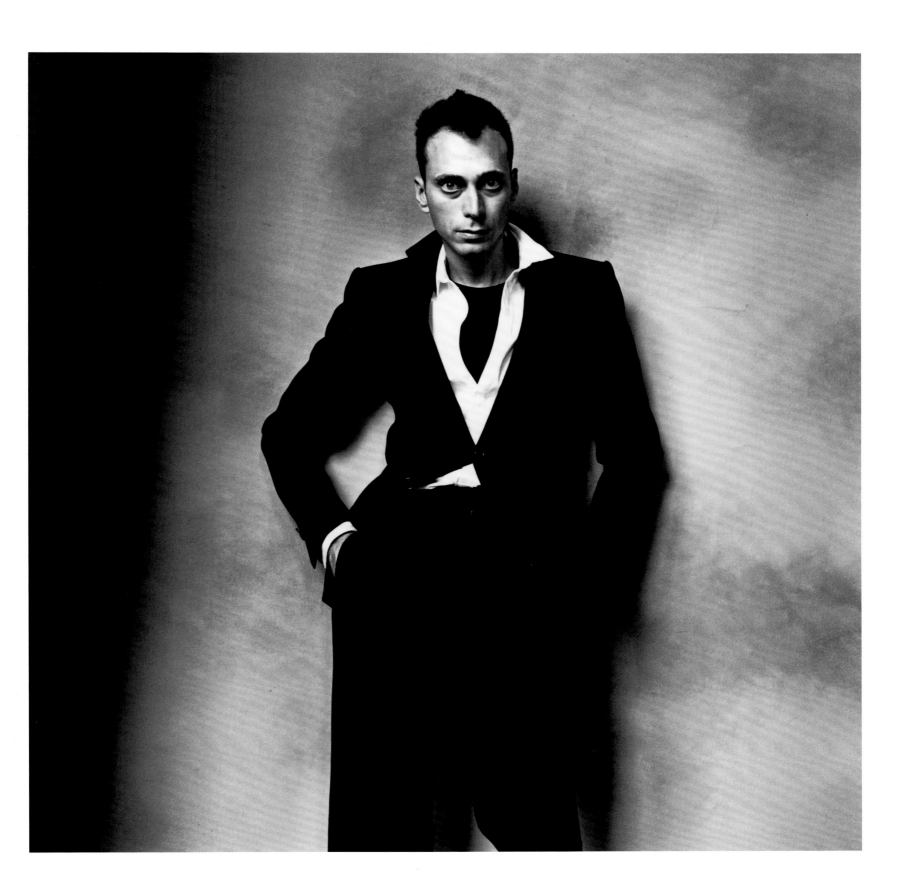

191

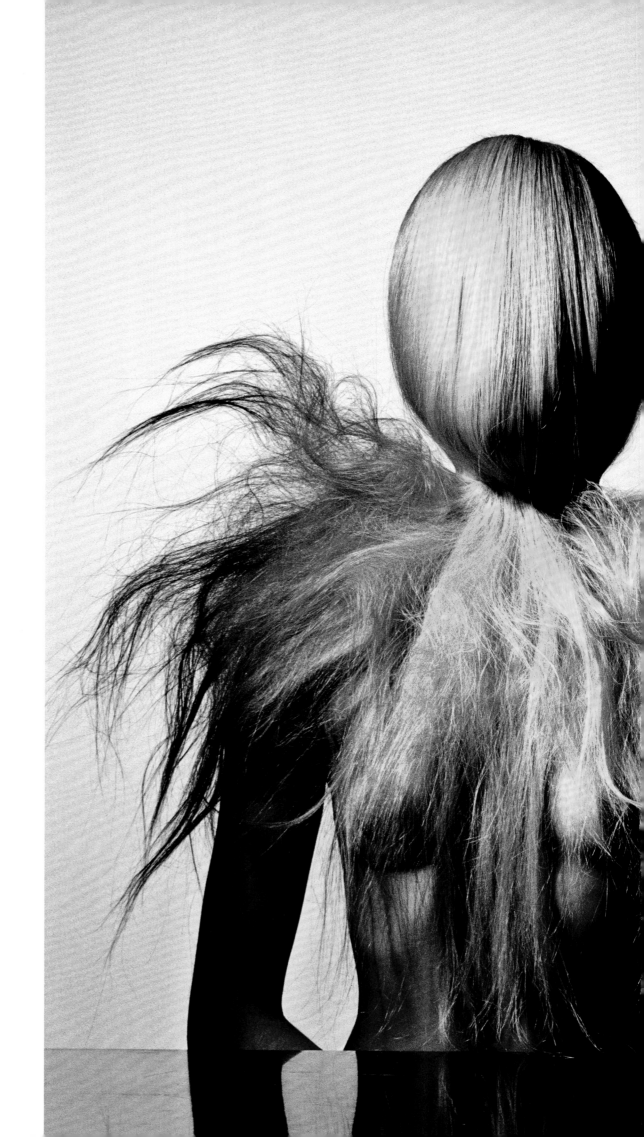

"Phyllis introduced me to
Mr. Penn and he taught me the
most important lesson I learned
in my career. He taught me how
to pay close attention to every
detail in the photo, not just
hair, but also lighting, makeup,
composition, fashion, subject, and
originality. He opened my mind
and my world. I will be forever
grateful to Phyllis and Mr. Penn
for that. I adore working with
Phyllis. She will call you about
a week before the shoot to talk
about the photo session ahead.
In her own special way she turns
your creative engine on. The day
of the shoot, she lets you soar.
She is an 'instigator of creative
beauty.'" —ORLANDO PITA

Two Hairy Young Women
New York, 1995

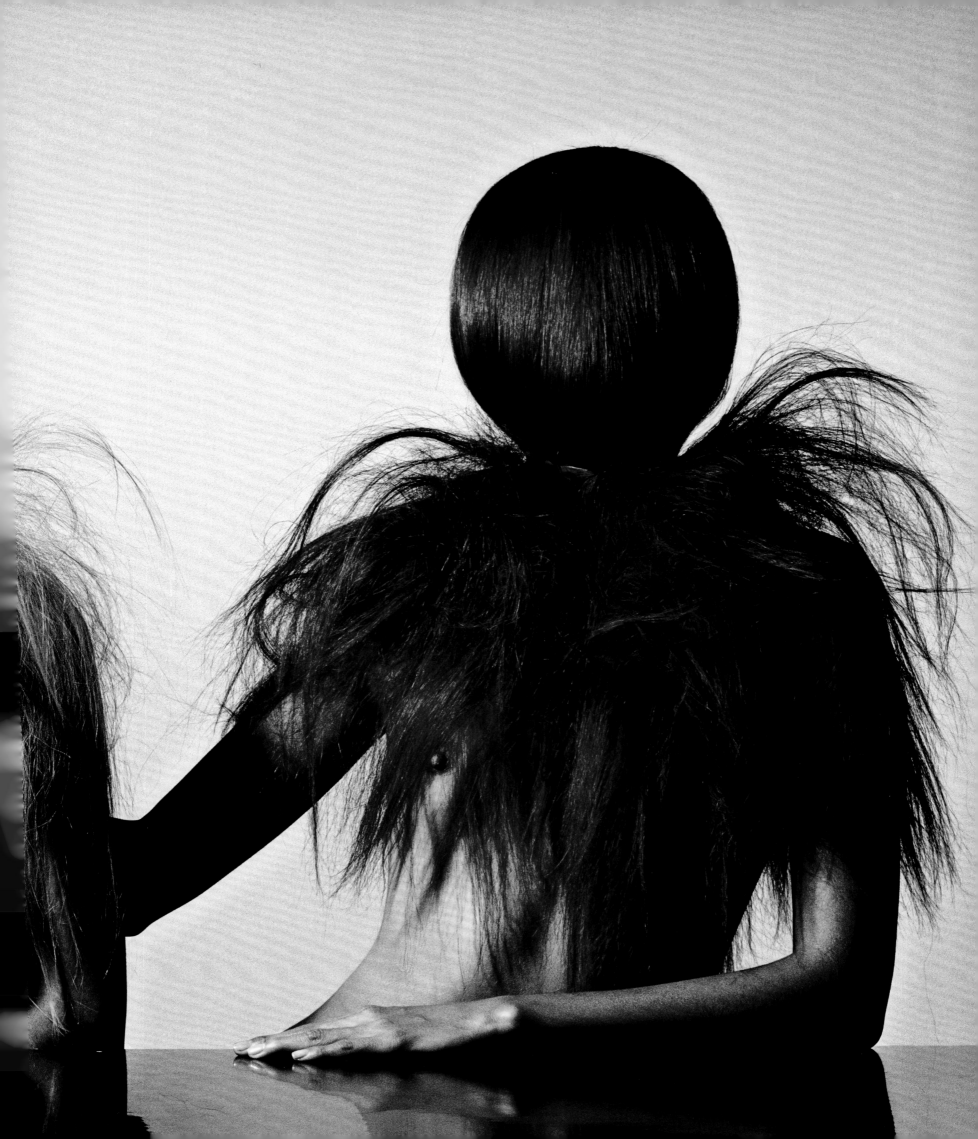

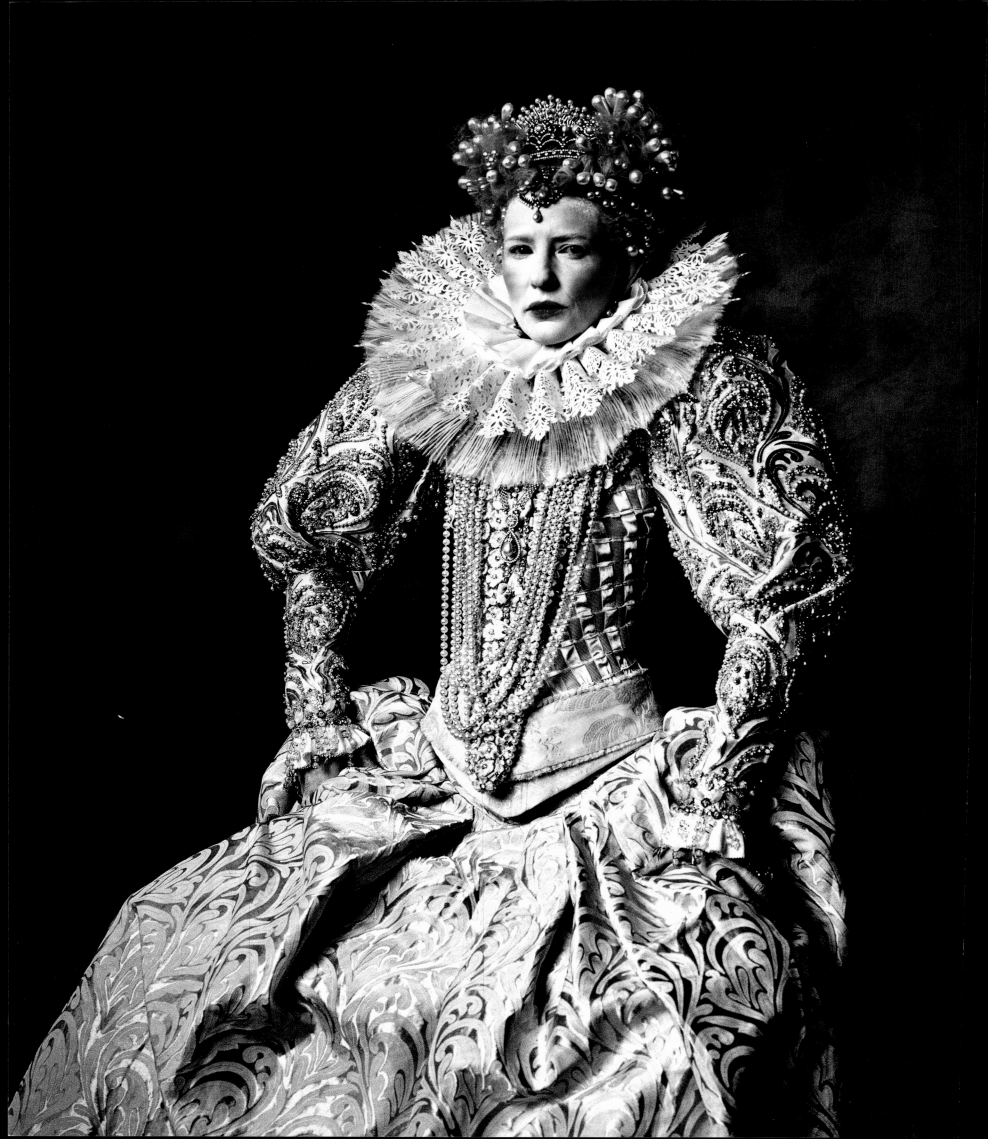

Cate Blanchett's film *Elizabeth: The Golden Age*, was due to open in October 2007, and we were hoping that Penn would do a portrait of her as Queen Elizabeth I. He rarely agreed to photograph actors because he believed that they would present the face they wanted the world to see, rather than let him penetrate their inner self. Asking him to photograph Cate in one of the extravagant costumes she wore in the film would eliminate the issue of an actor acting for a portrait. At first, the dresses appeared to be everything that Penn liked— wonderful shapes, luxurious and long, with texture and detail. We met at the studio to talk about the sitting, Penn sat across the table from me, carefully studied film stills of Cate, sat back in his chair, sighed and said that he wanted to photograph her but the costumes just weren't good enough. I realized that an entirely new costume had to be created. But who could design the most ravishing dress? One person instantly came to mind, and I asked the brilliant Nicolas Ghesquière, then designer of Balenciaga, to create his interpretation of Cate's Elizabeth. He sent a drawing and Penn, who had great admiration for Nicolas, loved what he saw. All good so far. Then Nicolas called to say that he was having difficulty finding fabric that he liked for the ruff, but paper doilies were exactly the look he was after. Did I think Penn would mind the change? Penn loved it! When I saw Nicolas to talk about this book, he told me when Cate's "costume" arrived in New York, Penn called him and told him that "it was absolutely beautiful and even better than anything he was dreaming of."

Cate Blanchett as
Queen Elizabeth I
New York, 2007

195

"Meeting Penn for the first time was a defining moment in my artistic life. My aesthetic was forged by his work and I've always been fascinated by his eye and his perspective. His work is intriguing and extremely meticulous. He has the ability to create images that clash—academic classicism with an absolute modernity. An artist whose talent goes way beyond photography. He is, in my opinion, one of the greatest portraitists of all time, and when he told Anna Wintour that he wished to photograph me for *Vogue*, I knew it would leave an indelible mark on my life. Of course, one does not meet Penn overnight, it's an initiatory process. Thanks to the recommendations and expert eye of Phyllis Posnick, I finally made it to his studio on Fifth Avenue for tea. I will never forget his natural elegance in his turtleneck; that morning, I met a man whose high standards and sense of perception will always make him a role model for me. We spoke about this and that, his experience with Cristóbal Balenciaga, his loyal collaboration with Issey Miyake, his relationships with designers, his thoughts about my work, the importance of protecting my artistic integrity, and above all, he inquired about Paris. He shared his fondness for the French culture and his unconditional love for Paris, talked about the city, its streets and places where he stayed when he came to photograph the collections for *Vogue*. I think he saw in me the young and outspoken Parisian that I was. This is still what the image symbolizes today. A few weeks later during the shoot, Paris remains in his questions. We were both in his spartan studio whilst Phyllis waits off set ready to intervene just in case. He whispers behind his camera and I recall this powerful moment set in a religious calm. I will always be grateful to have been able to share this moment with him, even if it was fleeting. His wisdom and audacity continue to guide me today.—NICOLAS GHESQUIÈRE

Nicolas Ghesquière
New York, 2000

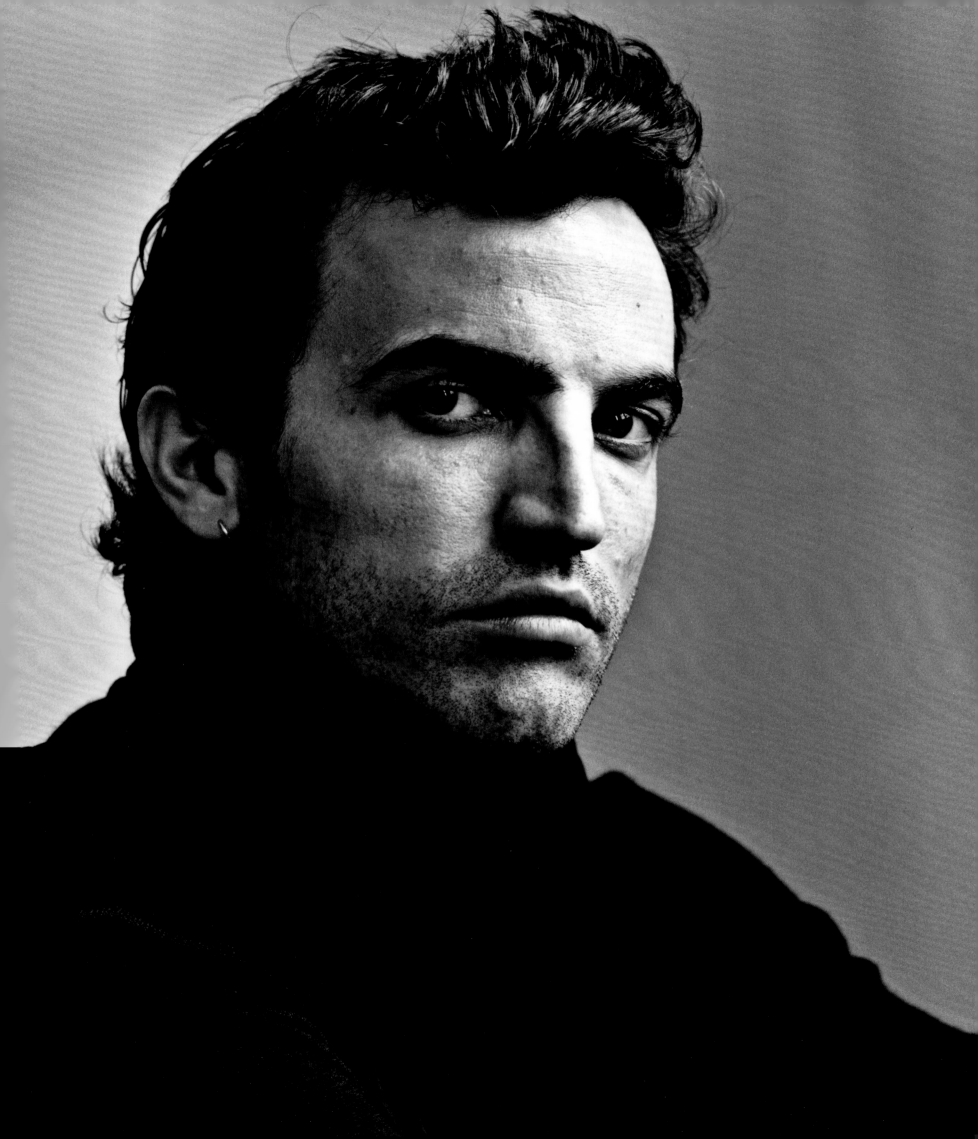

"What can I say! You, the team, the best of everything. I am missing this time of perfection, the little stress to be perfect, to please you and Mr. Penn. It was like going to school at 9 A.M. The silence and peace of the studio, the squeaky floor was the only sound. My corner for all my magic accessories prepared by Vasilios, the first assistant. I would ask, 'Mr. Penn, what do we do today?' He with his little drawing explaining his idea and us following, wondering what he was going to think. And you, Phyllis, your eyes like an eagle, pointing, judging everything. Sometimes I wanted to kill you!!! You, makeup, model, and me like a family wanting to create a timeless image. Mr. Penn telling the model 'See something' when her mind wandered. Every detail meant something. The light moving slowly and changing everything. Mr. Penn following the light. So many magic moments—Cate Blanchett, Nicole Kidman and Carolini Trentini, Madame Bijou. It is a luxury to share that with you. We go home when the day is over. We remember only the best. 'See you next time, Mr. Penn.' Thanks, Phyllis, for all that." —JULIEN D'YS

Balenciaga Wedding Gown
(By Ghesquière)
New York, 2005

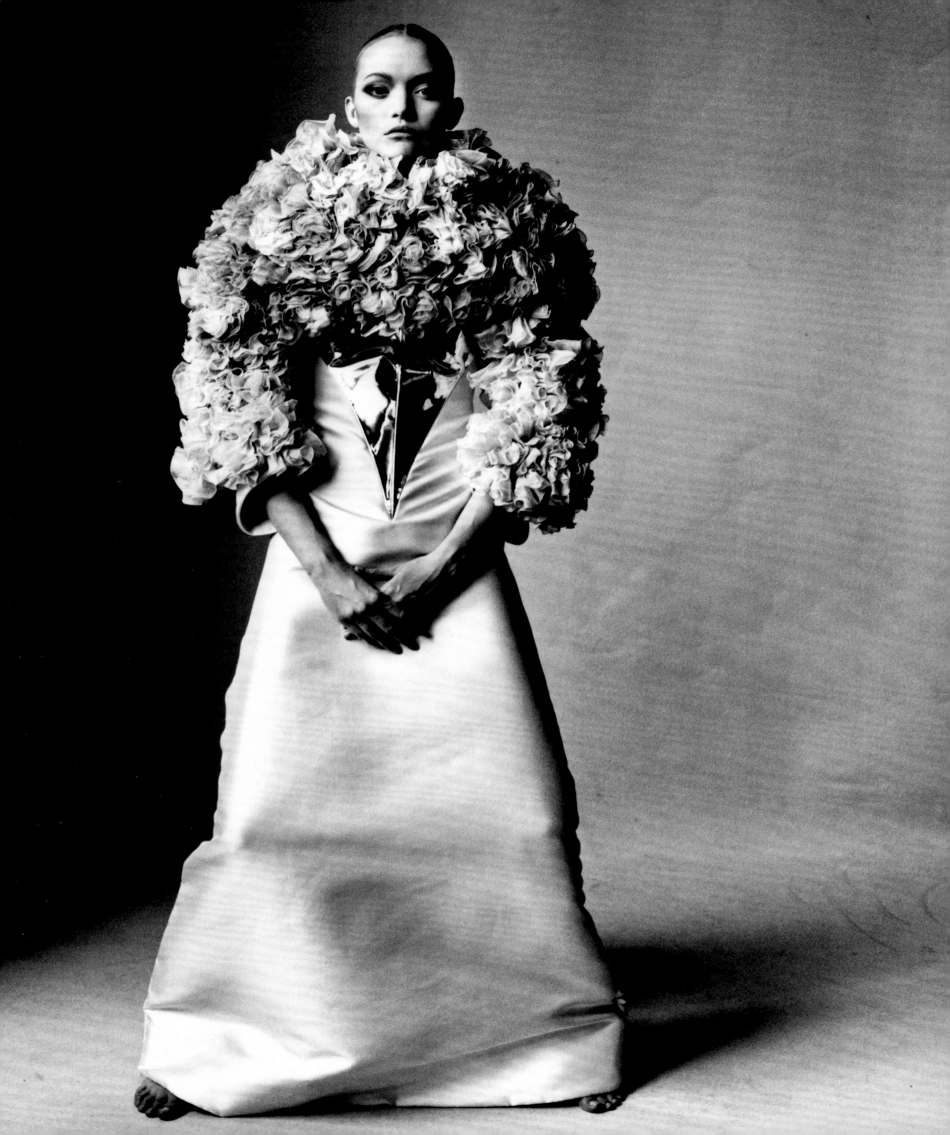

Head in Ice
New York, 2002

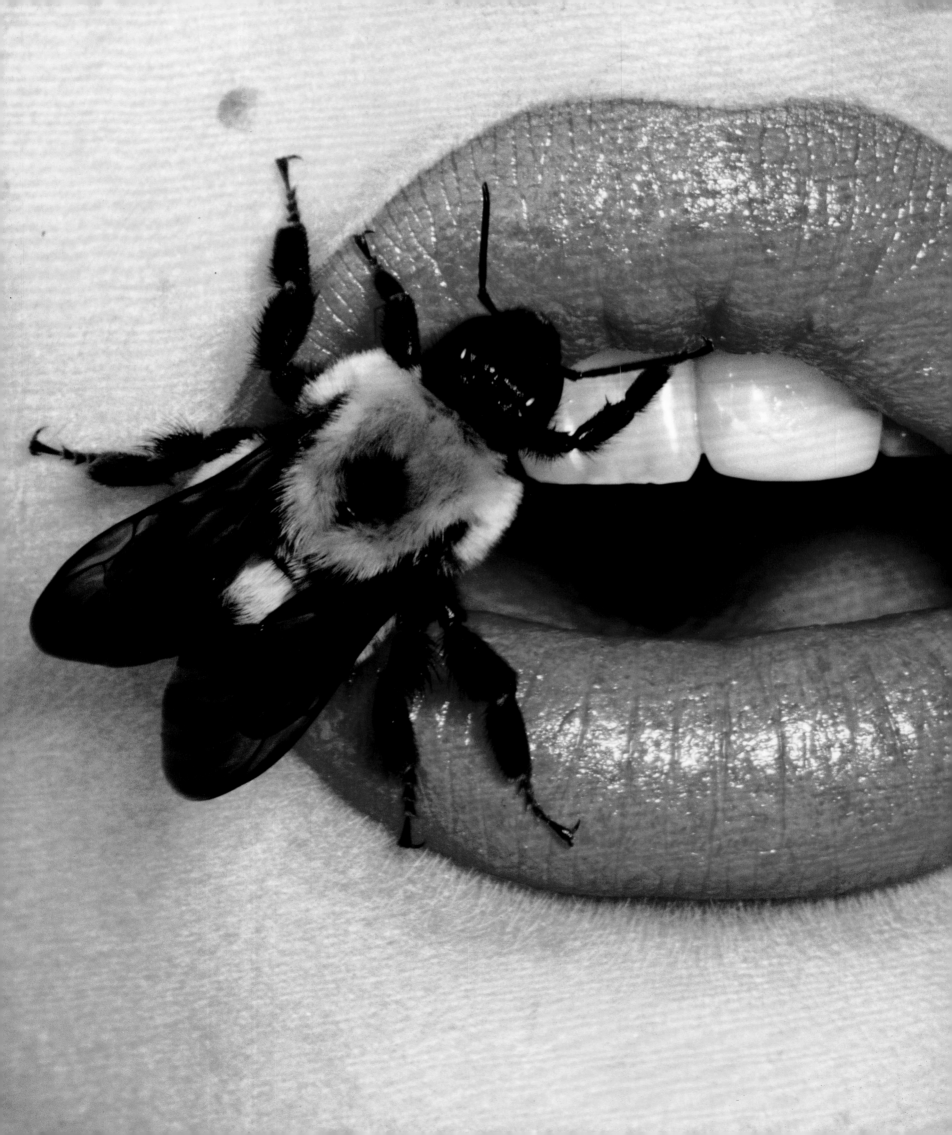

203

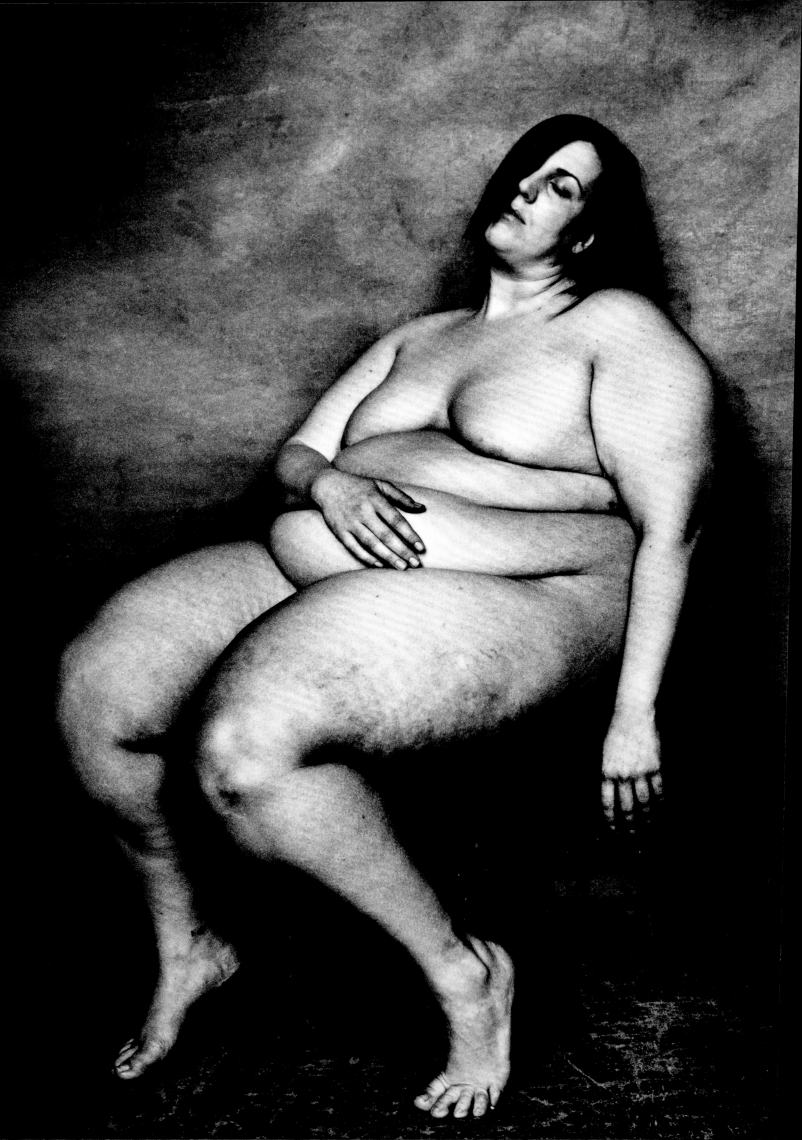

If anyone is wondering what contribution I made to this photograph, I found the model. Casting is important, whether we're shooting fashion, beauty, backs, or close-ups. There's always more than one model who'll be right, but each model will give you a different picture. This time, our article was about obesity and we needed to look beyond the world of fashion to find a model who was not only comfortable posing nude but who also moved gracefully. I worked with agencies that specialized in character casting for film and advertising, described the height, weight, shape, age range, and look of the model that we wanted. I interviewed more than twenty young women before sending one to meet Penn. He studied her body and spent time talking to her to be sure she would have the patience and temperament to do the photo. Penn started shooting in the morning using natural light, working slowly as he directed her to change her position while he photographed. He asked her to sit, turned her to the right, to the left, twisted her body, asked her to stand, turn to the back, then stopped so she could rest and began again until, after four hours, he got his picture.

**Large Nude Woman Seated
("Epic Proportions")**
New York, 2004

205

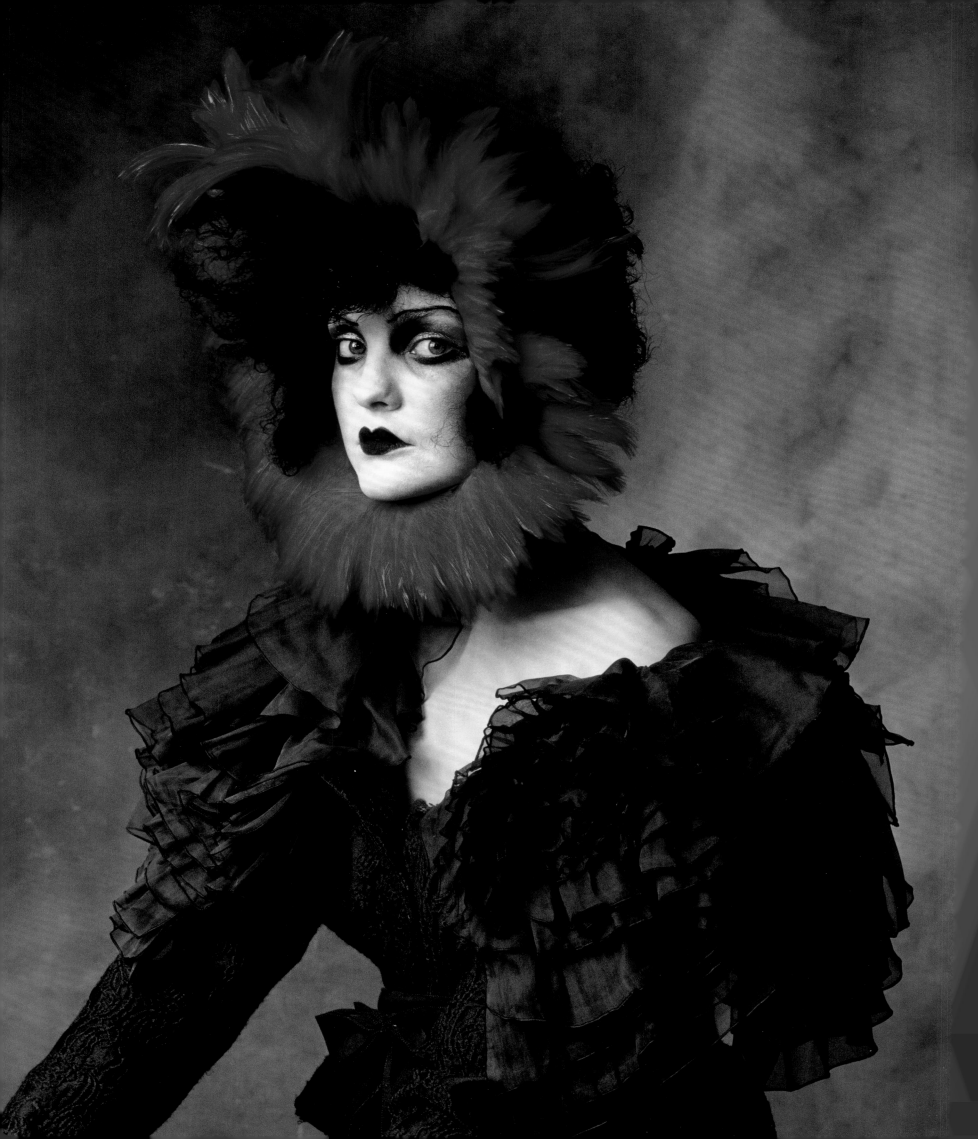

"Often when I was tired or stuck on a particular dress, I would imagine that Mr. Penn might choose to photograph it if it was VERY, VERY good, and this made me go that extra mile. This is the man who captured the line better than inspirational line drawings that are often more inspiring to the draftsman than the photo itself. He paints with light. Particles of dust are the only evidence of his brushwork, daylight and its fleeting moment a seductive dance around me, a gossamer whisper. And tales of Lisa Fonssagrives, and traveling around Andalusia—she, too, then fueled an haute couture collection. I love Brassaï's Madame Bijou. She is a lady of the night. Her nightly rituals make the most difficult times easier to deal with. The slippery cool pearls glide through her fingers, the chapeau softens her wise face, her wine-stained fingertips. Imagine how proud I am of this muse, captured, immortalized by the great Mr. Penn. When he did my portrait, I was trembling like a leaf and invited to sit opposite him at a table, alone, no hair, maquillage, or stylist, or the lighting I am familiar with and know how to drink. They were not allowed in the room and I, so self-conscious, so vulnerable, so naked. And then I became bewitched by the sparkle in his eye and totally fell for him. It was that simple. I feel so lucky and blessed to have known him."—JOHN GALLIANO

John Galliano Silk Wool
Jacquard Jacket with
Red Feather Headpiece
New York, 2007

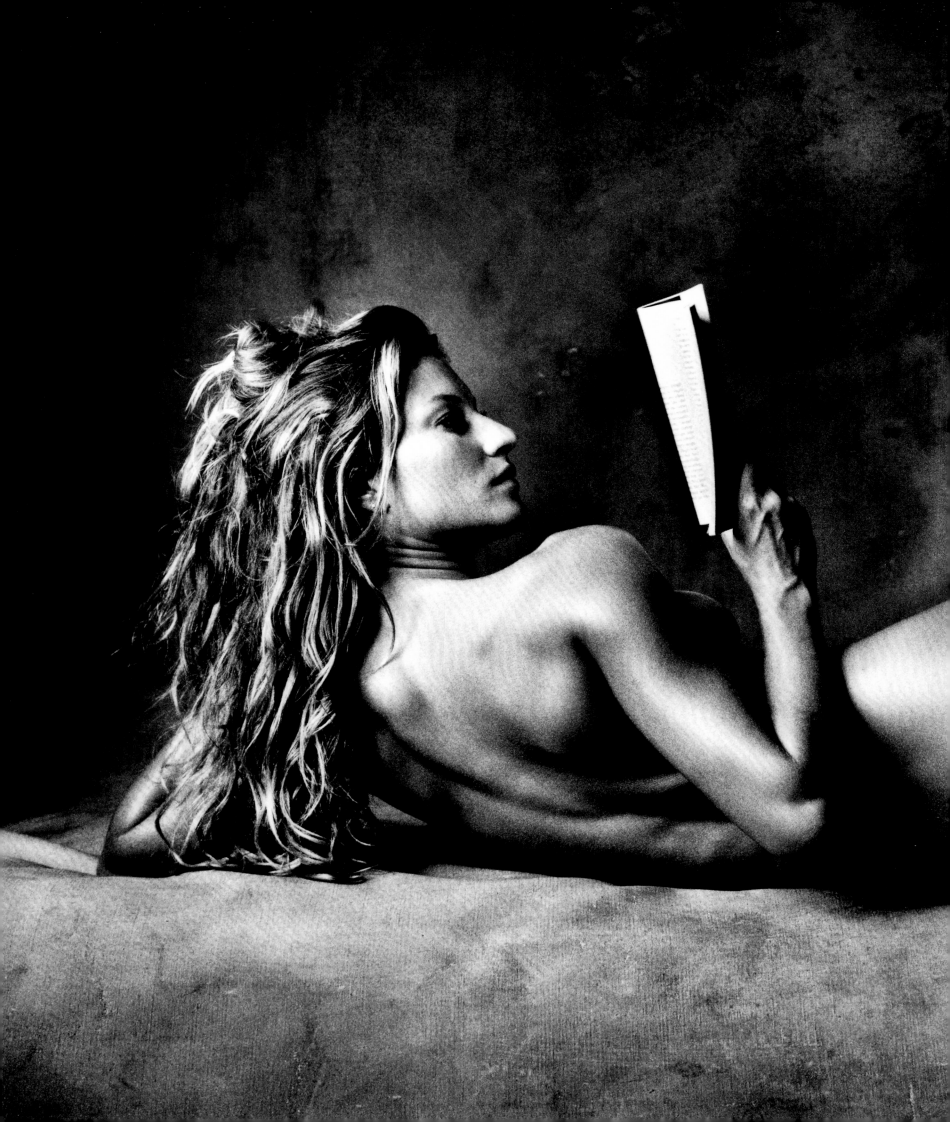

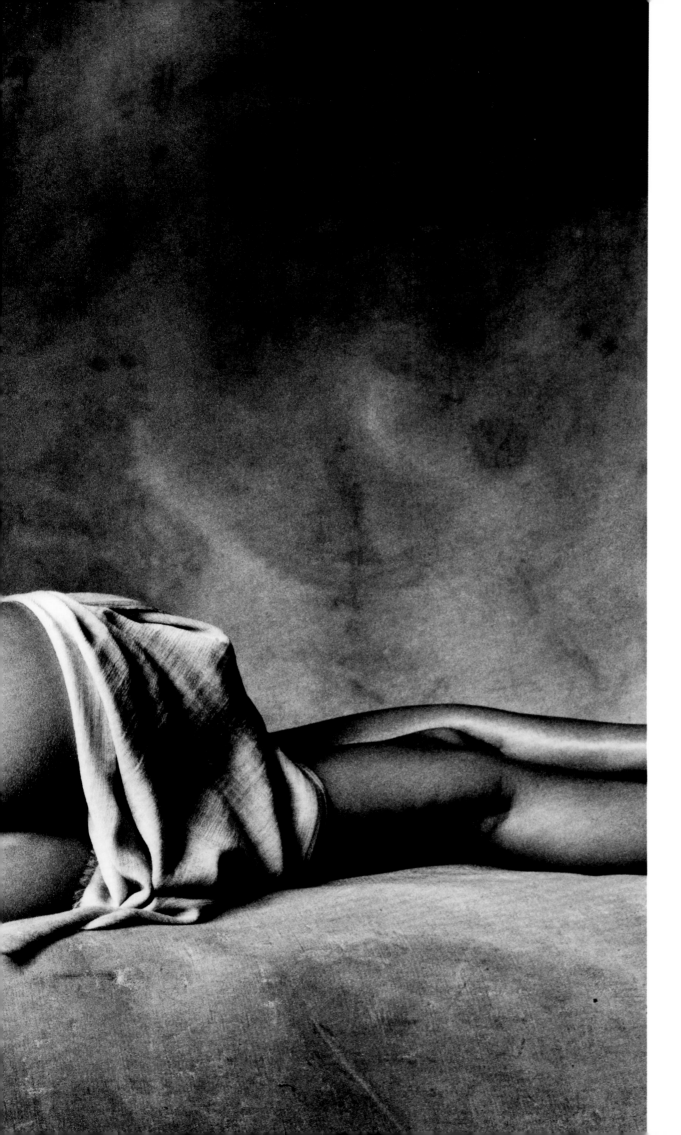

For an article about back problems, Penn only wanted to photograph Gisele. "And please be sure to let her know that her face wouldn't show." Really? Ask the most famous model in the world to do a photo of her back? When I reluctantly called she instantly said yes. I'm sure he realized something I didn't—that Gisele would want do it whether we saw her face or not. On the day of the shoot, Penn showed her his drawing of what he had in mind, then asked her to lie down on the set, facing away from his camera. At first she was still, but after a few minutes, she delighted him by wriggling her body into different shapes, and seductively looking over her shoulder and asking, "Does this look OK, or should I turn more like this?" (Another wiggle.) Of course we saw her face, and he may have always intended to have it show. Penn was very tender with his favorite models and a fun day was had by all.

Gisele Reading (A)
New York, 2006

Some of Penn's favorite sittings were the
still lifes to illustrate Jeffrey Steingarten's
food articles. There was no editor (me)
with an opinion about the hair, makeup,
or clothes, no hairdresser or makeup
artist—no one to get between him and his
subject. He did it all. For an article about
chocolate, he thought of how children look
after they've eaten messy desserts and
he imagined a model licking chocolate off
her lips as he photographed. Casting was
tricky. There were go-sees in my office to
find the right mouth and examine tongues
licking. You might be surprised at how
different every tongue is. Finally we found
the right mouth with the right tongue,
and on the day of the sitting, a food stylist
prepared melted chocolate for Penn to
apply to our model's lips. He photographed
as she slowly licked it off, while he told her
how wide her mouth should open while
directing her tongue. Then we cleaned
the chocolate off and started again . . . and
again and again getting different shapes of
her mouth, her tongue, and the chocolate.
We stopped to have lunch and send
the film to be developed. When the film
came back, he studied it to be sure he
had his photo, and, of course, he did.

Chocolate Mouth
New York, 2000

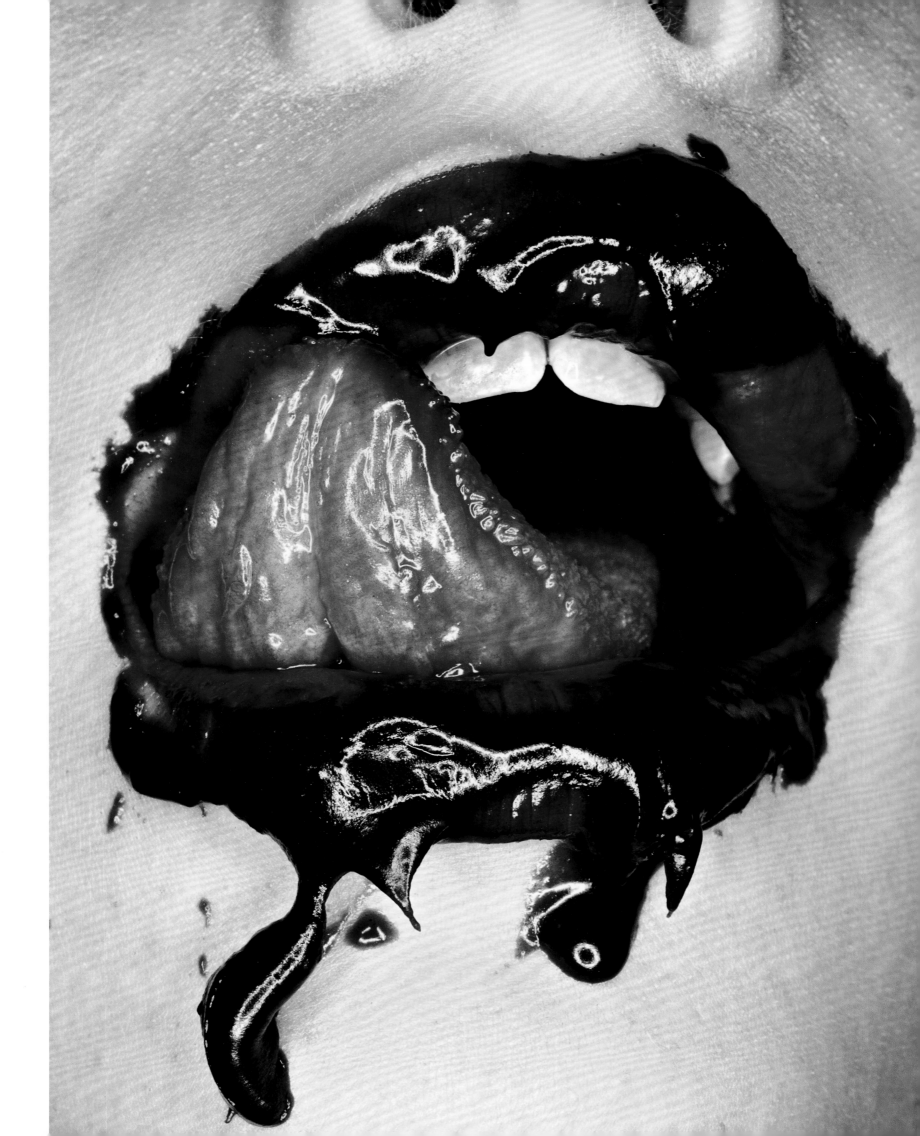

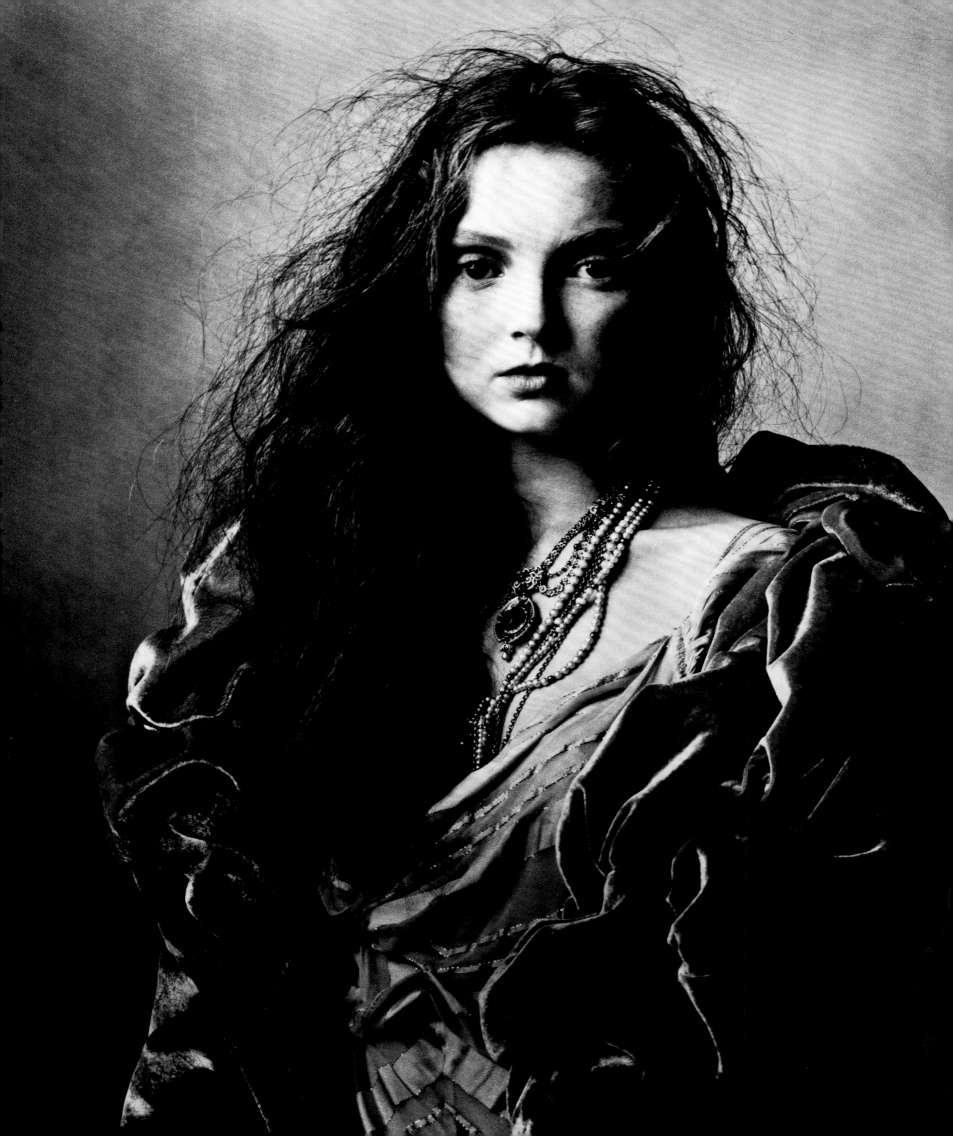

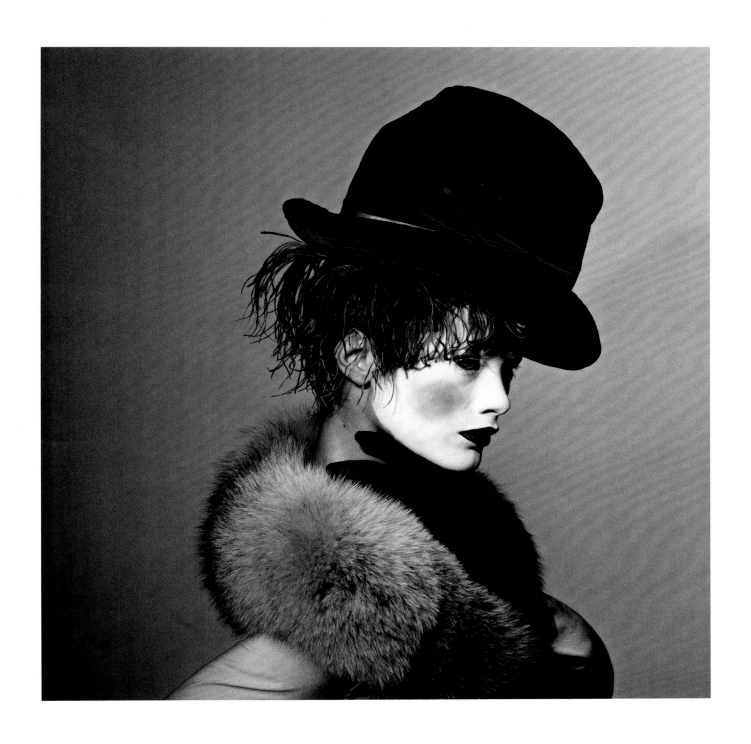

THIS PAGE:
Flemish Face
New York, 2005

OPPOSITE:
Black Hat and White Face
New York, 1997

213

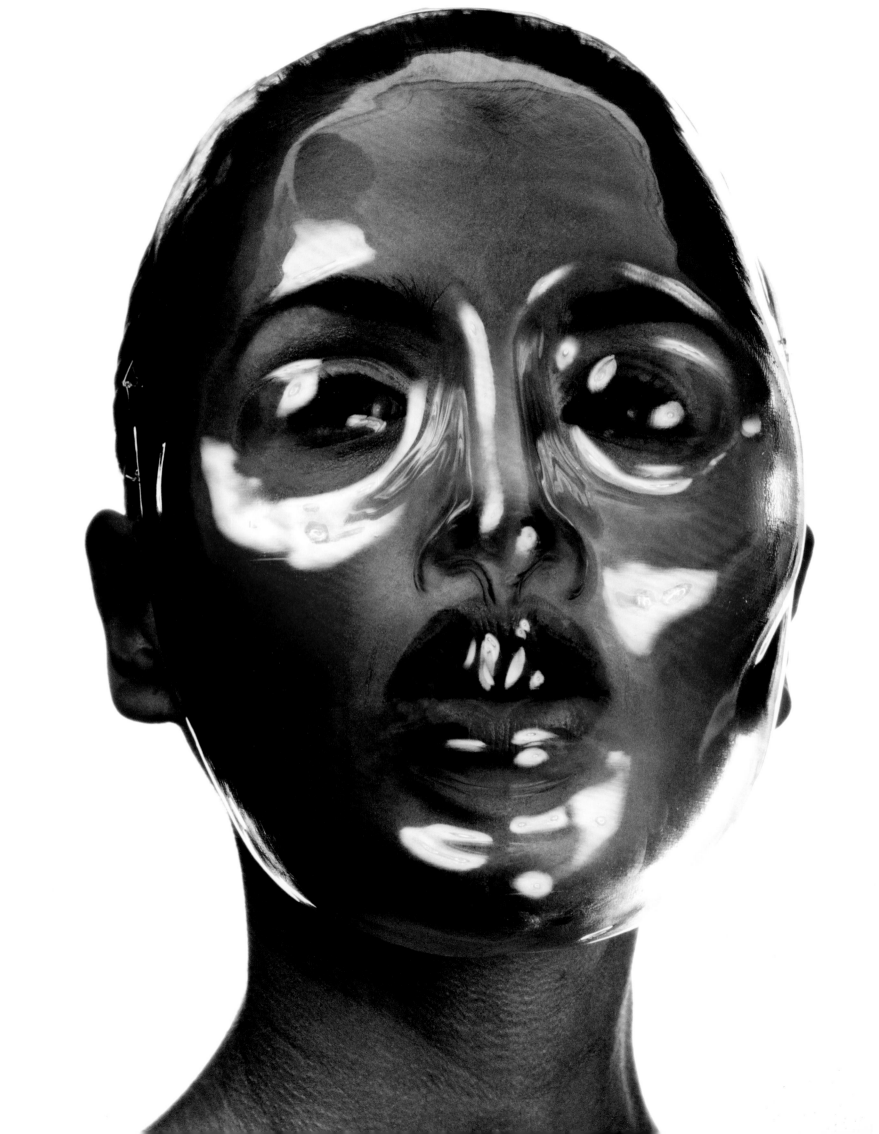

Clear Plastic Beauty Mask
New York, 1996

Many of Penn's ideas seem obvious once you see his picture: Feet=Dr. Scholl's, aging=Turkey Neck, plump collagen lips= Bee Stung Lip. But these ideas weren't obvious until he came up with them. This time, our article was about advances in sun protection, and the news was about clothes made from fabrics treated with sunscreen. But these clothes were definitely not the chic looks seen in *Vogue*. In fact, they made the model look like she was wearing a sack. So why not have her actually wear a sack? We got burlap bags used for shipping coffee, and booked beautiful Shannan Click. To keep his models steady during long exposures in natural light, Penn had attached a long pole to a metal plate. He asked Shannan to stand on the plate and lean against the pole, which kept her from wobbling. Although she couldn't see through the sack, she knew just how to change her position and adjust the drape of the burlap until he got the shape he was looking for. This photograph echoes of two of my favorite Penns: "The Guedras" and "The Three Market Women of Rissani" from his *Worlds in a Small Room* series.

Woman in a Burlap Sack
New York, 2007

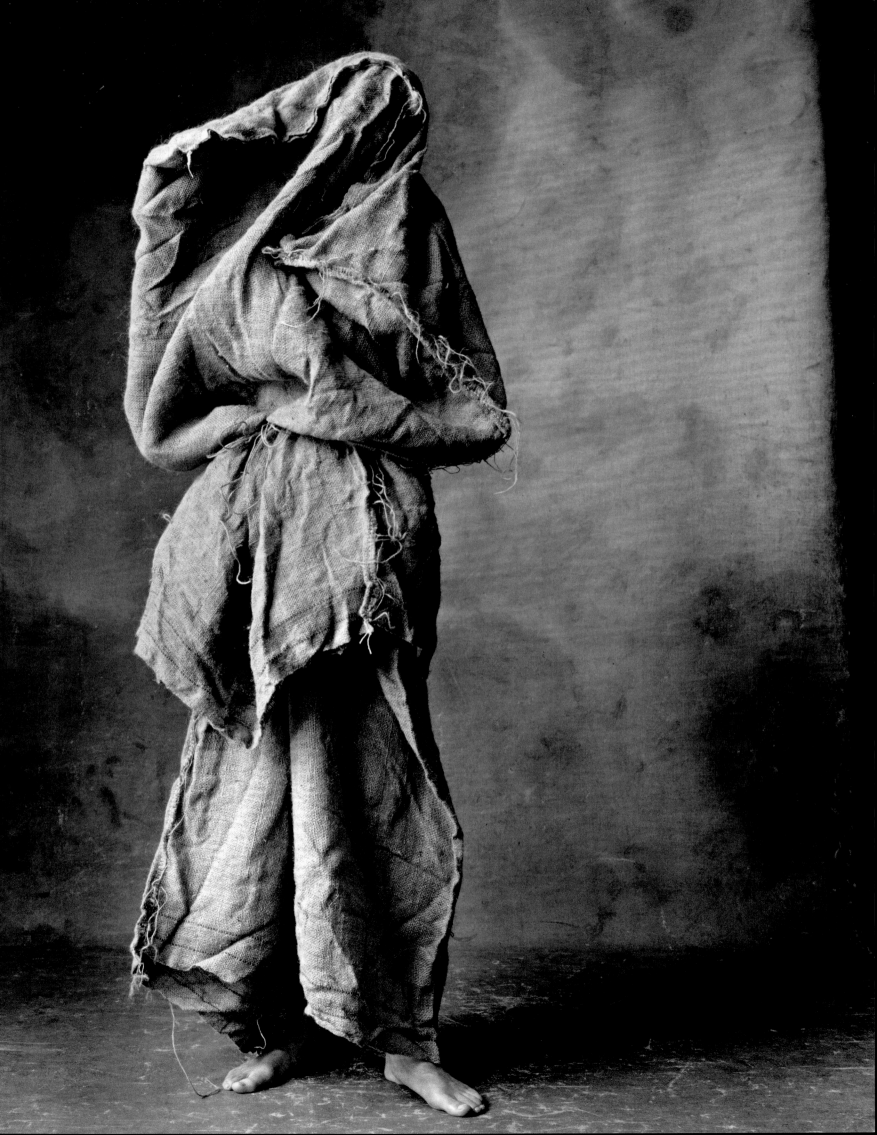

After a shoot with another photographer, the makeup artist, Peter Philips, showed me some beautiful masks that he designed in his studio in Belgium. I liked the "Minnie Mouse Couture" look of this one and brought it to Penn. He thought it was charming and imagined it on a "young woman wearing an old-fashioned negligee." I found negligees, blouses that looked like negligees, blouses that didn't look like negligees, vintage negligees, anything that could be considered a negligee and brought a rack of clothes to the studio. Penn liked just one. On the day of the sitting, Peter made Lisa Cant's face very pale so she would look more mysterious behind the mask, whitewashed her body, and, just as Penn began to shoot, Julien sprayed her hair white.

Yves Saint Laurent Blouse
New York, 2005

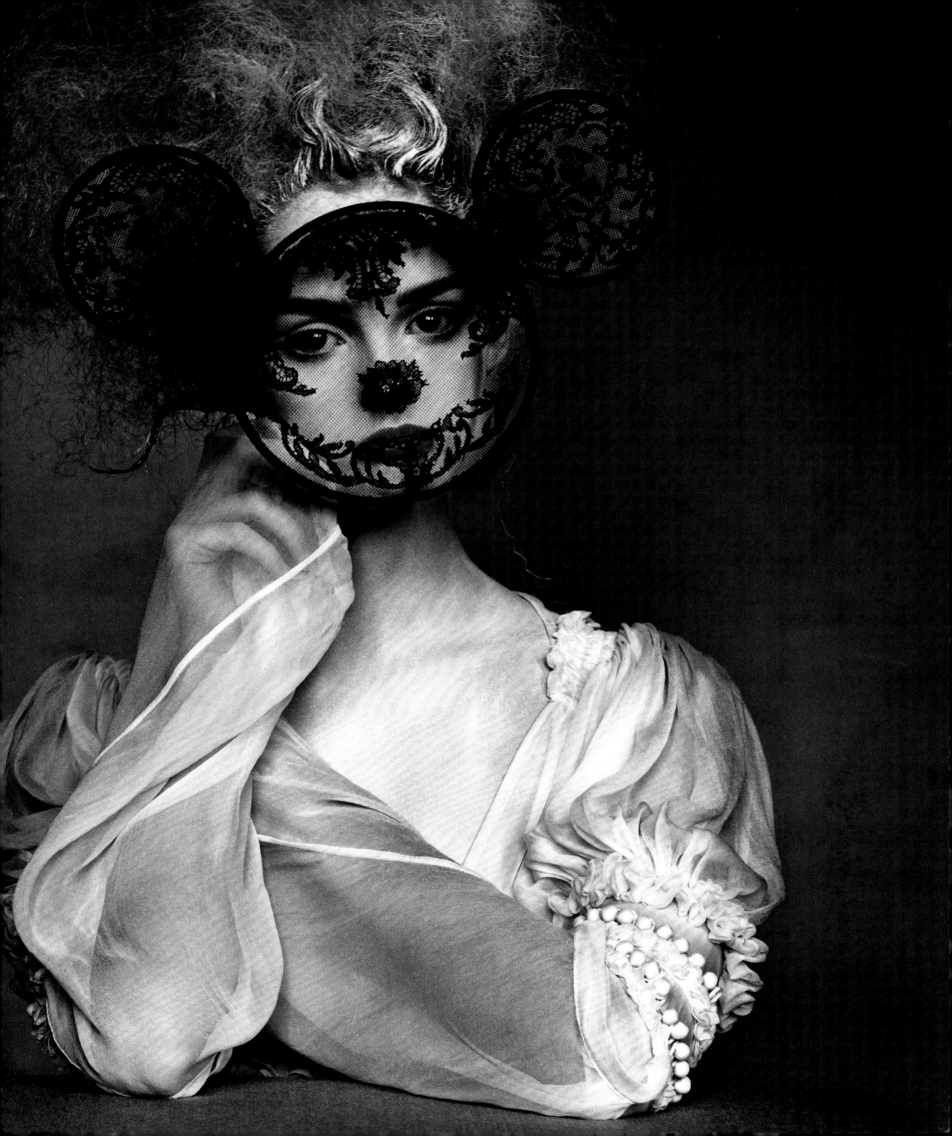

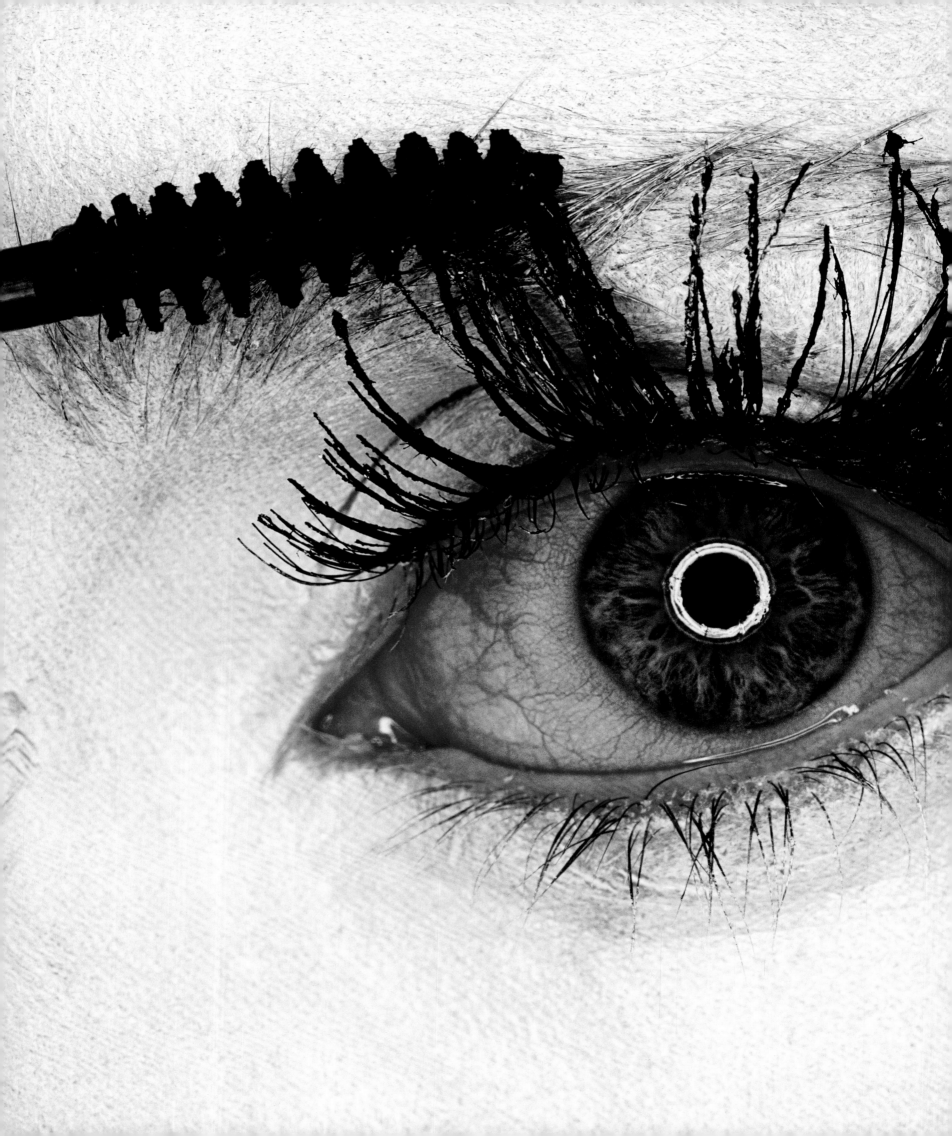

Mascara is no small business and brushes sell mascara. Companies spend millions of dollars developing breakthrough technology, and we were reporting on the latest "Mascara War" between two of the giants. The model's eyes were closed for two hours while Penn photographed every possible variation of the dueling brushes. He had a picture that wasn't especially exciting or memorable, but there was nothing that he hadn't already tried. Still standing behind his 6 x 8 cm camera, he said, "Thank you. We're all finished." Our model opened her eyes, and I saw that they were completely bloodshot. Penn said, "Don't move." He did just two or three more exposures. Here was the shock that was missing. Then we were finished.

Mascara Wars
New York, 2001

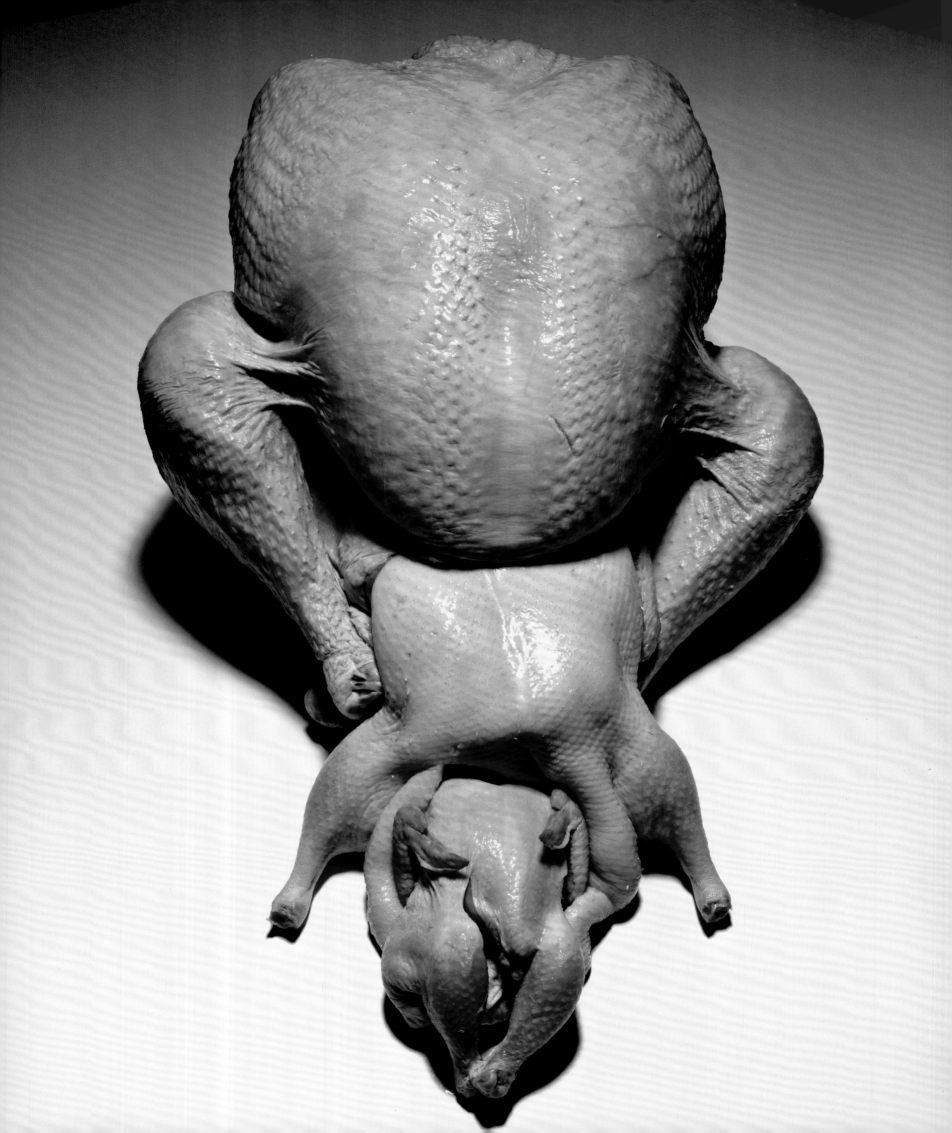

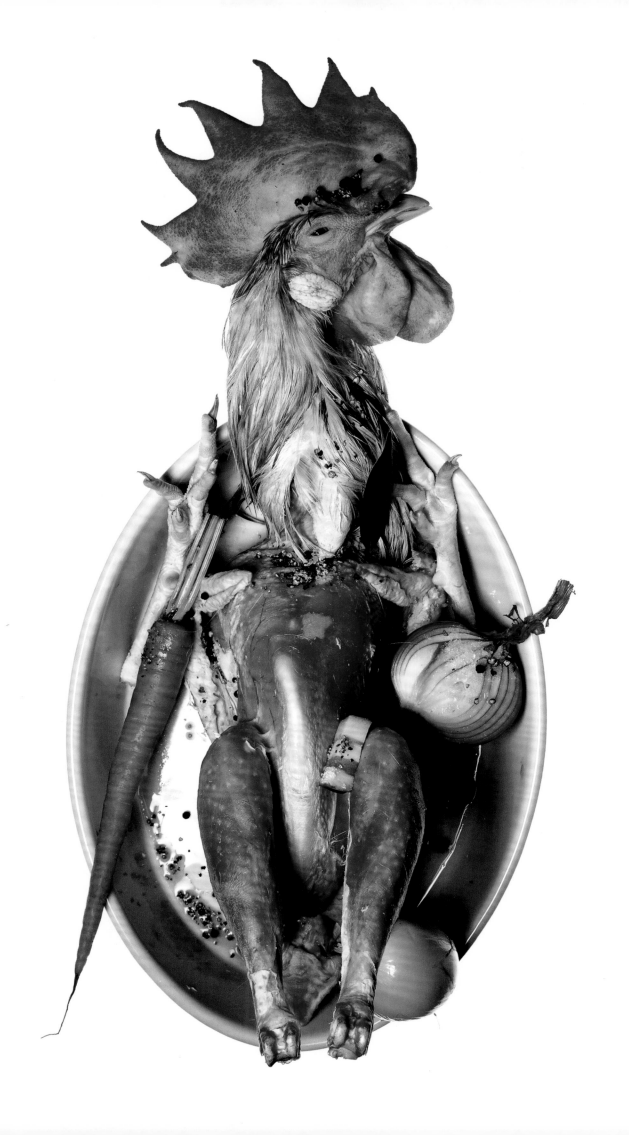

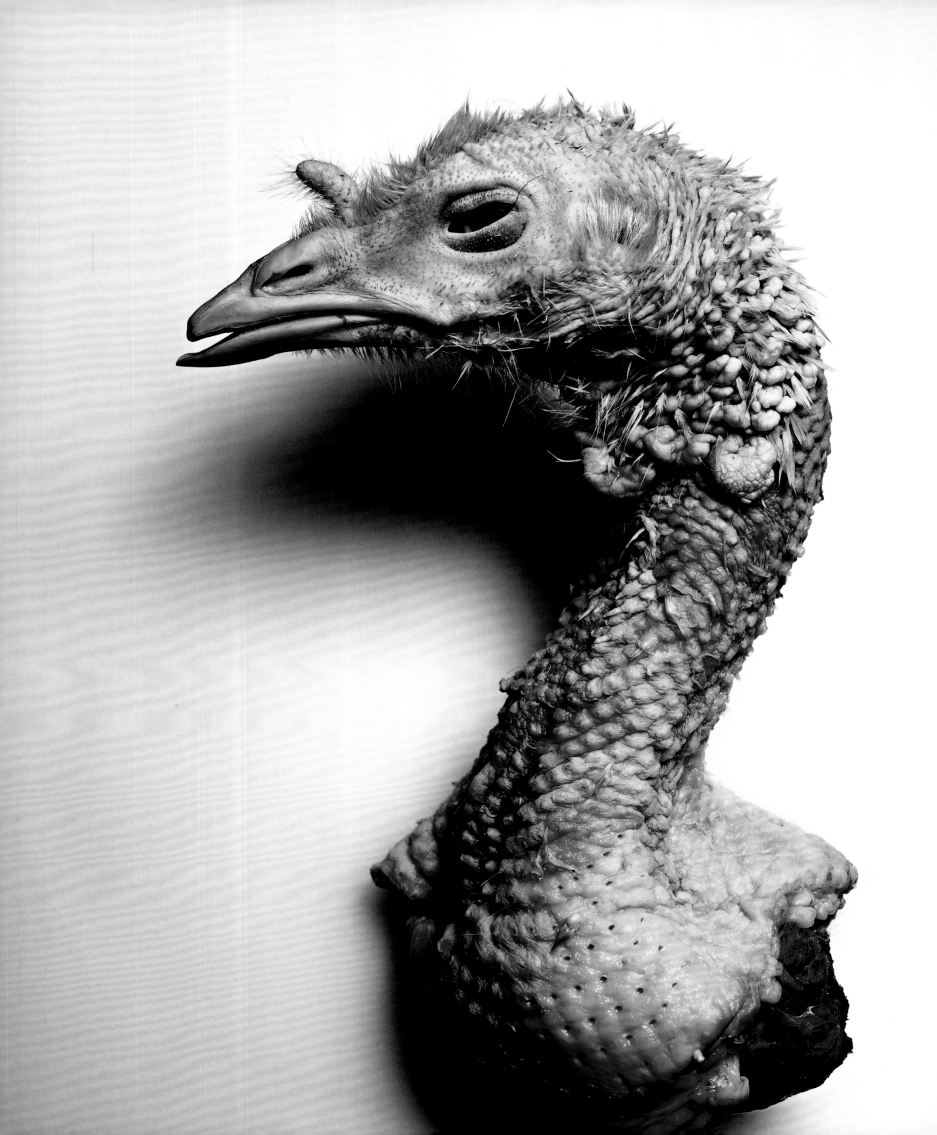

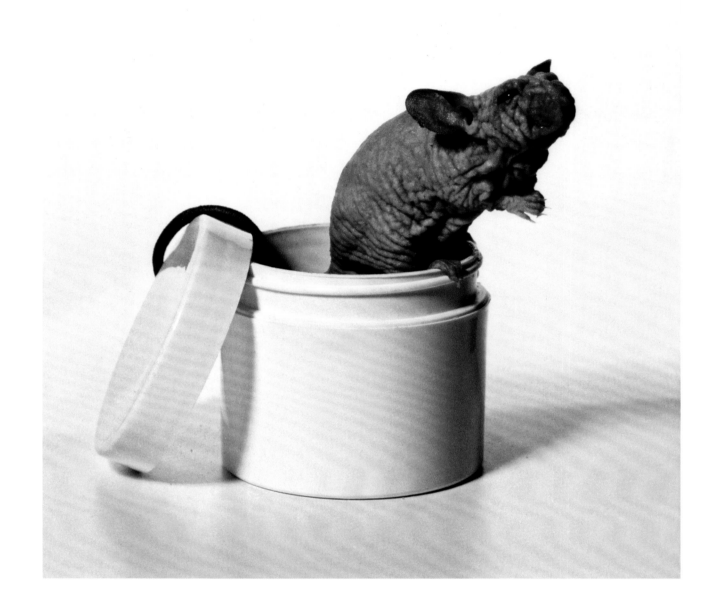

Girl with Tiny Goggles
New York, 1994

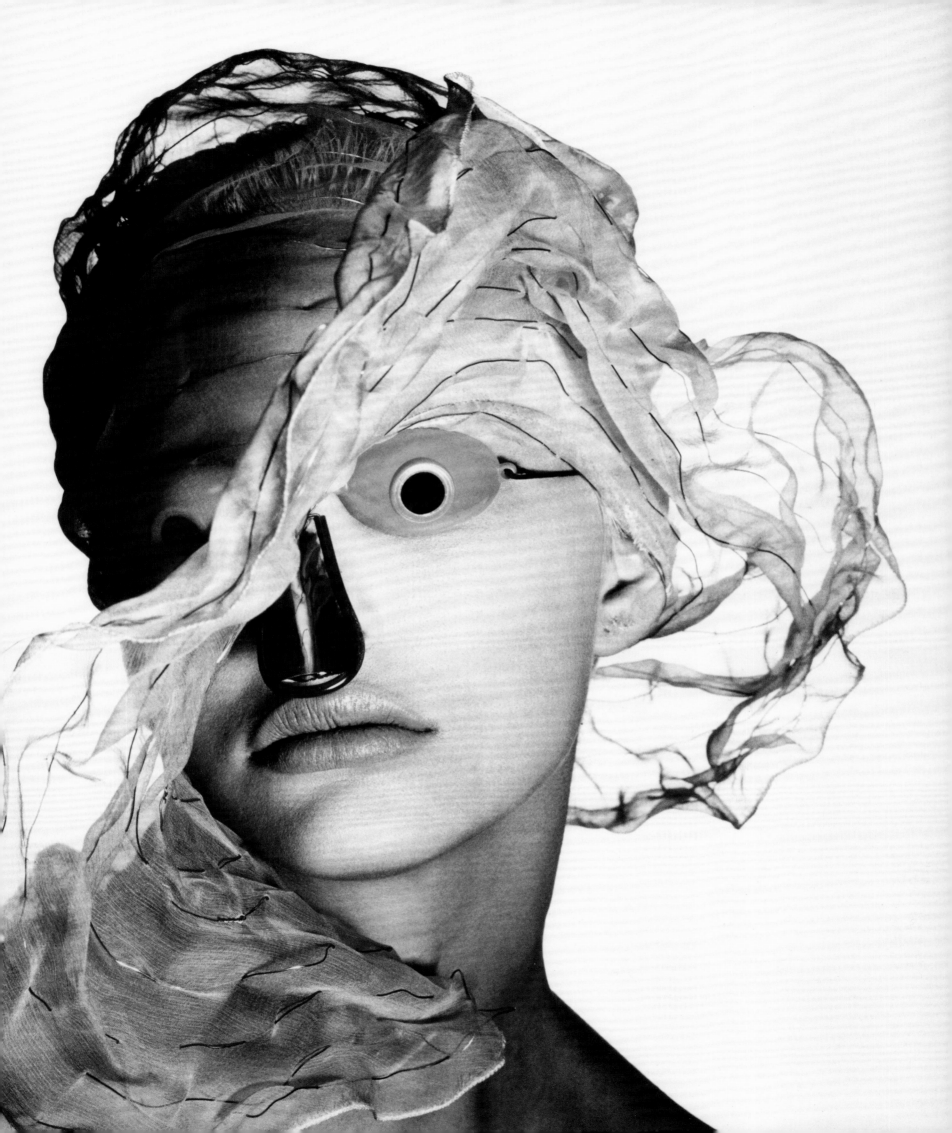

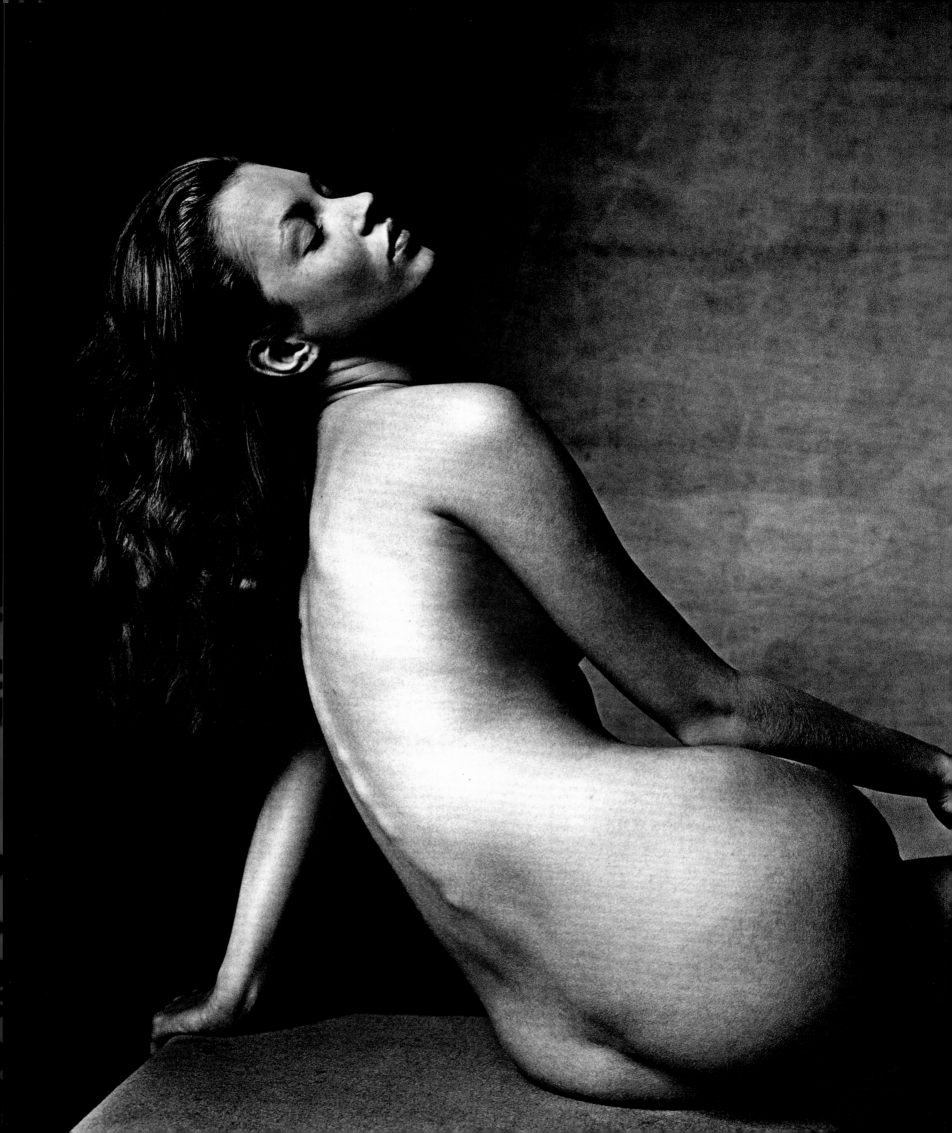

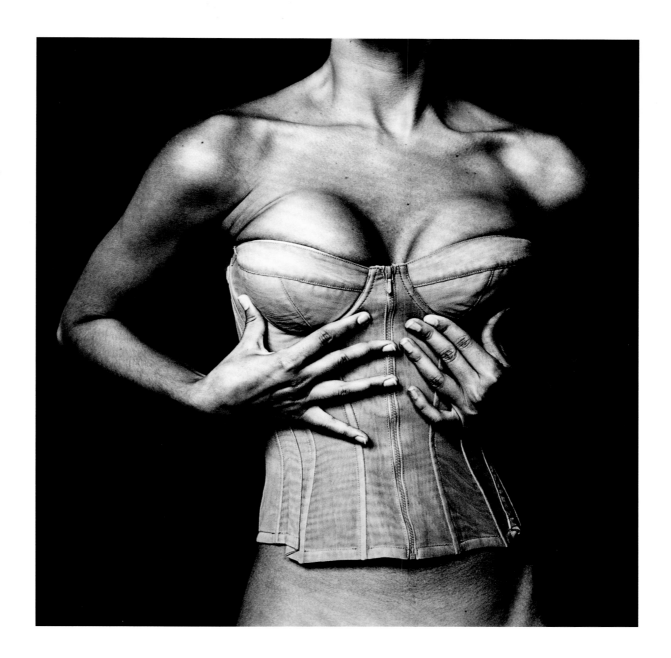

THIS PAGE:
Corset (Karl Lagerfeld for Chanel)
New York, 1994

OPPOSITE:
Kate Moss
New York, 1996

229

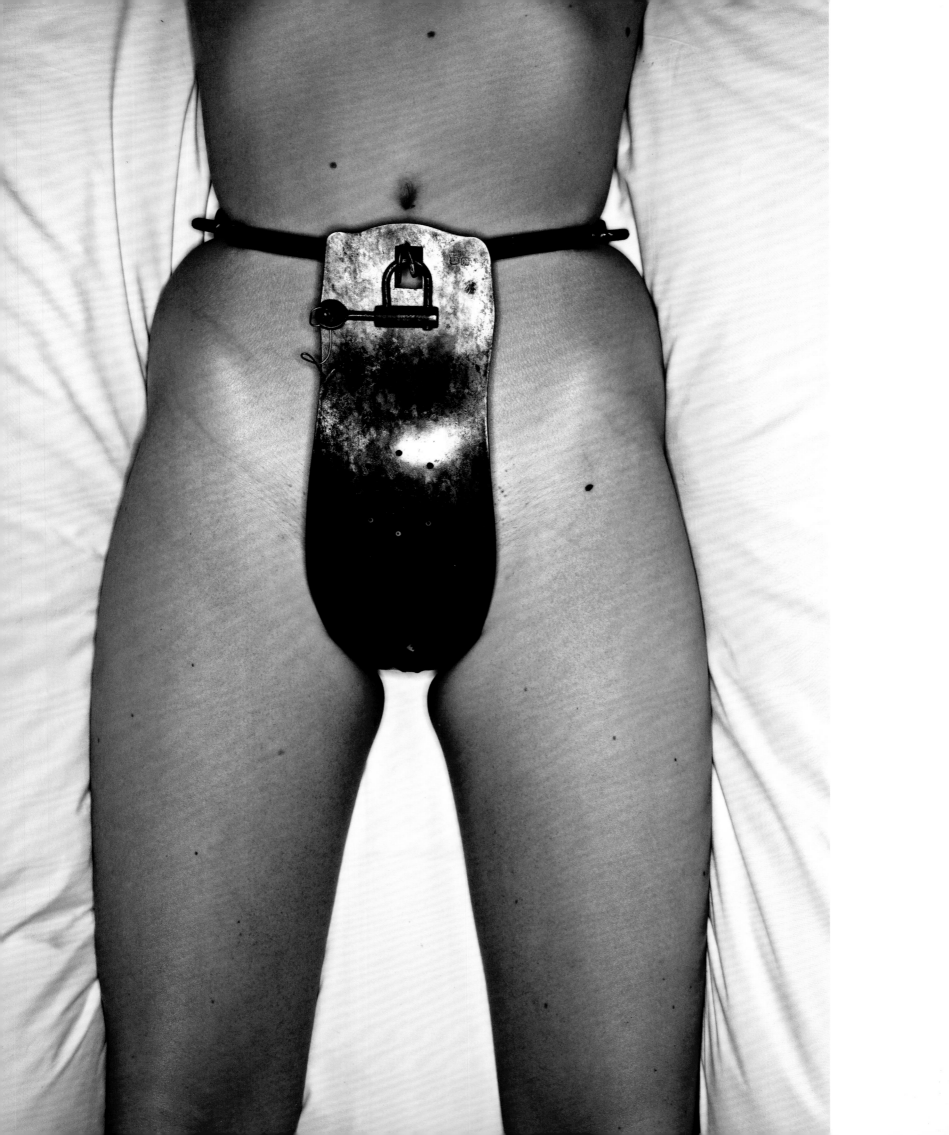

Another advancement in birth control! Another article about a pill! Another picture! I suggested a chastity belt to Penn. During the Middle Ages and the Renaissance, the purpose of these belts was to enforce fidelity but they had the auxiliary effect of promoting birth control. Penn was interested . . . but only if I could find a real one. He insisted on photographing genuine articles. If it was a hand holding a pizza, that hand had to belong to a pizza maker; if we used bees, they had to be live bees; and if we were to use a chastity belt, it had to be an original. This photo was taken before the Internet, so, relying on the Yellow Pages and talking with

dealers of Renaissance armor, we located a number of "collectors" of fetish objects who were eager for me to examine their historical devices. They were mostly an unsavory bunch. Finally, I found one who seemed to have what we were looking for, and I persuaded him to send a Polaroid of his belt. Soon I was climbing the dark creaking stairs of a run-down building in the Meatpacking District. Success! But women were smaller in the age of chastity belts, so we needed a fitting. Another interesting casting session. Penn photographed our model lying on a light box, and since she could hardly move, he got his picture very quickly.

THIS PAGE:
Mr. Meat Free
New York, 2001

OPPOSITE:
Chastity Belt
New York, 2002

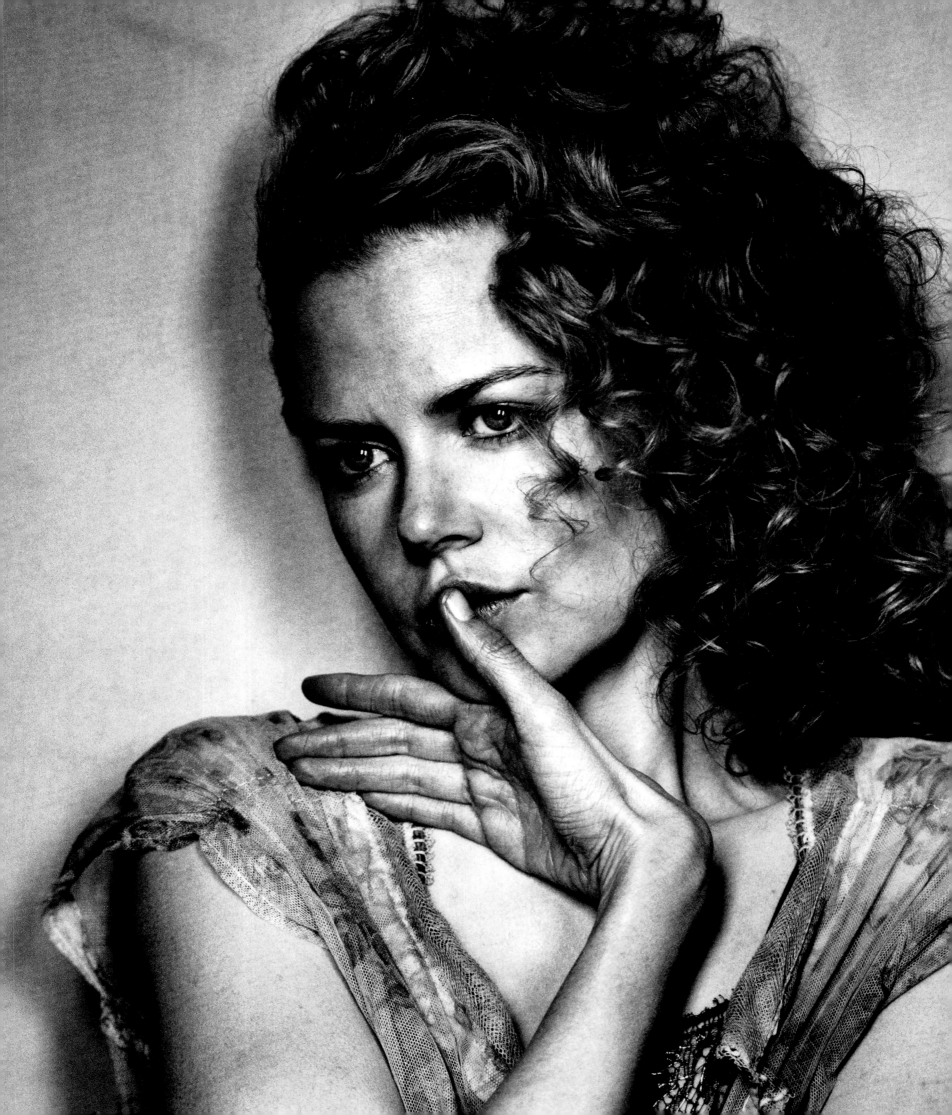

"I wanted to work with Irving Penn because he was the greatest. For me, it's Kubrick for film and Penn holds that place for photography. Great photographers have a way to communicate where words seem superfluous. He was so meticulous and had an immense gentleness. He could look into one's soul. I had heard how much he loved his wife and that appealed to me. It speaks so much of a man who has that ability to love a woman. This portrait is something I cherish."—NICOLE KIDMAN

Convincing Penn to photograph Nicole Kidman took two years of gentle persuasion. He thought she was very beautiful but still didn't enjoy photographing actors. Finally, after she made *The Hours*, a film about Virginia Woolf, I tried again, this time armed with film stills of Nicole as Virginia Woolf, complete with a prosthetic nose. It appealed to Penn that her movie star presence had been replaced by a plain character and that she could let go of vanity. He agreed to photograph her. BUT ONLY WITH THE NOSE. Somehow, I managed to talk him out of the nose idea, and this haunting portrait is the result. He was inspired by Nicole, and we did two more sittings together. One was the S/S 2004 Couture, and when Anna saw the photos, she wanted to use one for the May cover. Penn said, "No." He didn't want type running across his photos, and covers always had cover lines. But then Anna proposed a cover without them and he relented. It was the first time since 1962 that a picture on a *Vogue* cover didn't have text. It was also the last cover he did.

Nicole Kidman
New York, 2003

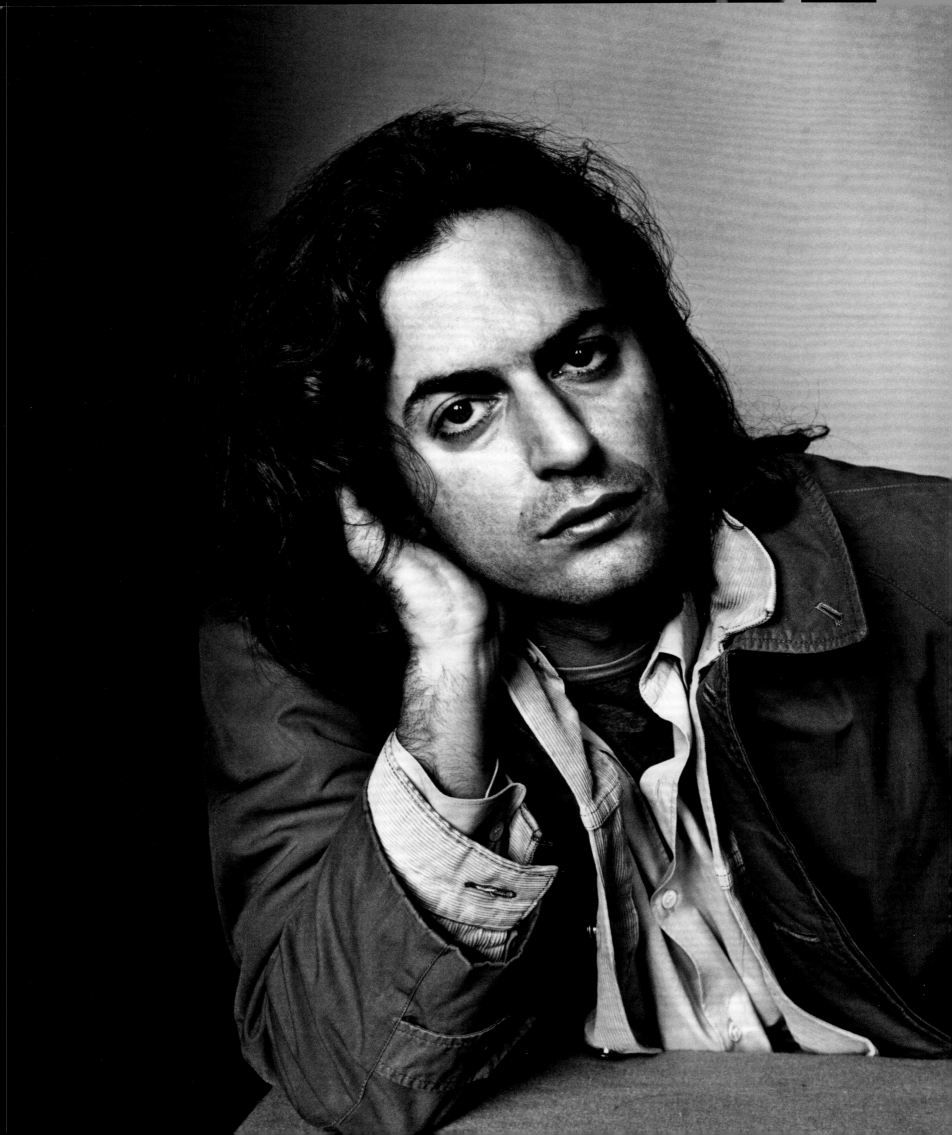

"I remember how thrilled I was when I received a phone call requesting to be photographed by Irving Penn for American *Vogue*. I was so honored to join the illustrious group of individuals he so marvelously captured on film. My portrait was scheduled to take place in the days following my show that season, which was September 10, 2001 (Spring/Summer 2002). The next morning, the whole world changed. While the portrait was the furthest thing from my mind following the chaos, fear and mourning in the days after September 11th, I received a call from Phyllis on September 13th informing me that Mr. Penn would still like me to sit for a portrait. I was immediately reminded of the story a dear friend frequently shared about her neighbor Irving Penn and how every morning at the same time he would leave for his studio—whether he was working or not . . . There was something about this little vignette into his life that felt like an important metaphor in the days following September 11, 2001. I was asked to come ungroomed and unshaven wearing the rain Mac and clothes he had once seen me in. I vividly remember that day—meeting the genius Irving Penn whose photographs I had always loved and how nice, gentle, and thoughtful he was to me. His studio was so beautiful in its simplicity. There was no tricky lighting setup, teams of assistants, or studio managers—just Mr. Penn, his assistant, and Phyllis. I remember this overwhelming feeling of the perfection, precision, and vision that came directly from him. He spoke calmly as he directed me to a gesture and explained that he was most interested in capturing the moment just before the motion took place. The beauty of what made an Irving Penn portrait a Penn portrait was quite literally Irving Penn."—MARC JACOBS

Marc Jacobs
New York, 2001

"Penn's collaborations with Phyllis on projects for *Vogue* were of great importance to him. He relied on her to provide him with the 'ingredients' he determined were necessary to realize his visions and stir his imaginings. Although there was much love and respect between them, there could also be tension. Having experienced this myself working with him during the last fifteen years of his life, I came to appreciate the delicate balance they maintained during their collaborations. But, this all seemed to come to a boiling point around 2005. There was a disagreement. About what, I don't recall. Phyllis left the studio in a huff. Penn sat brooding at our shared desk. 'I wish I could work with another editor,' he said. After some moments of observing his misery, I began to suggest other *Vogue* editors he might work with on future assignments. As I ran down the (short) list naming each one, his responses were 'No, not her.' 'No, wouldn't be a good fit.' 'Never.' Finally I suggested 'Maybe you should speak with Anna about finding a new editor for you?' He didn't like that idea either. I think that when he considered the alternatives to Phyllis, he began to appreciate more his reliance on her and his faith in her efforts. The next sittings were calmer, although there continued to be moments of tension between them. I came to realize how important the work they did together was to Penn, how he trusted her and her opinions, even though they could rub him the wrong way. In fact, he adored her."—DEE VITALE HENLE

Beauty Treatment with
Gauze Mask
New York, 1997

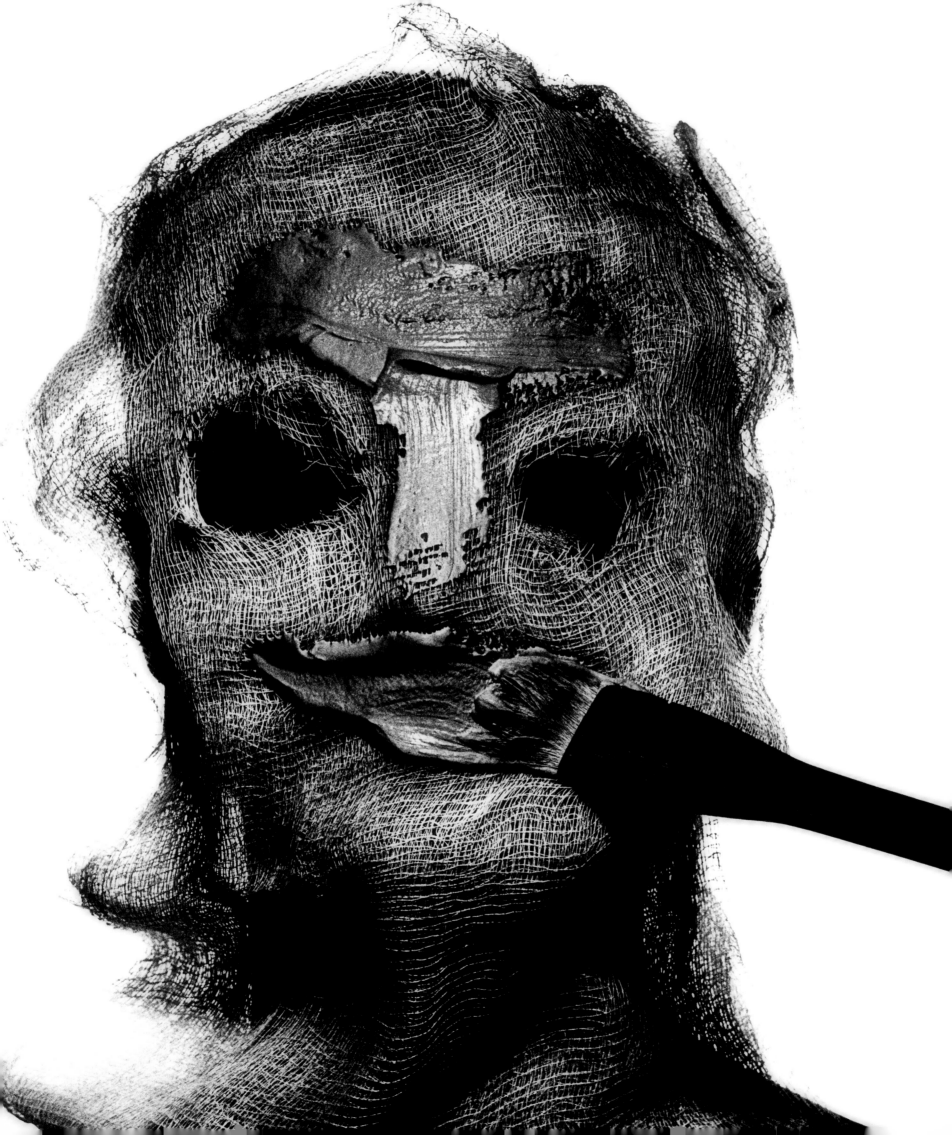

Sometimes when the editor and hair and makeup artists are very pleased with the look that they've created for a photo—or should I say, especially when the editor and hair and makeup artists are very pleased— the photographer has other ideas. We spent at least two hours getting Caroline Trentini ready to be photographed in this beautiful dress, designed especially for our sitting by Olivier Theyskens, designer at Nina Ricci at the time. When Penn walked into the dressing room to find out what was taking so long, he stood motionless for what seemed like an eternity. There was a long silence, a little intake of breath, and an almost imperceptible shake of his head. Not a good sign. He turned around and went straight back to the simple office he shared with Dee Vitale Henle. I found him sitting with his head in his hands: "It wasn't what I was dreaming of . . . Can you make her hair look like a cloud?" We began again and you see the result.

Ball Dress by Olivier Theyskens
for Nina Ricci
New York, 2007

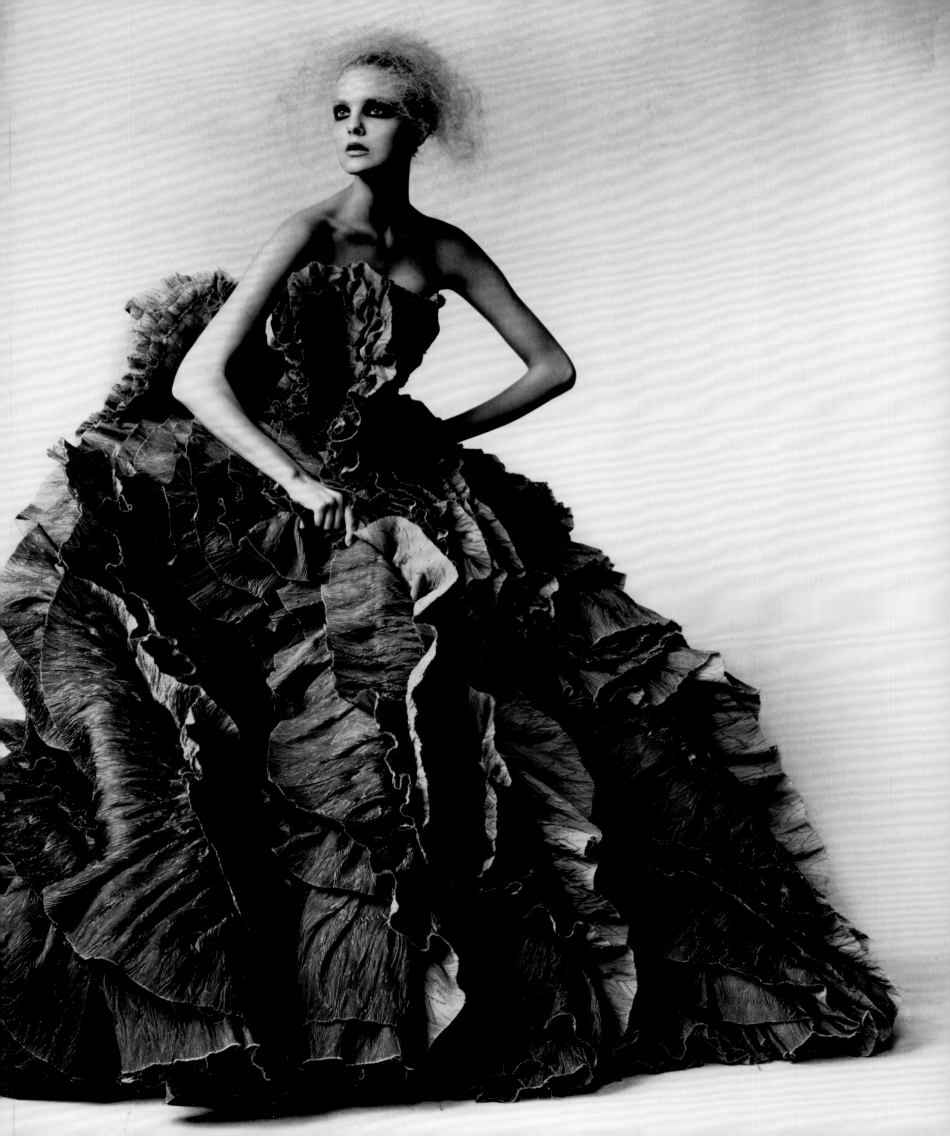

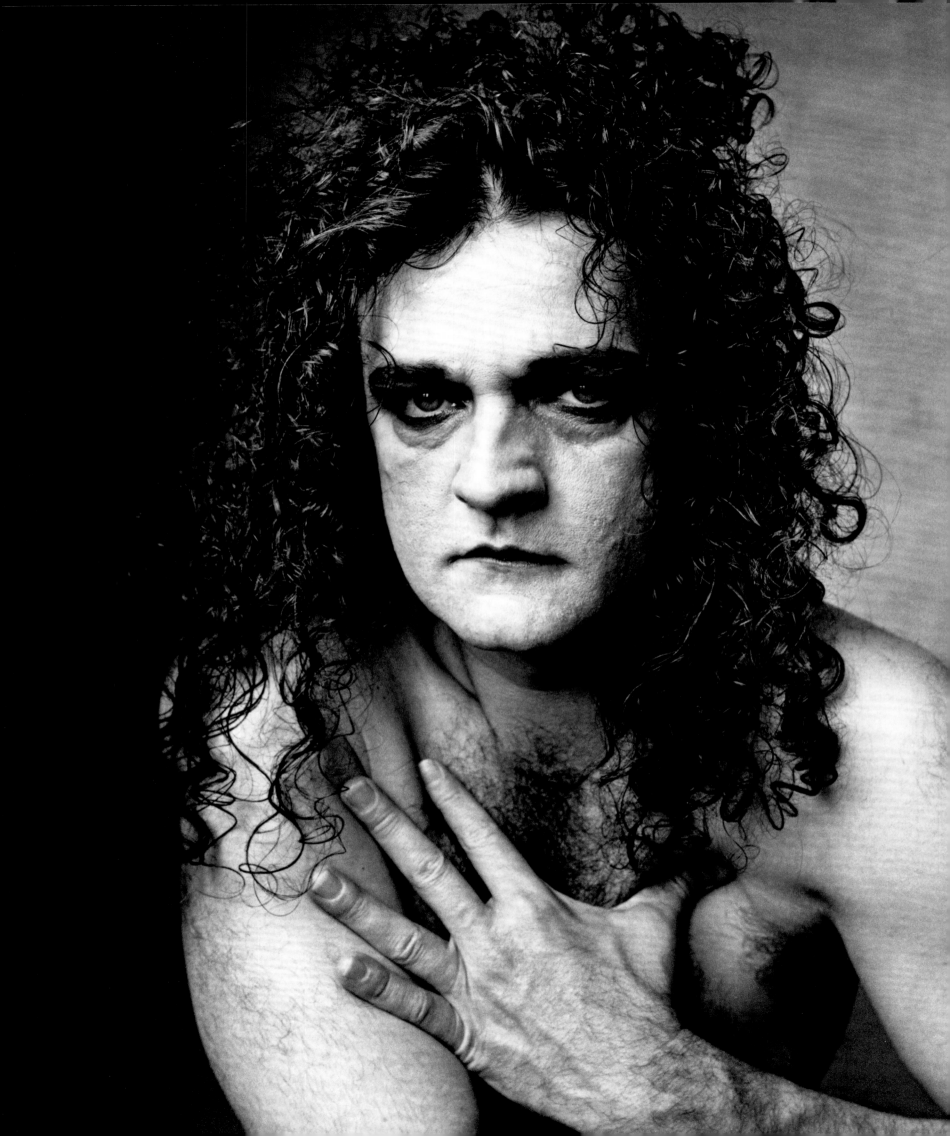

Every day, Penn walked the five blocks
from his apartment to his old studio
with high windows facing west, on lower
Fifth Avenue. He arrived in his "street
clothes" and changed into a blue tab-collar
Issey Miyake shirt, blue jeans, and navy
Superga sneakers. He liked quiet; there
was no music, and if we got too noisy in the
dressing room, Penn would come in to see
what was going on. There was no smoking
permitted, even in the days when smoking
was allowed. When he did portaits, Penn
would sit with his subjects before he began
to photograph them and speak in a very
quiet voice. The purpose was to create an
intimacy and make people comfortable in
the studio. This calm was shattered one
morning when the great choreographer
and director, Mark Morris, came to be
photographed. Mark, a larger than life
presence, arrived, met Penn, sat down to
talk, and lit a cigarette. Penn's assistants
and I froze, exchanged looks, and didn't
know what to do. Penn acted like nothing
happened, continued the conversation,
discussed the photo—Mark would put on
his performance makeup and wear no shirt
for the photo, and they had a lovely day.

Mark Morris
New York, 1996

241

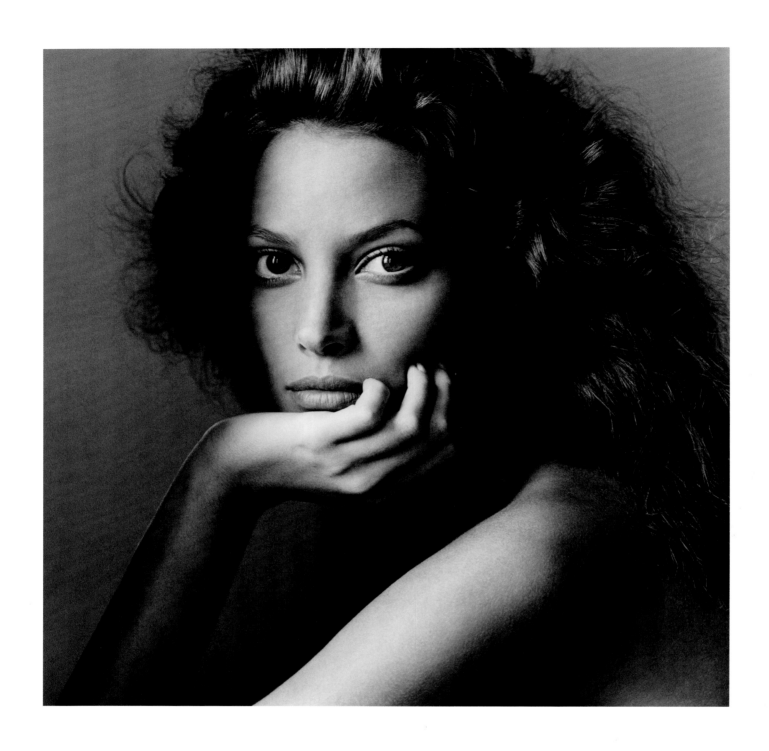

THIS PAGE:
Christy Turlington
New York, 1994

OPPOSITE:
Canvas Head with Hardware
(Design by Jun Takahashi)
New York, 2006

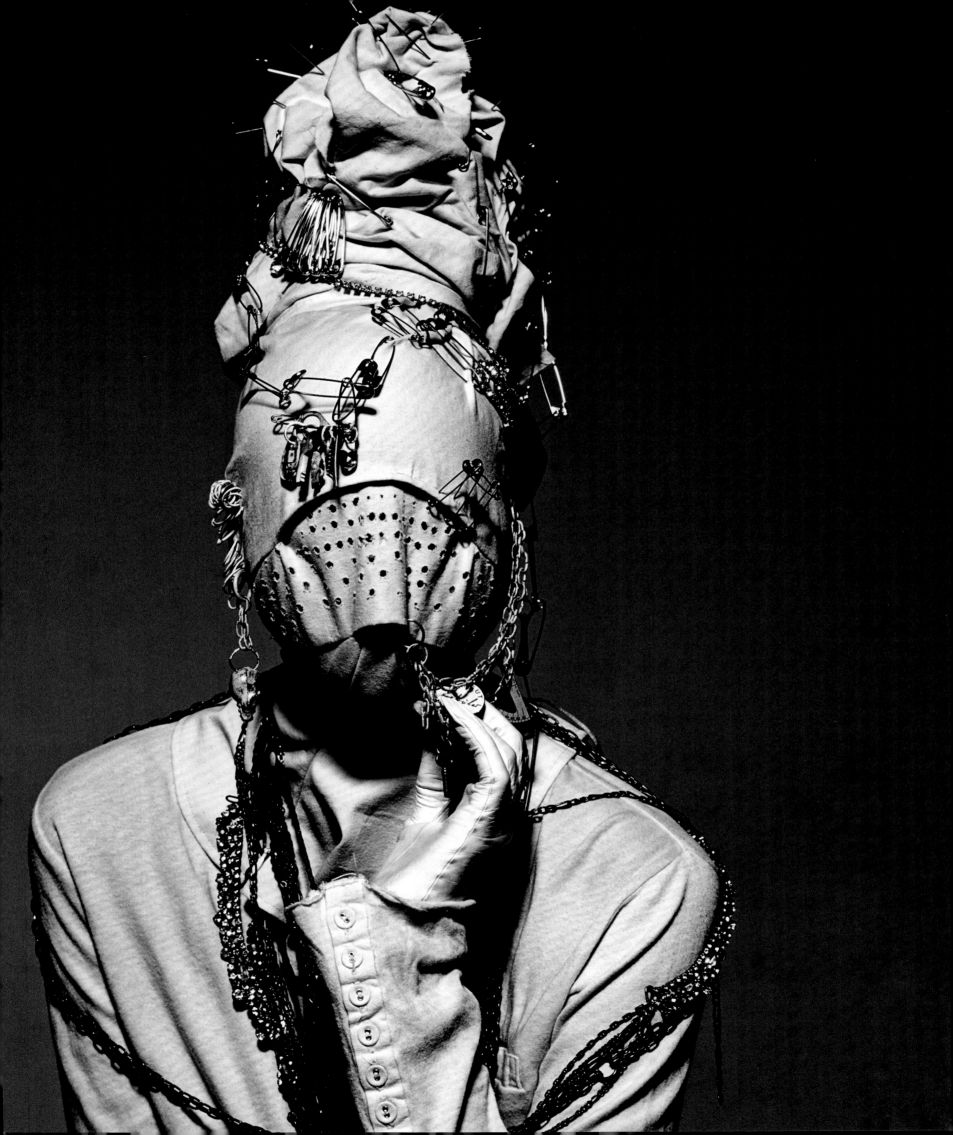

The "Art of Couture" sitting that Penn
photographed in the daylight Paris studio
lasted a week. In addition to photographing
couture dresses from Chanel, Lacroix,
Versace, and others, we photographed other
designers and créateurs like Mr. Pearl and
Philip Treacy who designed the "hats" for
Chanel Couture. Mr. Pearl was the legendary
and elusive designer of extraordinary corsets
that were responsible for the perfect line of
the dresses. Couture is as beautiful on the
inside as it is on the outside, and his corsets
were made of rich silks, lace, and the finest
cotton. His one-of-a-kind, handmade corsets
take months to make and can cost more
than $10,000. Mr. Pearl also practices what
he preaches. He's an elegant man who has
an eighteen-inch corseted waist, and wears
his corset twenty-four hours a day, seven
days a week, except to bathe. Leigh Bowery
discovered him and in 1989 introduced
him to Thierry Mugler who brought him
to Paris to work on his couture and ready
to wear collections. Mr. Pearl designed for
Alexander McQueen, John Galliano, Vivienne
Westwood, and Christian Lacroix, and has a
list of private clients who cannot be named.

Mr. Pearl
Paris, 1995

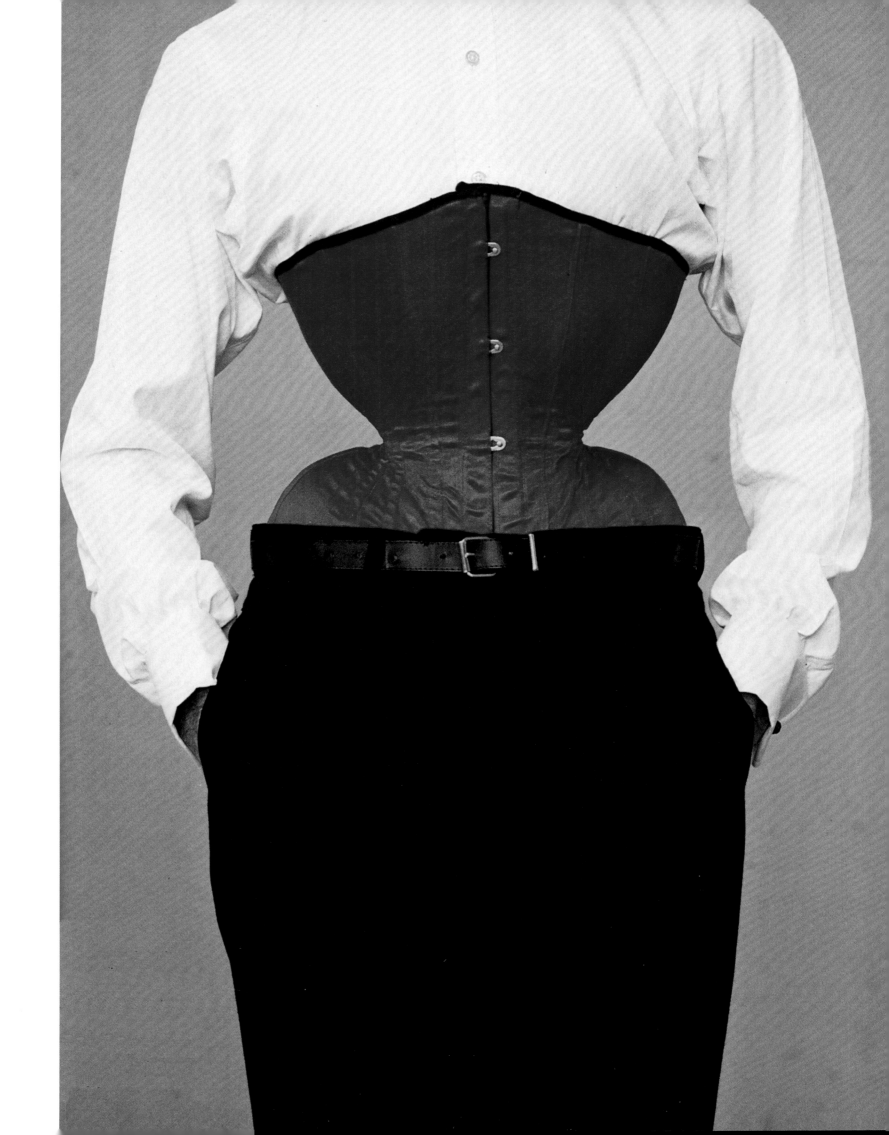

Sweetie (A)
New York, 2002

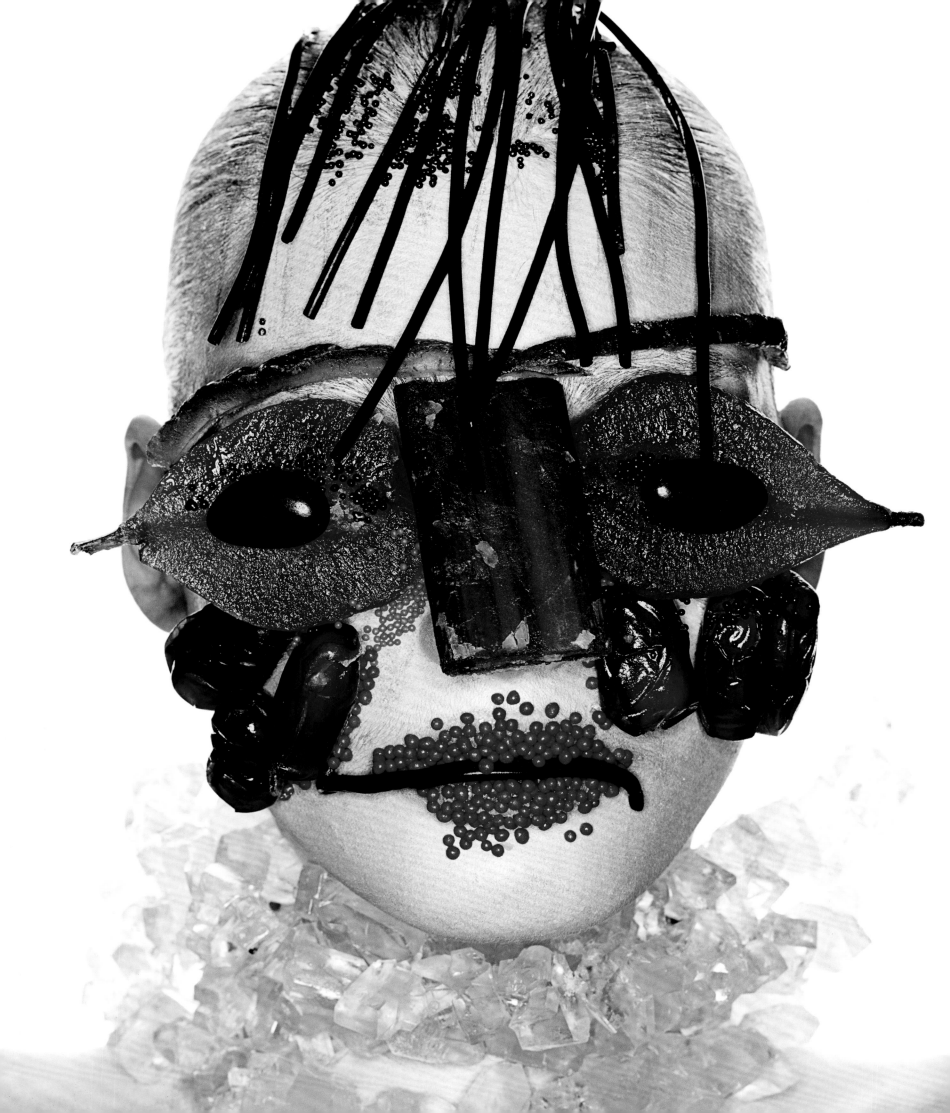

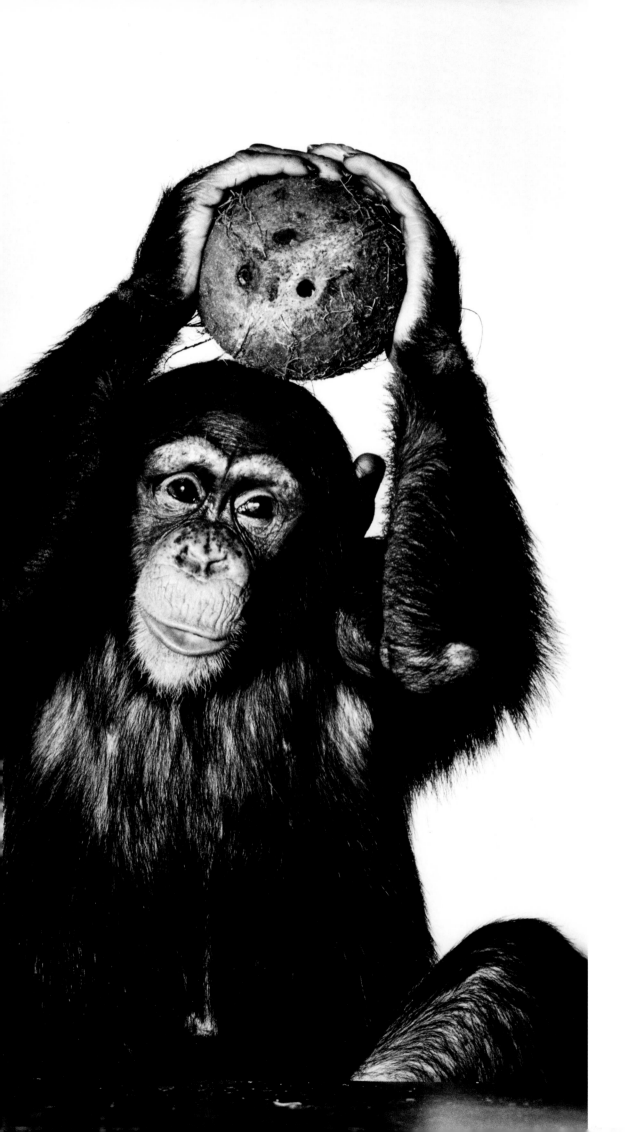

While Penn photographed, his soft voice would purr commands to his models. "See something." "Think lovely thoughts." When he said "move your arm," he meant no more than an inch. His praise was just as restrained. "That's just fine" or "That's very beautiful" was as good as it got. When models heard those words, they would respond by becoming even more beautiful. But not all his models responded to him in that way. When Penn worked on this photo, he was enchanted by the little orangutan . . . less by the chimp. As soon as he sat them in front of his camera, the chimp picked up his coconut and threw it on the floor. Penn began to direct the animals as if they were models. Of course, they paid no attention to him. He would start over, talking to them, telling them to "hold the position— don't move." The chimp threw the coconut on the floor again and again. Penn quickly realized what he was doing and laughed and laughed. So did we. People sometimes said that his studio was like a cathedral, but there was joy and laughter and love and a squeaky floor in that cathedral.

**Orangutan and Chimpanzee
(with Two Coconuts)**
New York, 2004

Credits

COVER

Image © Condé Nast

Nadja Auermann in Chanel Haute Couture by Phillip Treacy; Hair and feather styling, Julien d'Ys for Atlantis; Makeup, Kevyn Aucoin; December 1994.

ENDPAPERS

Dan Belknap.

FRONT PAGES

p. 4 Dress, Dolce & Gabbana; Background, Eres swimsuit; Hair, Paul Hanlon; Makeup, Linda Cantello for Giorgio Armani Beauty; Produced by Libi Molnar for North Six; Set design, Mary Howard; August 2012.

p. 8 Image © Condé Nast

p. 10 Nicole Kidman in Rochas; Hair, Luigi Murenu for Streeters; Makeup, James Kaliardos; September 2003.

p. 16 Clockwise from top left: Tim Walker, 2015; Patrick Demarchelier, 2008; Jonathan Becker; Bruce Weber, 2011; Norman Jean Roy, 2004; Patrick Demarchelier 2008; Bruce Weber, 2006; Matthias Gaggl, 2010; Davé (in frame.)

p. 17 Clockwise from top left: Irving Penn (framed photos); Herb Ritts, 1997; Arthur Elgort; Steven Klein, 2008; Bruce Weber, 2007; Alexandra Cronan, 2015; Alexandra Cronan, 2015.

p. 18 Clockwise from top left: Unkown; Steven Klein, 2006; Annie Leibovitz, 2012.

p. 19 Clockwise from top left: Bruce Weber, 2015; David Jakle, 1998; Vasilios Zatse, 2004; Vasilios Zatse, 2007; Mary Howard, 2013; Sara Moonves, 2009; Bruce Weber, 2013; © The Irving Penn Foundation, 1995; Yohana Lebasi, 2016 (center.)

p. 21 Dan Belknap.

STEVEN KLEIN

All images © Steven Klein

pp. 22-25 Dress, Dolce & Gabbana; Été swimsuit, Michael Kors turtleneck, Marc by Marc Jacobs shorts; Hair, Paul Hanlon; Makeup, Linda Cantello; Produced by Libi Molnar for North Six; Set design, Mary Howard; August 2012.

pp. 26-27 Karlie Kloss in Marc Jacobs; Hair, Garren; Makeup, Kabuki; Produced by North Six; Set design by Mary Howard; November 2013.

pp. 28-29 Anais Pouliot in Rochas; Hair, Garren; Makeup, Linda Cantello; Produced by North Six; Set design, Mary Howard; February 2012.

pp. 30-31 Caroline Trentini in Agent Provocateur; Hair, Jimmy Paul; Makeup, Stéphane Marais; Set design, Andrea Stanley; Produced by North Six; February 2010.

pp. 32-33 Shannan Click. Hair, Ben Skervin; Makeup, James Kaliardos; Set design, Andrea Stanley; August 2007.

pp. 34-35 Liisa Winkler in Proenza Schouler; Hair, Julien d'Ys; Makeup, Fulvia Farolfi; Set design, Andrea Stanley; Produced by North Six; December 2007.

pp. 36-37 Caroline Trentini in Wolford tights and Louis Vuitton lace-up gillies; Hair, Julien d'Ys; Makeup, Carla White; Set design, Mary Howard Studio; November 2004.

pp. 38-39 Lisa Cant; Makeup, Stéphane Marais; January 2006.

pp. 40-41 Benjamin Walker as Patrick Bateman in Brooks Brothers; Makeup and special effects, Carla White; Grooming, Thom Priano; Set design, David White; March 2016.

pp. 42-43 Karlie Kloss in Vera Wang; Hair, Garren; Makeup, Diane Kendal; Set design by Mary Howard; Food styling by Victoria Granof; Produced by North Six; May 2011.

pp. 44-45 Angela Lindvall in Ralph Lauren Collection; Hair, Luigi Murenu; Makeup, Peter Philips; Set design, Mary Howard; August 2006.

pp. 46-47 Dita Von Teese in Vivienne Westwood and Marilyn Manson in John Galliano Homme; Hair, Danilo Dixon; Makeup, Kathy Jeung; Produced by North Six; Set design, Mary Howard Studio; March 2006.

pp. 48-49 Caroline Trentini in Dolce & Gabbana; Hair, Orlando Pita; Makeup, Peter Philips; Produced by Dana Brockman for Viewfinders; Set design, Andrea Stanley; December 2008.

pp. 50-51 Karlie Kloss; Veil painting, cap, and hair, Julien D'Ys; Makeup, Stéphane Marais; August 2009.

pp. 52-53 Daria Strokous in Altuzarra; Hair, Garren; Makeup, Sammy Mourabit; Set design, Andrea Stanley; May 2014.

pp. 54-55 Hair, Luigi Murenu for Streeters; Makeup, Mark Carrasquillo; Photographed at Bot, NYC; January 2002.

pp. 56-57 Shannan Click in Ellen Tracy; Hair, Christiaan; Makeup, Peter Philips; Produced by Jessica Brown and Larry McCrudden. Set design by Andrea Stanley; April 2007.

pp. 58-59 Coco Rocha in Narciso Rodriguez dress; Hair, Oribe; Makeup, Kabuki; Set design by Mary Howard; Produced by Sabine Mañas; November 2008.

pp. 60-61 Caroline Trentini; Hair, Julien d'Ys; Makeup, Stéphane Marais; Produced by Libi Molnar; Set design by Viki Rutsch for Mary Howard Studio; July 2011.

pp. 62-63 Marta Berzkalna in Christian Louboutin and Tobias; Hair, Bill Westmoreland; Makeup, James Kaliardos; August 2008.

pp. 64-65 Guinevere van Seenus; Hair, Jimmy Paul; Makeup, Carla White; Production design by Mary Howard Studio; Photographed at River Meadow Farm, LLC Windsor, CT; June 2005.

pp. 66-67 Karlie Kloss in Naeem Khan; Hair, Julien d'Ys; Makeup, Linda Cantello; Production by Libi Molnar for North Six; Set design by Viki Rutsch at Mary Howard Studio; Kitchen by IKEA; October 2011.

pp. 68-69 Angela Lindvall in Dolce & Gabbana; Hair, Jimmy Paul; Makeup, James Kaliardos; Set design, Mary Howard; August 2006.

pp. 70-71 Lisa Cant in Louis Vuitton and Guinevere van Seenus in Chanel; Hair, Julien d'Ys; Makeup, Peter Philips; Set design, Andrea Stanley; 3Star Productions; May 2008.

pp. 72-73 Catherine McNeil in Oscar de la Renta; Hair, Eugene Souleiman; Makeup, Peter Philips; Produced by North Six. Set design by Mary Howard Studio; August 2008.

pp. 74-75 Lisa Cant in Giorgio Armani; Hair, Julien d'Ys using Mokuba ribbon; Makeup, Stéphane Marais; Set design, Mary Howard Studio; Photographed at the Hackensack University Medical Center, New Jersey; January 2006.

TIM WALKER

All images © Tim Walker

pp. 76-77 Raquel Zimmermann in Valentino; Hair, Julien d'Ys; Makeup, Sam Bryant; Produced by Padbury Production; Set design, Emma Roach; September 2015.

p. 78 Xiao Wen Ju in Lanvin; Hair, Julien d'Ys; Makeup, Val Garland. Set design, Emma Roach; September 2012.

pp. 156-157 Daniel Radcliffe and Richard Griffiths in Rochester Big & Tall Clothing; Grooming, Stacy Skinner; Set design, Wade & Strauss; Photographed at Tiffany Acresin Colts Neck, NJ; September 2008.

pp. 158-161 Viktoriya Sasonkina, Coco Rocha, Karlie Kloss, Jourdan Dunn, and Raquel Zimmermann in John Galliano. Julien d'Ys and Raquel Zimmermann in headpiece by d'Ys for Comme des Garçons; Hair design and headpieces, Julien d'Ys; Makeup, Stéphane Marais; March 2009.

MARIO TESTINO

All images © Mario Testino

pp. 162-165 Karlie Kloss (p.166, Michael Kors bodysuit, mask by Katsuya Kamo for Undercover, and Rochas pumps); Hair and headpiece, Julien d'Ys; Makeup, Gucci Westman; Produced by Marcus Kurz; July 2013.

p. 166 Lara Stone in Donna Karan New York; Hair, Christiaan; Makeup, Stéphane Marais; January 2011.

pp. 167-169 Karlie Kloss. Hair, Julien d'Ys; Makeup, Stéphane Marais; July 2012.

ANTON CORBIJN

All images © Anton Corbijn

pp. 170-171 Alex Sharp; Menswear Editor: Michael Philouze; Grooming, Thom Priano; Produced by Wanted Media, Inc.; September 2014.

p. 172 Cary Fukunaga in Dolce & Gabbana; Menswear Editor, Michael Philouze; Grooming, Claudia Lake; Produced by Kate Collins-Post for North Six; November 2015.

p. 173 David Chang; Photographed at Ssäm Bar; September 2013.

p. 174 Christopher Wool; Photographed in his East Village studio; October 2013.

p. 175 Francis Alÿs; Photographed in his Mexico City studio; May 2011.

pp. 176-177 Nicola Walker, Mark Strong, and Phoebe Fox in A View from the Bridge; Costumes, An D'Huys; Makeup, Celia Burton; Produced by 10-4; October 2015.

pp. 178-179 Savion Glover; April 2014.

p. 180 Bjarke Ingels; 2015

p. 181 Michael Williams; Photographed at his studio, Queens, New York; August 2015.

pp. 182-183 Simon Paisley Day in The Lorax; Costumes and set design, Rob Howell; Hair, Campbell Young; Makeup, Val Garland; Puppetry, Finn Caldwell; Produced by 10–4, London; December 2015.

pp. 184-185 Philip Seymour Hoffman in Calvin Klein Collection; Grooming, Thom Priano; March 2012.

IRVING PENN

All images © Condé Nast unless otherwise noted.

pp. 186-187 Nadja Auermann in Chanel Haute Couture by Phillip Treacy; Hair and feather styling, Julien d'Ys; Makeup, Kevyn Aucoin; December 1994.

p. 188 Shalom Harlow in Christian Lacroix Haute Couture; Hair, Julien d'Ys; Makeup, Kevyn Aucoin; December 1995.

p. 189 Carolyn Murphy in Dior Haute Couture; ; Hair, Orlando Pita; Makeup, Pat McGrath; © The Irving Penn Foundation; December 1997.

p. 191 Hedi Slimane in Dior Homme; May 2001.

pp. 192-193 Irina Pantaeva and Valerie. Hair, Orlando Pita; © The Irving Penn Foundation; July 1995.

pp. 194-195 Cate Blanchett in Balenciaga. Hair, Julien d'Ys; Makeup, Pat McGrath; July 2007.

pp. 196-197 Nicolas Ghesquiere; March 2001.

pp. 198-199 Gemma Ward in Balenciaga; Hair, Julien d'Ys; Makeup, Peter Philips; March 2006.

pp. 200-201 Makeup by Susan Sterling; Ice styling by Joe O'Donoghue for Ice Fantasies, NY; February 2003.

pp. 202-203 Christian Dior Haute Couleur Lipstick; Makeup, Kevyn Aucoin; Bees, All Tame Animals; © The Irving Penn Foundation; December 1995.

pp. 204-205 Hair, Renato Campora; Makeup, Max Delorme; April 2004.

pp. 206-207 Caroline Trentini in John Galliano; Hair and red feather headpiece, Julien d'Ys; Makeup, Pat McGrath; July 2007.

pp. 208-209 Gisele. Hair, Thom Priano; Makeup, Stephane Marais; © The Irving Penn Foundation; April 2006.

pp. 210-211 Food styling, Victoria Granoff. February 2001.

p. 212 Lily Cole in John Galliano; Hair, Julien d'Ys; Makeup, Stephane Marais; July 2005.

p. 213 Carolyn Murphy in Dolce & Gabbana; Hair, Orlando Pita; Makeup, Pat McGrath; © The Irving Penn Foundation; December 1997.

pp. 214-215 Hair, Kevin Mancuso; Makeup, Pat McGrath; © The Irving Penn Foundation; November 1996.

pp. 216-217 Body makeup, Meredith Baraf; © The Irving Penn Foundation July 2007.

pp. 218-219 Lisa Cant in Yves Saint Laurent; Hair, Julien d'Ys; Makeup and mask, Peter Philips; December 2005.

pp. 220-221 Makeup, James Kaliardos; July 2001.

pp. 226-227 Jaime Rishar; Hair, Didier Malige; Makeup, Kevyn Aucoin; April 1994.

p. 228 Kate Moss; Hair, Julien d'Ys; Makeup, Kevyn Aucoin; September 1996.

p. 229 Susan Holmes in Chanel Haute Couture; October 1994.

p. 230 Chastity belt, New York Body Archive; Body makeup, Fulvia Farolfi; April 2002.

pp. 232-233 Nicole Kidman in vintage chiffon dress from Southpaw Vintage Clothing and Textiles, NYC; Hair, Orlando Pita; Makeup, Diane Kendal; September 2003.

pp. 234-235 Marc Jacobs; November 2001.

pp. 236-237 Beauty treatment, Marcia Kligore; December 1997.

pp. 238-239 Caroline Trentini in Nina Ricci; Headpiece and hair, Julien d'Ys; Makeup, Stéphane Marais; March 2007.

pp. 240-241 Mark Morris; January 1999.

p. 242 Christy Turlington; Hair, Orlando Pita; Makeup, Kevyn Aucoin; September 1994.

p. 243 Gemma Ward in Undercover; September 2006.

pp. 244-245 Mr. Pearl in his own design; December 1995.

pp. 246-247 Hair, Thomas Hintermeier; Makeup, James Kaliardos; Candied fruit, Fauchon; January 2003.

pp. 248-249 Orangutan and chimpanzee, All Tame Animals; December 2004.

BACK PAGES

Image © Steven Klein

p. 254 Steven Klein; Catherine McNeil in Christian Louboutin; Produced by North Six; August 2008.

Acknowledgments

I am grateful to Anna Wintour who encouraged this project from the beginning. More than that, she is the force behind the pictures, inspiring me, giving me freedom and, in fact, telling me to "Try it!" again and again. Thank you, Anna.

Thank you to the late Alexander Liberman, Editorial Director of Condé Nast Publications (1960–1991), for taking a strong interest in me, watching over me and bringing me to *Vogue*—twice. He introduced me to Irving Penn, whose pictures he described as "stoppers," thus providing the title for this book.

Special thanks to all the photographers, models, hair and makeup artists who gave their time, sometimes for only one picture a day, who made my job so rewarding and never, ever let me down.

I am indebted to Tom Penn and Dee Vitale Henle of The Irving Penn Foundation and to June Newton of the Helmut Newton Foundation for their generous support.

Grace Coddington has been my dear friend for so many years that I don't dare count them. We have been colleagues at *Vogue* during most of that time and she made me do this book.

Thanks to Raul Martinez, whose fine eye made it better; to David Byars, who put it all together; to Martin Hoops, for the finishing touches; and to Sandra Klimt, for seeing it through to the end.

I have enjoyed working with Rebecca Kaplan, my editor at Abrams, and thank her for the perceptive suggestions and her indulgence with me.

Thanks to my many long-suffering assistants for making all the photographs happen.

And to Michael Boodro, Valerie Boster, Nan Bush, Jessica Calgione, Charlie Churchward, Alexandra Cronan, Fiona Da Rin, Jill Demling, Jiminie Ha, Rosemary Hansen, Timothy Herzog, Oneta Jackson, Billy Jim, Dodie Kazanjian, Roger Krueger, Joe Lally, Ernie Liberati, Christiane Mack, Tiggy Machonichie, Polly Mellen, Sara Moonves, Karen Mulligan, Candice Murray, Michael Sand, Babs Simpson, Ivan Shaw, Adam Sherman, Anet Sirna-Bruder, Virginia Smith, Helena Suric, Hannah Townsend, Shelley Wanger, Andrew Wylie, Danielle Young, Vasilios Zatse, and all the photographers' assistants.

Special thanks to Paul Cohen who encouraged and inspired me every step of the way.

—PHYLLIS POSNICK

Steven Klein
West Kill Farm
Bridgehampton, NY
August 2008

DESIGN DIRECTOR
Raul Martinez

PRODUCTION
David Byars
Sandra Klimt

COORDINATOR
Alexandra Cronan

FROM ABRAMS:
Editor: Rebecca Kaplan
Production Manager: Anet Sirna-Bruder

Library of Congress Control Number: 2015955655

ISBN: 978-1-4197-2244-8

Printed and bound in Italy
10 9 8 7 6 5 4 3 2 1

Abrams books are available at special discounts when purchased in quantity for premiums and promotions as well as fundraising or educational use. Special editions can also be created to specification. For details, contact specialsales@abramsbooks.com or the address below.

ABRAMS The Art of Books
115 West 18th Street, New York, NY 10011
abramsbooks.com

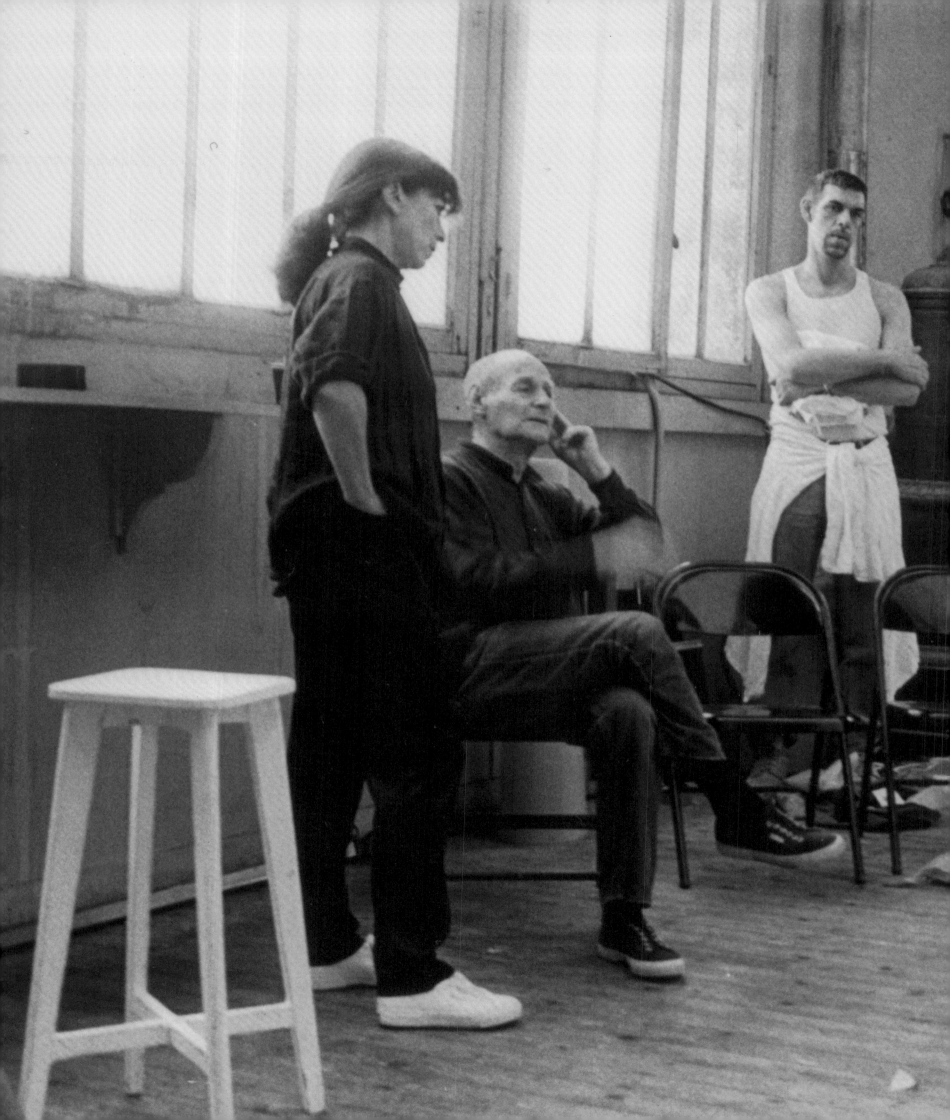